Muriel Cooper

Muriel Cooper

David Reinfurt and Robert Wiesenberger

The MIT Press Cambridge, Massachusetts London, England

This book was set in Neue Haas Grotesk by the MIT Press.
Printed and bound in Italy.

Published with the generous support of the Jeptha H. and
Emily V. Wade Fund.

Library of Congress Cataloging-in-Publication Data
Names: Reinfurt, David. Soft copy. | Wiesenberger, Robert. Hard copy.
Title: Muriel Cooper / David Reinfurt and Robert Wiesenberger.
Description: Cambridge, MA : The MIT Press, 2017. | Includes index.
Identifiers: LCCN 2016053528 | ISBN 9780262036504
(hardcover : alk. paper)
Subjects: LCSH: Cooper, Muriel – Criticism and interpretation. |
M.I.T. Press.
Classification: LCC NC999.4.C67 M47 2017 | DDC 741.6092 – dc23
LC record available at https://lccn.loc.gov/2016053528

10 9 8 7 6 5 4 3 2 1

I guess I'm never sure that print is truly linear.

— Muriel Cooper

Contents

Acknowledgments

This project has been a media archaeology of the recent past. It would have been impossible without the archivists and librarians who were so generous with their time and collections. They include Paul Dobbs, Sally Barkan, and Danielle Sangalang of the Morton R. Godine Library at the Massachusetts College of Art and Design; Gary van Zante of the MIT Museum; Jeremy Grubman of the Center for Advanced Visual Studies Special Collection at MIT; Myles Crowley, Nora Murphy, and Kari Smith in the MIT Institute Archives and Special Collections; William Whitaker at the Architectural Archives, University of Pennsylvania; and Carolyn Yerkes of the Avery Architectural and Fine Arts Library, Columbia University.

We are deeply grateful to Cooper's students, colleagues, and family, who helped us get the story straight and made it more vivid. The following people spoke enthusiastically and at length about Cooper: Ralph Coburn, Helen Curley, Gloriana Davenport, Karen Donoghue, Nathan Felde, Mario Furtado, Rob Haimes, Michael Hawley, Suguru Ishizaki, Bernd Kracke, Henry Lieberman, Donlyn Lyndon, John Mattill, Katherine McCoy, Elizabeth Resnick, Wendy Richmond, Lauri Rosser Slawsby, Joan Shafran, Lee Silverman, Joel Slayton, David Small, Sylvia Steiner, Lisa Strausfeld, Gary van Zante, Dietmar Winkler, and Richard Saul Wurman. Existing interviews with Cooper by Janet Abrams, Janet Fairbairn, Steven Heller, and Ellen Lupton were also invaluable. We are particularly grateful to Cooper's collaborator of twenty years, Ron MacNeil, who offered insights with generosity and good humor, and to Cooper's sister, Charlotte Lopoten, and nephew, Jonathan Jackson, in whose family kindness, energy, and wit clearly run. We also wish to thank our editor at the MIT Press, Roger Conover, for whom this material is of personal and professional significance.

We are indebted to the Graham Foundation for Advanced Studies in the Fine Arts, which generously supported this project through a 2013 Research and Development grant. We would like to thank Larissa Harris for inspiring and facilitating the initial research for this project at the MIT Center for Advanced Visual Studies, and Barry Bergdoll, Noam Elcott, and Felicity Scott at Columbia University for their steadfast support and shrewd insights. Margot Case, Wendy Richmond, and Molly Steenson were of great help in reviewing drafts of this work. Thank you to Mark Wasiuta, Adam Bandler, and the exhibitions team of Columbia's Graduate School of Architecture, Planning and Preservation for realizing our 2014 exhibition on Cooper at the Arthur Ross Architecture Gallery. Special thanks to Nicholas Negroponte and Deborah Porter for their patience and support.

Foreword

Lisa Strausfeld

There was so much more I wanted to know about Muriel Cooper. In 1994, I was a year into a master's program at MIT and had found my first true mentor. But that evening in May — sitting on the floor of the Cyclorama building in Boston, holding Muriel's hand at an unexpectedly intimate moment — would be our last together. She was lying serenely on her back after collapsing at a sponsor dinner for the Media Lab. Someone had phoned 911 and EMTs were readying a stretcher. Muriel thought it was an unnecessary "fuss" and told me that she was just tired and wanted to go home. She died a few hours later at the hospital from heart failure.

I was Muriel Cooper's student from August 1993 to May 1994. Graduate students at the MIT Media Lab do not exactly feel like students. They're called research assistants and are fully funded with tuition and a stipend. As one of six new students (among around twelve in total) in the Visible Language Workshop (VLW), I spent my days and most of my nights working in an open but intimate carpeted lair on the fourth floor of the iconic I. M. Pei building that housed the other dozen or so small research groups of the Media Lab. Tod Machover's Opera of the Future group was next door. Marvin Minsky worked in an office next to Muriel's. Walter Bender's News in the Future group was downstairs, and Glorianna Davenport's Interactive Cinema group was across the hall.

Whatever formal instruction took place at the VLW came from Ron MacNeil (Muriel's collaborator and VLW cofounder), David Small (a PhD student and coding genius who had been working in the VLW since his undergrad computer science days at MIT), and Suguru Ishizaki (a PhD student with a graphic design background and European modernist aesthetic closely aligned with Muriel's). Muriel would be in and out every day, on no apparent or predictable schedule unless it was time to review our work or meet with sponsors. She breezed in, draped in billowy black and gray fabrics, always accompanied by her black and gray poodle, Suki.

Because Muriel didn't really teach me directly or in any traditional sense, it took me a long time to fully understand and appreciate her influence on my work and way of thinking. At the time, I felt that my work was completely my own. But as I look back I realize how brilliantly guided and nurtured it was by the environment that Muriel created:

• The physical space of the VLW felt both safe and exploratory — a bit like a family den or a preschool playpen with a couple million dollars' worth of toys. It very specifically fostered community, encouraged collaboration, and supported personal risk taking.

• Although each student had to have some degree of computer programming experience to enter the Lab, the mix of students at the VLW was adroitly curated by Muriel to create an overall balance of talents across the design and computer science divide. Most of my hands-on learning came from working alongside my VLW classmates, often late into the night. My thesis project, for example, was done jointly with Earl Rennison, another VLW student with a depth of computing skills that complemented my design background. We ended up founding a company called Perspecta in 1996.

• Every VLW (and Media Lab) student had required "demo duty" a couple of times a week. We had to learn, operate, and present software prototypes created by our VLW predecessors (over the previous decade or so) to visiting sponsors. These visitors included senior government intelligence officials, telecom execs, and a number of media publishers fearing their obsolescence. Despite the two-year turnaround of master's students, the research output of the VLW continually progressed along a clear line of design inquiry rather than becoming repetitive – something Muriel would never have tolerated.

• The sponsors of the VLW were oriented to information rather than entertainment. At the time this seemed unsexy and like a missed opportunity for a VLW student on the fourth floor of the Media Lab watching the celebrity visitors of the Cinema and Music groups. But it was Muriel's clear preference. I know this because I once asked her about it. She was far more interested in solving the gnarly information overload problems of the day and of what she must have known was coming soon to our desktops and devices. But Muriel was no mere functionalist. She knew then what I know now after many years of working as an interactive designer: the solutions to the most challenging information problems can be far more compelling than nearly any other design challenge.

• The VLW always had the latest display and rendering technology, which included, in 1993, a Connection Machine and a 6,144-by-2,048-pixel display (the highest resolution in the world at the time) known by students as "the big guy." Shortly after I arrived we were fortunate enough to receive the first batch of Silicon Graphics (SGI) workstations running OpenGL, a 3D graphics rendering language. We also had one of the few SGI Onyx Reality Engines on the market (selling for a quarter-million dollars at the time) for very high resolution real-time 3D graphics rendering. The timing of the arrival of these 3D workstations was especially fortunate for me. I was trained as an architect and only knew how to design in three dimensions (rather than two). I also was able to dust off my undergrad knowledge of IRIS GL and matrix algebra, which came in handy.

• The VLW had an "open source" ethic, years before the free software movement proposed the term. David Small documented and maintained an extensive repository of code developed by VLW staff and students over the years – software libraries and tools, including the VLW's own version of Windows. This code sharing allowed new VLW students to pick up a thread of research and even a code base from former students, ensuring a continuity and evolution of design work.

• Lastly, a digital library of fonts was made available to VLW students. This was, perhaps, Muriel's most cleverly unifying offering. They were anti-aliased, carefully kerned (unlike the digital fonts available at the time), and in enough weights that no one felt constrained. And they were all in one typeface: Helvetica.

Beyond the environment of the VLW, I took away a few other key lessons from Muriel, both from how she worked and how she lived.

From Muriel I learned to be the author and editor of my work, as well as the designer. For my first project at the VLW I was working with a 3D model of intersecting planes. I had a form, but it was in need of content. One morning I returned to the VLW and Muriel had left a stack of floppy disks at my workstation. They were disks of mutual fund data from Morningstar. I became a quick expert on mutual funds and curated a set of data to populate my 3D model. The dialog between form and data was beneficial to both, and the marriage of the two took the project far beyond where the form had begun.

From Muriel, I learned to separate design and technology conversations. This may sound antithetical to what you would expect of an MIT Media Lab professor, but Muriel was known in the VLW for, essentially, forbidding technology conversations. She knew they needed to happen but insisted (often with an index finger on an outstretched arm pointing to the door) that they take place "in another room." She focused the important dialogue on design, narrative, and human experience. Technology wasn't unimportant or unconsidered, but its role was clearly in service of something other than itself. The need to separate design and technology conversations turned out to be one of the most valuable lessons I learned during my VLW experience.

I brought this ethic to Pentagram, the international design firm founded in London in 1972. I joined the New York office in 2002, as the first digitally fluent partner. At the time, clients were still commissioning design "artifacts" at various scales such as books, posters, business cards, annual reports, building signs,

exhibitions, and buildings. Clients now needed digital artifacts as well, which is how I initially built my business inside Pentagram. I was initially known as the "digital" partner, and people assumed I would be leading the "interactive department" of Pentagram. I knew that would be shortsighted, strategically, both for Pentagram and for my own career. By maintaining the separation of design and technology conversations, both internally and with clients, I was able to help my formerly nondigital partners seamlessly transition, as Muriel did, into the digital realm. Pentagram's great strength is in designing brand identities for corporate and cultural clients. The work became, in effect, media-agnostic as clients learned to shift their requests and creative briefs from a focus on specific artifacts to a focus on a mission or a message they needed to reach a specific audience. It became part of each design partner's strategy to determine which artifacts to produce across any medium, whether print, 3D, or digital.

From Muriel, I learned to trust my design instincts — even my restlessness. Muriel always seemed to trust her instincts about design. She trusted her impatience with repetition of design solutions and moved from designing book jackets and one-off book layouts for the MIT Press to conceiving of systems, first analog and then digital. Through the transition, Muriel remained devotedly passionate about design. She continued to allow herself to be seduced by it. I vividly recall a design review session with her on the Reality Engine. She was in the "passenger seat" next to me while I "piloted" us through my 3D grid of Morningstar financial data. We spent a long time, at her request, just moving around inside a dimensional space of numbers. Eyes glued to the screen, Muriel sat back in her chair and fully immersed herself in this new world, taking it in, feeling it more than intellectualizing it. It took me years to understand the significance of that moment and to trust my own design instincts as fully.

Lastly, and this one I'm still working on, from Muriel I am learning a healthy defiance of protocol. I knew she was the most senior female professor at the Media Lab and a designer at the forefront of technology. I did the math on her age when she started the VLW (49) and when she received tenure at MIT (63). I observed that she had a preference for not wearing shoes. But I really got to know who Muriel was, as a person, at her memorial service and from relationships that followed with those who were closest to her. I learned about her lapsed driver's license and chronically unpaid parking tickets. I learned that she did not marry or have children, but that many people in her life regarded her as family. I learned about her uncensored interactions with VLW Defense Department sponsors (who all apparently loved her).

As far as I can tell, Muriel had a liberating disregard for a number of protocols embedded in her time and place, including patriarchy, marriage, age, parking rules, and shoes. This is even more true of her work and central to her ability to innovate in her field of design for over 40 years.

Muriel was always driven to push and probe the boundaries and conventions of the medium within which she was working. In her early career, she regarded books as neither static nor linear, but as dynamic "random access" content. At the VLW she created an environment that explored typography in motion and 3D, and intelligent systems for laying out content on multiple and diverse displays. Her curiosity was limitless and inexhaustible, and always in service of what engaged her the most — what was possible.

This book is a thoughtful and long-overdue tribute to the legacy of Muriel Cooper. As today's technology-and-design-focused research labs imagine robotic furniture, new bio-imaging tools, and wearable input devices, the majority of our waking time is still spent looking at text, data, images, and video on illuminated displays slightly smaller than the size of our hands or a bit larger than the size of our heads. There are still significant problems to solve and far better possibilities to envision. I hope this book inspires designers and technologists to push and probe some more. To use her own words, Muriel's research still "stands as a sketch for the future."

Introduction

Muriel Cooper (1925–1994) worked across four decades at the Massachusetts Institute of Technology in overlapping roles as a graphic designer, teacher, and researcher. Spanning the transition from print to early explorations of digital typography to immersive information environments, her career maps onto one of the most dynamic periods in the Institute's history. At the MIT Press, Cooper designed the publisher's iconic logo, gave form to many volumes central to the history of art and architecture, and developed design and production standards still in use today. At the Visible Language Workshop within MIT's Department of Architecture, she taught experimental printing and hands-on production and tested new photography and video systems. And as a founding faculty member in the MIT Media Lab, she developed new software interfaces and mentored a generation of designers.

Yet hers is not a household name. Cooper is not in the pantheon of "great men" of graphic design, despite being the rare or even singular figure whose achievements were marked in both print and digital media, at the threshold of a historic transition between the two. She was more interested in process and research than product; her technical projects were often difficult to understand and not always public; and she worked behind the scenes or collaboratively, rather than under her name alone (a fact which vexes the attributions throughout this book). Cooper worked too hard, and died too young, to document her own career in any comprehensive way. This book, which appears more than twenty years after her passing, aims to bring together her activity at MIT alongside that of her students and colleagues, and place it in the context of currents in art, design, architecture, and media at and beyond MIT.

The two essays discuss Cooper's early and late work in print and software, respectively. These are followed by three portfolio sections, organized according to her overlapping but roughly chronological activities of design, teaching, and research from the mid-1950s to her death in 1994. The foreword is a remembrance of Cooper from a former student; the afterword, one from a collaborator and friend. The book's structure separates the text and image sections, as her Bauhaus book did, to let each speak for itself. The essays, however, use marginal images as a kind of visual table of contents pointing toward the portfolio sections that follow.

The work presented, from a variety of media, is given flat, equivalent treatment. In her early career as a designer and teacher, Cooper created or oversaw vast quantities of printed matter. What is included here demonstrates her approach and suggests the multiple discourses with which her work intersected, from art and design to architecture and artificial intelligence. Cooper's late work produced fewer durable artifacts. It was a period of research proposals, live demonstrations, and ideas that took electronic form. The records that survive are 35 mm slides, videotapes, and legacy code. Cooper's ideas persist in today's responsive user interfaces, digital media templates, and ubiquitous and powerful software tools. Yet her work's promise also remains, to some degree, open: Cooper signaled a direction that many artists and designers are actively pursuing. This book is intended, then, not as an archive but as a sourcebook for future production.

Hard Copy (1954 –1974)

Robert Wiesenberger

The poster, almost two feet square, reads: "Messages and Means." Or perhaps "Means and Messages," depending on where one begins. Vivid against a black square, the words pinwheel around the center, appearing to blink on and off, like a neon sign, or text on a screen. Cyan, magenta, and yellow, overprinted, produce purple, red, green. Around three sides are four neatly gridded columns of fine print set in Helvetica type. The first bears the legend: "Explorations of multiple forms of visual and verbal communication in print." Beside that, a new entity is named: "Sponsored by the Visible Language Workshop." And then the people behind the poster, and the class it advertises: "Jointly taught by Muriel Cooper of the MIT Press and Ron MacNeil of the Department of Architecture." A course and room number follow, and the date of the first meeting, September 13, 1974.

Cooper designed the poster and printed it with MacNeil on a sheet-fed offset press in MIT's Department of Architecture. It uses her favored "rotation" technique. Forgoing the time-consuming process of producing negatives on multiple plates, Cooper applied rub-on press type to acetate and exposed the plate directly from it. She ran the square sheet of paper through the press four times, rotating it and changing inks with each pass. Students in her classes, working in small groups, used this technique for their first assignment, often adding cumulatively to the design and creating densely layered, Dadaistic explosions of text and image.

Cooper described the value of the rotation prints this way:

It is a simple and a very complex idea. It is used because it provides immediate and maximum interaction with an offset press which is normally a mysterious and highly specialized reproduction tool.

The professional designer or user is separated from such communication tools and an entire intermediate language is devised for the user and the printer. Once the commitment to print is made, there is no return without great cost. Mistakes are irretrievable. Options minimal. Creativity is confined to the beginning of the process. Mass production requires this in order to survive.

Experiment and play as a part of professional discipline is difficult at best. This is not only true of an offset press but of all activities where machines are between the concept and the product.

The re-establishment of a complete relationship between process and product and person is perhaps the most valuable aspect of this course and the workshop.[1]

In addition to creating this direct and immediate relationship to tools, the prints also reflected Cooper's long-term formal interests in dynamism, simultaneity, transparency, and superimposition, whatever the medium.

In her four decades at MIT, Muriel Cooper constantly tested new technologies, from print to pixels. She also designed and redesigned her own roles at the institution, in contexts hitherto unknown, and as a woman among men, an artist among scientists, a humanist among technologists. Across these different media and forms of engagement, Cooper's concerns remained remarkably consistent: she turned reproductive technologies to productive ends; made or

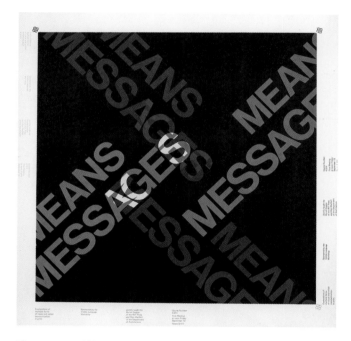

Messages and Means course poster, Muriel Cooper and Ron MacNeil, 1974 > p. 110

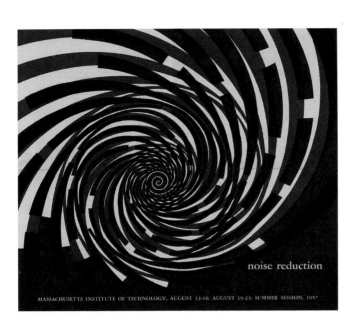

Summer session pamphlet, "Noise Reduction," 1957 > p. 39

modified tools and systems to achieve quicker feedback between thinking and making; and dissolved the lines between design, production, and different media. While these concerns are evident in her exploration of software starting in the mid-1970s, they are also already visible in her early print work.

Designer as Interface

Starting in 1952, not long out of college, Cooper designed announcements for summer courses at MIT with names like "High Temperature Ceramics," "Transonic Aerodynamics," and "Control Problems of the Executive." As the first designer in the Institute's newly formed Office of Publications, she created reports, announcements, and even record album sleeves for MIT events. Her most prolific output during these years was the series of fliers she produced for the approximately 30 courses MIT offered each summer to specialists in science, technology, and industry. To make them, she consulted course instructors to discuss their subject and find relevant artwork. She then visualized each topic in a square, bifold format, using bold colors, diverse typefaces, and a mix of illustration, photography, and photomontage. Technical photography, microscopic and telescopic, of cells and of cities, offered ready, abstract patterns to structure her compositions. Never had topics like "Soil Technology" (1954) or "Structural Sandwich Design" (1957) appeared so lively.

Before this time, the design of publications had not been a major concern at MIT. The Institute established its Office of Publications in 1951 to improve the quality and consistency of communications, which proliferated along with the Institute's growth during the Cold War, at the heart of the military-industrial-academic complex. Prior to this, the dean's office had gone directly to the printer with its orders for prospectuses or course catalogs. The idea for a centralized, in-house design department came from John Mattill, an administrator in MIT's News Office.[2] Mattill just needed a designer. For that, he consulted Gyorgy Kepes, the Hungarian émigré who had been teaching visual design in MIT's Department of Architecture since 1945. A former colleague of Bauhaus master László Moholy-Nagy in Berlin, London, and then Chicago, where Moholy invited him to teach at the New Bauhaus, Kepes spent three decades at MIT fostering exchange between the arts and sciences while also pursuing his own practice in painting, photography, film, and graphic design. Kepes suggested Cooper for the job.

Muriel Ruth Cooper was born in the Boston suburb of Brookline in 1925, the middle daughter of three. After a brief stint at the Ohio State University, she transferred to the Massachusetts School of Art, where she earned a degree in "General Design" in 1948. For the next year, Cooper worked unhappily in New York advertising agencies—she hated dealing with clients—before returning to the Massachusetts School of Art to earn a teaching degree. She then worked briefly as a designer for Boston's Institute of Contemporary Art, where she likely worked with Kepes.[3] He had been brought in to design the installation and publicity for the ICA's 1952 retrospective of his friend Walter Gropius, the Bauhaus founder who stepped down that year as chair of architecture in Harvard's Graduate School of Design.[4] Boston at this time, as these names suggest, was one of the major American hubs for avant-garde European émigrés in art, design, and architecture.[5] Yet their teaching had not yet suffused American curricula, particularly in graphic design: Cooper did not learn modernist typography in school. Rather, she would absorb its tenets from other sources, before translating and later subverting them.

Kepes's 1944 book *The Language of Vision* was an important text for Cooper, as it was for so many American students of art, design, and architecture. Visual communication, he argued, was a powerful means of reintegrating a culture atomized by overspecialization and a rift between science and the arts—or what the chemist and novelist C. P. Snow would call "the two cultures."[6] Kepes's book opens with the observation that "today we experience chaos" (in visual, psychological, and cultural terms), and closes with the chapter "Toward a Dynamic Iconography," in which he upholds the value of "contemporary advertising art."[7] Illustrating this section with work by the leading designers of the day—Paul Rand, the Bauhaus émigré Herbert Bayer, and himself—Kepes presents graphic design as a singularly modern, popular medium, unconstrained by tradition and able to improve public taste and disseminate socially useful and easily comprehensible messages.

Cooper saw her role at the Institute in a similar light, and considered herself a kind of interface between science and the public. Reflecting on her work in the Office of Publications, she noted:

I have been particularly concerned with the urgent need to make more intelligible the highly complex language of science, and have attempted to articulate in symbolic, graphic form the order and beauty inherent in the scientist's abstract vision. The growth and success of this program has demonstrated that a responsible design approach can interpret between scientist and layman; influence the aesthetic values of people within such an institution; convey the character of such a large, specialized institution to the public; and can encourage the development of similar design programs in other institutions.[8]

The year the Office of Publications was founded, an exhibition organized by Kepes opened down the hall in MIT's Hayden Gallery. Titled "The New Landscape," it featured photographs made with technical and scientific equipment, drawn from his extensive personal collection and mounted on floor-to-ceiling posts in the gallery. Kepes invited viewers to perceive organizing patterns operating at all levels in this field of floating patterns. The images, many of them generated in the research labs of his MIT colleagues, were in some cases the same as those used by Cooper on the covers of her summer session course pamphlets. This exhibition previewed Kepes's next major publication, *The New Landscape in Art and Science* (written 1947–1952, published in 1956), "a picture book," as he put it, "made to be looked at rather than read."[9] The book title added art and architecture to the discussion, arguing that both were suffused with nature's organizing patterns. Kepes envisioned an exchange, or feedback loop, between scientists and artists, in which the scientists' specialized, technical imagery offered abstract patterns for artists, who in turn communicated these images back to scientists, aiding them in seeing the world anew.[10] The idea of feedback loops, or self-regulating systems, had been theorized in 1948 by the MIT mathematician Norbert Wiener in his landmark work *Cybernetics; or, Control and Communication in the Animal and the Machine.* As a young designer fluent in the "language of vision," who mined technical images for their abstract patterns and fed these back to the scientific community, Cooper in many ways embodied Kepes's vision of what graphic design was capable of.

To manage the increasing workload in the Office of Publications, Cooper expanded her design team. In 1955 she hired her college friend Jacqueline Casey to join as a second full-time designer. Casey had studied fashion design at MassArt, where she and Cooper worked as cashiers and then bookkeepers in the school store, using it as a kind of studio after hours.[11] Casey would go on to lead the Office of Publications, soon renamed Design Services, for the next three decades, shaping the visual landscape of MIT with elegant posters that exemplified the rigorous Swiss style. (Cooper's work was always a bit messier; she once insisted, dismissively, "I do not use color very well, I don't like detail very much. … I am much more grand sweep, I get the idea, I know it is going to work, and I move on.")[12]

By 1958, with the office in good hands, Cooper was indeed ready to move on. "I get bored very easily," she explained. "I have a very low threshold for repetition."[13] The repetitious tasks and individual solutions Cooper executed for the Office of Publications would be exactly the kind she would seek to standardize in her work at the MIT Press in the 1960s and 70s, and later to automate via artificial intelligence software in the 1980s and 90s — a medium that allowed her real-time feedback and actual dynamism, beyond the illustration of it in print. In the context of her career at MIT, the printed matter Cooper designed for the Office of Publications was anomalous. Inventive, animated, and formally accomplished, it is in line with the best of midcentury American graphic design. Yet it was also an inflection point for Cooper, the first of several.

Seeking fresh inspiration, Cooper went to study in Milan on a Fulbright Fellowship. She picked Italy as a country "engaged in a creative renaissance" yet firmly "in touch with its history" (her second choice was "Denmark and the Scandinavian countries"). Cooper had applied to study exhibition design, writing in her application: "Exhibition design is the most inclusive and perhaps the most pervasive of design tools. The combination of every facet of design with light and [a] structural third dimension provides dynamic experiences that influence judgment and taste."[14] In Milan she planned to meet and possibly collaborate

Photograph from Milan, 1958 > p. 40

with leading designers like Alberto Carbone, Max Huber, Bruno Munari, Giovanni Pintori, and Gio Ponti; design offices like the renowned Studio Boggeri, and the in-house teams at companies like Olivetti and Pirelli; and design and architecture magazines like *Casabella* and *Domus*.

The trip was not a success. Cooper was bedridden with hepatitis and returned earlier than expected when her mother died of a brain tumor. There is no record of her having designed exhibitions at any point in her career, though thinking in terms of spatial metaphors would structure some of her later work. Even if her ambitions for the trip were unrealized, however, she could not have missed the richness of Italian design culture in the late 1950s, a hotbed attracting talent from across Europe and a nexus of transalpine exchange with advanced graphic designers coming from Switzerland.[15] What survives of the mostly abortive trip are photographs, of which Cooper was quite proud. These snapshots of Milanese street scenes reveal a growing interest in formal qualities that she would seek to emulate in her print work and later in software, such as abstraction, dynamism, mobile viewpoints, reflectivity, and transparency. Upon returning, Cooper set up a studio in her home, Muriel Cooper Media Design, whose commissions included logotypes and publications for corporate, civic, and educational clients in and around Boston.[16]

In Cooper's absence, the design competency she had cultivated at MIT continued to flourish. Casey hired a young painter named Ralph Coburn, who had studied architecture at MIT. The hard-edge abstraction of Coburn's art practice — he was a lifelong friend and confidante of Ellsworth Kelly, and their work appears to have been mutually influential — was reflected in the shrewd sense of form he brought to his design work at MIT. The office also hosted visiting designers from Europe. Among them was a young Swiss named Therese Moll who arrived in 1958. Moll had an outstanding modernist pedigree, as a student of the graphic designer Armin Hofmann at the Allgemeine Gewerbeschule in Basel who went on to briefly work at Studio Boggeri in Milan, in the design department at the Geigy pharmaceutical firm in Basel, and with the designer Karl Gerstner. Her brief stint at MIT helped bring so-called Swiss, or International, typographic style to MIT, and both Casey (in direct collaboration with Moll) and Cooper, indirectly, learned a great deal from her.[17] A designer visiting from Germany in 1965, Dietmar Winkler, stayed on as the Office's third full-time designer. With Casey, Coburn, and Winkler, Design Services brought a precise language to MIT publications that was typified by modular grid systems, asymmetric layouts, sans serif typography, and forms reminiscent of concrete art in Europe and hard-edge abstraction in America.

MIT in turn became one of the earliest and most prominent sites for the dissemination of International Style typography in the United States. The visual rhetoric of a modern and systems-driven approach that was "neutral," "functional," and authoritative seemed a fitting image for the Institute.[18] That Helvetica had become the lingua franca for international business also meant that MIT was speaking the same language as many of the corporate and defense sponsors who invested heavily in it. Cooper would later explain, "I was a modernist, but I was an uneasy Swiss, if you know what I mean."[19] What she means, it seems, may have been conditioned by her reflexive iconoclasm, her suspicion of styles and the pretense of neutrality, and her tendency toward a certain kind of messiness and flux.

Publishing Program

In 1962, MIT's publishing imprint, Technology Press, became an independent department and was reorganized as the MIT Press. The new entity needed a new look, prompting Press director Carroll Bowen to seek the counsel of America's leading graphic designer, Paul Rand. He asked Rand whom he might hire "to make typewriter monographs beautiful" for an academic publisher whose titles were of great scholarly significance despite being, as he put it, "ugly ducklings." Bowen visited Rand's home in Weston, Connecticut, where Rand offered three names of promising designers in Boston, suggesting Bowen "find one whose ideas excite you and who you can work with, and grow a relationship."[20] Cooper was one of the three, known to Rand from her brief period seeking work in New York.

Cooper's first major assignment for the Press, still as a freelancer, was to design its graphic identity. She explored many directions for the mark, which collectively form a telling index of midcentury American design. These concepts attempt everything from the heraldry of an open book, to stylized script lettering evoking a mathematical curve, to heavy, meandering lines that presage the final design. Ultimately she arrived at the Press's iconic seven-bar logotype, or colophon, still in use today. The mark represents the vertical strokes of the lowercase letters "mitp" as abstracted books on a shelf, with one raised to suggest the ascender of the "t" and another lowered to form the descender of the "p." Bowen was thrilled, noting that the mark fit the spirit of MIT and the Press: "The basic materials were supplied, but intelligence and imagination … produced the end result, information with elegance."[21]

The mark is constructed from an elemental kit of parts, as one might dispose lines within a grid in a modernist basic design course, and indeed there is reason to believe Cooper might have been inspired by one such exercise.[22] It also uncannily suggests a machine-readable graphic, as if to anticipate her later interest in computing.[23] An undated sketch of the mark shows it as an axonometric projection of volumes in space, progressively flattened into or emerging from two dimensions and suggesting its possible applications as a three-dimensional or animated object.

In 1967, Cooper was named the first Design Director and Media Director at the MIT Press, and her colophon came to represent a publishing program. Of the more than 500 books designed at the Press during Cooper's tenure, most were not directly by her hand. Yet she authored the systems that created them, rationalizing production through the division of labor and standardization of formats, typography, and grid systems. Designing individual solutions for each book, at one of the largest academic presses in America, would simply not have been feasible, even with a much larger team. According to Cooper, "The bulk of the work was standard and repetitious and required a set of systemic but variable design solutions for limited budgets. Developing systems that would accommodate a wide range of variable elements was very much like designing processes."[24] The processes Cooper designed also tracked the routing of Press projects in spreadsheets for optimal efficiency, first by hand, and by the 1970s with in-house computers. An internal Press memo of 1970, titled "year past and future concerns," explains:

We have evolved some simple but effective methods of analysis of typographical structures and layout relationships which provide us with an expanding base for judgment and decision making. Such data may well be an appropriate base for the beginnings of a computer program for graphic/book design problems. When information can be reliably analyzed and can be effectively accessible and updated we increase our ability to move quickly with quality when necessary as well as to explore in depth problems or projects that concern us.

In setting standards for a "style-book" we are moving not so much towards the old fashioned "house-style" idea or even adapted formats, but towards sets of variables which are regenerative and always in context with the complexities of the book system as well as with the implicit time experience.[25]

These variables did produce a recognizable look for the Press. To manage the volume of work, book covers were often outsourced to local designers. As the designer and educator Katherine McCoy recalls from her time just out of college working at the Boston agency Omnigraphics in the late 1960s, MIT Press covers typically featured abstract geometry, ample clear space, and asymmetrically placed sans serif Helvetica type, often with serifed body text inside.[26] By the 1970s, the variations on the typographic grids that structured these covers were generally limited: a square image in either the top or bottom three-quarters of the page; a two- or three-column grid; the book's title in the Medium weight of Helvetica and the author's name in the Regular weight. The systems developed by Cooper would be advanced and inventively modified by her colleague Sylvia Steiner, who started working in the production department of the Press in 1968 and with Cooper in the design department starting in 1970.

MIT Press titles stood out as some of the most modern on the shelf, certainly of those by an American academic publisher. (Cooper once noted proudly that in 1972 "MIT Press books constituted 35% of [the books in the] AAUP show," the annual design award show of the Association of American University Presses.)[27]

Mechanical artwork for the MIT Press colophon, 1962–1963 > p. 45

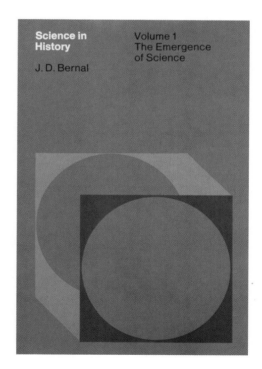

J. D. Bernal, *Science in History*, volume 1, *The Emergence of Science*, 1971 > p. 107

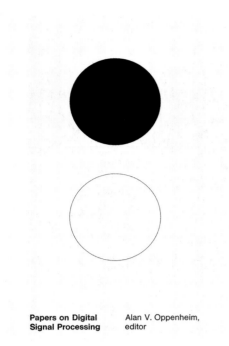

Papers on Digital Signal Processing — Alan V. Oppenheim, editor

Alan V. Oppenheim, ed., *Papers on Digital Signal Processing* (Cambridge, Mass.: MIT Press, 1969), design by MIT Press Design Department
> p. 70

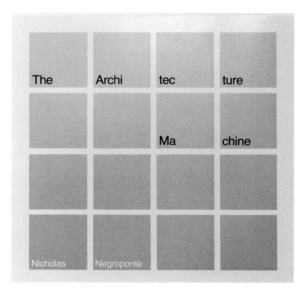

The Archi tec ture Ma chine
Nicholas Negroponte

Nicholas Negroponte, *The Architecture Machine: Toward a More Human Environment* (Cambridge, Mass.: MIT Press, 1970), design by Muriel Cooper and Nicholas Negroponte > p. 73

Cooper's "style-book" also worked to unite diverse forms of knowledge with a visual language that cut across the divide of specialized disciplines. The titles in a series on math, for example, were linked internally by subtle, serial variations in design while appearing genetically related to works in the humanities.

Many Press titles grew directly out of research and teaching at the Institute. Some were reprinted course readers or conference proceedings, photomechanically copied in all their typographic heterogeneity and wrapped within the modern package of Cooper's program. Alan Oppenheim's *Papers on Digital Signal Processing* (1969), for example, is no more than a course reader of scientific papers made available to a wider audience, but distinguished by the radical economy of the binary image on its cover. Cooper formed long-term relationships across the Institute while working at the Press, both with faculty members whose books she designed and later with those interested in her experimental printing practice emerging within the Press.

One of these long-term relationships was with the young architect-turned-computer-scientist Nicholas Negroponte. Cooper audited a summer course with him in 1967, marking the first of her several unsuccessful attempts to learn programming. The two soon became friends, and Cooper designed his first book, *The Architecture Machine* (1970). The book argued for an "architect-machine symbiosis," a fulfillment in the design context of the "man-computer symbiosis" called for a decade earlier by MIT's J. C. R. Licklider.[28] In the 1960s, MIT had become a hub for research in artificial intelligence, with mathematicians Marvin Minsky and Seymour Papert active in MIT's Artificial Intelligence Laboratory. (Cooper would also design their 1969 book on artificial neural networks, *Perceptrons: An Introduction to Computational Geometry*, and the authors, Cooper, and Negroponte would all go on to be founding faculty members of the MIT Media Lab.) Negroponte argued for the development of computational tools that would not just aid but also learn from and collaborate with designers. The cover of *The Architecture Machine* features a foil-stamped, four-by-four grid corresponding to the modular typographic grid inside. It recalls the program SEEK, shown in the Jewish Museum's "Software" exhibition that year, in which gerbils manipulated small metal blocks and a computer program attempted to accommodate their design intentions by rearranging the cubes accordingly.[29] The book's title, in Helvetica type disposed somewhat awkwardly across the squares on the cover, hints at the tensions of accommodating human intention within the constraints of a rigid system.

Cooper was intrigued by the potential of computers in the design process, and her ambitions for graphic design tools would in many ways come to run parallel with Negroponte's for architecture, converging on the graphical user interface and artificial intelligence. As she looked forward to new forms of electronic reading, Cooper still saw an essential role for the designer, and even for the print book as well. In a 1970 memo to the MIT Press she wrote:

While it is predictable that the book will remain an unparalleled solution for "random access" information and a unique functioning object capable of eliciting deep involvement, it is equally predictable that storage, distribution, electronic and mixed media/non-verbal forms of communication will play an increasing role in the organizing, producing and disseminating information [sic]. The kinds of information, the time demands, the economics, the kind of consumption all will help to determine the form which it may best take. But whatever the form, the intent of the communications is the same, and design for self-destructing information of obsolescence must be as orderly and as effective – or more so – as a rare book from a private press.

Designers as specialists in the organization of non-verbal and verbal communications and committed to the expression of human values are an important interface with technology, and must be involved in the revolution which while not yet here occurred irrevocably thirty odd years ago. It is a very exciting prospect.[30]

By the late 1970s some of the Press's typesetting and layout processes were automated with computer assistance. This, and Cooper's standardized "style-book," went a long way toward managing the massive design program she headed. It also allowed her to lavish attention on a few projects of personal interest.

Weimar and Vegas

Two projects in particular stand out in Cooper's work, as they did in her own estimation. In close succession the MIT Press published monuments to late modernism and early postmodernism, respectively. In 1969 came Hans Maria Wingler's *The Bauhaus: Weimar, Dessau, Berlin, Chicago*, a tome of documentary material drawn from the recently formed Bauhaus Archive in Germany, and still the most complete and authoritative reference on the subject.[31] *Learning from Las Vegas*, authored by Robert Venturi, Denise Scott Brown, and Steven Izenour, followed in 1972.

The Bauhaus stands 14.25 inches tall, 10.25 inches wide, and over 2.5 inches thick. It contains some 200 archival documents, many never before published, and 800 illustrations. It is the revised and substantially expanded — in contents and dimensions — English translation of Wingler's 1962 volume *Das Bauhaus: Weimar, Dessau, Berlin* (the addition of Chicago to the list of places, and the chronicling of the New Bauhaus in its various iterations, accounts for much of the additional size of the English-language edition).[32] The book filled a major gap in English-language scholarship on the school, and came out at a time of the Bauhaus's continued hegemony as the model for global design pedagogy and modernist aesthetics.

From its black slipcover printed with BAUHAUS in massive white Helvetica Bold, the book emerges in white, with a black title, as a kind of negative image. A three-column grid structures the interior. In the documents section, which forms the bulk of the book, Bauhaus-related primary texts fill the right two-thirds of the page, with editorial information about them floating in the left-hand column, flush with the start of each. In the illustration section that follows, plates are disposed rhythmically across the page. Ample white space flows throughout. Far from the Bauhaus nostalgia of the German edition, which featured Oskar Schlemmer's retrospective view of the *Bauhaus Staircase* on its cover and as its frontispiece, Cooper's purely typographic treatment acknowledged the still lively influence of the school at the time of the book's publication: Bauhaus students, masters, and successor institutions were still active at this time; Walter Gropius and Mies van der Rohe lived until the year the book was published.

Cooper's design was clearly indebted to Bauhaus typography, but was by no means a flatfooted homage. Instead of mimicking the typography of Bauhaus masters like Herbert Bayer or Josef Albers, Cooper used the Swiss style embraced by her colleagues in MIT Design Services. While the typeface Helvetica had appeared in Europe at the end of the 1950s, it only became widely available in America a decade later; the book thus appeared startlingly fresh at the time of its publication. Cooper's design, which rejected period illustrations and typography and monumentalized its subject, underscored the book's epigraph from Mies van der Rohe: "The Bauhaus was an idea."[33] *The Bauhaus* held a special place in Cooper's work at the Press. She spent almost two years designing it, far in excess of the time expected or budgeted for. It is also one of the only books from her time there, a period typified by collaboration across the design department she had built, that bears her name in the colophon.

The book also had a long and active life for Cooper after its publication, and she used it as a test subject, to be remediated in other forms.[34] Shortly after completing it, she mounted a 16 mm camera on a copy stand and shot three frames for every page spread of the book to create a film spanning almost 700 pages in about a minute. The book's construction, and many of its main characters, are legible even at high speed. The film also dramatized the book's design: "All of my books explored implicit motion," Cooper explained. "*The Bauhaus* was designed both statically and filmically with a mental model of slow motion animation of the page elements."[35]

Seen in this way, images dance across the page spread, as if in an abstract film. Long columns of text almost appear to scroll down the page, as if to presage Cooper's engagement with on-screen reading experiences a decade later. The stop-motion process also creates the illusion that the book is constructing itself, without hands, as if through one of the artificial intelligence systems Cooper would test to automate the page layout process. Cooper showed her film of *The Bauhaus* to her students at MIT as a kind of retroactive proof of concept for the book, illustrating the construction of page flow and how much can in fact be

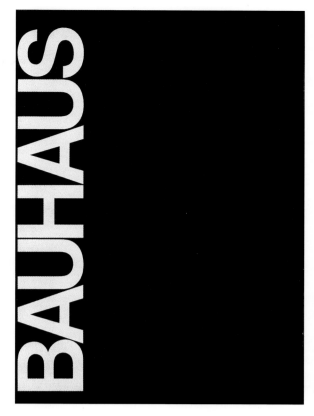

Slipcover for Hans Maria Wingler, ed., *The Bauhaus: Weimar, Dessau, Berlin, Chicago* (Cambridge, Mass.: MIT Press, 1969), design by Muriel Cooper > p. 56

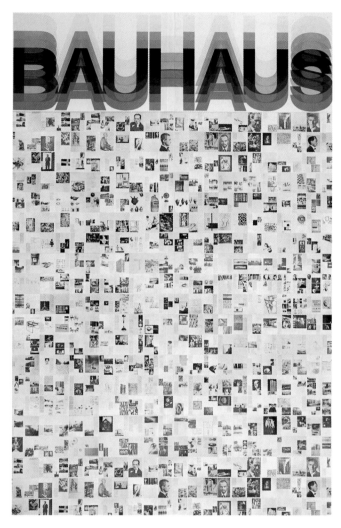

Poster to promote *The Bauhaus*, 1969 > p. 67

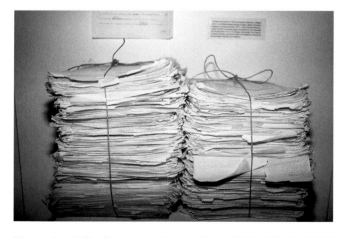

Manuscript of *The Bauhaus* as shown in the exhibition "Books 2000," 1979 > p. 69

grasped at a steady clip. Good design, Cooper believed, whether in print or later on screen, could help filter large amounts of information into a coherent whole.

It was no coincidence that Cooper chose the Bauhaus book as her test case. "The people and works of the Bauhaus were my conceptual and spiritual ancestors, so I felt a particular bond with the material. ... My approach always emphasized process over product, and what better place to express this."[36] In particular, she felt a bond with the work of Bauhaus master László Moholy-Nagy. The Bauhaus film, for example, appears to illustrate his sense of "vision in motion," or "simultaneous grasp ... [which] instantaneously integrates and transmutes single elements into a coherent whole."[37] In her 1989 essay "Computers and Design," Cooper praised Moholy-Nagy's graphical film score *Dynamic of the Metropolis* for exploring "visual and verbal means of interrelating the different time frames of sound and moving image in the print medium."[38]

Cooper restaged *The Bauhaus* in other ways. She also made posters, some of which served to promote the book. In several of these she enlarged selected plates — such as portraits of Gropius or Moholy-Nagy, or Marcel Breuer's iconic "Club chair" — to heroic scale, highlighting the rough halftone texture of their production, and the pop celebrity of their subjects. In another poster, she tiled more than two hundred of the page spreads arbitrarily across the surface of the poster. Where the film had shown the book in a rapid-fire, linear fashion, Cooper here spatialized it, creating a nonlinear, simultaneous overview of the book's contents. Even a decade later, in a 1979 exhibition called "Books 2000," on the occasion of the Press's 2,000th publication, the Bauhaus manuscript was presented as two enormous stacks of paper, a kind of archival surplus of data for the designer to sort and surface. As Cooper later explained of her priorities for software design: "Our goal is to make information into some form of communication, which information alone is not. Information by itself does not have the level of 'filtering' that design brings to it."[39]

From the standpoint of the book as an interface technology, these two presentations — filmic and graphical — can be considered two "views" on the same content. They also appeared at a moment of major breakthroughs in the development of the software interface. In 1968, in his renowned "Mother of All Demos," Douglas Engelbart of the Stanford Research Institute presented the concept of "view control" as a feature that would soon be integral to personal computing.[40] Closer to home, and established the same year, Negroponte's Architecture Machine Group was also experimenting with display technology and graphical user interfaces. Among its contributions to the problem of type on screen, the group soon developed an approach to anti-aliasing, or smoothing the jagged lines in letterforms on screen. Consultation on typography came from Negroponte's friends Casey, Coburn, and Cooper.

Even two decades after the Bauhaus book's publication, Cooper thought of it as a rich case study in imagining the future of digital media, and the new breed of designers needed to manipulate them. In 1989, she predicted the "elimination of the distinction between graphics for print and graphics for animation or television. All tools are soon going to be together, which will change specialized design professionals into something called design generalists." She continued: "The design of the Bauhaus book, for example, would no longer be limited to text and photographs but would include film, video or animation, and three-dimensional or holographic visualizations of the sculpture, architecture, or performances of that moment in history." For Cooper, books should be dynamic and open: "Hypertext and hypermedia principles would extend the editing and authorship of such an archival database so that a reader interested in the political and social influences of the Bauhaus would be able directly to pursue multimedia bibliographic information in depth, rather than referencing footnotes."[41]

In 1972, MIT published another monumental volume, this time an early manifesto of postmodernism. *Learning from Las Vegas* compiled the presentation materials from a 1968 studio at the Yale School of Architecture which sent students to Las Vegas to study sprawl and the nature of architectural symbolism.[42] Their approach, pursued against what they saw as modernist prescriptions, was to make a nonjudgmental study of the city and how it worked. The authors and their students documented their research with photographs, films, maps, and diagrams. They often assumed the position of the "automobilized" observer, perceiving the city through the car windshield.[43] This filmic, mobile viewpoint had

also appeared in Cooper's photographs from Milan, and in the very premise of one of her first books for MIT, *The View from the Road*, which had considered highway planning as "a problem of designing visual sequences for the observer in motion."[44] The first-person gaze through the windshield also foreshadowed the "information landscapes" Cooper would design later in life, which Richard Saul Wurman likened to the experience of "flying through information."[45]

Cooper's task was to help translate the diverse findings and exhibition materials from the studio into book form. Her design for *Learning from Las Vegas* measured 14.5 by 11 inches, not accidentally closer in scale to a geographic atlas than to an architecture book. Channeling the glitzy spirit of the material, Cooper planned a bubble wrap book jacket, with fluorescent dots underneath. Ultimately, a glasine jacket wrapped the book, superimposing its running section headings over the title. Inside, Cooper used, and occasionally departed from, a sequential grid system, with one column in the first section, two in the second, and three in the third, freely interspersing text and image. "The visual materials were not only graphically rich but as content-laden as the text, so the interdependent rhythms of those relationships were important. I wanted to arrange visual and verbal materials spatially in a nonlinear way to enhance the reader's comprehension. Creating virtual time and space in two dimensions has always intrigued me."[46] The effect of Cooper's design is to create a simultaneous, richly textured experience of the material that unfolds across the page spread. The body copy, which Cooper set on an IBM Composer electric typewriter in the modern sans serif typeface Univers, is flagged with figure numbers hovering above the lines of text, like signage on the Vegas strip.

The authors were not impressed. In the preface to the revised and fully redesigned second edition of 1977, a pocket-sized paperback that is required reading in many surveys of architectural history, Denise Scott Brown pans the first edition's "'interesting' modern styling." She notes "the conflict between our critique of Bauhaus design and the latter-day Bauhaus design of the book," an attack based on the subject of Cooper's earlier book more than the substance of her design for this one. The authors' second edition was more conservative in every way, changing the type from Univers to the eighteenth-century serif typeface Baskerville, reemphasizing their writing by alternating dedicated pages of text and image, and in Scott Brown's words, generally "de-sexing" the first edition.

Cooper considered the conflict a battle of wits. One sees this battle play out dramatically in an annotated copy of the first edition, in which Scott Brown's pencil notes ask if Cooper might make an asymmetrical, ragged-right chapter heading into a centered and justified one, and Cooper answers with a large and emphatic "NO." The conflict also seems to have been a battle of roles, with Cooper's interpretive approach to the book's material impinging on what the authors considered their own, privileged territory of forming its message. Indeed, the authors likely disapproved of the book because of, not in spite of, its form being a postmodern manifesto in its own right.[47] Locking horns with single-minded academics became a growing source of frustration at the Press for Cooper, who had entered the academy precisely to avoid the client relations she had briefly experienced in New York ad agencies.

Research and Development

Not all projects were such a source of anxiety. Cooper's design for Herbert Muschamp's 1974 book *File under Architecture*—bound in corrugated cardboard, printed on brown kraft paper, and likewise typeset by Cooper on an IBM Composer—was a favorite of hers and the author's, who felt it performed his argument on the ephemerality of the built environment better than the text had. The Composer let Cooper change fonts by switching out the golf ball-sized typeball, enabling her to set the main text and the author's eccentric marginalia in different typefaces, from sans serif to script. Using this readily available consumer product and embracing its raw aesthetic made Cooper both designer and producer, giving her greater control and quicker feedback, and saving money as well. Where changes might once have come back in weeks and at great cost from the typesetter, she could now make them in real time and produce photo-ready pages.[48] From using an electric typewriter to produce the book, it was a short step to using a computer.

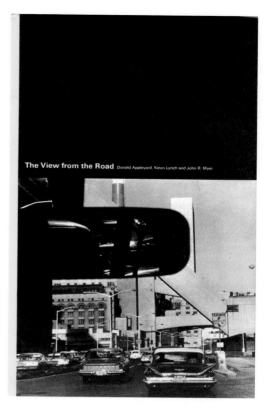

Donald Appleyard, Kevin Lynch, and John R. Myer, *The View from the Road* (Cambridge, Mass.: MIT Press, 1964), design by Muriel Cooper > p. 46

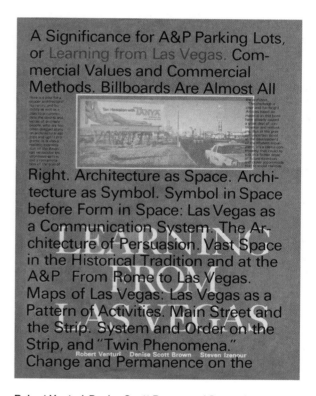

Robert Venturi, Denise Scott Brown, and Steven Izenour, *Learning from Las Vegas* (Cambridge, Mass.: MIT Press, 1972), design by Muriel Cooper > p. 76

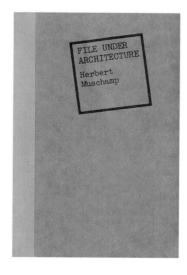

Herbert Muschamp, *File under Architecture* (Cambridge, Mass.: MIT Press, 1974), design by Muriel Cooper, Sylvia Steiner, and MIT Press Design Department > p. 89

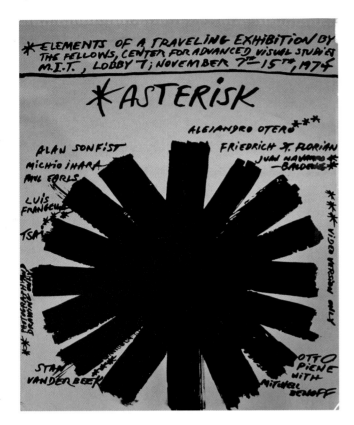

Exhibition poster for "*Asterisk," designed by Otto Piene, printed at the Visible Language Workshop, 1974 > p. 113

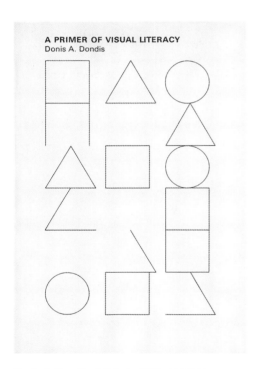

Donis A. Dondis, *A Primer of Visual Literacy* (Cambridge, Mass: MIT Press, 1973), design by Muriel Cooper, Donis A. Dondis, and MIT Press Design Department > p. 88

During the 1970s Cooper established an informal "research and development" unit within the Press to explore new printing and production techniques. She and her colleagues used tools like a 3M Color-in-Color machine (an early color photocopier), and brought computers into the offices with the help of Negroponte, and with MIT UROP (Undergraduate Research Opportunity Program) students to operate them. Cooper recalls:

The 70s was the period of alternative book art – Xerox machines and corner copy shops were beginning to spread out, becoming more available. I was at MIT Press. I got support from the director to look into other media, electronic media. I pushed to get computer typesetting in house, which would give me an opportunity to explore the medium. I pushed for an experimental arm of the press that would do smaller edition experimental books. … So I had a little support for this R&D unit at MIT Press. It was eventually shut down for financial reasons. We did some stuff with rubber stamping, cut and paste – it was the *Whole Earth Catalog* era.[49]

In fact, in 1972 the Press's newsprint catalog was actually an homage to *The Whole Earth Catalog*, the legendary counterculture publication founded in 1968. The reference is apt: the *Catalog*'s mantra of "access to tools" resonated with Cooper's own approach to hands-on production and tinkering, and indeed the real *Whole Earth Catalog* listed many intellectual tools, including books from the MIT Press.[50] This experimental activity embraced dual tendencies of that moment, of cut-and-paste layouts and new software, working to automate the publishing process and, as Cooper recalls, "actually inventing a primitive form of desktop publishing."[51]

A textured, collage aesthetic typified many Press books in the mid-1970s, bringing the Massachusetts Institute of Technology improbably close to the DIY aesthetic of punk and protest zines of the period. As with some earlier course readers, several projects were little more than photomechanically copied typescripts wrapped in a modern cover design. Edward Allen's *Responsive House* or Lawrence Halprin and Jim Burns's *Taking Part: A Workshop Approach to Collective Creativity* (both 1974) gain their multivalent, freewheeling personality by marshaling disparate materials in a single volume with minimal design intervention. The first book compiles conference proceedings inspired by the work of the Architecture Machine Group, and the second brings together notes from the Halprin workshops' experiments in "collective creativity," which combined interests in architecture, landscape, dance, and performance.

Cooper also supervised the design of another future MIT colleague in the arts. The German artist Otto Piene's 1973 *More Sky*, published by the Press, was a kind of handbook for the engaged artist-planner considering large-scale, collaborative public interventions. The next year, Piene would become director of the Center for Advanced Visual Studies at MIT, the studio art and media group which Kepes had established in 1967. Like Cooper's Visible Language Workshop, CAVS would be located in the Department of Architecture, and the VLW's offset presses would be the site of much collaboration, also with Cooper's colleagues in Design Services. The MIT Press, particularly via Cooper, was thus an early nexus for the arts at MIT, which would come to include CAVS and the Media Lab, and soon the Master of Science in Visual Studies program. There is much to be made of networked communications in Cooper's later career, but the local network within the halls of the Institute was exceedingly generative.

Besides shaping the formal program at the Press, Cooper also had a hand in acquiring titles. Her college friend Donis Dondis, who was teaching visual design at Boston College, published *A Primer of Visual Literacy* with the Press in 1973.[52] The book became a legendary design primer, still in print today, which Cooper would use in her classes. Many of its examples of formal design principles are drawn from recent MIT Press books and Design Services posters. That same year, the Press also published a title Cooper had brought in out of personal conviction, Donald McCullin's large-format photo book *Is Anyone Taking Any Notice?*[53] Cooper presented McCullin's photojournalistic work, much of it from the war in Vietnam, with dramatic white space and accompanied by captions that juxtaposed the photographer's terse reflections with excerpts from Aleksandr Solzhenitsyn's Nobel Peace Prize speech of that year. In staging this conversation, as her former colleague Sylvia Steiner observed, Cooper was also serving as editor.[54]

By the mid-1970s, Cooper added "Director of Special Projects" to her title at the Press, allowing her to focus to a greater degree on matters of personal interest and to explore new publishing technologies.[55] These "special projects" – and the kinds of agency Cooper achieved in her late years at the Press, in making and modifying tools for quicker feedback and in shaping the messages themselves – began to occupy her full attention. Boredom with repetitive tasks, a small budget, and the frictions of being a service provider to demanding academic authors were growing sources of anxiety for her. In 1989, Cooper recalled a litany of concerns about designing books:

The inequitable constraints placed on verbal and visual information by the double page; the early closure demanded by the mass production cycle; and the crush of deadlines that prevented research into new solutions for communication problems all contributed to my growing frustration with the print medium. It was clear that the computer would soon have a profound impact on these limitations.[56]

These frustrations, which fueled Cooper's experimentation at the Press, also laid the groundwork for what would become the Visible Language Workshop.

Visible Language Workshop

Cooper taught her first course at MIT, Messages and Means, while still at the Press. Ron MacNeil, her co-instructor, was originally trained as a physicist and came to MIT to apprentice with the photographer Minor White, who was then starting a photography department there. Like Cooper, MacNeil had also been pushing against the hard boundaries of his medium. As he recalled, "the fact that the makers of the photo materials I was using dictated to a large extent the way the thing would look began to grate more and more."[57] In his photography, MacNeil experimented with non-silver media and photogravure techniques, and when his acids ate through the graduate darkroom plumbing, he was forced to seek a new space. He found himself in the Department of Architecture, occupying the office of a professor who had gone on sabbatical, and soon teaching an experimental multimedia class called PhotoGraphics. MacNeil somehow induced the department to devote the resources and space necessary to acquire a sheet-fed offset press. He also began experimenting with silkscreen, etching, and lithography.[58] A mutual friend, Tom Norton, who had brought the 3M Color-in-Color machine to the MIT Press, introduced MacNeil and Cooper based on their shared interests, and would go on to teach alongside them. The Department of Architecture was and would continue to be the default home for visual art and design at MIT. Research into new imaging techniques flourished there in the 1970s, if not in opposition to the architectural discipline as it was currently conceived, then not directly or obviously serving architecture's traditional aims.[59]

As Cooper described it, "Messages and Means was design and communication for print that integrated the reproduction tools as part of the thinking process and reduced the gap between process and product."[60] The students came from across MIT, undergraduates and graduates, aspiring architects and engineers, with studio experience and without. It was not Cooper's first time teaching, but it was the first time she had designed a course from the ground up, with an experimental, hands-on, production-oriented approach in mind.[61]

The course title "Messages and Means" captured multiple strands in the culture of MIT at that moment. On the one hand, "Messages" implied the course's emphasis on "visual and verbal communication in print," in which subjective responses and personal forms of expression were welcomed. Students kept journals for the duration of the course in which they recorded assignments and reactions. One assignment was to find a political message in the world and bring it in to be visualized; another was to express a given word in as many fitting forms as possible, citing Karl Gerstner's *Compendium for Literates* (1974), which Cooper helped bring to the MIT Press. "Messages" also implied basic, content-agnostic units of cybernetic exchange and information theory, the rubric for so much thinking at MIT during that period. The emphasis on "Means" underlines Cooper's interest in process and technique in various media, and the possibility that these two aspects of a work could inform one another.

Messages and Means would become the cornerstone of the new Visible Language Workshop (VLW), founded by Cooper and MacNeil in 1974. The words

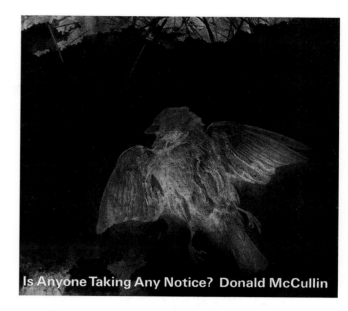

Donald McCullin, *Is Anyone Taking Any Notice? A Book of Photographs and Comments* (Cambridge, Mass.: MIT Press, 1973), design by Muriel Cooper, Sylvia Steiner, and MIT Press Design Department > p. 85

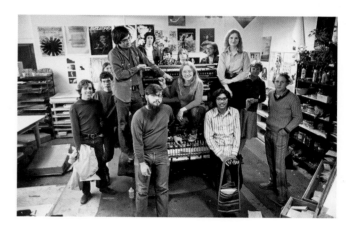

Students in the Visible Language Workshop's Building 5 workshop, Department of Architecture, c. 1975 > p. 115

"Visible Language" pointed back to the communications fundamentals discussed in Kepes's groundbreaking *Language of Vision*, and also to the journal *Visible Language*, published quarterly since 1967, with whose editorial staff and contributors Cooper was in dialogue. "Workshop," in addition to being the modish organizational unit of the moment (for example, Halprin and Burns's "workshops for collaborative creativity," described in *Taking Part*), implied a pedagogical principle of experimentation, collaboration, and hands-on making, in distinction to the Institute's many "labs." The reference to the teaching units of the Bauhaus, which emphasized an experimental, craft-intensive, communitarian, and antihierarchical approach against that of the academy, was likewise not accidental. Cooper's own politics were evident in her pedagogy. In job materials, she once listed among her "Interests and Goals": "Significance of participatory and non-authoritarian communication forms in relation to specialization and professionalism"; and "Structured/unstructured relationships in learning."[62]

Mastery of the "means," at least with regard to computing, was to a large extent the province of MacNeil, whose technical know-how and tinkering maintained and made real the tools and projects Cooper had in mind (students in engineering at the Institute were also helpful in this regard). MacNeil and Cooper's close relationship was not unlike the two-pronged instructional model of the Bauhaus workshops, each of which was initially led by a master of "form" and one of "craft," revealing a persistent difficulty in fully integrating aesthetic and technical mastery in a single figure. Yet, as at the Bauhaus, many students who passed through the VLW did join artistic sensibility with technical ability, and in turn worked as teachers in the program. They included Laura Blacklow, Peter Droege, Rob Faught, Rob Haimes, Nancy Gardner, Virginia Holmes, Lee Silverman, Tom Norton, Wendy Richmond, and Joel Slayton. Even as the VLW added courses in more advanced production techniques, Messages and Means effectively remained its "preliminary course," focused on basic design as a function of production.

By 1977 Cooper had become an assistant professor in the Department of Architecture. She was and would remain one of the only women on a faculty composed primarily of white male architects and engineers (in 1988, she would become the first woman tenured at MIT's Media Lab). Cooper was also aware of being the only graphic designer in an institution known for the hard sciences. Commenting on her unique status, she later admitted: "There is plenty of baggage that goes along with that position. ... It is awful being a woman, in that kind of environment, and you just kind of have to move along." Yet this status also conferred some advantages in organizing the VLW: "I do really think women have a greater sense of relationships across the board. For me it shows up in my work in the kind of conditions I try to set up."[63] Under these conditions, Cooper mentored many young female designers in her time at MIT.

As it grew, the VLW's course offerings came to include three different categories based on the tools used: typographics, photographics, and electrographics. Typographics dealt with offset printing, or ink on paper, and eventually computer graphics (i.e., the combination of text and image on screen, just as their (re-)union in art had been the concern of the historical avant-garde, with montage practices like Moholy-Nagy's "typophoto"). The practice of photographics involved the light-based chemical processes of photography, including instant, cameraless, and large-format photography. Electrographics broadly included "processes and processors that handle images by electronic phenomena." It incorporated video imaging, digital hard copy output, and color and black-and-white xerography. In a guide to electrographics produced for the VLW, Norton and Holmes write that even the humble photocopier can be used for any number of artistic applications:

Why? Because it provides for immediate communication and interaction of ideas. Because it disseminates massive amounts of information. Because it serves as an incredible tool for braking [sic] the barriers for those who have never dealt visually (many MIT students) and thrusts them into not only generating thoughts and concepts visually, right on the spot, but opens the desire to do more. It gets rid of the foreign-ness of printing.[64]

In 1979, the summer session offered at the VLW in advanced typography was called Graphic Design, Computers and Other Tools. Here the computer could be used to draw typefaces and facilitate page layout. The title still implied that

the computer was one among several tools, as opposed to the medium itself and the exclusive focus of and environment for research, as it would later be at the MIT Media Lab. Nevertheless, Cooper clearly saw the promise of computing in reshaping design practice itself. In a September 1979 memo on the VLW, she announced: "The electronic revolution has broken traditional definitions of disciplines of photography, printmaking, graphic design, and graphic arts. Reproduction technologies and media proliferate, influencing both information transfer and artistic expression."[65]

Cooper considered the VLW, as an interactive pedagogical environment, to be one of her greatest design achievements. The program migrated from its inky space in the Department of Architecture, centrally located in MIT's building 5, to a more polished and clinical one with graphics terminals in building N51, before finally moving to E15, the Media Lab's Wiesner Building. In each location, the emphasis was on a generative space that fused design and production. When asked years later about her self-expression as a designer, Cooper answered: "My personal statement ... is in building environments in which I would like to work and other people can work productively."[66] In 1981 she would present the VLW as follows:

The workshop is committed to verbal and visual communication as information and as art, on both personal and public levels. Emphasis is on the synthesis of concept and production from a base of personal conviction, informed by both traditions and technology. The environment functions as a large, interrelated, interactive, hands-on tool in which mechanical, photo-mechanical, and electronic inputs and outputs may be used generatively. Print and Communication Graphics concerns are expressed in workshop areas of Print, Photo, Computer, Electro, Media and Typographics.[67]

Cooper made few public, programmatic statements. But in 1980 she articulated her design practice and pedagogy, both retroactively and looking forward, in a few brief points. The School of Architecture and Planning's journal *Plan* asked the VLW for a contribution, and Cooper responded with a 12-page visual essay produced together with students in the Workshop, and using its tools. The article is about the work of the VLW, and also about the process by which the article itself was made. The visual material includes a lightbox strewn with slides of past VLW work, compositing tools, and Polaroid documentation — a format favored by Cooper for its rapid feedback — of VLW software demonstrations. The montage of multiple media formats in a single frame simulates what would soon coexist, at first awkwardly and then with increasing refinement, within the frame of the computer display. The cover page of the essay presents a kind of manifesto, typewritten on the letterhead of the Visible Language Workshop, with its bold color gradient brushstroke across the top, signaling the group's ambitions at the nexus of art, technology, and something indistinguishable from magic. The article that followed, Cooper wrote, would attempt to fulfill four criteria:

1. It would make use of the tools, processes and technologies of graphic arts media as directly as possible and the tools would be integrated with concept and product. ...
2. The author would be the maker contrary to the specialization mode which makes the author of the content the author, the author of the form the designer, and the author of the craft the typographer/printer.
3. Visual and verbal representation of the ideas would be synthesized rather than separate.
4. Time would remain as fluid and immediate as possible, leaving room for feedback and change.[68]

Cooper closes the letter by promising: "This stands as a sketch for the future." This manifesto for her work and teaching to that point would also guide her explorations of software over the next decade and a half.

Coda: Convergence

In excavating the archives of Cooper's work, it is impossible to ignore the profusion of media formats she used in the course of the 1970s alone. These include handwritten, typewritten, printed, collaged, and photocopied papers and books; designer's mechanicals; slides, negatives, film rolls, instant film, and developed photos in different formats; and analog and digital audio and video cassettes of various sizes, optical video discs, and magnetic floppy discs. Each, as Cooper taught her students, had its own specificity, imposed its own rules, and yet could

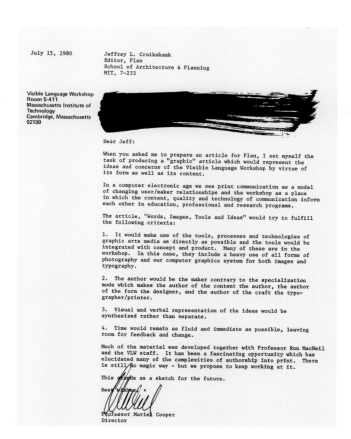

Muriel Cooper and Visible Language Workshop, "Words, Images, Tools and Ideas," *Plan: Review of the MIT School of Architecture and Planning*, no. 11 (1980): 105–116, first page > p. 135

be coaxed in different ways. These various media would eventually coexist within what the computer scientist Alan Kay has called the "metamedium" of software.[69]

The issue of *Plan* in which Cooper's "*Words, Images, Tools and Ideas*" appeared also included an article called "Arts and Media Technology" by Negroponte that proposed what would, five years later, open its doors officially as the MIT Media Lab. Negroponte began by observing the fragmentary teaching of different media and the compartmentalization of disciplines, and suggested that their shared substance should be developed under the rubric of arts and media technology. "This new field of study," he explained, showing a Venn diagram with three overlapping rings, "can be positioned at the intersection of film/broadcast; print/publishing; and electronic information processing/display/input."[70] These three areas had to that point barely overlapped, in training, technology standards, or business practice, but their convergence would come in a state of what Negroponte later called "being digital."[71] Cooper referred to this diagram, used to pitch the Lab for fundraising, as the "teething rings."[72]

Arts and Media Technology was to be a new facility and a new field of interdisciplinary research. It was "a plan to combine six teaching and research programs … the Architecture Machine Group, the Visible Language Workshop, the Film/Video Section, the Creative Photography Laboratory, the holography component of the Center for Advanced Visual Studies, and the Experimental Music Studio."[73] From these, ten major areas of study would be created. Cooper's expertise and the work of the VLW were of obvious relevance to nearly all of them:

1. computer graphics and animation;
2. interactive and digital video processing;
3. experimental hard and soft copy;
4. man-machine relations and human factors;
5. color theory and applications;
6. photo-electronics and dry photographic processing;
7. digital and spatial audio processing;
8. consumer electronics and personal computing;
9. holography and holographic movies;
10. projection technology and experimental filmmaking.[74]

The article cited early collaborations between the Architecture Machine Group and Cooper's Visible Language Workshop as exemplary for the new program's interdisciplinary spirit.

The Media Lab officially opened in the I. M. Pei-designed Jerome Wiesner Building in 1985. Its founding researchers included members of the Architecture Machine Group such as Walter Bender, Andy Lippman, and Chris Schmandt; Marvin Minsky working on artificial intelligence; Seymour Papert studying artificial intelligence and learning; Ricky Leacock addressing film and video; Barry Vercoe in music; and of course Cooper, whose group still went by the name Visible Language Workshop, even as other divisions were newly christened. Some of the first projects at the Media Lab included software for early childhood education, news delivery services, synthetic holography, research into new approaches to television and movies, and immersive media environments, nearly all of these focused in one way or another on the human-machine interface. Cooper and students David Small, Lisa Strausfeld, and Suguru Ishizaki worked on software projects such as "expressive typography," which was dynamic and responsive to its environment and integrated sound as it stretched, twisted, and turned. The slides of "words in freedom" by Italian futurist typographers that Cooper had shown her students in lectures at the VLW now had their complement in software.

Shifting somewhat from the defense funding model of the Architecture Machine Group, the Media Lab relied primarily on corporate sponsorship through a membership system. The VLW garnered its support from companies like the nearby Polaroid Corporation, IBM, and the German print technology company Hell, and later worked with Apple, Xerox, Canon, and others. Its initial funding of a quarter million dollars was the smallest of the Lab's founding divisions, but surely made Cooper and her team some of the best funded and equipped graphics researchers at that moment.[75]

Cooper acknowledged the complicated nature of this funding. On the subject of long-range research "having to do with the development of machines that will become 'creative' and autonomous," she reflected, "it should be recognized that

MIT Media Lab promotional laser disc, jacket by Betsy Hacker, MIT Design Services; video text produced at the Visible Language Workshop, 1986 > p. 172

they represent a challenge to our world as profound as the continued destruction of our ecosystems, and the threat of nuclear war. The ultimate interface may well be a robot that can learn and think for itself." She went on: "The thrust of this long-term research has intellectual underpinnings that are supported by government and industry, and one must be alert to the intentions that drive such support. There is an inevitable Jekyll-Hyde syndrome that must be recognized and managed by us all."[76] Exactly what managing this syndrome entailed for Cooper was unclear, but importantly, and presciently, she did recognize it, again seeing the role of the designer as that of a kind of interface between science and technology on the one hand and society on the other.

Already in her later years at the MIT Press, and moving into her time at the VLW, Cooper had begun to design herself out of design in a traditional sense. Asked in 1991 about her design career, she answered: "I don't design as such any more. I deliberately stopped being a graphic designer. I deliberately decided that I could not understand design in a clean way while still trying to solve peoples' problems. So, I made a deliberate choice not to take on existing design problems but to get my mind out of that set."[77] The long-term arc of Cooper's career went from designing objects, to processes, to pedagogical environments, and ultimately to software interfaces, sometimes conceived of as environments. In her later years she turned to designing graduate research, much of it focused on designing the tools of design, and the human-computer interface. Though it was never fast or intuitive enough for her taste, software allowed Cooper to create immediate, open-ended, and nonlinear experiences of multiple, intermingled media that were flexible, dynamic, and responsive. It did what she had been doing all along.

Notes

1. Muriel Cooper, "Educational / Messages and Means / The Rotation System," n.d., Visible Language Workshop Archive, MIT Program in Art, Culture, and Technology, VLW document binder.

2. John Mattill, interview by author, telephone, March 16, 2015. Cooper claimed that MIT's Office of Publications was the first in-house design department at an American university.

3. Cooper collaborated with Kepes on a few design projects, but none, seemingly, at MIT. Muriel Cooper, draft C.V., Muriel R. Cooper Collection, Morton R. Godine Library, Archive, Massachusetts College of Art and Design, box 12-393.

4. "Gropius Exhibition," *Institute of Contemporary Art Bulletin* 1, no. 1 (February 1952): n.p.

5. See the author's essay, "The Bauhaus and Harvard," in Harvard Art Museums Special Collection, *The Bauhaus*, http://www.harvardartmuseums.org/collections/special-collections/the-bauhaus.

6. C. P. Snow, *The Two Cultures and the Scientific Revolution* (New York: Cambridge University Press, 1959).

7. Gyorgy Kepes, *Language of Vision* (Chicago: P. Theobald, 1944), 13.

8. Muriel Cooper, draft application materials for Fulbright Fellowship, c. 1957, n.p., Muriel R. Cooper Collection, box 12-393.

9. Orit Halpern has shrewdly observed Kepes's reframing of his project between these two books: "the terms 'language' and 'vision' mutated into 'environment' and 'process' by way of a new form of computational sense. This scene marks a critical moment in the histories of visuality when perception gained autonomy as a material process and the image was no longer understood as representational (a language) but rather as a landscape or environment." A comparable shift is visible in Cooper's career, from printed matter to processes to environments. Orit Halpern, "Perceptual Machines: Communication, Archiving, and Vision in Post-War American Design," *Journal of Visual Culture* 11, no. 3 (December 1, 2012): 329.

10. Reinhold Martin posits this feedback loop as follows: "Thus had the 'new vision' opened onto a 'new landscape' of images coming out of the research laboratories of the military-industrial complex, where the alienation of the scientific specialist was overcome by the retrained eye of the artist." Reinhold Martin, *The Organizational Complex: Architecture, Media, and Corporate Space* (Cambridge, Mass.: MIT Press, 2003), 67.

11. Muriel Cooper, unpublished interview with Ellen Lupton, May 7, 1994, http://elupton.com/2010/07/cooper-muriel/. See also Ellen Lupton, ed., *MIT/CASEY* (New York: Herb Lubalin Study Center of Design and Typography, 1989); Dietmar R. Winkler, ed., *Posters: Jacqueline S. Casey: Thirty Years of Design at MIT* (Cambridge, Mass.: MIT Museum, 1992).

12. Janet Fairbairn, "The Gendered Self in Graphic Design: Interviews with 15 Women," MFA thesis, Yale University School of Art, 1991, n.p.

13. Ibid.

14. Cooper, Fulbright application.

15. For more on this exchange, see Museum für Gestaltung Zürich, *Zürich—Milano* (Baden: Lars Müller Publishers, 2007).

16. Cooper created logotypes for the Air Force Cambridge Labs, Cambridge's Technology Square, the Boston Redevelopment Authority, and the Sylvania company. Other clients included Amherst, Radcliffe, Simmons, and Wellesley colleges; the New England Colleges Fund; and the Boston real estate firm Cabot, Cabot and Forbes. See Addison Gallery, *Communication by Design: Muriel Cooper, Malcolm Grear, Norman Ives, Carl Zahn* (Andover: Addison Gallery of American Art, 1964), n.p.

17. For more on Moll's work and influence at MIT, see "Basel to Boston: An Itinerary for Typographic Modernism in America" by the author and Elizabeth Resnick (forthcoming).

18. The design tradition begun by Cooper at MIT would be recognized in 1982 by the American Institute of Graphic Arts (AIGA) with a "Design Leadership Award" jointly honoring Sylvia Steiner at the MIT Press, Jacqueline Casey of Design Services, and Cooper at the Visible Language Workshop. See "Design Leadership Award," in *AIGA Graphic Design USA: The Annual of the American Institute of Graphic Arts*, vol. 3 (New York: Watson-Guptill, 1982).

19. Cooper, unpublished interview with Ellen Lupton.

20. Carroll G. Bowen, letter to Tom Wong, August 31, 1994, Muriel R. Cooper Collection, box 12-205.

21. Ibid.

22. Cooper may well have seen one of Therese Moll's assignments for Armin Hofmann, which he published and which bears striking resemblance to the final MIT Press colophon. See Wiesenberger and Resnick, "Basel to Boston."

23. I am indebted to David Reinfurt for this observation. David Reinfurt, "This Stands as a Sketch for the Future: Muriel Cooper and the Visible Language Workshop," 2007, n.p., http://www.dextersinister.org/MEDIA/PDF/Thisstandsasasketchforthefuture.pdf.

24. Steven Heller, "Muriel Cooper" (interview), in *Graphic Design in America: A Visual Language History* (Minneapolis: Walker Art Center, 1989), 97.

25. Muriel Cooper, memo, "July 1, 1970 year past and future concerns," Muriel R. Cooper Collection, box 12-242.

26. Katherine McCoy, interview by author, telephone, August 19, 2013.

27. Muriel Cooper, "Curriculum Vitae, 6/82," 2, Muriel R. Cooper Collection, box 12-284.

28. Nicholas Negroponte, *The Architecture Machine: Toward a More Human Environment* (Cambridge, Mass.: MIT Press, 1970), 8. J. C. R. Licklider, "Man-Computer Symbiosis," *Transactions on Human Factors in Electronics* HFE-1 (March 1960): 4–11.

29. *Software: Information Technology: Its New Meaning for Art* (New York: Jewish Museum, 1970), 23. The exhibition was curated by Jack Burnham. See Felicity D. Scott, "DISCOURSE, SEEK, INTERACT," in *Outlaw Territories: Environments of Insecurity/Architectures of Counterinsurgency* (Cambridge, Mass.: Zone Books, 2016), 339–382.

30. Muriel Cooper, MIT Press memo, Muriel R. Cooper Collection, box 12-293.

31. For more on Cooper's design of *The Bauhaus*, see Robert Wiesenberger, "Latter-Day Bauhaus? Muriel Cooper and the Digital Imaginary," in Martino Stierli and Nanni Baltzer, eds., *Before Publication: Montage in Art, Architecture, and Book Design: A Reader* (Zurich: Park Books, 2016), 93–107.

32. Hans Maria Wingler, *Das Bauhaus, 1919–1933: Weimar, Dessau, Berlin* (Bramsche: Gebr. Rasch, 1962).

33. Paul Shaw, *Helvetica and the New York City Subway System: The True (Maybe) Story* (Cambridge, Mass.: MIT Press, 2011).

34. See Jay David Bolter and Richard Grusin, *Remediation: Understanding New Media* (Cambridge, Mass.: MIT Press, 1999).

35. Heller, "Muriel Cooper" (interview), 97.

36. Ibid., 99.

37. László Moholy-Nagy, *Vision in Motion* (Chicago: P. Theobald, 1947), 12.

38. Muriel Cooper, "Computers and Design," *Design Quarterly*, no. 142 (1989): 14.

39. Cooper, unpublished interview with Ellen Lupton.

40. Engelbart and Ted Nelson were also instrumental in the development of hyperlinking, which allowed for nonlinear connections within or between documents, a concept that was of great interest to Cooper.

41. Heller, "Muriel Cooper" (interview), 99.

42. Less needs to be said on the design of *Learning from Las Vegas*, given some excellent recent historical work on it: Aron Vinegar, *I Am a Monument: On Learning from Las Vegas* (Cambridge, Mass.: MIT Press, 2008); Aron Vinegar and Michael J Golec, eds., *Relearning from Las Vegas* (Minneapolis: University of Minnesota Press, 2009); Martino Stierli, *Las Vegas in the Rearview Mirror: The City in Theory, Photography, and Film* (Los Angeles: Getty Research Institute, 2013). To the extent that Cooper has received scholarly attention, it is in these accounts.

43. Martino Stierli writes: "The basic premise of *Learning from Las Vegas* is that the car has significantly shaped the form of the contemporary American city. Assuming that urban space is first of all perceived by a mobile, in fact, 'automobilized' observer and that the experience of this space is simultaneously an experience of driving, Robert Venturi and Denise Scott Brown used moving images, the apparatus of film-making, and protocinematographic sequences in their analysis of the Las Vegas Strip." Stierli, *Las Vegas in the Rearview Mirror*, 149.

44. Donald Appleyard, Kevin Lynch, and John R. Myer, *The View from the Road* (Cambridge, Mass.: MIT Press, 1964), 2. Cooper's design in a tall, slim format emphasized dynamism and multiple directions and temporalities of reading, with a rhythmic typographic grid, arrows instructing viewers to read up and down, and a flipbook in the outer margins of the pages. According to Cooper, "The author[s] hated it—It was out of the reach of the engineers. Too big, arty." Cooper, unpublished interview with Ellen Lupton.

45. Recording of Richard Saul Wurman with Muriel Cooper at 5th TED Conference presentation, Monterey, California, 1994, courtesy of Richard Saul Wurman.

46. Heller, "Muriel Cooper" (interview), 98.

47. Cooper's design appeared to be a fitting visualization of the authors' argument, which one might even have expected them to appreciate: "Cooper's attempt to find a coherent yet flexible order within the complex amalgam of image and text in the book would seem to be in sync with *Learning from Las Vegas*'s attempt to find the 'order' within the 'chaos' of the Las Vegas strip." Vinegar, *I Am a Monument*, 120.

48. This direct access to the means of production, with all its political implications, makes Cooper an exemplar of what the graphic design writer and curator Ellen Lupton has called "the designer as producer." See Ellen Lupton, "The Designer as Producer" (1998), reprinted in Andrew Blauvelt and Ellen Lupton, eds., *Graphic Design: Now in Production* (Minneapolis: Walker Art Center, 2011), 12–13, in which a photograph of Cooper at work appears as an illustration for the essay.

49. Cooper, unpublished interview with Ellen Lupton.

50. The most complete accounting of the MIT Media Lab, incidentally, is by the founder of the *Whole Earth Catalog*, Stewart Brand. Yet Brand severely underrepresents Cooper's work, surprisingly given its centrality to the aims of the Lab and consonance with many of Brand's interests. Brand describes Cooper's Visible Language Workshop as "trying to cure the chronic ugliness of computer graphics and visual design," which is correct as far as it goes, though it does not go far enough. Stewart Brand, *The Media Lab: Inventing the Future at MIT* (New York: Viking, 1987), 12.

51. Heller, "Muriel Cooper" (interview), 99.

52. Dondis graduated from the Massachusetts School of Art in 1945. While enrolled, her name was Helen D. Asnin.

53. Richard Saul Wurman, interview by author, telephone, February 14, 2012.

54. Sylvia Steiner, email to author, April 12, 2015. Steiner recalls the process for this book, and has helped with the attribution of all others mentioned here.

55. Among these personal interests, in building the Press roster, Cooper advocated for the formation of a new list of titles under the heading "Visual Communications." This would include both new publications and reprints of out of print classics. The first three she suggests are of self-evident personal interest: Paul Rand's *Thoughts on Design* (1947), Karl Gerstner's *Designing Programs* (English edition, 1964), and Gyorgy Kepes's *Language of Vision* (1944), and *The New Landscape in Art and Science* (1956). Muriel Cooper, "DRAFT – Visual Communications Proposal., 4/3/1978," box 6, AC 287, Visible Language Workshop, Records of Muriel Cooper, Institute Archives and Special Collections, Massachusetts Institute of Technology.

56. Heller, "Muriel Cooper" (interview), 99.

57. Ron MacNeil, email to author, January 28, 2014.

58. Ron MacNeil, telephone interview by author, February 22, 2012.

59. Steenson describes the activities of the Architecture Machine Group as "oppositional" to the architectural discipline as it was currently conceived. There were likewise aspects of the Visible Language Workshop which were, to use Steenson's words, "anti-architect" if not "anti-architectural." Molly Wright Steenson, "Architectures of Information: Christopher Alexander, Cedric Price, and Nicholas Negroponte and MIT's Architecture Machine Group," Ph.D. diss., Princeton University, 2014, 3. See also Arindam Dutta, ed., *A Second Modernism: MIT, Architecture, and the "Techno-Social" Moment* (Cambridge, Mass.: MIT Press, 2013).

60. Heller, "Muriel Cooper" (interview), 99.

61. In 1951 Cooper worked for a year teaching design at the University of Maryland; in 1959–1960 she taught night classes in design at Boston University; and from 1962 to 1964 she was Associate Professor of Design at the Massachusetts College of Art.

62. Muriel Cooper, "Interests and Goals," n.d., Muriel R. Cooper Collection, box 12-284.

63. Fairbairn, "The Gendered Self in Graphic Design," n.p.

64. Tom Norton and Gini Holmes, "Electrographics" (draft), n.d., n.p., MIT Institute Archives, Visible Language Workshop, Records of Muriel Cooper, 61, AC 287.

65. Muriel Cooper, untitled memo, September 1979, Muriel R. Cooper Collection, box 12-284.

66. Fairbairn, "The Gendered Self in Graphic Design," n.p.

67. Muriel Cooper, draft summer session materials, 1981, Visible Language Workshop Collection, MIT Museum, box 6.

68. Muriel Cooper and Visible Language Workshop, "Words, Images, Tools and Ideas," *Plan: Review of the MIT School of Architecture and Planning*, no. 11 (1980), 105.

69. Lev Manovich has explored the fate of "medium" after software, and traces an intellectual history of software in the 1960s and 70s that includes some of the figures mentioned in this essay, albeit not Cooper. Manovich, *Software Takes Command: Extending the Language of New Media* (New York: Bloomsbury Academic, 2013), 3ff.

70. Nicholas Negroponte, "Arts and Media Technology," *Plan: Review of the MIT School of Architecture and Planning*, no. 11 (1980): 20.

71. Nicholas Negroponte, *Being Digital* (New York: Knopf, 1995). The term "convergence" and its social implications were first formulated by MIT social scientist Ithiel de Sola Pool. In reference to Pool, Steenson writes: "a technological condition in which computing devices become more compatible, convergence referred to the alignment and unification of content, media, delivery, and governance. … The relationship between content and medium had collapsed and would continue to do so." Steenson, "Architectures of Information," 260–261.

72. Brand, *The Media Lab*, 10.

73. Negroponte, "Arts and Media Technology," 19.

74. Ibid., 24.

75. Brand, *The Media Lab*, 12.

76. Cooper, "Computers and Design," 30.

77. Fairbairn, "The Gendered Self in Graphic Design," n.p.

Soft Copy (1974–1994)

David Reinfurt

Self-Portrait

A double self-portrait offers some clues to Muriel Cooper's thinking around human-computer interface design. This composite picture registers at least three different photographic times and as many imaging feedback loops. It's a layered image on its surface, and baroque in its construction; the picture was assembled over 10 years, beginning around 1974. Around that time, Cooper wrote a bio which laid out her interests: "… beginnings and process. More with change and technology and their meanings to human communication than with rigorous graphic design theory and style."[1]

Cooper was not a traditional graphic designer. She was certainly not a computer programmer. But she was persistently interested in graphics, new technologies, and their interfaces. In the summer of 1967, she attended a computer-aided design and programming class in the Department of Mechanical Engineering at MIT taught by Nicholas Negroponte. Negroponte had joined the faculty in the School of Architecture and Planning, establishing the Architecture Machine Group in 1968. By 1972, Cooper was beginning to explore how computers might apply to graphic design, and Negroponte arranged for the installation of one computer at the MIT Press under the short-lived umbrella of a graphic research unit.

While Media Director at the Press around 1973, Cooper was introduced to Ron MacNeil. Cooper and MacNeil co-founded the Visible Language Workshop (VLW) within the MIT Department of Architecture in 1974 and worked together for twenty years. In 1971 MacNeil had also enrolled in Negroponte's programming class and by 1978 he apprenticed himself to the Architecture Machine Group, spending six months and leaving with a cast-off teletype interface board and a 16-line machine language program.

Although Cooper was not technically conversant with the computers, she did immediately recognize their potential:

I was convinced that the line between reproduction tools and design would blur when information became electronic and that the lines between designer and artist, author and designer, professional and amateur would also dissolve.[2]

Beginning with her exposure to the Architecture Machine Group, continuing with brief computer experiments at the MIT Press, and eventually through direct engagement with the electronics and software that MacNeil brought into the VLW, Cooper sporadically attempted to teach herself to program. She never learned but remained fascinated by the relationship between technology and graphic production; computers offered a bright new horizon for direct, immediate control plus the promise of real-time feedback. In the slideshow introduction to an MIT Summer Session at the Visible Language Workshop in July 1981, Cooper described

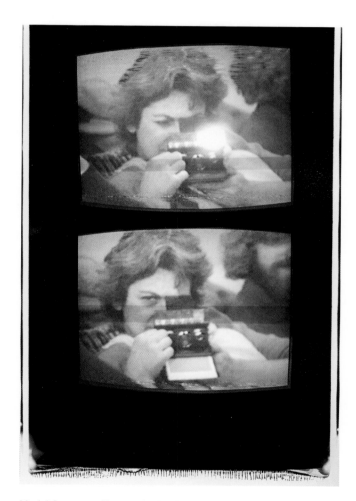

Muriel Cooper, self-portrait with Polaroid SX-70, video imaged and printed at the Visible Language Workshop, c. 1984 >p. 145

Computer self-portrait, Muriel Cooper (right) with Donis A. Dondis, produced in Nicholas Negroponte's design and programming class, MIT Department of Mechanical Engineering, 1967 > p. 51

that idea of instant visualization, of effecting the production tool, or the reproduction tool, being able to respond back to the tool very fast, "oh it's too red", "oh it's too green", all that sort of comes from the frustrations of having dealt professionally ... the new tools are going to, if they are in some way controlled or understood by the users, become as interactive as these cruder things that we have described ... the idea of typesetters on your desk gives you a kind of control you haven't had since you were a medieval monk.[3]

The source images for Cooper's double self-portrait are from around 1974, still frames excerpted from a video recording. Ron MacNeil suggests these were captured by a Portapak battery-powered black-and-white video camera system, a new technology at the time. Portable 16 mm and 8 mm film cameras were widely available for recording moving images on the go, but the film medium and its processing limited what could be shot and where. There was a necessary delay between exposing an image and viewing it. Film is light-based and chemical, but video is electronic and magnetic and so removed this time gap – images could be captured and played back on a monitor immediately.

The photographic camera that Cooper points back at the video camera is a Polaroid SX-70 compact instant camera, identified by its flash bar and all-black body. Based just around the corner on Main Street in Cambridge, Polaroid routinely provided development versions of its advanced imaging technologies to the VLW for experimentation. The SX-70 was quickly adopted in the workshop as an immediate, responsive image-making tool.

The SX-70 produced instant photographic prints, although this technology was nothing new. Since its first consumer camera, the Land Camera Model 95 launched in 1947, Polaroid had manufactured film that produced photographs within minutes of exposure without any additional darkroom processing. The SX-70 significantly improved the film technology by packaging paper and chemicals as a single unit, preloaded into a replaceable cartridge. After taking a picture, the image emerged directly from the SX-70 with no further manipulation. Unlike earlier films, the new film left no chemical residue and produced no additional waste, and SX-70 pictures could be made in rapid succession. (At the product launch, Polaroid president Edwin Land unfolded an SX-70 from his suit pocket and shot five photographs in 10 seconds.)

Like the Portapak video camera, the SX-70 was designed to be portable, with a compact, collapsible form. It could be tucked into a bag or coat pocket so that the camera traveled with its user. Also like the Portapak, the SX-70 provided immediate feedback in the form of a printed image, visible moments after it was exposed. This concise imaging loop opened up a wide range of novel uses for the camera. Cooper's designer at the MIT Press and student in the Visible Language Workshop, Wendy Richmond, recalls: "We documented every step of the way. We learned this from Muriel, who always had a Polaroid or 35 mm camera hanging from her neck. We were more interested in the process than the final product."[4]

The chronology of these two still frames is clearly marked. The top frame catches a moment of photographic exposure; Cooper's right eye is closed in framing and concentration while the flash from her Polaroid SX-70 fires. Although instant Polaroid was used extensively in the VLW, relatively few photographs include Cooper. More often than not, as here, she was behind the camera.

While the first frame is the instant of image making, the bottom frame records the moment of image printing. These two points in time as recorded on videotape are not far apart, but here the gap is essential. Between the first and second frames, an instant photograph emerges from the camera. The image captured in its chemical sandwich will develop in the next sixty seconds. Meanwhile, Cooper stares directly back at the Portapak video camera, one eye given to her SX-70. She is a cyborg – her left eye replaced and upgraded by the Polaroid lens. The undeveloped photograph coming out of her camera is a record of what she sees, and soon it will reveal the Portapak, its operator, and the surrounding context. For now, that picture remains blank.

Around 10 years elapsed between the making of these two video images and the assembly of the composite print. The finished double print was produced on a large-format printer in the Visible Language Workshop. This "printer" was more of a camera, and used large-format (24-inch-wide) instant photographic paper provided by Polaroid. One such apparatus was a 20-by-24-inch experimental Polaroid camera that printed an electronic image directly to instant photographic

paper. MacNeil described the hybrid machine: "You would send a color signal to this amazingly sharp flat screen full tone scope and it would do the rotating filter-wheel dance to get all the colors."[5]

In this inside-out camera, the screen displays an electronic image that provides the light source used to expose a sheet of photographic paper. An early version of the printer exposed red, green, and blue channels of the image in sequence to build up a composite color image. The large, high-resolution digital print was ready in a matter of minutes, and "digital Polaroid" became a primary output tool at the VLW. Workshop coordinator Rob Haimes worked with this technology at the VLW and later attempted to adapt this technology on a wider scale with Agfa Corporation. Competing inkjet printers proved more commercially viable, and this idiosyncratic digital printer remains principally an experiment.

By 1980, MacNeil was fully engaged in another ambitious hard copy output system, the Airbrush Plotter. Funded by grants from the Outdoor Advertising Association, this multiyear project supported much of the other work in the VLW, was cobbled together using rejected computer chips from Fairchild and National Semiconductor. The Airbrush Plotter combined digital image capture, image-processing software, and large-format digital output. Capture was handled by a line-scanning chip bolted to the film plane of a Nikon camera and moved via a stepping motor. A hacked one-color print head produced the output using airbrush inks.

In addition to the large-scale inkjet printer that was at the center of this project, MacNeil, Rob Faught, and other VLW students over several years also developed a proto-Photoshop image-editing suite called SYS. MacNeil recalls the pieces of SYS as including "a 32 bit Super Mini (128K of core memory, but cost of $125K), a 300MB hard drive as big as a refrigerator on its back, a full color frame buffer with real time frame grabber, and a virtual disk image management system that let us zoom in and out." The architectural scale of Airbrush Plotter images required a very high-resolution electronic work area, and SYS addressed a frame buffer capable of 2,000 by 7,000 pixels. SYS became a central image-processing tool in the VLW, and workshop coordinator Lee Silverman suggests that the video source images in the Cooper self-portrait were likely captured and processed by SYS.[6]

The final composite double image was produced alongside slow-scan television transmission experiments from around 1980–1983 at the Center for Advanced Visual Studies (CAVS), and to a lesser degree, in the Visible Language Workshop at the same time. Slow-scan television (SSTV) was a means of sending and receiving images over an analog telephone line. The slow-scan unit digitally stored a frame of video which was encoded, scanned line by line into frequency-modulated audio waves, and transmitted as a standard audio signal over a telephone line to a remote receiver. There, a slow-scan unit received the audio signal and its waves were translated back into pixel values and reassembled one row at a time on the remote video display. Image transmission was reduced to the relatively slow speed of 8 seconds per frame to fit the limited bandwidth of existing telecommunication networks, and this gave the technology its name.

Slow-scan technology had been around since the late 1950s and was used to send images back from the first U.S. and Soviet space missions. At MIT, artists including Aldo Tambellini and Bernd Kracke in the Center for Advanced Visual Studies, Peter Droege from the Architecture Machine Group, and Lee Silverman from the VLW were actively experimenting with its potential.

One such experiment was organized on February 16, 1980. "Artists' Use of Telecommunications" was a three-hour multilocation electronic conference organized by the San Francisco Museum of Modern Art. At MIT, the event involved artists, architects, and engineers from CAVS, the Architecture Machine Group, and the Visible Language Workshop. Other participants were geographically dispersed, with nodes in Tokyo, Vienna, Vancouver, New York, and Toronto, all transmitting images and text to one another. Transmitted images were transcribed to a digital videodisc at the Architecture Machine Group.

Documentation of the event captures exuberant multimedia chaos. Remotely sent images appear, almost magically, line by line on a video monitor from the top of the screen, accompanied by the wild squeal of its encoded audio data. Each image slowly erases the previously transmitted image over the course of its eight-second transmission. Assembled participants witness the received images while actively preparing for the next to be sent. At one point, Marvin Minsky of

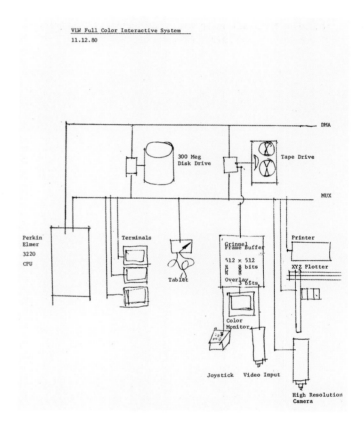

Schematic diagram of electronic image manipulation and output system at the Visible Language Workshop, 1980 > p. 141

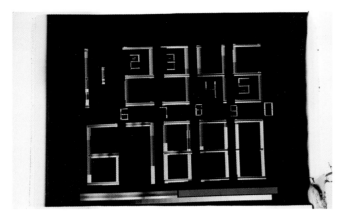

Large-format Polaroid digital print, slow-scan transmission, c. 1982
> p. 165

the MIT Artificial Intelligence Laboratory records a contest between a live turtle and its artificially intelligent robot equivalent.

Another slow-scan event, "Interfaces," was organized between CAVS and the American Center in Paris. An image of recently inaugurated U.S. President Ronald Reagan was split into a grid of smaller images, then slow-scan-transmitted from Cambridge to Paris. In Paris, the receiving video monitor was photographed with a Polaroid instant camera and the images were reassembled to produce a 10-by-12-foot mural. A similar image of French President Valéry Giscard d'Estaing was sent in the opposite direction.

Slow-scan transmission events were also organized directly with and in the Visible Language Workshop. TransMIT was a day of slow-scan transmissions and talks on the possibilities and consequences of electronic image circulation, held on January 19, 1983. Cooper delivered the opening remarks, which were followed by talks including "Graphic Information Systems" by Patrick Purcell of the Architecture Machine Group, "Not Art, Teleculture" by Robert Horvitz, editor of *Coevolution Quarterly*, and a transmission performance event, "I Am a Machine," staged together with the School of the Art Institute of Chicago.

About 10 years after the initial video was shot, the footage of Cooper and her SX-70 was frame-captured, transmitted, and displayed, stacked on two identical monitors which were captured in turn by a large-format Polaroid camera. The resulting double self-portrait is a remarkably resonant image. Cooper is caught somewhere in between the original image, its transmission, and the transmission's reproduction. Silverman recalls that Cooper was only superficially engaged in the slow-scan transmissions at the VLW. And yet, as with many other new graphic technologies, she immediately recognized slow scan's potential, and this picture concisely encapsulates its possibilities. Ron MacNeil neatly summarized what was eventually at stake in this image:

In time, images stay on the screen. And now they travel through networks. I think what Muriel finally discovered was the act of communication design in the process of radical change away from creating single artifacts to creating design processes that need to have a life of their own over these networks.[7]

A tangle of technologies worked together to produce this double self-portrait. If an interface can be described as a shared boundary across which two separate components of a system exchange information, then this photograph might be considered one, and also a prototype for Cooper's thinking about interfaces. The final image collapses its original videotaping, Cooper's Polaroid photographing, frame digitizing, audio conversion, transmission, reception, decoding, documentation, and large-format reproduction all in one shared surface. The composite manifests, even conjures, an interface; it is the space where these imaging techniques connect and exchange information. It was a first step for Cooper, and, typically, the resulting image is less important for her than its process. This picture was around 10 years in the making—a long way from the real-time interface she was looking for.

Books without Pages

In 1978, Cooper with Negroponte and Richard Bolt prepared a proposal to the National Science Foundation to explore the transition of published information onto electronic screens. The proposal, titled "Books without Pages," begins: "This proposal is about SOFT COPY."[8] "Soft copy" was a neologism, best understood in opposition to its opposite, "hard copy." Soft copy is fluid, dynamic, mutable, carried in a digital medium and appearing on electronic screens. Hard copy is fixed, registered, permanent, found in books and printed matter.[9] These two forms are opposed, but the authors suggest that each is mediated by the interface through which it's delivered. They proposed to study the interface of a book, and from this departure point they would consider how its format might transition from paper to a digital medium, from hard to soft copy. The proposal's abstract continues:

It is both forward and backward looking upon information systems as qualitative, human resources. On the one hand we propose to evaluate specific visions of the future. On the other hand, we posed questions of hindsight to assure that some of the old fashioned qualities of communication are not lost.

"Books without Pages" (storyboard for a page-flipping interface), proposal to the National Science Foundation by Nicholas Negroponte, Richard Bolt, and Muriel Cooper, 1978 > p. 156

"Books without Pages" emphasized the distinct and complementary backgrounds of its authors. Negroponte, Cooper, and Bolt are described, respectively, as "a researcher in computer / TV media, an expert in graphic design, and a psychologist with a computer background." The varied perspectives of the participating researchers were essential, as interface design would require a broad perspective. Understanding social and cultural convention together with individual user considerations was essential in order to offer any specific technical or design recommendations. The work was divided into four areas of concentration: text as a graphic event, media-inherent bases of orientation, videodisc technology, and sound synchronized with text.

Much of the proposal builds directly on ideas Negroponte had developed in the Architecture Machine Group, but it also reads in line with Cooper's emerging thinking about digital interfaces. In print, Cooper designed for an active reader. A digital medium held even more promise for its reader to guide and effect the process: "Books without Pages is about interaction and dynamism. ... The reader becomes an active agent in the information system with data in the round, itself a world's fair of sound and light."

The proposal details differences between hard and soft copy. In a section titled "On not throwing away the message with the medium," a letter received through the U.S. Postal Service is considered. This letter arrives with marks which indicate its journey, and the color of the envelope, handwritten address, even the stamp all pack extraliteral communication into the object. These cues partly account for the persistent preference for using a physical object for communication. The experience is richer, more dimensional. Soft copy fails to account for any of these physical communication properties; but it has other expressive dimensions, and these offer the possibility of compensating for the missing tactile qualities. Sound, graphics, and animation are all possible in an electronic book. Most importantly, however, soft copy is mutable.

A book's interface is entirely learned. The page-turning, left-to-right, front-to-back conventions of a codex book were established and implemented by repetition. Page numbers, sizes, chapters, paragraphs, paragraph breaks, and so on, all the way down to the forms of the letters on the page, all evolved slowly as standard typographic furniture. These were invented, not discovered, and reading a book requires decoding these design cues.

With the move to a digital format, all of these conventions were up for grabs. "Books without Pages" made this clear, asking: "What is a Book without Pages? Why is it still called a book?" Conventions of the book weren't simply tossed out by Cooper, Negroponte, and Bolt. They were reconsidered, and many were kept and adapted. For example, having discrete pages was identified as a useful orientation device. The authors suggested replacing the endless scroll of soft copy with a page-based interface, complete with a page-flipping animation. Using this real-world analogy, a user might gain a sense of her place within the body of the text that would be missing in a digital text. The authors expanded on the idea:

By "sense of place" is meant orientation stemming from the tangible specifics of the context in reading/viewing activity: e.g., where one is in the text; how far one has come, how far one has yet to go; formatting suggestive of what is to come ("frame"-like function); ever-present tables of contents, with tangible, interactive "pointers," progress indicators, and so forth.

Section 5.1 in the proposal, "Understanding text as a graphical event," describes how a dynamic, electronic typography might work. It starts by examining how form modulates meaning in an analog medium by examining a used-car advertisement: "'CAR WARS' said a poster, with text reading into a one-point perspective, followed by the name and address of a used car lot offering galactic loans and astronomical discounts." At first this appears to be a trivial example, a cheap visual pun pushed into the service of selling used automobiles. But Cooper, Negroponte, and Bolt suggest that dimensional typography like this might have greater capacity for carrying meaning in a digital medium. Three-dimensional information environments allow for multiple connections between texts that would be more difficult to render within the two static axes of a printed page.

Cooper, Negroponte, and Bolt addressed existing computer interfaces as well. Scrolling text had appeared in the earliest computer interfaces. When a text was too long to fit on a screen, one line after another appeared, flashing on at

the bottom of the display as the rest of the text moved up. This was a relatively intuitive interface, and one that mapped onto a physical object seen through a window too small to enclose it. But the authors suggested that this scroll animation was not as effective as it could be. When lines appeared on the bottom of the screen, they appeared at once, flashing and causing the previous line to jump one line up. Text was not legible during the move.

The authors suggested easing this transition with a simple bitwise animation that draws the text on screen scanline by scanline. Instead of each full line flashing on in succession, this technique would continuously redraw the screen and insert intermediate steps in the perceived animation. The scroll would appear smoother, the text would be presented continuously, and a reader would be able to continue reading as more information was dynamically added. The technique, named "Hollywood scroll" by one manufacturer, became the standard for presenting long texts and is now omnipresent in browser, desktop, and mobile interfaces.

Negroponte, listed as the principal investigator in the proposal, summarized what was at stake with such designs:

future systems will not be characterized by their memory size or processing speed. Instead, the human interface will become the major measure, calibrated in very subjective units, so sensory and personalized that it will be evaluated by feelings and perceptions. Is it easy to use? Does it feel good? Is it pleasurable?

In the end, the proposal wasn't funded by the National Science Foundation. Cooper found other outlets for the ideas, and the name was repurposed by Negroponte for work funded separately by the Office of Naval Research and the Defense Advanced Research Projects Agency.

Bolt and Negroponte had previously worked together on the Spatial Data Management System (SDMS), a multimodal computer interface for accessing digital information. Bolt was the lead scientist on this project, sponsored through the Defense Advanced Research Projects Agency and run under the umbrella of Negroponte's Architecture Machine Group. SDMS is repeatedly referenced in the 1978 National Science Foundation proposal and forms the conceptual basis for many of its ideas.

Spatial data management asserted that computer interfaces relied too heavily on symbolic, linguistic links. Data were stored in hierarchical relations of nested directories and files, organized by type and recalled by a filename. To locate a specific document, the user would have to recall its name. Analog filing systems, such as an actual desktop, work differently. The user might remember that a certain document is in the third pile from the left, or is collected with others from about the same time in a folder on the floor, or even is the one with a red cover. These spatial organizational cues had not yet been applied substantially to the organization of files within a computer interface. In spatial data management, every file had a location, an address, rather than simply a name. Each file exists somewhere, and the graphic interface allows quicker, visual access to its contents.

The data in SDMS were stored on videodisc. This optical storage format facilitated random access to the digital contents as well as responsive control of playback speed. Videodisc was a central medium for work in the Architecture Machine Group, where previous experiments had exploited the specific capacities of the medium. "Books without Pages" describes one such disc which, instead of including continuous video data, was comprised of 54,000 distinct still images culled from the slide collection of MIT's Rotch Architecture and Planning Library. The videodisc could be quickly scrubbed forward or backward to locate a particular slide, displayed as a still frame. The collection could be browsed by chapter headings.

Multimodal inputs, of both voice command and touch, guaranteed redundancy, aiming to approximate human interaction. Thirty years before the first iPhone or iPad, the authors of "Books without Pages" wrote: "When the reader indicates that he wants to turn the page, he indicates by a simple finger-gesture captured on a small touch-sensitive pad located on the arm of the chair in which he is sitting."

SDMS was staged in the Media Room, a space within the School of Architecture which included a wall-sized projection screen and a multimedia interface including touchscreen, trackpad, and joystick centered around an Eames lounge

Figure 2-1.

The Media Room
-showing the adjoining room with the GE Light Valve for back-projection onto the large 6' by 8' screen.

-14-

"Books without Pages" (diagram of The Media Room), proposal to the National Science Foundation by Nicholas Negroponte, Richard Bolt, and Muriel Cooper, 1978 > p. 162

chair. Computers were removed from this user space, sequestered to a machine room located behind the projection screen. The result was a seamless, immersive user environment.

SDMS preceded "Books without Pages," and many of its ideas were embedded in the latter. In spatial data management, location was employed as a metaphor. A model could be imagined, an intuitive multivalenced relation between distinct pieces of data which creates an immersive, enveloping information space. The user navigates by reading from one file to the next. These ideas followed Cooper from this unrealized proposal.

Computers and Design

In 1989 Muriel Cooper guest-edited *Design Quarterly* no. 142, a special issue on "Computers and Design." As the magazine's managing editor Mildred Friedman describes in her introduction, it continued directly from the issue on "Design and the Computer" (1966), guest-edited by Peter Seitz. Where that issue had looked forward, speculating on how design would approach the new electronic tools becoming available, "Computers and Design" looked first in the other direction, uncovering precedents for the application of computer logic to graphic design and connecting these to current work in the MIT Media Lab and Visible Language Workshop. Cooper's own engagement with the changing tools of graphic design put her in a useful position to connect the dots, as Friedman describes:

Design Quarterly, no. 142, "Computers and Design" (cover), 1989
> p. 175

The contributions to design theory and practice of Muriel Cooper – who in mid-career as a highly regarded designer of books and other graphic materials threw it all over to take on the issue of new graphic languages that bridge art and technology – are both rare and remarkable. Her example is a challenge to the self-satisfied streak in us all.[10]

As guest editor, Cooper split the issue into three sections. "The New Graphic Languages" is a retrospective audit of designers and artists working before computers in ways that anticipated software. The second section introduces the Media Lab, and the third describes current work of the Visible Language Workshop.

At the start of "The New Graphic Languages," Cooper places the computer within a historical trajectory and identifies a new, synthetic design discipline that will evolve as a consequence:

Today's personal computer is a functional tool that mimics old tools. But the next generation of graphic computers will permit the merging of previously separate professional tools; at the same time, powerful networking, increased bandwidth and processing capabilities will make the transition from print to electronic communication the basis of a vast industry. The primary interaction of electronic communication environments will be visual. Traditional graphic design skills will continue to be important for display and presentation, but a new interdisciplinary profession, whose practitioners will be adept in the integration of static and dynamic words and images, will be required to organize and filter information growing at an exponential rate.[11]

She suggests that new design practices often emerge in parallel with the appearance of new media. As print media expanded, graphic design emerged. With the explosion of electronic media such as broadcast television and videotape, new design fields emerged around motion graphics and animation. Emergent media had their own constraints: the paper formats and inks of a printed page; the 4:3 aspect ratio and low resolution of television; the mass economics of broadcasting and publishing. Each imposed practical bounds on what could be communicated and how. As Cooper describes, "reality was filtered and organized through the limitations of the media."[12] But digital media are something else – there is no natural frontier to the amount of information they can carry. Previous media marked their own boundaries, which in turn were used to organize their contents. With digital media, the amount of information is practically infinite, and so the job of filtering and organizing is increasingly urgent. Cooper describes a near future where the flow of information will be too fast for any designer to format it. Design will become a task of creating templates and processes rather than bespoke pieces of communication.

Following Marshall McLuhan, Cooper acknowledges that each new medium first embeds and then evolves conventions from the medium it replaces. The

digital medium of the computer is no exception. Electronic graphic design softwares for typesetting and image editing were first created to accelerate print production, but soon enough the computer itself became a communication vehicle: "programmers began to experiment with personal graphic ideas. It was only a matter of time until these tools migrated into the creative domain." But Cooper suggests that software can only make this move from graphic design tool to medium if its user interfaces are responsive and intuitive. "At this stage the term user-friendly was unheard of."[13]

The defining quality Cooper identifies for a digital medium is its unique ability to integrate other media. The computer can merge video, sound, static text, animated text, and interactivity. Unlike traditional media which rely on linear formats and closure, digital media are open-ended, dynamic, and nonlinear. Bringing together various media in this new form also requires a new type of designer.

There are precedents, and Cooper compiles a list. The first was László Moholy-Nagy and his diagrammatic score for a proposed film, *Dynamic of the Metropolis*. This graphic used typography to communicate both the temporal structure as well as the feeling of the proposed film sequence: "In fact, the score itself becomes a piece of meta-art. It is not hard to imagine Moholy using a computer."[14]

Next was Gyorgy Kepes, her colleague at MIT, who published a series of books that eloquently argued for the interconnectedness of art, technology, and design and a refreshed graphic language to reflect changing relationships. Charles and Ray Eames follow, identified for their interdisciplinary thinking and practice that bridged product design, film, and exhibitions. Cooper describes a teaching demonstration the Eameses assembled together with designer George Nelson in 1953 called "Sample Lesson for a Hypothetical Course." The multimedia performance, staged at the University of Georgia and at UCLA, included projected still images, graphics, film, sound, and even the smells of baking bread, all integrated into a classroom lecture in a university hall.

Cooper also describes Swiss graphic designer Karl Gerstner's book *Designing Programmes* from 1964, which "explores the structure of design as programmed systems and resultant processes rather than as unique product." Although out of print by this time, the book, she writes, is "just beginning to be seen not only as an homage to the grid but as a way of thinking that permeates all forms of human and natural design, one that is particularly appropriate to future computer design and art."[15]

Cooper understood interface design as a question of media integration, closely related to theater and performance, and fundamentally concerned with creating a plan for synchronizing various information streams. She recognized that this new design problem also required a new vocabulary. Early attempts at graphic computer interface design evolved from work at the Xerox Palo Alto Research Center and relied on a string of metaphors including overlapping windows, files, and folders. The familiarity of such real-world analogies was only transitional for Cooper. She saw something else coming:

A multi-media work environment will not only provide the user free browsing through media but the opportunity to interact with three-dimensional information in real time. Animated and simultaneous multi-media events in linear time, which are mapped dynamically in space, present a challenging design problem.[16]

Interfaces had yet to explore this problem adequately, clinging to models that employ a physical environment to provide a familiar transition to the flat, mysterious digital world. She compares the desktop computer interface to a printed Advent calendar where windows in the calendar are marked with dates and appear seamlessly. When opened, these windows offer portals into other (imaginary) spaces. In the same way, a folder on the desktop or a window in a software application appears as a portal to another space. Existing interfaces provide an easy transition as a mirror of the world, but software doesn't need to be so literal. Cooper's most precise insight follows:

But in fact, it is not the real world, and at some point on the learning curve moving iconic metaphors around is as tedious as rummaging through filing cabinets. At that point the user understands that the computer is a medium different from the physical world, one that offers the power of abstraction.[17]

The next two sections of "Computers and Design" describe the work of the Media Laboratory and of the Visible Language Workshop, Cooper's research group within it. "The Media Laboratory is a pioneering interdisciplinary center that is a response to the information revolution, much as the Bauhaus was a response to the industrial revolution."[18] The Media Lab was established to eliminate the isolation of separate approaches by mixing the most forward-thinking research together with technical advances in imaging, software, interactivity, computation, and human cognition. It evolved directly from Negroponte's Architecture Machine Group and collected the Logo Group, the Artificial Intelligence Laboratory, Electronic Music, and Cooper's Visible Language Workshop within a brand-new building designed by I. M. Pei in a prominent campus location. The Media Lab worked across disciplines, and this followed Cooper's belief that computer interface design problems center on the integration of different media and could not be solved without the broad approach that varied perspectives offer.

The Media Lab was comprised of thirteen research groups at that time: Human Interface; Epistemology and Learning; Computers and Entertainment; Electronic Music, Performance and Technology (The Cube); Computer Animation and Graphics; Electronic Publishing; the Visible Language Workshop; Film/Video; Spatial Imaging; Vision Sciences; Speech Recognition; Advanced Television; and Telecommunications. Significant cultural and language differences existed among the disciplines. Communicating and negotiating criteria within the Lab was a model of what happens beyond its walls when disciplines intersect. Typically, Cooper considered this an opportunity rather than a handicap:

The Media Lab's greatest strength may prove to be the collision of the disparate disciplines and values represented there. The valuation models of a scientific community do not easily mesh with those of the art community although they avowedly seek the same grail. In much the same way, the meaning of the Bauhaus was in the conflict between painters like Klee and Feininger, and technocrats like Moholy-Nagy.[19]

The final section of the issue, on the Visible Language Workshop, is something between a mission statement and a working manifesto.

In an electronic environment, the volume of real-time information will outstrip our ability to process it. The use of graphics as a filter for this complex information, as a means of making it both meaningful and expressive, is the critical research challenge of the Workshop.[20]

Cooper restates the problem in terms of media integration, using the multiple sensory dimensions available in a dynamic medium in order to organize this massive digital flow. She inventories techniques that the VLW was actively exploring, including translucent, anti-aliased, and layered text; very high-resolution displays; simultaneous video, text, and sound; and dynamic interfaces capable of processing information in real time. "Designers will simply be unable to produce the number of individual solutions required for the vast number of variables implicit in real-time interaction. Design will of necessity become the art of designing processes."[21]

The cover of the *Design Quarterly* special issue neatly illustrates these themes. It presents a three-by-three grid of thumbnail renditions of the cover as it dynamically shifts through a temporal sequence. Software to produce these images was written by Suguru Ishizaki, but the image was choreographed by Cooper. It is more a provocation than a working prototype, but as with much of her strongest work, this imagined interface suggests a path forward. It is rhetorically succinct and telegraphs many of the themes that she developed at length in the issue. The cover image is captioned on the back:

Four images and three text segments are used to explore ways simultaneously to represent multi-tiered information using changes of size, placement, color, and translucency. Each frame will change as the "reader" browses in real time with text and image cues dependent on the linkages that have been designed for browsing. On one level this series is analogous to a book printed on translucent paper, but it takes advantage of the potential for change inherent in the computer.[22]

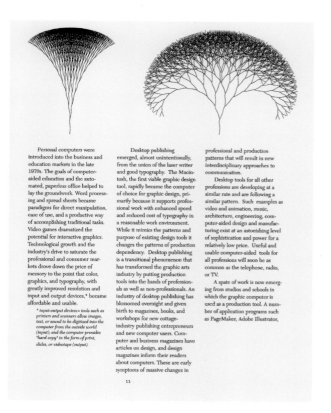

Design Quarterly, no. 142, "Computers and Design" (interior layout with computer graphics by Hugh Dubberly), 1989

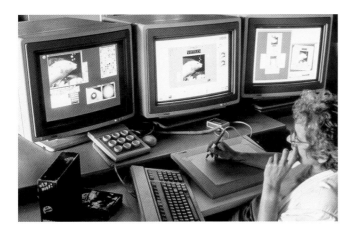

Muriel Cooper at three-screen workstation, 1989 > p. 176

Intelligent Graphics

Design Quarterly's cover image was created in 1988. One year before, artificial intelligence researcher Henry Lieberman joined the Visible Language Workshop. Intelligent graphics that responded to the user, similar to what's imagined on the *Design Quarterly* cover, soon emerged as a research locus in the Workshop.

Lieberman came from the MIT Artificial Intelligence Laboratory where he worked on computer graphics with Seymour Papert's Logo Group. Logo was an experimental software that leveraged machine intelligence to teach children about problem solving and, by proxy, computer programming. The software allowed a child to direct a surrogate "turtle" on screen, creating drawings by telling the turtle where it should move. In this way, the child would have to work backward from the intended drawing to produce its recipe as a logical sequence of steps. In an article published in 1996, Lieberman recalls: "I was struck by how engaging the computer graphics domain was for the kids and by the power of combining both visual and abstract problem solving."[23] Lieberman and Cooper came together around the idea that computer interfaces might do more than simply present information or facilitate data manipulation. A more responsive, intuitive interface combined with machine intelligence could produce software that worked symbiotically as a designer's assistant.

Ron MacNeil was consistently exploring this research territory at the VLW. His TYRO was an intelligent design assistant which visualized a particular graphic layout as a function of the total set of constraints on its arrangement. The program visualized the design problem as a "spiderweb" network of connected parts expressed by their hierarchical relationships. The software would generate multiple design alternatives based on these assumptions. Introducing TYRO in Kobe, Japan, MacNeil began with a sequence of alternate versions of a slide generated by the program, apologizing tongue-in-cheek that he could not make up his mind which to show.

VLW student projects by Dorothy J. Shamonsky ("Scripting Graphics with Graphics: Icons as a Visual Editing Tool," 1977), Russell Greenlee ("Using Abstract Descriptions and Visual Properties to Generate Page Layouts," 1981), and Timothy Shea ("Use of Computer-Based Rule Systems in Graphic Design," 1984) built a vocabulary of approaches for applying software intelligence to graphic design.[24]

Another area of intelligent graphics research centered on automatic layout. Cooper had recognized that information flow was accelerating to such a degree that the role of the designer would necessarily evolve. Lieberman, paraphrasing Cooper, recalls: "Digital data simply comes too fast, and is too dynamic to have every visual presentation designed by hand."[25] Automatic layout software, assisted by templates and drawing on an expert knowledge base of design rules, was a promising avenue. A project started in 1986 explored this territory. Working with IBM, VLW researchers began to explore how digital tools could supplement the mechanical process of graphic design. Cooper collaborated with art director Joan Musgrave, whose work involved designing and producing serial corporate publications for IBM.

Work began by documenting typical graphic design processes at IBM, chronicling the day-to-day work of Musgrave and her staff. Graphic design was principally a mechanical, repetitive process, and the tools, steps, and approaches were inventoried and recorded in a database. Digital alternatives were created, software tools and techniques to match, replace, or augment the analog design tasks. As Musgrave described:

A new way of working was explored. The model of collaboration was for me to sit next to a programmer and create a design that would then be visualized on a computer screen. The collaborations were in real time, thus immediate results could be seen as we worked. Although I was familiar with giving direction to illustrators who in a week or two would return artwork on paper, this new interactive way of working was visually quite exciting when "instant" results were seen.[26]

Cooper and VLW researchers put these ideas into practice on a cover design for *Perspectives in Computing*, an IBM systems journal published from 1980 to 1988. Illustrations and photographs were commissioned to accompany each article, cropped, scanned, and placed into a digital image library. A grid

was established for the cover, and the illustrations would be placed within its square boxes. The masthead typography was scanned and all of the elements brought together in an application at the VLW. This layout software, written by VLW student Russell Greenlee, grew out of work funded by Hell GmbH and Hewlett-Packard for which IBM provided a case study. The interface presented a thumbnail collection of low-resolution illustration tiles on the right. These proxies could be recropped, color-adjusted, and scaled using VLW paint software. From the collection of images, the software drew on the database assembled through observation of design practices at IBM. The rules in the database were stated in the IF-THEN logic of a computer program. For example:

Selection: IF overall color dominance is not similar and has the desired relation of contrast, THEN keep the selected image, ELSE reject the image that has least popularity OR change the color of the image.

Or:

Style relation: IF the images are of a similar style and there exist more styles to choose from, THEN select an image from a style not already selected.

Full cover alternatives were programmatically constructed according to these rules, the software radically accelerating the design process. Previously, after initial pencil sketches, one or two cut-and-paste mockup alternatives might reasonably be prepared. The computer produced as many mockups as requested, and the design problem quickly became a question of too many alternatives. Still, a rules-based approach to computer-assisted graphic design was promising. Grids for flexible but structured page layout are a tenet of modernist graphic design, and the programmatic thinking of software was a natural complement.

Other projects with IBM included using VLW animation software to produce computer images for publication covers. Animated software models could be manipulated in real time, and cover design candidates were excerpted from the moving image: "By stopping the action and using a still in the animation progression, a dynamic approach to looking at options was possible."

As with earlier interfaces, the value Cooper saw in intelligent graphics was the possibility for the computer to become a medium flexible enough to match a designer's intuition, fast enough to provide immediate visual display, and responsive enough to engender a feedback loop between the graphic designer and her tool.

Visual programming was another area explored. Cooper recognized that harnessing a computer's power relied on knowing how to program it, and she imagined that more visual, intuitive, responsive interfaces to computer languages would open the door for a different kind of programmer. At the VLW, artificial intelligence programs were applied to visual design problems, but this was also done in reverse: visual design principles were applied to constructing artificial intelligence programs. It was this approach that she hoped to facilitate by bringing a more immediate, visual approach to computer programming.

No matter how new and high-end the machine, computers were never responsive enough for Cooper. The logic of computer programs made intuitive sense, and she was persistently interested in learning to code. She was equally frustrated by never learning it, as her programming knowledge remained more conceptual than practical: "Because she was such a visual thinker, she was flabbergasted to the point of being offended that programming wasn't as visual as it had the potential to be."[27]

Around 1991, Lieberman led a project that constructed three-dimensional visual models of a program's structure built as the program runs. These graphics, somewhere between a cereal box and a building, communicated the logical program and provided a visual surrogate to the literal code that directed its flow.

Intelligent graphics research at the VLW was also gathered under the heading "Learning by Example." Pursued through a number of student and staff projects from around 1986 through 1994, the methodology built on the expert rules employed by IBM. But, instead of merely feeding design knowledge into a database, graphic design that learned by example recorded both previous solutions to a specific layout problem as well as further attempts. The design software became smarter and more personalized the more it was used.

3D program representation, Henry Lieberman, c. 1991
> p. 180

Cooper was convinced that graphic design was best taught by providing concrete examples rather than laying out a series of rules. Examples are multidimensional, and, while these may be applied toward one specific design problem, aspects of other problems are always embedded in them. Providing multiple examples was essential for a student to unpack the underlying principles for herself.

Likewise, learning by example required quantity. It thrived when it was used extensively, and the repetitive tasks of graphic design provided a good case. In a feedback loop with its user, a learning-by-example program could further program itself. Lieberman made several softwares to model this, including a page layout software, Mondrian, and a programming software, Tinker. Tinker offered a graphic interface to programming logic, and could be used by a seminovice to produce new software. One example showed Tinker programming a Pong game by example, as the user modeled configurations of the game to the software, and demonstrated how its rules were applied by showing examples of their use.

Graduate student Suguru Ishizaki worked on programming-by-example projects at the VLW. Among other work, Ishizaki developed an electronic map system that learned to update the migration patterns of certain animals based on past behaviors. He also applied the approach directly to graphic design software, building a recording engine that ran underneath existing page layout software to collect a designer's decisions. Typeface choices, color selections, arrangement, and scaling of objects were assembled to develop a particular user profile. The software would develop over time by becoming more responsive to its user. In his dissertation, "Typographic Performance: Continuous Design Solutions as Emergent Behavior of Active Agents,"[28] Ishizaki identified an approach that he called "Improvisational Design," which imagined that a document might dynamically, fluidly change as a user reads it and might evolve as she changes her intentions over time. The thinking was indebted to Cooper's drive toward more responsive interfaces which, through immediate feedback, would facilitate deeper, more exhaustive design thinking. This type of interface was really more of a software space, a total environment—smooth, immersive, and most importantly, working dynamically in real time.

Information Landscapes

By 1993, Ishizaki and David Small were working on a prototyping software to facilitate sketches for such a spatial interface. Small was an MIT undergraduate when he first got involved with the Visible Language Workshop in 1986. He continued as a graduate student, receiving an MS in Media Arts and Sciences from the Media Lab in 1990. Small was a Research Specialist by this time and Ishizaki was working toward his PhD, completed in 1996. Small finished his own PhD in 1999, with a dissertation titled "Rethinking the Book."

Small worked closely with Cooper, and his work provides a consistent line through 10 years at the VLW. His master's thesis on "expressive typography" explored how type might develop within software. This graduate work built from previous VLW projects around "soft" typography for improving screen legibility, but also took the possibilities of a purely dynamic typography seriously: "Perhaps the most exciting property of the computer is the ability to create images that evolve and change over time."[29]

At MIT, Small had access to increasingly fast computers, including a newly developed supercomputer. He described its potential for design:

The use of the Connection Machine, a massively parallel supercomputer, provides us with a radically different way of thinking about the nature of graphics. It is possible to think of the screen, not merely as a canvas on which images can be pasted, but as an active, computationally rich medium.[30]

This thinking echoes what Cooper had been working consistently toward and had crisply articulated in "Computers and Design." Graphic software would evolve from production tool to communication medium only when its interfaces were sufficiently responsive. At that point, the tool would dissolve into the medium, and users would become readers.

Ishizaki insisted on this distinction in the opening pages of his dissertation, footnoting his first use of "reader":

Information Landscapes (still from introduction animation), Muriel Cooper, David Small, Suguru Ishizaki, and Lisa Strausfeld, 1994,
> p. 183

A reader is a person (or a group of people) who is actively involved in the reading of information presented by the design system. The term "reader" is preferred to the term "user" or "recipient" because of its emphasis on the sense of active communication.[31]

Another strand of VLW research at this time used three-dimensional renderings to articulate complex information architectures. A project for NYNEX used a spatialized representation of connected nodes for a networked video conferencing tool. Relationships between individual communication points could be visualized by physical location, by status, and by recent activity, each of which adjusted the three-dimensional representation. Another interface for air traffic controllers displayed complex and overlapping flight paths using a constellation of adjustable views. Each of these was produced in the conventional manner as a static three-dimensional computer model, surveyed by a camera that moves through the scene and then rendered as static animations.

These projects were included among VLW works in progress at the fourth Technology, Entertainment, and Design (TED) conference in Kobe, Japan, in 1993. TED was a new idea at that time, a conference bringing together leading figures in these three increasingly related industries to present their work. Like Negroponte, TED's founder, Richard Saul Wurman, also trained as an architect. (Characteristically, Cooper called Negroponte and Wurman by abbreviated nicknames, Nicky and Ricky.)

Other VLW projects demonstrated infinite zoom, real-time information display, layers, filtering, and gestural control. All of the VLW work was presented under the rubric "information that arrives too quickly to design." In these projects, templates, animation, and machine intelligence replaced the conventional role of the graphic designer to render this high-bandwidth information flow legible.

On the return flight from Kobe in spring of 1993, Small, Ishizaki, and Cooper conceived the idea of collapsing these various research strands into one real-time information space.[32] That fall, a Silicon Graphics Onyx workstation with Reality II Engine display arrived at the Visible Language Workshop on short-term loan. This cutting-edge, quarter-million-dollar computer workstation could finally render dynamic, three-dimensional typography in real time, which would make the interface imagined on that flight possible. Small and Ishizaki got to work immediately on a submission for the Computer-Human Interaction (CHI) conference to be held in Cambridge in April 1994.

The software was assembled over one month of intense work, with Small and Ishizaki programming on the loaned computer in shifts, working asynchronously and discussing in between. The software used to produce their CHI submission was named simply Typographic Space. It allowed for the quick investigation of issues involved in populating a three-dimensional typographic environment which could be dynamically navigated by a user. The animation and composition engine which made this possible was built on work by VLW student Bob Sabiston.

Typographic Space was experimental software, without specific tasks or a real user interface. It was a tool used to realize interface sketches. The first spaces used geographic information systems to render physical maps overlaid by additional information. The maps grounded the scene in a familiar spatial metaphor, on which was layered abstract, typographic information. The three-dimensional interfaces soon moved to more assertively abstract "spaces," typically a constellation of colored type, with architectural-hierarchical relationships, rendered in an ink-black environment. Translucency, dynamic color, and blur were all employed as graphic filters capable of translating the rush of electronic information into meaningful, coherent chunks. The user was offered a first-person perspective, flying through this information space, reading by navigating its structure.

Even on the new SGI machine, programming an immersive, navigable field of information was a technical challenge. Small developed an efficient approach to rendering typographic glyphs in 3D space, based on previous VLW font work. Anti-aliased font rendering, which paradoxically renders type more legible on screen by blurring its edges, was a signature achievement of the Architecture Machine Group. In 1981, Ron MacNeil had built on this work and digitized a "very funky typewriter font" while developing SYS. Type-digitizing experiments continued in the VLW, including the "2-bit font" and "Brute-force Bodoni."

By this time, typographic rendering at the VLW was considerably more sophisticated but also more computationally intense. Small responded with an ingenious solution. Individual letters were rendered as texture maps (one-color images) applied to regular polygons. This was computationally less demanding, so that instead of calculating x, y, and z positions for every point along the complicated Bezier curves of a specific letterform, the software used the approximations of regular geometric primitives. To the user, the effect was the same. But this method, combined with Silicon Graphics' Performer code library, allowed for rendering a very large quantity of letters in one three-dimensional scene, fast enough for the user to navigate with no delay. (This font-rendering scheme was later repurposed in Processing, a Java-based software sketching tool developed at the Media Lab. Processing's font format employs remnants of Small's code and signals its debt through an idiosyncratic file extension, .vlw.)

Typographic Space implemented a simple flight simulator interface. This provided an off-the-shelf visual metaphor for navigating three dimensions. Nothing in the model changed, but instead a camera provided a surrogate for the user's view as it moved around the unbounded space. The mouse controlled viewing distance, and a collection of keys adjusted rotation and translation. Small describes the result as "smooth, simple, and as fast as your thoughts ... where information 'hangs' like constellations and the reader 'flies' from place to place, exploring yet maintaining context while moving so that the journey itself can become as meaningful as the destination."[33]

Typographic Space was submitted as a videotape of software experiments together with a short paper.[34] Around the time of the CHI submission, Cooper gave this space a more imaginative name: Information Landscapes. It was a term that slotted into a contemporary lexicon populated by many "information"-prefixed neologisms, including information anxiety, overload, superhighway. Cooper's name provided a frame for others to understand the possibilities inherent in its prototype form. Typically, although she was not engaged in the technical, procedural details of the software, she grasped its ramifications.

"Information Landscape" suggested an electronic environment that extends from the user's screen in all directions. This was not a new idea in interface design — even a Unix command line interface hints at the larger space beyond, accessed by a linguistic-symbolic command. But, in an "Information Landscape," this was made both explicit and literal. The user's graphic interface became a virtual window, a windshield, to peer into and navigate through the information landscape within.

Existing interfaces relied on the distinction between user input and display. From Xerox PARC's Alto and Star to Apple's Lisa, from Macintosh to Microsoft Windows, prevailing models employed a WIMP (windows, icons, menus, pointing device) paradigm and a mouse to control onscreen proxy objects. These were often hinged to a metaphor. Direct manipulation of the virtual object (a trashcan, paintbrush, file folder, document) via the mouse's cursor issued a command to the underlying operating system. For example, dragging a file to the trashcan deletes it from the hard disk, opening a folder allows the user to see its contents, dragging a window expands the view into its contents. An Information Landscape dispenses with these proxies in favor of a more immediate relationship to its data. There are no onscreen buttons, no objects, menus, or control panels. Instead, a concrete three-dimensional "landscape" of its data is presented for the user to navigate directly.

Cooper, Small, and Ishizaki realized that the legibility of the underlying data was critical. Cooper asked:

How do you retain the integrity of the information, and at the same time, retain the context and clues that allow you to traverse complex information? You are, in a sense, in an architectural construct, but you don't have the constraints of having to believe a physical building. So you can both use the abstract conceptual issues, as well as the physical cues that people are accustomed to.[35]

The structure of the information landscape would have to mirror the structure of the material it presents. This is a typical graphic design problem, but here an extra dimension complicates it. Drawing on city planning, Small quotes Kevin Lynch from *The Image of the City* in his dissertation:

By this [legibility] we mean the ease with which its parts can be recognized and can be organized into a coherent pattern. Just as this printed page, if it is legible, can be visually grasped as a related pattern of recognizable symbols, so a legible city would be one whose districts or landmarks or pathways are easily identifiable and are easily grouped into an over-all pattern.[36]

By calling this a "landscape," Cooper placed its information in a context that is connected and meaningful. Traversing a landscape reveals the relationships between its constituent elements. Moving from one place to another is continuous, and the overall environment reveals itself as a function of the user's exploration. Small encapsulates this idea:

We must also consider that any journey through space is also one through time. No movement is ever truly instantaneous and the way in which we move and how the journey unfolds through time can be of great help in revealing the underlying structure of a landscape.[37]

But this structure could, and would naturally, change, as it was composed of electronic data with continuously shifting relationships. The tradeoff for an information landscape was clear: the more static the model, the more understandable. The more dynamic, the greater the possibility to reveal some of the relations between its data. The models could change, but not too much. Cooper, Negroponte, and Bolt had identified this issue years before in "Books without Pages":

Not only can dynamic text depart from the statically usual, but it can modulate in real-time before the reader, even as a function of where he is looking. Consider a text line where any word may dynamically change in size, shape, color, luminosity. This additional dimension, call it "Z," can be an intrinsically "non-spatial" dimension (color, luminosity), or can be along spatial dimensions into or across the page, exhibiting actual movement.

They continue:

Why should text move or change? We see at least five reasons: to convey information that itself is changing, to pace the observer, to save "real-estate," to amplify, and to be attention getting. Each reason can be addressed in terms of kinds of change, which include (but are not limited to): 2-D/3-D translation and rotation; color changes; shape transformations; transparency; and transfigurations between icons and symbols.[38]

Following Cooper's and Lieberman's leads, Ishizaki was also investigating how artificial intelligence might make the new interfaces more user-friendly and more meaningful. Software understands the data model that manifests an information landscape and therefore could manipulate its display as it is being used. He imagined small chunks of data interacting with other small chunks of data, rearranging their relations in an infinite design process which he described as closer to dance than to graphic design. He proposed what he calls "A Model of Dynamic Design," in which

the visual designer can think during the course of designing ... creating visual design solutions that are as active and dynamic as a dance performance. A design solution, such as a display of on-line news, is considered a performance consisting of a number of active design agents, or performers, each of which is responsible for presenting a particular aspect of information, such as a headline or a news story.[39]

In "Dynamic News Display," a software project included on the CHI videotape, Ishizaki demonstrated this idea. An analog watch face floating on top of a world map provided the central interface to a news delivery system. Stories were anchored to their geographic reference and appeared on screen as they happened, tethered to the sped-up clock display. The interface used blur to push less immediate information to the background, dynamic linespacing to indicate nested relationships, and shifting color to indicate temporal shifts. Animation between these filtering strategies helped the user navigate the shifting terrain. This interface was also an information landscape.

Another information landscape was imagined by VLW student Lisa Strausfeld. Having previously studied architecture, Strausfeld addressed the spatial aspect of data directly, producing three-dimensional blocks of information that communicated different data relationships depending on the user's point of view. In her thesis "Embodying Virtual Space to Enhance the Understanding of Information," Strausfeld describes one such setup:

Information Landscapes (still from Galaxy of News), Muriel Cooper, David Small, Suguru Ishizaki, Earl Rennison, and Lisa Strausfeld, 1994
> p. 185

Imagine yourself without size or weight. You are in a zero-gravity space and you see an object in the distance. As you fly towards it, you are able to recognize the object as your financial portfolio. From this distance, the form of the object conveys that your portfolio is doing well. You move closer. As you near the object, you pass through an atmosphere of information about your net assets and overall return statistics. You continue moving closer. Suddenly you stop and look around. Your financial portfolio is no longer an object, but a space that you now inhabit. Information surrounds you.[40]

In an information landscape, the feedback loop between a graphic instruction and its realization had finally caught up to where Cooper always wanted it to be. The gap between a user's decisions and their consequences was more or less removed, and the tightness of this loop offered the possibility of continuous feedback and adjustment. Perhaps the most radical consequence of this work was its collapse of the user interface with its display. These two pieces become one in an information landscape – a user is completely immersed in the data she is manipulating. The user marks a path through the landscape, and reveals its structure en route as a function of her constant readjustment within it. It is an almost total synthesis of tool and medium.

Cooper presented Information Landscapes at the fifth Technology, Entertainment, and Design conference held in February 1994 in Monterey, California. At the start of her talk, Cooper, joining Wurman on stage for a conversation, sits down, sips a glass of water, and promptly removes her shoes. The presentation that follows is notably improvised, but also immediate and affecting.

Information Landcapes provided a sparkling new look into the networked data space that increasingly surrounded contemporary life. This world was barely glimpsed in 1994 through text-only Internet Relay Chat rooms, Usenet groups, mailing lists, and the thin graphic windows of Netscape Navigator 1.0 browsers. The new software offered a profoundly richer vision.

In an Information Landscape, interface was not a boundary or a thin layer for exchanging information between two working parts of a system, but rather a deep, immersive space. There were no buttons, no surrogates, no menus. Direct manipulation, a tenet of successful interface design, was even more direct. Information Landscapes offered a real-time, dynamic, and ultimately invisible bridge between the representation of information and its manipulation, realizing the responsive, real-time interface Cooper was always after.

Following TED in February and the CHI conference in Cambridge in April 1994, Cooper actively traveled and demonstrated the new work. She visited corporate sponsors and technology companies and spoke to design audiences in a flurry of activity around the work. Returning to Cambridge (Massachusetts) from Cambridge (England), where she had presented Information Landscapes to an audience of influential designers at the Alliance Graphique Internationale, she hosted a Department of Defense dinner at the Cyclorama building in Boston. That evening Cooper collapsed unexpectedly. She died May 26, 1994 of an apparent heart attack at the age of 68.

Wurman dedicated his book *Information Architects* to Cooper, and her "real-time display of heavenly navigation." Negroponte eulogized her, acknowledging her new work as consistent with her searching approach. Information Landscapes was the latest and most profound step in a career of restless exploration: "She has broken the flatland of overlapping opaque rectangles with the idea of a galactic universe."[41] But Cooper was already there, years before the computers fast enough to realize her vision arrived. She succinctly identified what remains at stake:

You're not just talking about how the information appears on the screen, you're talking about how it's designed into the architecture of the machine, and of the language. You have different capabilities, different constraints and variables than you have in any other medium, and nobody even knows what they are yet.[42]

Muriel Cooper, presentation at TED conference, video, 1994
> p. 181

Notes

1. Muriel R. Cooper Collection, Morton R. Godine Library, Archive, Massachusetts College of Art and Design, box 12-240.

2. Steven Heller, "Muriel Cooper" (interview), in *Graphic Design in America: A Visual Language History* (Minneapolis: Walker Art Center, 1989).

3. Muriel Cooper, "Graphics and New Technology," slide talk at MIT's Visible Language Workshop, 1981; available as an audio file at http://messagesandmeans.tumblr.com/post/77128529451/graphics-and-new-technology-slide-talk-by

4. Wendy Richmond, "Muriel Cooper's Legacy," *Wired* 2.10 (1994).

5. Ron MacNeil, email to author, 2012.

6. Lee Silverman, email to author, 2015.

7. Tom Wong, "Muriel Cooper Memorial Exhibition," exhibition pamphlet, 1994.

8. Richard Bolt, Muriel Cooper, and Nicholas Negroponte, "Books without Pages," proposal to the National Science Foundation, 1978, Muriel R. Cooper Collection, box 12-284. The following quotations are also taken from this source.

9. Ellen Lupton, "Fluid Mechanics: Typographic Design Now," in Donald Albrecht, Steven Holt, and Ellen Lupton, *Design Culture Now: National Design Triennial* (New York: Princeton Architectural Press and Cooper-Hewitt, National Design Museum, 2000).

10. Muriel Cooper, ed., "Computers and Design," *Design Quarterly*, no. 142, (1989), 3.

11. Ibid., 4.

12. Ibid., 4, 7.

13. Ibid., 10.

14. Ibid., 14.

15. Ibid.

16. Ibid., 17.

17. Ibid.

18. Ibid., 18.

19. Ibid., 20.

20. Ibid., 22.

21. Ibid., 26.

22. Ibid., back cover.

23. Henry Lieberman, "Intelligent Graphics," *Communications of the ACM* 39, no. 8 (1996).

24. Available as PDF from http://dspace.mit.edu.

25. Lieberman, "Intelligent Graphics."

26. J. F. Musgrave and M. R. Cooper, "Experiments in Digital Graphic Design," *IBM Systems Journal* 35, nos. 3–4 (1996).

27. Henry Lieberman, email to author, March 25, 2015.

28. Suguru Ishizaki, "Typographic Performance: Continuous Design Solutions as Emergent Behavior of Active Agents," PhD diss., Program in Media Arts and Sciences, School of Architecture and Planning, MIT, 1996, 18.

29. David Small, "Expressive Typography: High Quality Dynamic and Responsive Typography in the Electronic Environment," master's thesis, Program in Media Arts and Sciences, School of Architecture and Planning, MIT, 1990, 7.

30. Ibid, 8.

31. Ishizaki, "Typographic Performance," 15.

32. Janet Abrams, "Muriel Cooper's Visible Wisdom," *I.D. Magazine* (September-October 1994), 54.

33. David Small, "Rethinking the Book," PhD diss., Program in Media Arts and Sciences, School of Architecture and Planning, MIT, 1999, 29, available at http://acg.media.mit.edu/projects/thesis/DSThesis.pdf.

34. David Small, Suguru Ishizaki, and Muriel Cooper, "Typographic Space," in *Conference Companion, CHI '94* (New York: Association for Computing Machinery, 1994).

35. Muriel Cooper, from video documentation of TED 5 conference, Monterey, California, 1994.

36. Small, "Rethinking the Book."

37. Ibid.

38. Bolt, Cooper, and Negroponte, "Books without Pages."

39. Ishizaki, "Typographic Performance."

40. Lisa Strausfeld, "Embodying Virtual Space to Enhance the Understanding of Information," master's thesis, Program in Media Arts and Sciences, School of Architecture and Planning, MIT, 1995.

41. Nicholas Negroponte, "Design Statement on Behalf of Muriel Cooper," presentation at the Chrysler Design Awards (1994).

42. Elizabeth Glenewinkel, "Muriel Cooper's Legacy to Design," master's thesis, Master's in Design Methods, Institute of Design, Illinois Institute of Technology, 1996.

Design

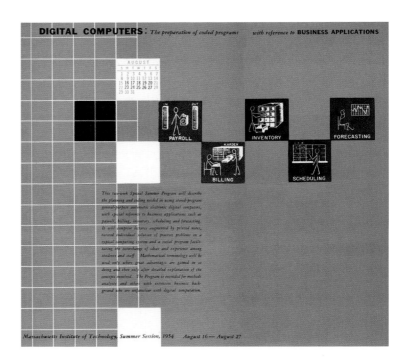

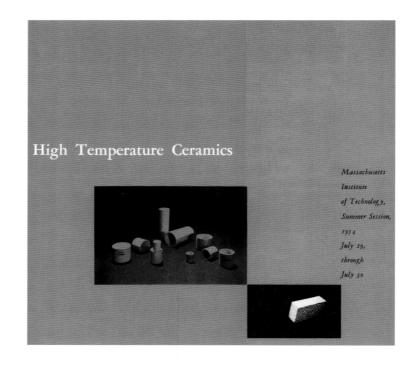

Selected summer session pamphlets for MIT Office of Publications,
1954–1957

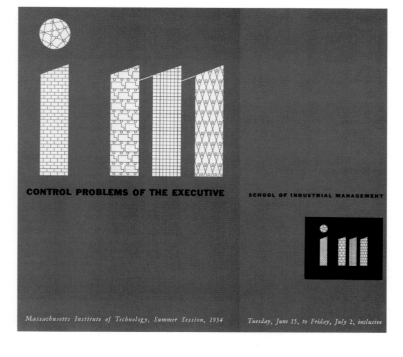

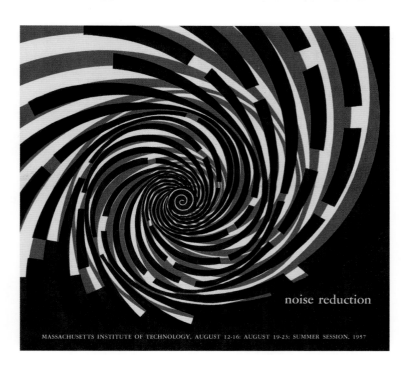

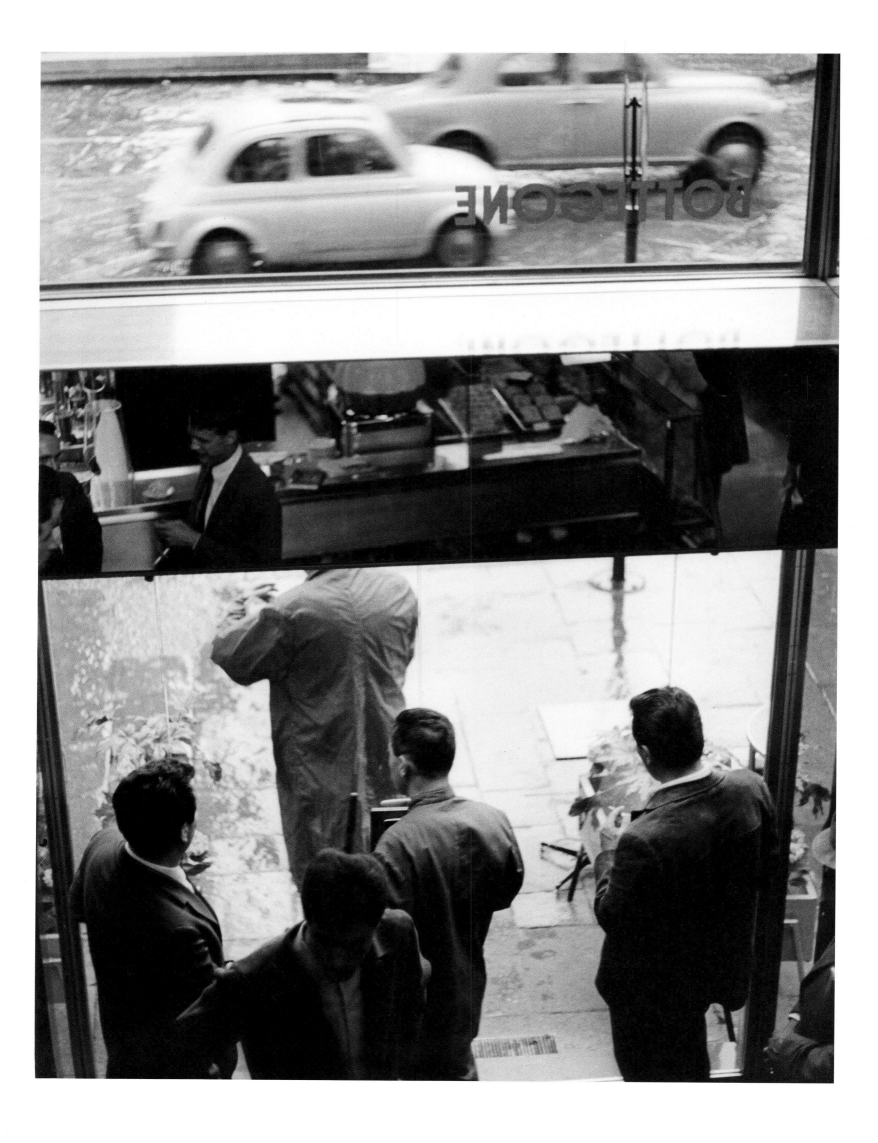

Design

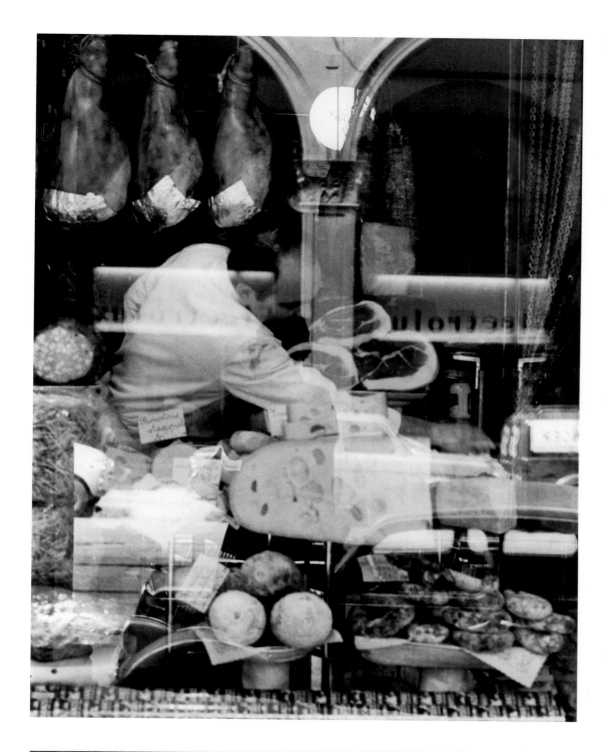

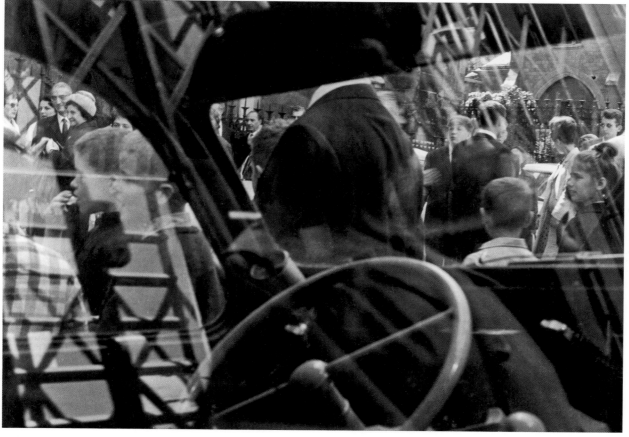

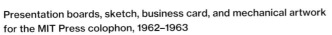

Presentation boards, sketch, business card, and mechanical artwork
for the MIT Press colophon, 1962–1963

Design

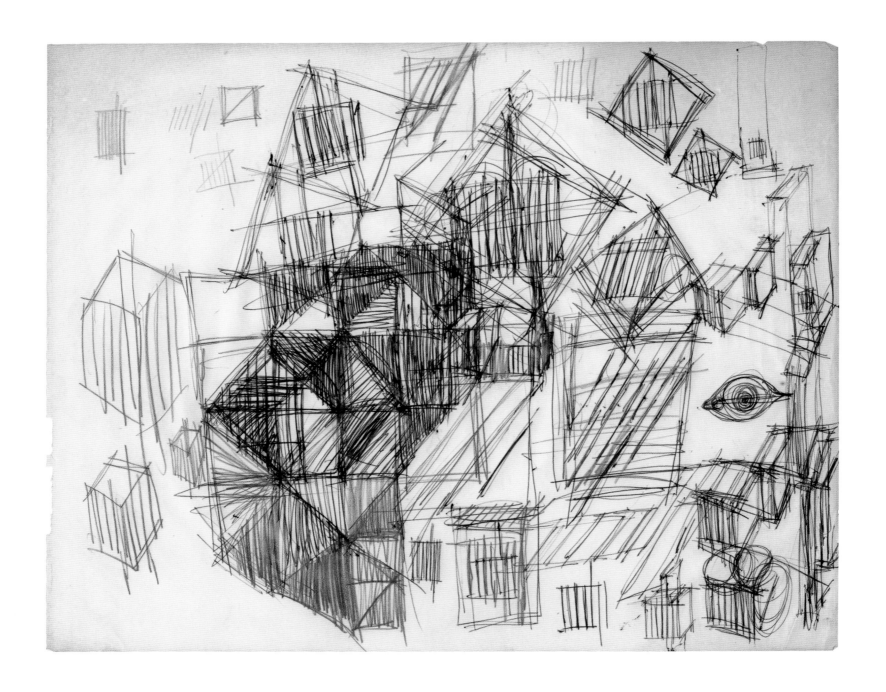

Muriel Cooper, Design Director **The MIT Press**

Massachusetts Institute of Technology, Cambridge, Massachusetts 02142, 617-864-6900

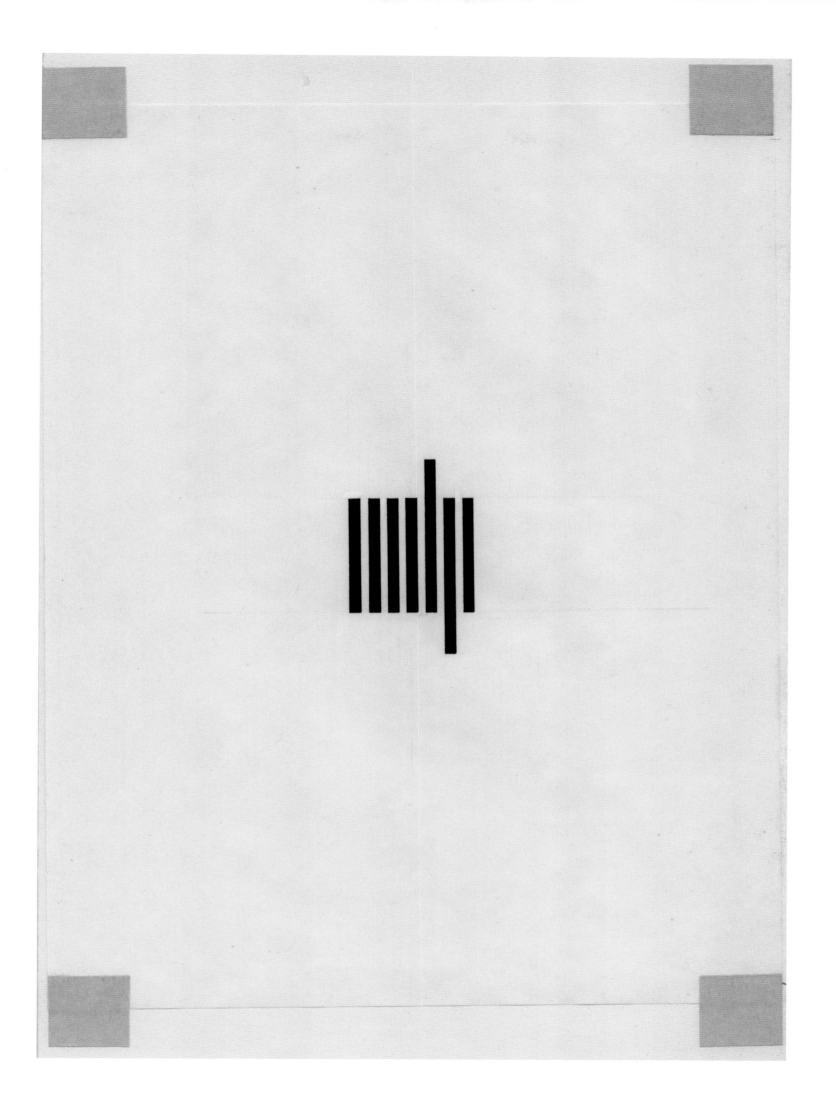

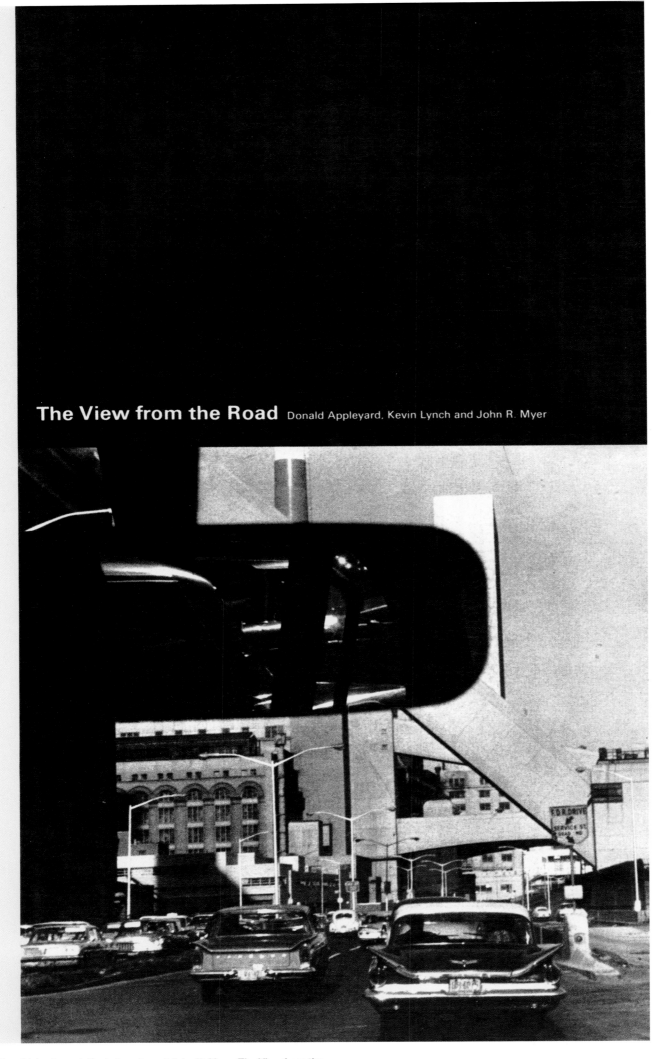

The View from the Road Donald Appleyard, Kevin Lynch and John R. Myer

Donald Appleyard, Kevin Lynch, and John R. Myer, *The View from the Road* (Cambridge, Mass.: MIT Press, 1964), design by Muriel Cooper

The View from the Road
Donald Appleyard, Kevin Lynch and John R. Myer

Published by The M.I.T. Press for the Joint
Center for Urban Studies of the Massachusetts
Institute of Technology and Harvard
University.

The View from the Road is the first com-
prehensive attempt to consider the urban
highway as a positive visual experience that
organizes motion, space and view to achieve
esthetic enjoyment.

The authors examine existing and proposed
highways, develop esthetic criteria for an
ideal highway system, analyze the attention
habits of the driver and suggest a system of
notation for the specialist. All told, they have
created an important and controversial book
for the engineer, the architect, the planner,
and the public administrator. The ideas put
forth in this book have already attracted
considerable attention. Prior to its publica-
tion, *The View from the Road* was the subject
of a major article in *Architectural Forum*.

This study is profusely illustrated with 72 half-
tones and 60 line drawings.

About the authors . . .

Donald Appleyard is a graduate of the Archi-
tectural Association School in London and
received his Master's Degree in City Planning
from M.I.T. He has worked in Italy and
Venezuela as well as the United States.
Since 1961 he has been Assistant Professor
of Urban Design in the City Planning
Department of M.I.T.

Kevin Lynch is Professor of City Planning at
M.I.T. A former student of Frank Lloyd Wright,
he has had wide practical experience as a con-
sultant on urban projects all over the country.
He is the author of *The Image of The City*, a
study of what the city planner can do to make
the city's image more vivid and memorable to
city dwellers.

John R. Myer received his Bachelor of Archi-
tecture from M.I.T. and is now Assistant Pro-
fessor of Architecture at M.I.T. In addition, he
is a partner in the architectural firm, Ashley,
Myer & Associates, whose design won first
prize in the competition for the proposed
Boston Architectural Center.

The M.I.T. Press
Massachusetts Institute of Technology
Cambridge, Massachusetts 02142

The Sense of Motion

Beyond the concentration on near detail, the fundamental sensation of the road, continuously referred to, is the visual sense of motion and space. This includes the sense of motion of self, the apparent motion of surrounding objects, and the shape of the space being moved through. These factors are all intertwined, since the visual judgment of motion is based on the apparent motion of exterior objects and is interpreted as being motion in relation to the enclosing spatial form.

18

19

20

The sense of motion of self is perhaps the primary feeling. True kinesthetic sensations are slight in a steadily moving car on a modern highway. The driver receives some cues through his controls, but if the passenger shuts his eyes it is very difficult for him to distinguish steadily held turning movements, levels of speed, or even gentle climbs or descents. Bodily sensations become strong only at points of abrupt changes in speed or in angle of climb or fall. Automobile riders depend on vision to give them a sense of the motion they are undergoing. They interpret the apparent motion of surrounding objects, which they know to be really fixed, to be the result of their own progression. These clues may include the passage of roadside detail,
18 the apparent rotation of near objects around far objects, the seeming outward radiation of
19 detail and textures from the point dead
20 ahead, and the illusion of growth as objects approach. Changes of direction are gauged from more complex relations. Occasionally, where the motion of the car is rather simple and regular, there may be a sudden reversal of sensation, and the landscape will seem to be rolling past under the wheels of a stationary vehicle.

21

Where surrounding objects are far off, or few, or featureless, or moving with the vehicle, then the sensation is one of floating, of no forward movement. This is the experience one has in an airplane, and the effect is felt on very elevated highways or those of simple alignment which have bare, open shoulders. Such a sensation may be a relief as an interlude, or as an opportunity to see things of special interest. But our superhighways can induce sleep, frustration, or excessive speed, simply because of this long-continued visual torpor, this apparent inability to reach a goal.
21 Objects might therefore be placed along the road simply to reassure the driver about his real motion, or even to accentuate his real motion, if it is desirable that he slow down. Perhaps most frustrating of all is a sense of local aimless movement (as in humping up and down), when it is coupled with this lack of apparent forward progression in the larger landscape.

Conversely, where the near environment has
22 many highly articulated objects, the sensation may be one of great velocity, so that the apparent speed at 30 miles per hour on a narrow forest road may be much greater than at 60 miles per hour on a wide open freeway. Things passing overhead are especially remarkable, but the detail close at hand—at the roadway edge or on the pavement—is also effective: the textured walls of a cut, the rhythm of lights, pickets or telephone poles,
24 or the passage of pavement joints or patterns underneath. All of these, according to their frequency and closeness, reinforce the sense of speed. Apparent speed also seems to be
23 A heightened on the downgrade or on a sharp
23 B turn, while tempo slackens going upward. Thus a curving dip occurring where speed-marking detail becomes close and frequent will impart a doubled sense of velocity, and vice versa.

The sense of varied motion is inherently enjoyable if continuous and not too violent. A strong dipping turn was one of the memorable moments of one route. An amusement ride capitalizes on this by creating an entire sequence of such motion sensations. Similar
25 sequences, though of a milder sort, may be found on highways: for instance, the rhythmical humping of the New Jersey Turnpike,
26 or the repetitive sweeping turns of the approach to Boston over the Mystic River Bridge.

Motions of this kind are most satisfactory if explained—explained not logically but visually. Puzzling variations in the line are minor irritants. If the road forms a hump, it should seem to be rising over something; if it sinks, it should flow down into something or be
27 forced down by an object overhead. If the
A,B,C road turns, it should pivot about something or
28 be deflected by some other object; if it diverges, it should be split by something. These objects clarify the motion, make it explicit and seemingly easier to perform. Although they may be relatively insignificant in size, they are crucial in the driver's view.

Read Up

22

23A

23B

24

25

26

9

27A

27B

27C

28

Philip J. Stone, Dexter C. Dunphy, Marshall S. Smith, and Daniel M. Ogilvie, *The General Inquirer: A Computer Approach to Content Analysis* (Cambridge, Mass.: MIT Press, 1966), design by Muriel Cooper and MIT Press Design Department

THE GENERAL INQUIRER
SOME STRONG FEELINGS CO
BUY ME JUST A GUITAR I AM
T SHE AND A GIRL A COMPUTER
UALLY GO TO THE APPROACH
 POOL I CANNOT SWIM TO
EM IF YOU FALL IN. CONTENT
 OF THE CONSIDER ANALYSIS
ON NOTHING THAT IS OLD TH
O THE BOYS WOULD STUDIES IN
AID. TAKE OFF A PSYCHOLOGY
E. YOU KNOW, HE SOCIOLOGY
HOUGHT THAT HE ANTHROPOLOGY
S YOUR FACE NOW MMM TO AND
8B THINK/9 YOU/1 POLITICAL
THINK HE WILL FINAL SCIENCE
OT WAIT UNTIL HE WOULD GET
IT PLAY. AND PHILIP J. STONE
 AND I WILL DEXTER C. DUNPHY
S IT MADE MARSHALL S. SMITH
E PROBABLY DANIEL M. OGILVIE
ELSE. HE MUST HAVE LEARN
CAN MAKE MONEY BY LEARNI

chine systems will bring added convenience, but it will probably not significantly change the sequence of computer content analysis procedures from what is described here.

Let us consider the features of these three types of machines.

Large-Memory Computers

These machines allow many category lists to be stored inside the computer memory. As the text material is processed through the computer, the applicability of various content analysis categories can rapidly be checked.

Large-memory computers are expensive and should not be kept waiting. Devices with high speeds of information transfer, such as magnetic tape drives, are used to feed information in and out of large computers at speeds up to many thousands of characters per second. The magnetic tapes are then brought to smaller computers where the information they contain is printed on paper or punched on cards. Similarly, small computers are used to transfer information punched on cards onto magnetic tape for use by a large-memory computer.

At present, the assignment of categories to text is programmed to operate on large IBM 7090–7094 computers.[5] Over 6,000 words and phrases (together with the computer program) can be simultaneously stored in the computer memory. As text is processed, thousands of lookups and checks are made per second (the basic memory reference time being under two microseconds). Depending on the complexity of the content analysis scheme, text is processed through this phase at between 7,000 and 12,000 words per minute. The computer, together with enough tape drives needed for General Inquirer operations, is shown in Figure 3.1.

A large random-access memory can also be provided for small computers by means of a rapidly revolving mechanical disk.[6] The

[5] Originally the entire General Inquirer system was programmed for the 709–7090–7094 series in the COMIT language by Philip Stone. Later, just the category assignment phase was kept on the 7090–7094 series, this time in COMIT II. In 1964–1965, a much faster version of the assignment phase was written in the BALGOL language by Horace Enea at Stanford University. The BALGOL language program has since been transliterated into the MAD language by Erik Steiner at Yale.

[6] A random-access storage device can have any of its information rapidly consulted. Thus a phonograph record is random access inasmuch as the user can play any part of the record by putting the needle on the chosen section. This differs from tape recordings, where the user must spin through to the section he wants to hear. If the section is far down on the tape, this takes a while.

different category lists are stored on the surface of the disks. Whenever one of these categories is to be checked, the computer must wait until the information next passes under a reading head. Storage capacity is very large; even a small disk can easily handle 20,000 words

FIGURE 3.1. The IBM 7090 computer.

and phrases. Yet, the processing speed at best is only a few hundred words of text per minute.

Using this second strategy, the assignment-of-categories phase is also programmed to operate on the much smaller IBM 1401–1460

FIGURE 3.2. The IBM 1311 disk storage unit.

series machine *together with the IBM 1311 disk attachment*.[7] Procedures are logically parallel to, albeit much slower than, those who have operated on the larger machine. A picture of the disk device, which stands the size of a small desk, is shown in Figure 3.2.

[7] The programs using the disk were designed and written by Phillip Miller at Washington University in St. Louis.

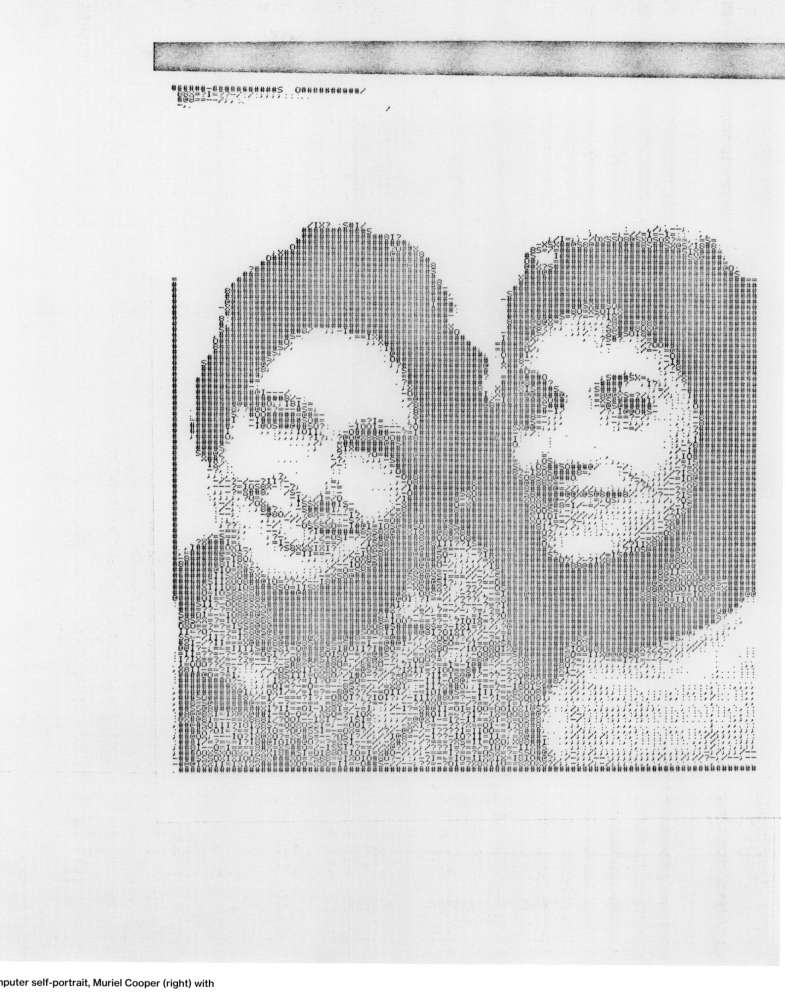

Computer self-portrait, Muriel Cooper (right) with
Donis A. Dondis, produced in Nicholas Negroponte's
design and programming class, MIT Department of
Mechanical Engineering, 1967

Hardcover and Paperback Books from the MIT Press, Spring Supplement to the Complete Annual MIT Press Catalogue, The Massachusetts Institute of Technology

- Akhiezer Collective Oscillations in a Plasma
- Albert Stochastic Approximation and Nonlinear Regression
- Amstutz Computer Simulation of Competitive Market Response
- Baddour Application of Plasmas to Chemical Processing
- Benison Tom Rivers: Reflections on a Life in Medicine and Science
- Bernal The Social Function of Science-hard
- Bernal The Social Function of Science-paper
- Brown Basic Data of Plasma Physics, 1966
- Cartan The Theory of Spinors
- Chilton Strong Water
- Coate High-Power Semiconductor-Magnetic Pulse Generators
- Crees The Legacy of Raymond Unwin
- Fejtö The French Communist Party
- Ferziger Theory of Neutron Slowing Down in Nuclear Reactors
- Feynman The Character of Physical Law-hard
- Feynman The Character of Physical Law-paper
- Fischer-Galati The New Rumania
- Gelfand The Method of Coordinates, Vol. 1-hard
- Gelfand The Method of Coordinates, Vol. 1-paper
- Gelfand Functions and Graphs, Vol. 2-hard
- Gelfand Functions and Graphs, Vol. 2-paper
- Gelfond Elementary Methods in the Analytic Theory of Numbers
- Goodwin Management Thought and Action in the words of Erwin H. Schell
- Griffith Communism in Europe, Vol. 1-hard
- Griffith Communism in Europe, Vol. 1-paper
- Griffith Communism in Europe, Vol. 2-hard
- Griffith Communism in Europe, Vol. 2-paper
- Griffith Sino-Soviet Relations 1964-1965-hard
- Griffith Sino-Soviet Relations 1964-1965-paper
- Halperin Sino-Soviet Relations and Arms Control
- Hein Grooks
- Hoffmann Search for the Real-hard
- Hoffmann Search for the Real-paper
- Horowitz The Rise and Fall of Project Camelot-hard
- Horowitz The Rise and Fall of Project Camelot-paper
- IGSY Annals of the International Year of the Quiet Sun, Vol. I

MIT Press catalog, spring supplement, 1967

the MIT Press of The Massachusetts Institute of Technology

- Isaacs No Peace for Asia-hard
- Isaacs No Peace for Asia-paper
- Kampf On Modernism
- Kendrick Programming Investment in the Process Industries
- Klimontovich Statistical Theory of Non-Equilibrium Processes in Plasma
- Lehiste Readings in Acoustic Phonetics
- Manne Investments for Capacity Expansions
- Marglin Public Investment Criteria
- Martin Magnetism in Solids
- Merten Desalination by Reverse Osmosis
- MIT Students System Project Project Metran
- MIT Students System Project Project Nero
- Montias The Economic Development of Rumania
- Myers The Impact of Computers on Management
- Oppenheimer Essays in the History of Embryology and Biology
- Otto Tensile Structures, Vol. I
- Passonneau Urban Atlas Special Pre-Pub Price until March 31, 1967
- Penfield Electrodynamics of Moving Media
- Rainwater The Moynihan Report-hard
- Rainwater The Moynihan Report-paper
- Ralston The Army and the Republic
- Rasmussen, London: The Unique City-hard
- Rasmussen, London: The Unique City-paper
- Rees Health Physics
- Regin McCarthy and the Intellectuals
- Scholfield A Scientific Autobiography of Joseph Priestley
- Shell Essays on the Theory of Optimal Economic Growth-hard
- Shell Essays on the Theory of Optimal Economic Growth-paper
- Steinhart Science, Technology, and American Foreign Policy
- Spreiregen The Modern Metropolis
- Stacey Modal Approximations
- Taylor The Art Nouveau Book in Britain
- Weinberg Reflections on Big Science
- Weinstein Gabon: Nation-Building on the Ogooué
- Wulff The Traditional Crafts of Persia

14 Political and Social Science

underpopulation may frustrate full development of these resources. Materially poorer neighbors and internal instability might also threaten the chances for economic development and for community-building, and the nature of traditional cultural values tends, as elsewhere, to hinder national construction. Attempts to overcome these difficulties by means of a strong single-party system have been unsuccessful. However, the Fang people, Gabon's dominant ethnic group, have provided an impetus to unity in their efforts to forge an effective organization within their own group. One might assume that any movement whose goal is some form of ethnic solidarity would be opposed to the process of nation-building. In the case of the Fang the reverse may be true; Fang activity seems to have provided a dynamic for national consolidation.

The face of the African continent, so recently changed, demands a literature to make the efforts of national construction in newly independent countries accessible to the general reader as well as to the sociologist and political scientist. As social science, Gabon: Nation-Building on the Ogooué serves that need.

Brian Weinstein has studied archival material and census data in Africa, France, and the United States, and has traveled extensively throughout Gabon on two occasions. He is Assistant Professor in the African Studies Program at Howard University, Washington, D.C.

Contents:
Preface. Acknowledgment. Part One: Motive Force in Nation-Building. The Arrival of the French and the Arrival of the Fang in Gabon. Anomie and the Motive Force of the Fang. Part Two: National Consolidation Through Shared Experience. Measurement of Shared Experience. A Developing National Culture. A Developing National History. A Developing National Belief System. Part Three: National Consolidation Through Human Decision-Making. Leadership in Nation-Building. Government Nation-Building Policies. The Formation of National Frontiers. Threats to a Developing National Order. Conclusions. Bibliography.
March-5⅞ x 8¾-320 pp. 8 pp. half-tones 3 tables-endpaper maps-$12.50a-100/--
May-U.K. and Europe
LC 67-13393

Reflections on Big Science
by Alvin M. Weinberg

With science advancing more rapidly than its cumulated results can be communicated, it takes a skilled "intuitive observer" to make the perceptive leap from where science seems to be at a given moment to where it really is, and to judge its probable speed and direction of advance.
Alvin M. Weinberg is one of the keenest of such observers. The reflections gathered

here represent many years of essaying answers to fundamental questions about the changes in science–changes not in content alone but in scale and scope, in method and purpose. Some of the more searching questions are these:
Given limited funds for scientific research –however large compared to prewar days– what are the criteria that should guide their distribution among basic science, research keyed to economic advancement and social betterment, and research keyed to international prestige?
Once these basic policies are established, what particular projects deserve support, and at what level? How, for example, can one determine the comparative priorities of desalination and cancer research?
What controls should be constituted or exerted to achieve the aims of policy? What is the proper allocation of control between the public and private sectors?
Both a creative physicist and a scientific administrator, he has been Research Director and then Director of the Oak Ridge National Laboratory for the past eighteen years. He is firmly convinced of the abiding value of these new institutions, the National Laboratories, whose role he sees as complementary to that of the universities. In addition, he has served on the Scientific Advisory Board to the Air Force, the President's Science Advisory Committee, and the Committee on Science and Public Policy of the National Academy of Sciences. And yet for all his commitment to the established institutions of public service and public science, Dr. Weinberg freely questions the existing state of scientific endeavor and openly probes the need for changing the order of scientific priority. His concern is more with the proper distribution of funds among conflicting interests than with seeking a larger slice of budgetary pie for his own field or laboratory. And he regards the limited working efficiency of committee machinery from the independent stance of the thoughtful individual:

"Now committees, in my view, can no more produce wisdom than they can design a camel. The atmosphere of a committee is too competitive, too verbal, too formal, for wisdom to sprout there. Wisdom is a very personal kind of thing; it flourishes best when a single mind thinks quietly and consistently –more quietly and consistently than is possible when one is engaged in the rough-and-tumble of committee work. . . . Thus, I have felt that some of the most troublesome questions . . . ought to be thought through by individuals who would then set their thoughts down in essays. Out of many such essays, written by different people, could come, if not clarity and guidance, at least a common language and framework in which to conduct the discourse. The committee

could then serve to criticize, or even to satisfy egos, rather than to create more wisdom than was contained in the individual essays."
These essays, then, constitute Dr. Weinberg's own report to the Committee of the Whole–to all those concerned with the activity and organization of science and its effects–planned and unforeseen–on the life of these times of big science, big conflicts, and big promises.
Individual essays treat a number of acute or chronic problems and in many instances prescribe remedies. Included are considerations of the population expansion and the concomitant expansion of energy and information, the new social structures built by the new technology, the effects of the organization and financing of Big Science on the nature of scientific inquiry, the potential contribution of the federal laboratories to science education, and the role of the scientist (which is distinct from, and as vital as, the role of the documentalist) in closing the Information Gap.
Contents:
The Promise of Scientific Technology: The New Revolutions. The Problems of Big Science: Scientific Communication, The Choices of Big Science: Criteria for Scientific Choice; The Two Cultures; The Coming Age of Biomedical Science; Scientific Choice and Human Values. The Institutions of Big Science: The National Laboratories and the Problem of Missions; The Universities and the Problem of Disciplines; The Federal Grant University and the Federal Laboratory. Index.
April-5¾ x 8-256a pp.-$7.50T-60/--
LC 67-14205
June-U.K. and Europe

Science, Technology, and American Foreign Policy
by Eugene B. Skolnikoff

In an age when science and technology are becoming the popular yardsticks for measuring progress or prestige in international affairs, it is strange indeed that little literature relevant to the role of science in relation to foreign policy exists. Thus the need for this book–a timely articulation of a relationship hitherto superficially accepted but usually denied in practice, because it is only vaguely understood.
Skolnikoff shows the breadth of the relationship and the character of the interaction between the scientific and other elements of major issues of foreign affairs. Most important, he shows how the uncertainties inherent in judgments about science and technology are affected by political factors, and, reciprocally, how political factors depend on scientific and technological judgments. Thus, for those issues in which scientific and technological factors figure

demands raised through political channels by regional and local pressure groups–a point of equal importance in other developing countries such as Nigeria.
One feature of this volume–the mathematical models and computing algorithms–will have a wide application to other countries. This pioneering work will be of interest to managers, engineers, operations researchers, and economists of many nations, particularly those concerned with industrialization and development planning.
Professor Manne has worked with planning agencies in Mexico as well as India. He spent two years in India and in this volume has had the assistance of a number of other economists and operations researchers. This work was initiated at the M.I.T. Center for International Studies in New Delhi and was completed at Stanford University. The resulting book is a pioneering effort that is unique in its scope.
Alan S. Manne is Professor of Economics at Stanford University and teaches in the Economics Department, in the Graduate School of Business, and in the Interdepartmental program in Operations Research. He is the author of a number of books and papers concerned with optimal economic planning–both within a single enterprise and within an economy as a whole.
March-5½ x 8½-96 pp.-$5.00 COBEX-40/--

Public Investment Criteria
by S. A. Marglin

This book explores some of the problems of finding investment criteria for the public sector of a mixed-enterprise, under-developed economy. (The first draft was written in India.) The typical essay on public investment criteria explicitly or implicitly postulates a single goal for economic analysis–maximization of a weighted average of national income over time–and explains all other objectives of public policy to a limbo of "political" and "social" objectives not amenable to systematic, rational treatment. In contrast, Professor Marglin assumes a multiplicity of objectives, and Chapter 1 explores ways and means of expressing the contributions of different objectives in common terms. The objectives analyzed are (1) aggregate consumption, (2) redistribution of consumption among groups or regions, (3) "merit wants" elevated by political decision above the market tests (for example, education), and (4) self-sufficiency in the sense of independence from foreign economic aid. Chapter 2 investigates the relationship of specific investment criteria to the objectives of public policy. Benefits and costs are defined separately for each time–and regions, as called "secondary" benefits. The choice of interest rate is explored at length, and more cursory attention is paid to budgetary constraints, uncertainty, dynamic aspects of

investment planning, and the role of the cost of private alternatives in public calculations. Pricing policy for public enterprise is discussed briefly.
S. A. Marglin is Assistant Professor, Department of Economics, Harvard University, and the author of Approaches to Dynamic Investment Planning.
March-5½ x 8½ -96 pp.-$5.00 COBEX-40/--

History of Science

A Scientific Autobiography of Joseph Priestley, 1733-1804:
Selected Scientific Correspondence, with Commentary
edited by Robert E. Schofield

Joseph Priestley's science was an activity of his leisure, for he was by profession and conviction a minister who prized his scientific reputation, because, as he wrote in his Memoirs, it gave weight to his "attempts to defend Christianity." His own account of his life, therefore, neglects just those aspects for which he is primarily remembered and on which we would most like to have his views. This work provides that account of Priestley's scientific pursuits, in his own words, through selections from his correspondence, related memoranda, extracts from his Memoirs, prefaces, etc., with a commentary that relates these writings to Priestley's life and to his scientific work as a whole.
This collection brings together the largest body of primary research materials relating to Priestley's scientific career that has been made available since Priestley's publication of his own scientific investigations. Nowhere else is there revealed so many details of the history of science as Benjamin Franklin, John Canton, Alexander Volta, Henry Cavendish, and Martin von Marum. Many of the letters have never previously been published; of those already in print, a large number have appeared separately and in scattered places. The letters constitute a continuing, year-to-year, first-hand account of Priestley's scientific career and for the most part have yet to be drawn upon to any significant degree. They give an insight into his private speculative thinking that his published writings, however discursive, do not provide.
Professor Schofield assembles the correspondence chronologically, dealing first with accounts of Priestley's initial interest in "experimental philosophy" and then with his research into the history of experiments on electricity, research that led him to do some experimenting of his own. Subsequent chapters focus on Priestley's life in Leeds, where he turned his attention from electricity to chemistry; his years of mammoth achievement under the patronage of Lord Shelburne;

History of Science 19

his scientific activity during the period from 1781 to 1794, when his theological opinions finally involved him in disastrous debate; and his years of self-imposed exile in the United States.
Professor Schofield's extensive commentary provides a factual framework for the correspondence and introduces a new interpretation of Priestley's work by demonstrating the significance of what had previously been ignored or considered out of context. The documentation is thorough and detailed; a complete list of the sources of the correspondence is included, as well as biographical details regarding all the correspondents. Valuable alike to the scholar and the interested layman, A Scientific Autobiography of Joseph Priestley is an important addition to the literature on British mechanistic natural philosophy and may encourage a re-evaluation of the achievements of eighteenth-century British science.
Robert E. Schofield is Professor of the History of Science at the Case Institute of Technology. Educated at Princeton University, the University of Minnesota, and Harvard University, he is author of The Lunar Society of Birmingham (1963) and editor of Joseph Priestley's The History and Present State of Electricity (1966).
Contents:
Introduction. Electrical Experiments and the History of Electricity, 1765-1767. The Testing Years, Leeds, 1767-1773. Time of Achievement, London and Wiltshire, 1773-1780. On the Defensive, Birmingham and London, 1781-1794. Antichmax, Northumberland, Pennsylvania, 1794-1804. Appendices. General Bibliography. Index.
April-5⅝ x 8¼- xiv + 528 pp., illus.-$15.00–120/--
LC 67-14099
June-U.K. and Europe

Essays in the History of Embryology and Biology
by Jane M. Oppenheimer

"Science, like life itself, indeed like history itself, is a historical phenomenon. It can build itself only out of its past."
Jane M. Oppenheimer
This volume is a unified collection of articles and lectures in the history of embryology and biology. Written by an investigator and teacher of experimental embryology, the book is designed to emphasize the coherence between history of science and experimental science and to bring the experience of past discoveries into the modern laboratory.
The essays are arranged roughly in reverse chronological order. To quote Professor Oppenheimer: "it is belief that we understand our contemporaries more clearly than our earlier predecessors, and our nearcontemporaries better than those from whom time separates us farther. The design of

18 Economics

tion of his work incorporates elements of intimate knowledge gained from constant reassessment of the substance of general business education. The editors have assembled, reviewed, and selected segments from his many books, articles, and unpublished material, and have put these together to demonstrate the confluence of Schell's ideas and capture the spirit of warmth in which they were conceived and delivered. And, indeed, Professor Schell's personality is inextricable from his writings. As a teacher, he realized that intellectual development could be most effective only when accompanied by social and emotional maturation. As a scholar of management, he perceived the necessity for responsible and reflective managers to maintain the productive growth of national industry. As a man, he knew that a full and well-spent life demanded the consistency that is born of a considerate and flexible philosophy. In the editors' words, "Professor Schell was, above all, a teacher of philosophy. . . . For him, life was an experience in management, and management was a constant challenge to his best thinking and exposition."
Editors Goodwin and Moore are former students of Professor Schell. They are currently associated with the Alfred P. Sloan School of Management at M.I.T. where Herbert F. Goodwin is a Senior Lecturer in Management, and Leo M. Moore is Associate Professor of Management. A Prologue, which is a tribute as well, is provided by Howard W. Johnson, President of M.I.T., and an Epilogue by James R. Killian, Jr.
Contents:
Preface. Acknowledgments. Prologue: Search for Understanding, by Howard W. Johnson. Introduction to Administration. Philosophy for Growth. Policy and Its Formulation. Change and Its Dimension. Measurement of Viewpoint. Attitude for Progress. Effectiveness in Execution. Environment of Freedom. Reflections in Satisfaction. Epilogue: Tribute to a Teacher, by James R. Killian, Jr. Bibliography. Index.
May-5½ x 8 -192 pp.- $7.50a-60/--
July -U.K. and Europe

The Economic Development of Rumania
by John Michael Montias

Critical areas of Rumania's Communist economy have been blanketed in statistical secrecy for nearly two decades. The gaps in official data and the proclivity of Rumanian economists to puff up their country's achievements without revealing its fundamental problems were obstacles that had to be surmounted in this, the first book-length survey in English of Rumania's postwar economy. The Rumanian Communist Party leaders believe in the value of industrialization per se, this rules out an objective appraisal of Rumanian industrial protectionism in terms

of costs and tangible benefits, even if all the relevant data are at hand. But the description and analysis of the industrialization process throw light on the intensity of the Party leaders' economic nationalism and on the political and economic gambles they are willing to make for its sake.
The organization of the book's material into four major areas–industrial output and structure, agriculture, foreign trade, and Rumania's relations with the countries of Comecon or CMEA (Council for Mutual Economic Assistance)–provides a broad view of the economy. The first chapter describes and analyzes the Rumanian "strategy of industrialization," the economic policy adopted soon after the Communists came into power, which called for a high and growing level of investments, to be devoted mainly to the expansion of heavy industry. What resources were mobilized to attain this goal, how the low-priority sectors of industry fared in the face of this expansion at forced draft, and what repercussions these policies had on Rumania's foreign trade are some of the underlying questions the author concentrates upon.
The second chapter contains what is probably the most comprehensive analysis of the effects of full-scale collectivization on farm output and state procurements in any Eastern European country. The discussion of state procurements of foodstuffs, essential to the export program, leads to the analysis of foreign trade in Chapter 3, which traces the organic links between the external sector and the domestic economy. The author's careful reconstruction of the composition of trade by region and by commodity analyzes on the basis of statistics scattered in Soviet and East European publications lays the groundwork for his analysis. The origins and the gradual aggravation of Rumania's dispute with CMEA are chronicled in Chapter 4, with an emphasis on the relation between underlying conflicts of interest and the theoretical disagreements between the member countries to which these conflicts gave rise. A short concluding chapter sets Rumania's domestic and external problems in the general framework of the stage of development Rumania has now attained relative to the other Communist countries of Eastern Europe.
To supplement the numerous corroborating statistical tables throughout the book, four appendices are included that cover the more technical aspects of statistical estimation. The first supplies an independent measure of industrial output on the basis of the methodology used in constructing output indices in the West. The second attempts to reconstruct official estimates of national income and the price indices used by the Rumanian statistical office to deflate current values in each sector. The third examines in some detail the dependence on imports

of Rumania's industry and the importance of some of its key exports in relation to their production. The last appendix contains a detailed survey of the problems affecting Rumania's not-so-flourishing petroleum industry.
As an example of a successful industrialization program financed almost exclusively from domestic saving, this book will be valuable to students of economic development. Insofar as it relates to the study of trade relations in the Soviet bloc, specialists in East European Communist affairs will wish to use it in conjunction with the companion volume by Stephen Fischer-Galati, The New Rumania: From People's Democracy to Socialist Republic.
John Michael Montias, Professor of Economics at Yale University, has traveled extensively in Eastern Europe and in Rumania in particular. His previous publications include Central Planning in Poland (1962) and a number of articles on planning and trade in Eastern Europe.
Vol. 11, Studies in International Communism, edited by William E. Griffith and published in cooperation with the Center for International Studies, Massachusetts Institute of Technology.
Contents:
Preface. The Industrialization of Rumania. Agriculture. Trade. Rumania and the Economic Integration of Eastern Europe. Appendices. Index.
June-6½ x 9¼-384a pp.-Tables-$10.00a-80/--
August-U.K. and Europe

Investments for Capacity Expansion:
Size, Location, and Time-Phasing
by Alan S. Manne

Investments for Capacity Expansion deals with both the theory and practice of long-range investment planning for a series of future manufacturing facilities. Case studies relevant to the needs of heavy process industries in India: aluminum, caustic soda, cement, and nitrogenous fertilizers. In these sectors there are significant economies-of-scale in manufacturing, and there is a close interdependence between the size, location, and time-phasing of new plant. He then goes on to examine the ways in which science can be improved, treating the practical side of the scientist's work as well as the character and ultimate orientation of scientific advance. The entire study is copiously documented; extensive bibliographies and appendices are included.
The viewpoint here is that of a preliminary investment survey, one that provides a rough framework within which to draw up a detailed proposal on the next project to be built.
The conclusions of such a pre-investment survey are intended to serve as the initial premises for a specific project: when, where, and how large a unit is construct.
Since these analyses relate to the Indian economy, some features relate to the specific conditions of that country. For instance, the author's experiences have led him to emphasize the importance of making explicit calculations of what it costs to satisfy the

prominently, real integration of science and technology in the policy process is essential. In this respect, the existing mechanisms of the U.S. Government, particularly in the Department of State, are demonstrated to be wanting.
To make these and other points, such as the use of science and technology as new tools of policy, the book discusses in turn the major areas of policy–arms and arms control, space, atomic energy, bilateral relations, international organizations and the like–using a combined analytical and case study approach. The discussion develops the nature of the technical elements of policy issues and points out the requirements posed for the policy process. Modifications of existing methods for providing scientific inputs in foreign affairs are offered. In addition, the book offers for the first time a history of the science advisory mechanisms for foreign policy in the White House and Department of State. A final chapter demonstrates the meaning of continuing technological advances for some of the basic assumptions underlying U.S. conduct in foreign affairs: for example, the changed significance of national freedom of action, the inviolability of national borders, the possibility of having to suppress or control technology, and the inevitable growth of decision-making on an international scale.
Science, Technology, and American Foreign Policy is certain to hold the attention of scholar and policy maker alike, for it is the first book to treat this subject from a policy vantage point. This assures the best kind of generality, for it allows an over-all view of not one but the spectrum of scientific issues that are constantly meeting and interacting with the political demands posed by an effective international policy.
Eugene B. Skolnikoff is Associate Professor of Political Science at M.I.T. and was formerly on the White House staff working for the Special Assistant to the President for Science and Technology. He has served as consultant to the Office of Science and Technology in the Executive Office of the President of the United States, the Agency for International Development, the Department of State, the Organization for Economic Cooperation and Development, and the Ford Foundation. Dr. Skolnikoff is also Visiting Lecturer at the Fletcher School of Law and Diplomacy at Tufts University.
Contents:
Part I: The New Relationship. Part II: Foreign Policy Issues Arising from Scientific Enterprise. Part III: Foreign Policy Issues with Important Scientific and Technological Elements. Part IV: Science in the Foreign Policy Process. Part V: Science and Future Patterns of International Affairs.
March-6 x 9 -xvi + 300 pp. $8.95T-72/--
LC 67-15239
May-U.K. and Europe

The Social Function of Science
by J. D. Bernal

"It is highly appropriate that this truly stimulating book by one of England's ablest young physicists, fellow of the Royal Society and member of the faculty of the University of London, should be widely read in America."
Scientific Book Club (1939)
". . . inspires a faith in the value to humanity of unselfish search for truth in the solution of its problems. . . ."
–Annals of the American Academy
". . . a provocative and valuable book which is badly needed."
–The New York Times
In 1939, John Desmond Bernal issued this blueprint for the function of science in a vigorous society. At that time, the modern scientific and technological revolution was just beginning, soon to be felt in the enormous destructive activity of the Second World War. The appearance of this book was a milestone in the orientation of science toward the advancement of the human race rather than its destruction. Its basic thesis–that science was for everyone, that it had a function in society and could operate for the incalculable benefit of modern civilization–has since been adopted by the scientific and political science communities everywhere.
Bernal's view of science originates in the conviction that a concern for the welfare of society is a natural dimension of scientific endeavor, not an obligation parenthetical to the real business of science. To quote Bernal: "Science implies a unified and co-ordinated and, above all, conscious control of the whole of social life." The Social Function of Science is an explicit statement of how science can achieve that control.
Bernal sees the advance as composed of two parts: the internal reorganization of scientific endeavor, and the systematic application of scientific discoveries to social, political, and economic phenomena. He opens The Social Function with a description of the characteristics of science as seen through his microscope, investigating how science was organized in Britain and elsewhere; science in education; the efficiency of research; and the relation of science to progress in other fields. He then goes on to examine the ways in which science can be improved, treating the practical side of the scientist's work as well as the character and ultimate orientation of scientific advance. The entire study is copiously documented; extensive bibliographies and appendices are included.
Since 1963, John Desmond Bernal has occupied the Chair of Crystallography at the University of London. He is a Fellow of the Royal Society and a member of numerous foreign scientific academies. Author of seven

Economics 15

books in science and the history of science, he was awarded the Grotius Medal in 1959.
Contents:
Introductory. Historical. The Existing Organization of Scientific Research in Britain. Science in Education. The Efficiency of Scientific Research. The Application of Science. Science and War. International Science. The Training of the Scientist. The Reorganization of Research. Scientific Communication. The Finance of Science. The Strategy of Scientific Advance. Science in the Service of Man. Science and Social Transformation. The Social Function of Science. Appendices. Charts. Index.
February-5¾ x 8 -xxiii + 482 pp -$12.50 CUSA- 100/--
LC 67-14526
Available in the M.I.T. Paperback Series, MIT-65, $3.95T 20/--

The Economic Development of Rumania
by John Michael Montias (see page 18)

Economics

The Impact of Computers on Management
edited by Charles A. Myers

Contained herein is an array of exciting and knowledgeable papers which discuss, from assorted disciplinary angles, the "present and future impact of computers on management organization and the role of the managerial work." No two papers cover the same ground or reach identical conclusions, for the purpose of this collection is to articulate as completely as possible the relationship between man and machine, and the role of both in industrial organization. Thus the question itself is defined in the succinct terms of its many answers.
The contributors to this volume reached the general agreement that "computers have affected certain management operations more than others, and that the dividing line is shifting as computer technology and even more experience with programming and systems design improves." Several points of disagreement create an atmosphere conducive to fresh speculation on old issues, and re-examination of dilemmas produced by recent advances in computer technology. The individual training, experience, and opinion of the contributors dictate divergent attitudes toward the problem of defining computerization-managerial relationships. Yet, there are numerous areas of concern common to all papers: the centralization of organization structures, data-processing, and information technology; the importance of outside factors to organizational changes; the changing nature of managerial work, and the implications of computerization for the higher levels of management. An excellent discussion of these problems, in light of the contributions of the various authors, is

Edward Allen, *Stone Shelters* (Cambridge, Mass.: MIT Press, 1969), design by Muriel Cooper and MIT Press Design Department

Figures 16 and 17
A typical *casella* of the coastal area north of Bari is roofed in concentric terraces. Outside stairs allow these terraces to be used for the drying of produce. The four niches, one exterior and three interior, are spanned with corbels. The exterior door lintel is of stone slabs, and the interior of the doorway opening is corbelled. Projecting flat stones form interior shelves.

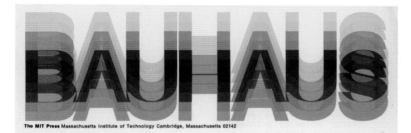

BAUHAUS

THE MIT Press Massachusetts Institute of Technology Cambridge, Massachusetts 02142

THE BAUHAUS:

an idea

an institution

and a magnificent new book

Dear Reader:

1969 is the 50th anniversary of the formal instituting of the
Bauhaus - the embodying of an idea - a major event of the 20th
century that took place in Weimar, Germany in 1919 through the
initiative of the late Walter Gropius. Ever since, the Bauhaus
and its successors have exerted an enormous influence not only
on art but on our environmental style and our life-quality as a
whole. This of course was its programmed intention - to treat
the environment as a totality, to base all the spatial arts on
an underlying science of basic design, to trace out the inter-
relations of art, technology, industry, and social function.
In particular, the famous "Preliminary Course" was designed to
instill in the student a fundamental, objective understanding
of the physical and psychological facts of vision, materials,
and construction, after which he was prepared to practice a
particualr art in a nonimitative way. This course influenced
art schools all over the world. Equally influential was the
Bauhaus mission of fabricating prototype models for industrial
production (models that are also one-of-a-kind objects of art).
These other influences remain strong and vital, and some of the
seminal undertakings of the Bauhaus are just now beginning to
bear mature fruit - total theater and kinetic light shows, to
name but two.

And yet for all this, the Bauhaus itself has never until now
been thoroughly studied in all its manifestations and succes-
sive phases, in its full unity and continuity. This gap in the
cultural history of our time has now been amply filled with
the publication of a book that encompasses and exhibits the uni-
tary interrelations of all the Bauhaus activities and traces its
continuity from the arts-and-crafts movement of the 19th century
to the happenings of our own present day:

Documents	Pictorial Groups
Gyorgy Kepes: Education of the Eye	Basic Workshop - Recent Works
School of Design, Faculty, 1939-1940	Photography
Laszlo Moholy-Nagy: Better than Before	Architecture 1937-1955
Serge Chermayeff: Remarks	Product Design
Anonymous Art Critic: Open House - Institute of Design in 1952	Foundation Course (and 6 other pictorial groups)
(and 28 other documents)	

There simply is not room enough in this letter to describe or
even mention the full range of contents of The Bauhaus. Besides,
description is not really adequate - the book has to be seen and
handled and sampled. Only at first hand does it become apparent
that the book's hefty solidity (about 12 pounds!) is exactly
counterpoised by the spaciousness and elegance of its design, a
design that is truly worthy of its subject. We invite you to
examine it for yourself; our usual 10-day free examination policy
applies of course.

Your order need not be accompanied by payment; we will send an
invoice with the book if you prefer. However, please note that
if you do pay in advance, the Press will pay the postage charge
on the book. Please remember that the special prepublication
price of $42.50 expires December 31, 1969. Reserve your copy now.

Just as the Bauhaus was a movement of the first importance in mod-
ern cultural history, so is The Bauhaus a publishing event of ma-
jor importance in the fields of cultural history, art, and educa-
tion. We take pride and pleasure in offering it to you at this
time.

Sincerely,

Henry Cage
Henry Cage
The M.I.T. Press

Announcements for *The Bauhaus*, 1969

Slipcover for Hans Maria Wingler, ed., *The Bauhaus: Weimar, Dessau, Berlin, Chicago* (Cambridge, Mass.: MIT Press, 1969), and softcover edition (1977), design by Muriel Cooper

Design

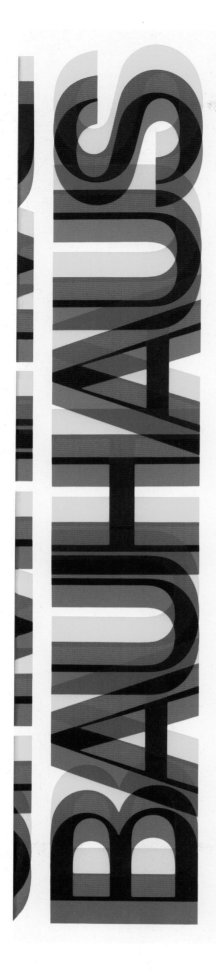

Contents

Products of the Workshops
4
Typographical work by Moholy-Nagy, Bayer,
and J. Schmidt. 1923-1929. Upper left: Joost
Schmidt, brochure for an office-supply house in
Weimar, 1924. Upper center: Herbert Bayer,
brochure (front and back) for a product of the
Fagus works, 1923. Upper right: Bayer, poster
for the Kandinsky exhibition at the Anhalt Art
Association in Dessau, 1926. Center left and
lower left: Laszlo Moholy-Nagy, prospectus
(front and back) for the Bauhaus-Verlag and for
the Bauhaus books originally planned for pub-
lication there, 1924. Center right: Bayer, invita-
tion to the building-completion festival in
Dessau, 1926. Lower right: Moholy-Nagy, "14
Bauhaus books," cover for an eight-page pro-
spectus of the Albert Langen Verlag in Munich,
1929.
Specimens of these prints are in the possession of the
Bauhaus-Archiv, Darmstadt.

5
Typographical work by Bayer and J. Schmidt.
1923-1926. Upper left: Herbert Bayer, cover for
a book edited at the Bauhaus in Weimar con-
cerning the work done during 1919-1923 at the
Institute, 1923. Upper right: Bayer, invitation to
the "White Festival" of the Bauhaus in Dessau,
1926. Lower left: Joost Schmidt, front cover of
the special edition of the journal "Offset, Buch
und Werbekunst" dedicated to the Bauhaus,
1926. Lower right: Bayer, poster for the exhibi-
tion "European Arts and Crafts 1927" at the
Grassi Museum in Leipzig; designed in 1926.
Specimens of these prints are in the possession of the
Bauhaus-Archiv, Darmstadt.

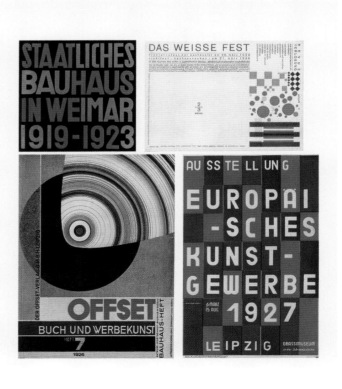

Hans Maria Wingler, ed., *The Bauhaus: Weimar, Dessau, Berlin,
Chicago* (Cambridge, Mass.: MIT Press, 1969), interior spreads

to the fullest extent. They are the content of the specific in its very individual way; the specific rests on the whole.

Something that is upright is something that is static and spatial, something solid, a weight that straightens and lifts itself. Since light is the foundation of color, anything static and spatial must correspond to color and must be in a state of ultimate equilibrium, in ultimate harmony, when its appearance emerges from the unity of color and sound. Static configurations bear a characteristic mark, just as light shines and becomes effective in colors. These configurations rest upon specific centers of gravity at particular points in the human body and rise from these in a specific manner. An ordering of static configurations will depend on the level of strain and expansion and will be identical with an arrangement of light and colors. This ordering of colors is equal to the chromatic structure of the tones from c to b. But the order of colors does not result from the intellectual calculation that the tone scale from c to b is based on progressive tension; instead, it is found subconsciously and spontaneously by anyone because of the gravitations within the living and active body. This order occurs as a circular one and constitutes an outward oriented tension of forces, of a length and a direction which correspond to the forces (colors) and which result from the structure and the composition of the human form. The interrelationships of colors and sounds, as well as the just mentioned circular order are the same for all human beings. The circle, a circle of gravity and equilibrium, the deepest, simplest color-harmony is, therefore, of universal significance. The circle is a fundamental phenomenon and is of the same importance to statics as the golden section had been for measurements. Since gravity, and not number, is the primary element, the order of colors ranks above the golden section as the determining criterion. In the living organism the forces join in particular measures and interrelate in definite degrees; from a center outward, outside with reference to a center. The act of weighing derives from the mind "judiciously," progressing materially from the heaviest, structurally firmest to the lightest, most ephemeral, most flexible. The scales and degrees increase and once more require a special order of colors (forces). This is a firm order, a unit of measure for all colors; it is based on the construction of the human figure, its frame, the spinal column, vertically in height and depth, and in expansion, horizontal, active, movable on the diaphragm. This order of colors, too, is subconsciously independent; it stands in particularly close connection with the lamellar nature of the muscular system. The dynamics are numerical and are identical with the order of octaves; downward and upward from the center and, furthermore, from low to high and from high to low. Compared with the first circle, as the circle of equilibrium, the second circle is the circle of dynamics, mechanics, matter, the intellect, the construction. The first circle already bears the second one within it; the second rests on the first, is only capable of deriving from it in the form of quantities from qualities. A dynamic element is equal to a specific element, deduced from the synthetic, the totality, which is of a lower or higher degree, a certain color, and is a form, size, material on the one hand, and a quality, scale, and weight on the other. The kinetic form of such a balanced force represents an angle, a right, acute, or obtuse, of a curvilinear type, and, as an entity completed on all sides, yields geometric shapes. They are physical forms of life that enter the consciousness and that in the living being spiritually form themselves into phantasies (beings and objects) according to their emphasis on form or material. And they are also actively felt in that they lead man to actions, creation, and production. Matter is sensed as entity, as force and energy, and further, as a condition. Materials such as stone, wood, etc., vegetable, animal and human forms and shapes, solidity, compactness, including the liquid condition and the atmospheric state, also psyche, are all forces and forms of life that are closely connected with light, with color. The material of which the human being is created, in all of its various kinds, intuitively enters the consciousness as imagination and as idea. Man behaves according to his intuition; with his awareness of the "I" and self-consciousness he expresses his will and governs himself as well as other things.

All living things and all beings outside of man are complementary to him; on the other hand, man transfers his perceptions and experiences into his environment and thus sees and forms the world. Those aspects complementary to man have been cultivated in much too small a range, and all that has been discovered, made, and thought has been taught from without with too much emphasis on civilizing points of view. And qualities were presupposed that are not living, deeply rooted, and available, since the second category, that of independent perceptions and experiences which are born in the unconscious, has not, or only insufficiently, been cultivated. So far, universal fundamental laws have been lacking. One should not be surprised that brilliant work and the highly creative and imaginative attitude have disappeared, that a much too perfunctory understanding prevails of things, people, and the world; and one often asks: "What does this mean?", "How is that done?" In a place where all endeavors are directed toward reconstruction and companionship in liveliest reciprocation with the world, as in the Bauhaus, the cultivation of independence, born in the subconscious, will, as beginning and constant aid, not be dispensable. For, only from such independence can a renewal, an intensification, and a strengthening of sensitivity and receptivity originate in the purest and most thorough way, can expressiveness develop which is living, pure, thorough, and rich. Both are prerequisites for a successful companionship of man and the world. Every age has its forms of life; they are expressive of the age and are ahead of the everyday world. Today's forms of expression represent the emergence of natural forces, which seem to be requisite for the blossoming of a great, universal art. The assumption that with the building of living form through color, form, and sound, a theory is in the foreground is contrary to the fact that works born of genius, independence, and the subconscious can never originate and develop theoretically. Moreover, if the metaphysical, the abstract is genuine, great, powerful, and pure, it then stands on a firm base; the metaphysical is

70

then the most sensitive spiritual perception of the physical, the abstract is the concrete within physical, chemical form, and emotion becomes reason. The artist creates subconsciously, and he must go beyond the conscious in order to act subconsciously.

Comments on the illustrations:
1. With the drawing of a vest (textile form), a sample of material and the instructions for its making, as well as with the three sketches of the texture, a woman student from the weaving workshop offers a first example of a lively imagination born of necessity. The drawing represents a form, directly acknowledging movement, and it does this on account of experiencing a color in regard to the second circle, dynamically balanced in scale and degree. The movement would have developed naturally into the forms of knitting or weaving, as the case may be, but in the drawing has been interrupted and modified for the sketching hand. The student's designation of "weaving color" refers to the color (force) on which the act of weaving is based.
2. "Second circle," cross next to connecting lines; and further,
3. Angular forms have been drawn up by two students who, by themselves, have found symbols for primary connections of forces and basic diagrams for exercises. Contrary to the first circle (equilibrium, static-dynamic) these diagrams have dynamic-static importance. The results of these exercises are the same with all people, individually modified and shaded.

31
1. Evolved from material out of the result of the first grade and second measure (individually Agnes Roghé). Green and unbleached color. Vest knitted to the right. Zephir wool.
2. Evolved from the loom (machinery) out of the result of the first grade and first measure. Blue on unbleached. Undulating form of strong material. Rayon.
3. Result of the first grade and third measure. Undulating form in very perfect technique. Close mesh. Fine silk.
4. Result of the second grade and first measure. White on unbleached. Linen binding. Linen weave in a single piece of goods, ratio 2:3 or as pattern form.

32 33
Schema. Fundamental for the construction. Evolved from the circular order of the next illustration.

31

32

33

71

Lyonel Feininger
From a Letter Dated August 2, 1926, to Julia Feininger
BR, gift of Julia Feininger (First publication)
Feininger did not teach at the Dessau Bauhaus. In order to keep up the artistic as well as the human contact with him just the same, the Bauhaus put one of the "Master houses," designed by Gropius, in Burgkühnauer Avenue at his disposal. Feininger moved into his house the end of July 1926. In one single-family house and three duplexes on the same street lived Gropius, Moholy-Nagy and Feininger, Muche and Schlemmer, Kandinsky and Klee. The last two houses in the row of duplexes survived the second world war with little damage; the first duplex was heavily damaged and the single-family house was completely destroyed.

Paul Klee and Walter Gropius
Correspondence of September–October 1926 on the Question of a Salary Cut
BD, Gropius collection (First publication)
In order not to overstrain the concessions made by the city of Dessau, which itself was in a difficult financial situation, Gropius suggested that the full-time teachers agree to give up, temporarily, ten per cent of their salary to relieve the burden on the Bauhaus budget. While their colleagues reconciled themselves to the inevitability of having to make a personal sacrifice, Klee and Kandinsky opposed this measure.

Dessau, August 2, 1926
. . . At last I unearthed a pen! I am sitting out on our terrace which is simply delightful. The overhang and the short south wall, about which we were so unhappy in the blueprints of the house, are just the things that make for that comfortable light—without these projections everything would be bathed in the sun and the mid-day heat. The same goes for all of the rooms—they are much more pleasant and almost invariably larger than we had imagined from the plans and without the furniture. . . . On Saturday I put our many boxes into the basement; all the moving-stuff is stowed away. Outside there are many gardeners and people digging, clearing away the rubble. They've put in paths, and the area is being leveled and packed. The many trees are a blessing, for even in the most glaring sun one is not blinded when looking out into the green, and the tree tops are so beautifully silhouetted against the sky. Here is some real *space*, and it feels like being in the open. I never thought I would get over the loss of our balcony in Weimar that easily—on the contrary, it is a thousand times more beautiful here. And airy, a lovely breeze, but broken by the pine forest, so that I can always find shelter somewhere. Our dining room is not at all too narrow, and Andreas' furniture adds so much color and warmth that, even without any pictures, it is already nice and comfortable. The large living room will be nice too—all the books are temporarily tucked away—to put them into order will be more than one's job? And the music is splendidly housed in the long, black, re-done bookshelf, so that the miserable drawer business has been done away with. . . . That wretched graphics cabinet of course looks quite atrocious in it, but Gropi told me the other day that "it would have to be taken apart," and as soon as there is time I'll remind him of it. Just now he is very pressed, for the Schlemmers are moving in tomorrow . . . therefore, I will grant Gropi a few days of rest; he has complied with all of the wishes I had expressed, immediately and sympathetically. Yesterday (Sunday) we had afternoon tea at 4:30 at Gropi's and all the Masters were there, as were a number of Dessau society people. The house is fabulously furnished and of course has been designed to be incomparably more spacious and much more for representational purposes. I can't give you a detailed account of all the time-saving appliances now—you will see them and be enchanted. Altogether one can honestly speak of a creation, of a new achievement in building. . . . Huge Junkers airplanes are flying overhead, across our little forest—they are magnificent to see. I am very happy about the balance, it is so bright and gay, with its red stripes against the flat cobalt blue of the bannister. We must have our wicker furniture painted, or I'll gladly do it myself with enamel paints. What do you think about light red? I think it would look very nice. The local inhabitants are just too curious; it is really amazing how naively they behave; of course, Gropi's house has aroused their interest the most. . . . He has now had to destroy the "façade effect" after all, by having a concrete wall 2-1/2 meters high built around the two sides facing the street, including a garage, for Gropi is now going to acquire a car. . . . He is doing much building, including sixty homes for a housing settlement. . . .

Bern, September 1, 1926
Dear Herr Gropius,
The impression gained at the last meeting remains extremely disgruntling, despite the vacation spirit, sunny days, etc. It seems not to be given us to breathe nonpolitical air, and time and again we are being forced (unfortunately) into politics. This time into city politics.
The fact that the Mayor declares himself powerless in regard to the additional financing necessary for our Bauhaus, and the fact that everyone of us is supposed to bleed for it, must be taken into consideration. But as far as I am concerned, I have to reject any attempt to push part of the moral responsibility for this period on me. It is the other way around: the city is beginning to cease justifying all the confidence we have put in it. This is particularly distressing—disappointing to me, having been urged emphatically to go along to Dessau.
I have avoided influencing any of my colleagues, but I cannot imagine how the reduction of the salaries, now being discussed, would be carried out. By no means by way of a vote, because in that case only unanimity can lead to a conclusion; unanimity which does *not* exist since I as well as Kandinsky, who before he departed for Müritz explicitly informed me and authorized me to that effect, would vote against it.
Thus, I look gloomily ahead to further negotiations and am afraid of something that was avoided even during the worst phase at Weimar: an *inner* disruption.
I am traveling south with the burden of such thoughts. . . .
With best wishes . . .
yours, Klee

Dessau, October 13, 1926
Dear Herr Klee,
I did not want to answer your letter of the beginning of September until the situation here had cleared up a little more. In the meantime this has happened.
Your letter disturbed me, and I am unable to understand even today your refusal in a situation, difficult for all of us, which according to the actual events you are not judging correctly. You cannot blame individuals if things have not gone as well as we thought they would a year and a half ago. Rather, the situation is to blame: the unforeseeable economic decline and the lack of understanding on the part of the public for our artistic conception, in particular as has been repeated time and again, for the representatives of modern painting. These two things make us unpopular. The Mayor, on the other hand, is the backbone of our existence. Unceasingly and intelligently he is striving to improve our state of affairs; I cannot admire him enough for the sense of responsibility with which he
120

goes about these things. We would do him a gross injustice if we did not gratefully acknowledge this fact. From what you wrote, I recognized how little you still remember about these events and [that] unfortunately, [you] underestimate his and my work—to protect you unremittingly so that you may be able to work in peace and quiet. Every visitor who comes to Dessau is astonished about the fact that the city has done so much for us, and notes that this would hardly have been possible, even in larger cities, under present conditions.
I am unable to understand why, considering all aspects of our situation, the money problem which has developed should in particular be supposed to cause an "inner disruption," as long as we are deeply engaged in our common task. If we no longer had that interest, then the inner impulse to continuously sacrifice myself for our cause would cease to exist for me too. In that case, the Bauhaus would then simply fall apart. Where subjective differences cause an inner crisis we must naturally resolve it together, and especially now I have well-founded confidence in our vigor to regenerate the structure of our Institute where weaknesses have appeared.
I personally find it just as difficult as the Mayor does to have to ask for personal sacrifices, but up to now no one has offered an alternative that might resolve our problems. In our latest calculations which are based on the upper limit that is still bearable for the budget, we have planned on a 10% reduction of the salary of each of the full-time teachers. This would have to remain in effect until further financial support, which will have to be brought in from other sources, will obviate the need for these reductions in our income. I simply cannot believe that you, dear Herr Klee, will desert me in this matter, and I cordially request you to support me. I am showing this letter to Kandinsky simultaneously and am making the same request of [him]. After you return, we will have to talk about this face to face; I have asked the Mayor not to rush anything and to let this matter mature quietly.
I thank you and Mrs. Klee for the greetings from Elba. . . . I am going off for a few days myself, to Paris and Bordeaux, finally to get acquainted with Le Corbusier's works. I hope to see you again very soon. With best wishes . . .
yours, Gropius

Notification by the Dessau Magistracy
The Bauhaus—Recognized as School of Higher Learning
From the newspaper "Anhalter Anzeiger" (Dessau), No. 256, October 31, 1926
When, in October 1926, the Bauhaus attained recognition as a "Hochschule," its educational policies became subject to supervision by the state of Anhalt, although the city of Dessau remained responsible for its financing. The teachers, who at Weimar had held the rank of "Masters," were now granted the title of "Professor." The awarding of university status was both educationally and psychologically of significance to the Bauhaus.

. . . According to the statute approved by the Anhalt State Ministry and the government, the Bauhaus will henceforth carry in its subtitle the designation "Institute of Design." . . . The *administration* of the institute will be carried out by the Director, and he will be aided by the Staff Council, the members of which, in addition to the Director, will be the Professors and the full-time teachers. There will also exist a *Board of Trustees* which will be constituted of the following: the Mayor, the Director, a representative of the government of the state of Anhalt, department of education, an elected representative of the Staff Council, a leading representative of the field of architecture in Germany, and five representatives to be elected by the City Council. It is the task of the Board of Trustees to promote the further development of the Bauhaus. The Board deliberates on the budget and is to be kept up to date about all matters of importance at the Bauhaus. The Board also has to be consulted about appointments of Professors and full-time teachers. . . .

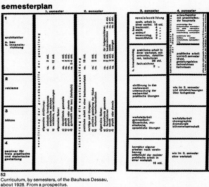

52
Curriculum, by semesters, of the Bauhaus Dessau, about 1928. From a prospectus.

121

The City Council of the City of Dessau
Letter of June 15, 1933 to Josef Albers
PA, Josef Albers, New Haven (First publication)
The premature termination of the contracts with the Dessau Bauhaus Masters was responsible for the fact that they were entitled to a continuation of salary payments. In 1933 Dessau discontinued the payments, basing its decision on a National Socialist law. The letter is characteristic of the manipulations of the law with which the Bauhaus was harassed to the end. Letters of the same tenor were received also by the other Bauhaus Masters who had been dismissed in Dessau in violation of their contracts.

The City Council Dessau, June 15, 1933
Teacher Josef Albers
Berlin-Charlottenburg 9
Sensburger Allee 29
Since you were a teacher at the Bauhaus in Dessau, you have to be regarded as an outspoken exponent of the Bauhaus approach. Your espousing of the causes and your active support of the Bauhaus, which was a germ-cell of bolshevism, has been defined as "political activity" according to § 4 of the law concerning the reorganization of the civil service of April 7, 1933, even though you were not involved in partisan political activity. Cultural disintegration is the particular political objective of bolshevism and is its most dangerous task. Consequently, as a former teacher of the Bauhaus you did not and do not now offer any guarantees that you will at all times and without reserve stand up for the National State.
Based on §§ 4, 15 of the law concerning the reorganization of the civil service of April 7, 1933 (Reich law publication p. 175) in connection with §§ 5, articles 3 and 7, 4 and 3 of the second regulation for the implementation of the law concerning reorganization of the civil service of May, 1933 (Reich law publication p. 233), payment of compensation will be suspended, effectively May 1, 1933.
The salary payments due, according to §§ 4 and 3 of the second implementation regulation, for a period of 3 months beginning at the end of the month during which the private contract of employment concluded between the City and you was dissolved, are regarded as having been made by the payments of salary for the period October 1, 1932 to March 31, 1933 and the payment of half the amount of the salary for the month of April 1933, especially since recoverable salary payments with consideration of the fact that the private contract of employment was concluded according to § 1, chapter I, section 4 of the economy regulations of Anhalt of September 24, 1931 (statute book of Anhalt p. 63, of September 30, 1932) had been dissolved and that after the dissolution obligation for further payment of salaries no longer existed.
The City Council Attested:
(signed) Sander Irmscher
 "Oberstadtinspektor"

Bauhaus Berlin
Minutes of the Meeting of the Faculty of July 20, 1933 (Decision to Dissolve)
BR (duplicate) (First publication)
The forced closing of the Bauhaus in April 1933 compelled Mies van der Rohe to ask the owners of the building to end the lease before the expiration of the lease period. The rights for the wallpaper designs had been transferred to the manufacturer (Rasch Brothers) in full lump compensation, since it was impossible to continue regular contractual design work.

Minutes of the conference of July 20, 1933
Present: Albers, Hilbersiemer, Kandinsky, Mies van der Rohe, Peterhans, Reich, and Walther.
Mies van der Rohe reports on the last visit with the county board of teachers and on the accounts which the investigating committee in Dessau published in Dessau newspapers. In addition, Herr Mies van der Rohe informed the meeting that it was possible to terminate the lease effective July 1, 1933, but that despite this the economic situation of the Institute, because it had to be shut down, was in such poor condition that it was impossible to think of rebuilding the Bauhaus.
For this reason, Mies van der Rohe moved to dissolve the Bauhaus. This motion was carried by a unanimous vote.
Following the review of the financial situation, Mies van der Rohe announced the agreement which had to be made on April 27, 1933 with the firm of Rasch Brothers. Herr Mies van der Rohe intends, however, to negotiate further with Mr. Rasch, in order to see if he can get another payment to help settle the debts.
If at a later date the financial situation should improve because of the royalties from the curtain materials, for example, Mies van der Rohe will try to pay the members of the faculty their salaries for the months of April, May, and June 1933.
(signed) Mies van der Rohe
[Original without capital letters]

Ludwig Mies van der Rohe
Notification to the Gestapo of the Dissolution of the Bauhaus Berlin, July 20, 1933
PA Mies van der Rohe (duplicate) (First publication)
Other notifications of the same content were sent to the proper administrative and supervisory authorities.

Office of the State Secret Police
for the attention of Ministerialrat Diels
Berlin, Prinz-Albrecht-Strasse
July 20, 1933
Dear Sir,
I beg to inform you that the faculty of the Bauhaus at a meeting yesterday saw itself compelled, in view of the economic difficulties which have arisen from the shutdown of the Institute, to dissolve the Bauhaus Berlin.
Your obedient servant,
Mies van der Rohe

188

Office of the State Secret Police, Berlin
Letter of July 21, 1933 to Mies van der Rohe
BR (copy) (First publication)
The conditions under which the Gestapo allowed the Bauhaus to continue its work were far too rigorous for the members of the faculty to be induced to withdraw their statement of dissolution; the fact that they would have been accepted had not the dissolution been already decided on, was later claimed solely for reasons of security.

Strictly confidential
State Secret Police
Berlin S. W. 11, July 21, 1933
Prinz-Albrecht-Strasse 8
Professor Mies van der Rohe
Berlin, Am Karlsbad 24
Regarding: Bauhaus Berlin-Steglitz
In agreement with the Prussian Minister for Science, Art, and Education, the reopening of the Bauhaus Berlin-Steglitz is made dependent upon the removal of some objections.
1) Ludwig Hilberseimer and Vassily Kandinsky are no longer permitted to teach. Their places have to be taken by individuals who guarantee to support the principles of the National Socialist ideology.
2) The curriculum which has been in force up to now is not sufficient to satisfy the demands of the new State for the purposes of building its inner structure. Therefore, a curriculum accordingly modified is to be submitted to the Prussian Minister of Culture.
3) The members of the faculty have to complete and submit a questionnaire, satisfying the requirements of the civil service law.
The decision on the continuing existence and the reopening of the Bauhaus will be made dependent upon the immediate removal of the objections and the fulfillment of the stated conditions.
By order: (signed) Dr. Peche
Attested: [illegible]
Chancery staff

Ludwig Mies van der Rohe
Announcement to the Students of the Dissolution of the Bauhaus
This information leaflet was the last statement of the Bauhaus.

To the students of the Bauhaus. August 10, 1933
At its last meeting, the faculty resolved to dissolve the Bauhaus. The reason for this decision was the difficult economic situation of the institute.
The Office of the State Secret Police, the Prussian Ministry for Science, Art, and Education, and the school administration have been informed of this decision.
This announcement has crossed with a notification by the Office of the State Secret Police in which we are told that "in agreement with the Prussian Minister for Science, Art, and Education, the reopening of the Bauhaus is made dependent upon the removal of some objections."
We would have agreed to these conditions, but the economic situation does not allow for a continuation of the Institute.
The members of the faculty are of course available to the students for advice at any time. Grade records for all students will be issued by the secretariat.
From now on please address all letters to Professor Mies van der Rohe, Berlin W 35, Am Karlsbad 24.
(signed) Mies van der Rohe.

70

10. 8. 33

An die Studierenden des Bauhauses.

Das Lehrerkollegium hat in seiner letzten Sitzung den Beschluß gefaßt, das Bauhaus auf-
zulösen. Für diesen Beschluß war die schwierige wirtschaftliche Situation des Hauses
maßgebend.

Dem Geheimen Staatspolizeiamt, dem Preußischen Ministerium für Wissenschaft, Kunst und
Volksbildung und der Schulbehörde wurde dieser Beschluß zur Kenntnis gebracht.

Diese Mitteilung kreuzte sich mit einem Schreiben des Geheimen Staatspolizeiamtes, worin
uns mitgeteilt wurde, daß „die Wiedereröffnung des Bauhauses im Einvernehmen mit dem
Herrn Preußischen Minister für Wissenschaft, Kunst und Volksbildung von der Beseitigung
einiger Anstände abhängig gemacht wird".

Mit diesen Bedingungen wären wir einverstanden gewesen. Die wirtschaftliche Lage läßt
es aber nicht zu, das Haus weiterzuführen.

Selbstverständlich steht das Lehrerkollegium den Studierenden jederzeit mit seinem Rat
zur Verfügung.

Die Zeugnisse für alle Studierenden werden durch das Sekretariat ausgestellt.

Alle Briefschaften bitten wir von jetzt an Professor Mies van der Rohe, Berlin W 35, am
Karlsbad 24 zu richten.

gez. Mies van der Rohe.

189

a
Etienne-Louis Boullée: design for a cenotaph for Newton, 1784.
Utopian architecture of the period of the French revolution: the units of which the building is composed have been reduced to basic stereometric elements. The architectonic quality, in the sense of a space-enveloping, abstract sculpture, attains near autonomy. The imagination of the revolutionary architects had, for the time being, hardly any influence on the technology of building.
b
Friedrich Schinkel: the Academy of Architecture in Berlin. Built in 1832–1835.
This represents a significant approach to functional architecture free of all esthetic ties to historical models.
c
Gottfried Semper: Federal Institute of Technology in Zurich. Built in 1860–1864.
Both the possibilities and the limitations of his period are more evident in Semper's work than in almost any one else's. A deep cleavage exists between his critical, even prophetic perceptions and his practice as an architect, in which he remains committed to the attitudes of historicism.
d
Hermann Eggert: middle section of the central railroad station in Frankfurt on Main. Opened for traffic in 1888.
Next to the *Galerie des Machines*, erected for the Paris World's Fair of 1889, this is probably the boldest of the large hall structures of the second half of the nineteenth century. It is engineering architecture, purely functional and developed from the requirements of a technical problem, incorporating a new esthetic impulse.
e
Louis Sullivan: Carson, Pirie, Scott department store, Chicago. Built in three stages: 1899, 1903–1904, and 1906.
This department store is the principal work of the Chicago School which since the eighteen seventies had set the standards for modern high-rise buildings. A new structural principle was developed from the skeleton construction, which was evident in both the three-dimensional organization and the design of the building facade.
f
Victor Horta: lobby in the *Ancien Hôtel Van Eetvelde*, Brussels. 1897–1899.
Art Nouveau architecture: the rampant floral ornaments and cast-iron and glass structure are characteristic for the merging of the decorative handicrafts with architectural conceptions, based on the accomplishments of engineering architecture.
g
Frank Lloyd Wright: Emma Martin House, Oak Park, Illinois. Built in 1901.
Wright emphasizes the "organic" element: he developed a country residential style which employed the vital elements of the American farm house, whereby accommodation to the climate and integration into the landscape were the primary considerations shaping his concept.
h
Charles Rennie Mackintosh: Windyhill House, Kilmacolm, Scotland. Erected in 1899–1901.
In England and Scotland at the end of the nineteenth century a growing awareness of the fundamentals of indigenous traditions led to the regeneration of country residential building. From the British Isles this movement spread to the Continent, above all to Central Europe.

224

225

Professors of the Weimar Art Academy

a
Walther Klemm (born in Karlsbad in 1883, died in Weimar in 1957) was appointed to the Grand-Ducal Saxon Academy of Art in 1913 as head of the graphics department after he had completed his studies at the Vienna Arts and Crafts School and had worked in the artists' colony at Dachau for some years. He played a considerable part in the reform plans of 1918. At the Staatliche Bauhaus, the academy's successor institution, he was a Master from 1919 until the re-establishment of that academy (in 1921). He was one of the last of the old academy professors to secede from the Bauhaus, and he continued to keep in friendly contact with some of the masters—especially with Feininger.
b
Professors of the Academy of Art, founded in 1921 and competing with the Bauhaus: (left to right) Walther Klemm, Richard Engelmann, Martin Krause, Alexander Olbricht, and Hugo Gugg.
c
Richard Engelmann (born in Bayreuth in 1868, died in 1966 in Kirchzarten in the Breisgau) studied in Munich, Florence, and Paris and did free-lance work in Berlin. In 1913 he was appointed professor of sculpture at the Grand-Ducal Saxon Academy of Art. He was one of the initiators of the reform plans which eventually lead to Gropius's appointment. Like Klemm, he joined the secession of the old professors from the Bauhaus, at which he had been a Master, only after long hesitation. Until 1930 he taught at the academy which was established in 1921 in competition to the Bauhaus.
d
Walther Klemm: "Wieland Square in Weimar." Woodcut. Klemm was a brilliant illustrator. Wieland Square, situated between the academy building and the center of town, was part of the scenery Bauhaus members saw every day.
e
Richard Engelmann: Wildenbruch monument in Weimar. Bronze. 1913.

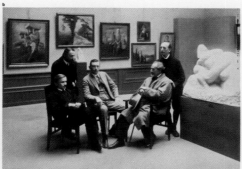

234

235

Laszlo Moholy-Nagy

Biographical notes: born in Bácsborsod (Hungary) on July 20, 1895, died in Chicago on November 24, 1946. The First World War interrupted Moholy-Nagy's law studies. He began painting while convalescing from serious wounds he had received in combat. He was impressed by the German Expressionists and the Russian avant-garde. Together with four friends he founded the group "Ma" ("Today") and beginning in 1919 he published their programmatical journal. He spent the years 1919 and 1920 in Vienna; in 1921 he met Lissitzky in Düsseldorf and lived from 1921 to 1923 in Berlin. There he established contact with Walden and exhibited in his "Sturm" gallery. In 1923 he was appointed to the Bauhaus as head of the metal workshop and made important contributions to the courses in preliminary instruction. He was co-editor of the Bauhaus Books and wrote two volumes for that series himself. In 1928 he moved to Berlin and experimented with film and stage designs (for Piscator and for the State Opera). He traveled to France, Scandinavia, Italy, and Greece. He was in Amsterdam in 1934. During the next two years in London he was primarily occupied with work on animated and documentary films. In 1937 he took over the direction of the "New Bauhaus" which had been founded by the Association of Arts and Industries in Chicago, but it had to be closed again because of financial difficulties. He therefore opened his own school in Chicago in 1938, the "Institute of Design," which he directed until his death in 1946.

a
Laszlo Moholy-Nagy during the Mid-twenties.
b
Laszlo Moholy-Nagy: "A m 3." Oil on canvas. 1923. Private collection, Munich.

275

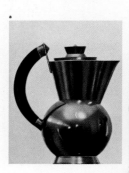

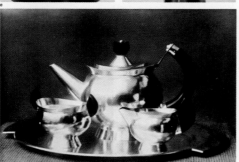

During the early years there predominated among the students a propensity for tackling designs with complicated forms, like a samovar. This showed how visual problems, too, were of prime concern. The object to be designed was viewed as a sculptural body, the parts of which were meant to be articulated and proportioned with esthetic clarity. But in Dell's pleasing and attractively shaped tea set one recognizes models such as became known, for instance, from the products of the Wiener Werkstätte. The efforts to arrive at uncompromisingly new forms emanated from the artists, teachers, and students; the master craftsmen, coming from a different background, adjusted to them.
In the products made around 1924 it becomes more and more evident that the consideration that things should be primarily functional and handy modified the desire for a strictly stereometric construction of the form. In this process, those involved—teachers and students—built on a free exchange of ideas. Not the least of the credit is due Moholy-Nagy for having helped the students to drop their partiality for the notions of cubism (as well as traditional ideas) and also their early formalistic play.

a
Christian Dell: decanter. German silver; silver-plated inside; ebony lid, knob, and handle. About 1924. On loan to the Bauhaus-Archiv, Darmstadt.
b
Wilhelm Wagenfeld: gravy container and tray. German silver, ebony handles. 1924. Bauhaus-Archiv, Darmstadt.
c
Christian Dell: tea set with teapot, cream pitcher, sugar bowl, and tray. German silver. About 1923–1924.
d
Wolfgang Rössger and F. Marby: pot. Tombac and German silver. 1924. Bauhaus-Archiv, Darmstadt.
e
Josef Knau: tea urn with spirit burner and small pot for tea essence. Tombac, German silver; handles made of ebony. Inside silver-plated. 1924.
f
K. J. Jucker: electric samovar. Brass; silver-plated inside. 1924.

316

317

Cabinetmaking Workshop
(Furniture Workshop)

The cabinetmaking workshop was headed by Marcel Breuer from the beginning of the Dessau Bauhaus until the spring of 1928. After he left the Institute, Albers took his place. Having done pioneering work in the functional design of chairs as a student in Weimar, Breuer constructed the first tubular steel chair in Dessau in 1925. This was a private project, which he carried out aided by a locksmith, and consequently not in the Bauhaus. Nevertheless, this tubular steel chair was in its conception a true product of the Bauhaus. It was of the greatest importance for the further development of the cabinetmaking workshop, for all at once the workshop was faced with the task of working with an unfamiliar material as well as with the conventional wood, namely metal. Though metal work within the program of the cabinetmaking workshop remained the exception, this new method of construction called for a fundamental modification. Now it was more exact to speak of a "furniture workshop" than of a "cabinetmaking workshop." In an article published in the magazine "Das neue Frankfurt" in 1927, Breuer wrote that the furnishings, the interior design, should be neither a "self-portrait of the architect" nor a way of living, attempting to impose itself on the occupant, forcing him, so to speak, into a predetermined pattern. "And so we have furnishings, rooms and buildings allowing as much change and as many adaptations and different combinations as possible. The pieces of furniture and even the very wall of a room have ceased to be massive and monumental, apparently immovable, and built for eternity. Instead, they are more opened out, or are placed freely in space. They hinder neither the movement of the body nor of the eye. The room is no longer a closed composition, a narrowly defined box, for its dimensions and different elements can be varied in many ways. From that, one may conclude that any object properly and functionally designed should 'fit' into any room as does a living object, like a flower or a human being."
The projects for development of furniture were concerned principally with problems of standardization, the design of unit furniture and folding chairs and generally with functional and constructional improvements. The most important commissions were the furnishing of the Bauhaus building, the Masters' houses in Dessau, and Piscator's home in Berlin.

a
The cabinetmaking workshop of the Dessau Bauhaus. About 1927.
b
Marcel Breuer: tubular steel chair. Nickel-plated steel tubing, seat, back and armrests made of fabric (iron yarn). Designed in 1925.
Specimen in the Bauhaus-Archiv, Darmstadt.
This is the very first steel chair. Since 1926 it has been manufactured and sold by a Berlin concern ("Standard-Möbel").
c
Marcel Breuer: standardized unit furniture. Design. 1925.
space divisions appr. 13 inches; vorderansicht = front elevation

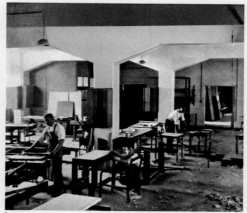
a

450

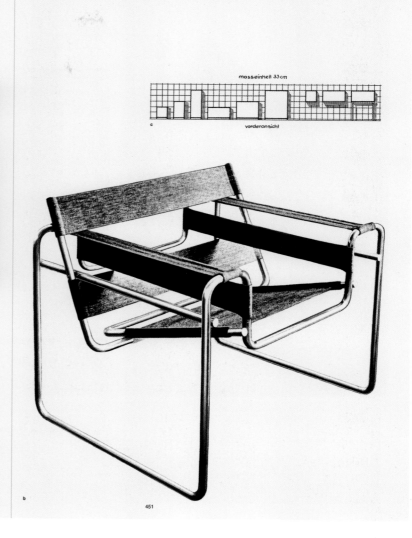

b

451

a

b

c

d

e

f

During the early nineteen sixties the ideas of the Bauhaus began reaching countries which previously had been little or not at all affected by them. Their dissemination was even promoted officially from Germany, where after the war the significant cultural contribution of the 'twenties had been rediscovered. Thus, on behalf of the government, a traveling exhibition was put together by Roman Clemens, who had studied in Dessau. It was shown in the larger Italian cities and then sent to the Far East. Australian museums showed a Gropius exhibition which had been arranged by the Bauhaus-Archiv in Darmstadt. Remarkable interest in the Bauhaus and its architecture developed in South Africa and above all in Latin America, where a display selected by Ludwig Grote provided an opportunity for getting acquainted with the Bauhaus painters. An exhibition of Bauhaus paintings found enthusiastic support in London in 1962. Although Klee and Kandinsky had long ago become part of the international artistic heritage, painters like Schlemmer, and the intellectual relationships of the artists at the Bauhaus and their stimulating power were not clearly understood. Slowly Schlemmer began to receive more favorable critical response—one of the manifestations being an extensive exhibit in Rome. The Bauhaus-Archiv made an appreciable contribution to the constantly increasing exhibit activity. It directed its attention to such sectors of the Bauhaus endeavors—as for example the weaving workshop—that had hitherto been neglected by the critics and had been insufficiently appreciated by the public. Traveling exhibits were assembled and sent throughout Europe, to America, Africa, Australia, and Asia, where they were shown in museums, universities, and centers of information. The most extensive Bauhaus exhibit put together up to the present has been largely the result of the painstaking research and acquisition work done in Darmstadt. It was prepared, with the support of the West German federal government, by the Württemberg Art Association and has been sent, after an initial showing in Stuttgart, to a large number of cities in Europe and North America. A considerable portion of the approximately 2000 objects in this assemblage comes from the collections of the Bauhaus-Archiv.

a
Milan, Palazzo Reale: Bauhaus Exhibition. October 1961.
Selected and designed by Roman Clemens.
In the foreground there is a reconstruction of a project from Albers' preliminary course ("Studies in construction and structural strength").
b
Rome, Galleria d'Arte Moderna: Bauhaus Exhibition. November—December 1961.
Selected and designed by Roman Clemens.
Collection of photographic plates (photographs of people and of the most important achievements of the Bauhaus) and reconstructions of sculptural projects (from the preliminary course). The arrangement was carried out using exhibition techniques developed at the Bauhaus.

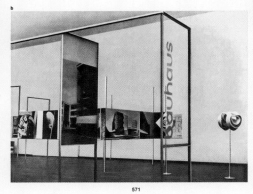

570

571

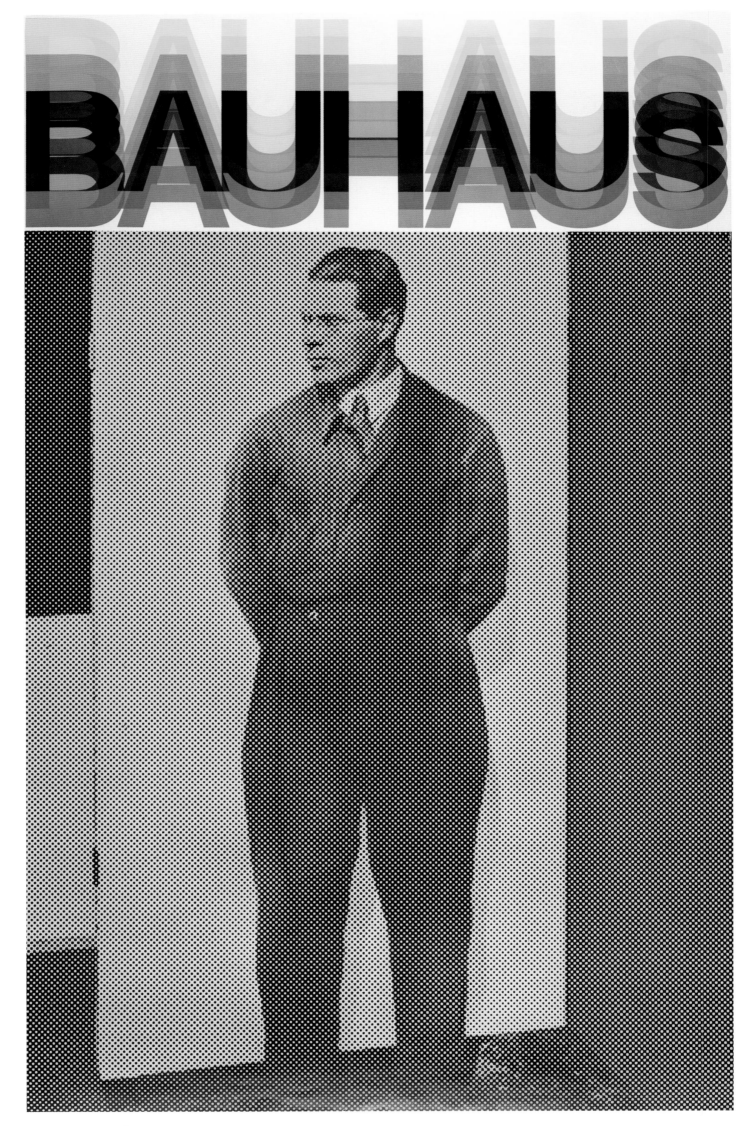

Posters to promote *The Bauhaus*, 1969

Design

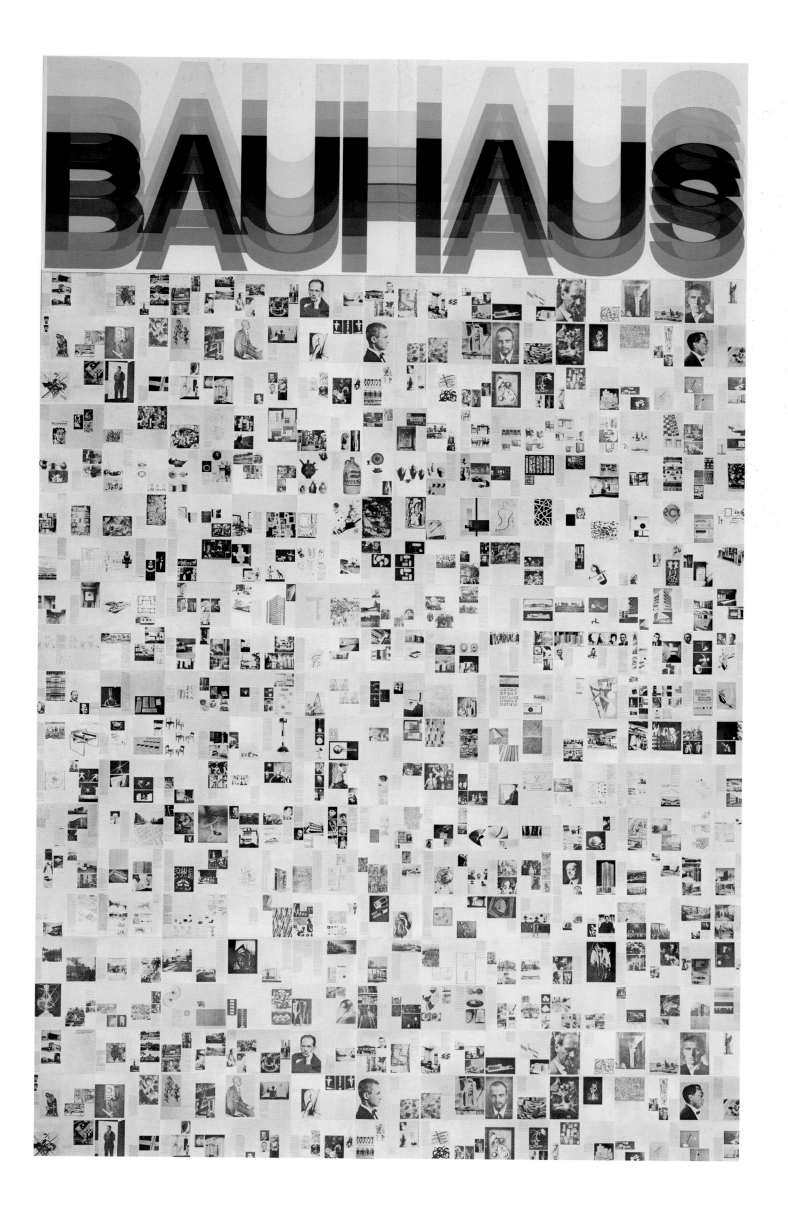

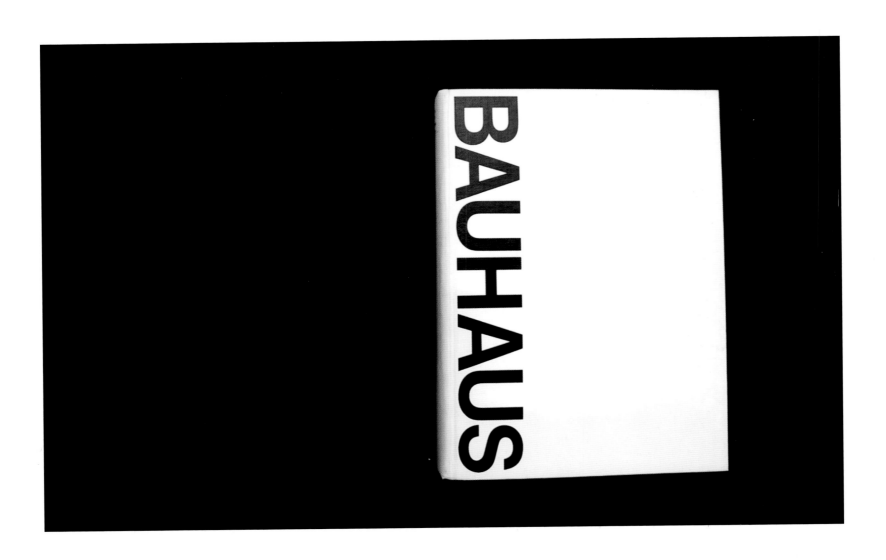

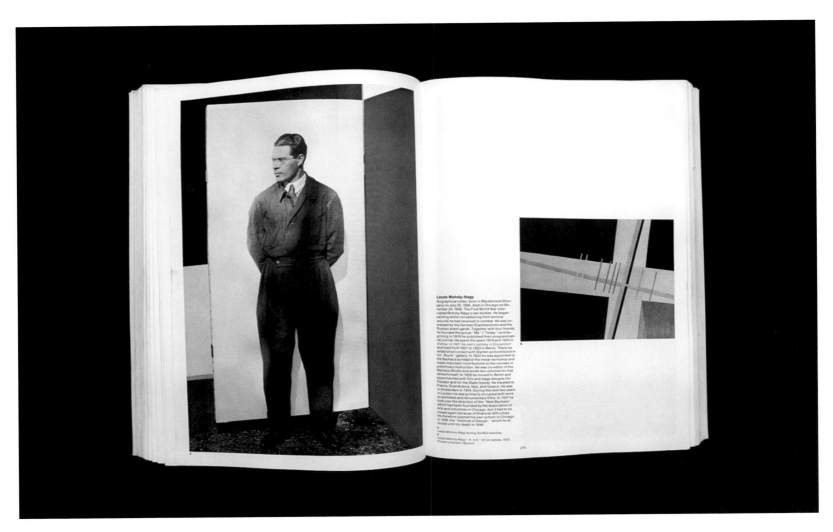

Stills from the film *The Bauhaus* (video based on a video by David Small, based on the original film), c. 1970

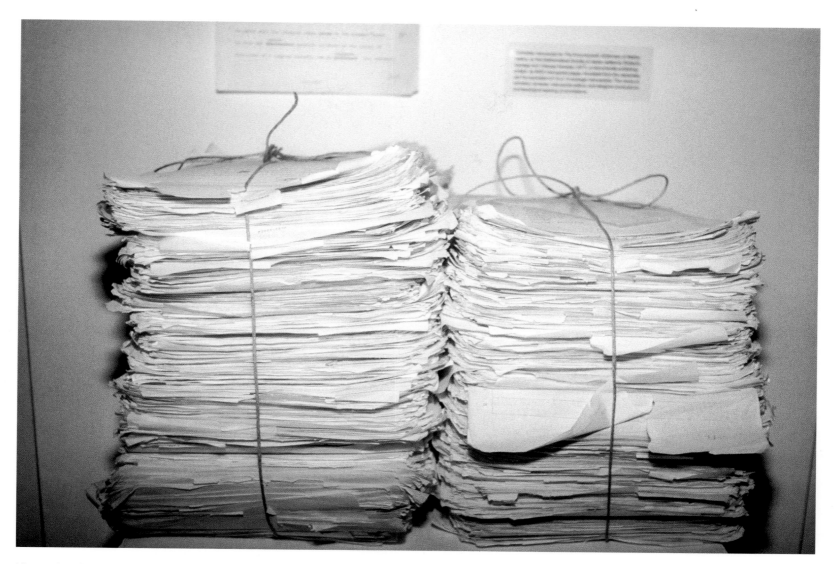

Manuscript of *The Bauhaus* as shown in the exhibition "Books 2000," 1979

Alan V. Oppenheim, ed., *Papers on Digital Signal Processing*
(Cambridge, Mass.: MIT Press, 1969), design by MIT Press
Design Department

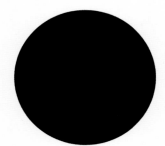

**Papers on Digital
Signal Processing**

Alan V. Oppenheim,
editor

REFERENCES

1. See, for example, J.B. Knowles and E. M. Olcayto, "Coef-
 ficient Accuracy in Digital Filter Response", IEEE Trans.
 Circuit Theory, Vol. CT-15, pp. 31-41, March, 1968.

2. I. W. Sandberg, "Floating-Point Round-off Accumulation in
 Digital Filter Realization", BSTJ, Vol. XLVI, pp. 1775-
 1791, October, 1967.

3. J. H. Wilkinson, Rounding Errors in Algebraic Processes,
 Prentice-Hall, Englewood Cliffs, New Jersey 1963.

IEEE TRANSACTIONS ON CIRCUIT THEORY, VOL. CT-15, NO. 1, MARCH 1968

Coefficient Accuracy and Digital Filter Response

J. B. KNOWLES, MEMBER, IEEE, AND E. M. OLCAYTO

Abstract—The frequency response of a digital filter realized by a finite word-length machine deviates from that which would have been obtained with an infinite word-length machine. An "ideal" or "errorless" filter is defined as a realization of the required pulse transfer function by an infinite word-length machine. This paper shows that quantization of a digital filter's coefficients in an actual realization can be represented by a "stray" transfer function in parallel with the corresponding ideal filter. Also, by making certain statistical assumptions, the statistically expected mean-square difference between the real frequency responses of the actual and ideal filters can be readily evaluated by one short computer program for all widths of quantization. Furthermore, the same computations may be used to evaluate the rms value of output noise due to data quantization and multiplicative rounding errors. Experimental measurements verify the analysis in a practical case. The application of the results to the design of the digital filters is also considered.

I. INTRODUCTION

SYSTEMS which are used to spectrally shape information are known as filters. Until quite recently, linear analog elements have been used almost exclusively in this context. However, with the increasing flexibility of digital equipment, attention has been directed toward digital filtering techniques. In particular, methods[11]-[13] have been developed which enable the conversion of certain well-established analog filter designs into digital filters having essentially the same frequency response over half the Nyquist interval. These techniques are significant in that the resulting digital filters largely maintain the frequency response of their analog "parents" even when relatively small sampling frequencies are employed. That is to say, frequency aliasing effects[1] are largely eliminated.

An electronic digital computer processes information in binary-number format. When the so-called "scientific programming" convention is employed in a fixed-point machine, the binary number $\gamma_0\gamma_1\cdots\gamma_{M-1}$ has the significance

$$\gamma_0\gamma_1\cdots\gamma_{M-1} = -\gamma_0 + \sum_{i=1}^{M-1}\gamma_i 2^{-i} \qquad (1)$$

where

$$\gamma_i = 0 \quad \text{or} \quad 1 \quad \text{for all } j \qquad (2)$$

and M is the word-length of the computer. In connection

Manuscript received July 3, 1967; revised October 3, 1967.
J. B. Knowles is with the Control and Instrument Group, United Kingdom Atomic Energy Authority, Winfrith, Dorset, England.
E. M. Olcayto was formerly with the University of Manchester Institute of Science and Technology, Manchester, England. He is now with the Turkish Post Office, Izmir, Turkey.

with (1), the width of quantization (*q*) is defined as:

$$q = 2^{-(M-1)}. \qquad (3)$$

By virtue of the finite computer word-length, the performance of a digital filter is inevitably degenerated. First, when continuous data are read into the computers, a quantization error[3] is incurred. Second, a roundoff error arises in the evaluation of each arithmetic product in the computation.[4],[5] Third, the coefficients of the difference equation which represents the digital filter are subject to amplitude quantization errors. In consequence, the frequency response of the actual filter realized deviates from that which would have been obtained with an infinite word-length machine. For the purposes of comparison, it is convenient to define "the ideal" or "errorless" filter as a realization of the required pulse transfer function by an infinite word-length computer.

The first two types of error described above have already been thoroughly investigated,[3]-[6] and this paper is concerned with the third. Although the problem of coefficient errors is not practically significant in the case of a digitally controlled feedback system, the loss of performance is important in digital filter applications due to the absence of overall negative feedback and greater digital system complexity. The effect of coefficient errors on digital filter performance was first investigated by Kaiser.[7] An absolute accuracy bound was derived for the difference equation coefficients within which the realization was still asymptotically stable. However, such an error bound is inevitably pessimistic, because coefficient quantization errors are intrinsically statistical. Furthermore, this analysis does not enable the computer word-length to be selected so that the degeneration in the real frequency response of the actual digital filter is maintained within acceptable practical limits.

This paper shows that the quantization of a digital filter's coefficients can be represented by a "stray" transfer function in parallel with the corresponding ideal filter. Also, by making certain justifiable statistical assumptions, the statistically expected mean-square difference between the real frequency responses of the actual and corresponding errorless filter can be readily evaluated by one short computer program for all widths of quantization. Further, the same computational results may be used to evaluate the rms value of the filter's output noise due to quantization and multiplicative roundoff errors.[4],[5] Unfortunately, while the method is always applicable to direct and parallel programming, it is generally unsuitable for cascade programming.

102

103

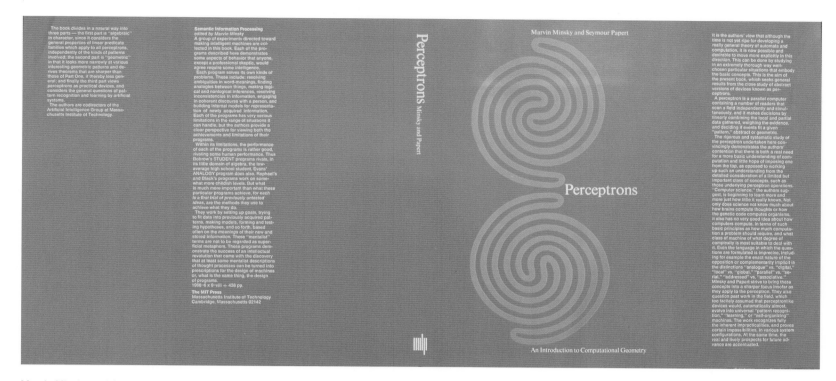

Marvin Minsky and Seymour Papert, *Perceptrons: An Introduction to Computational Geometry* (Cambridge, Mass.: MIT Press, 1969), design by MIT Press Design Department

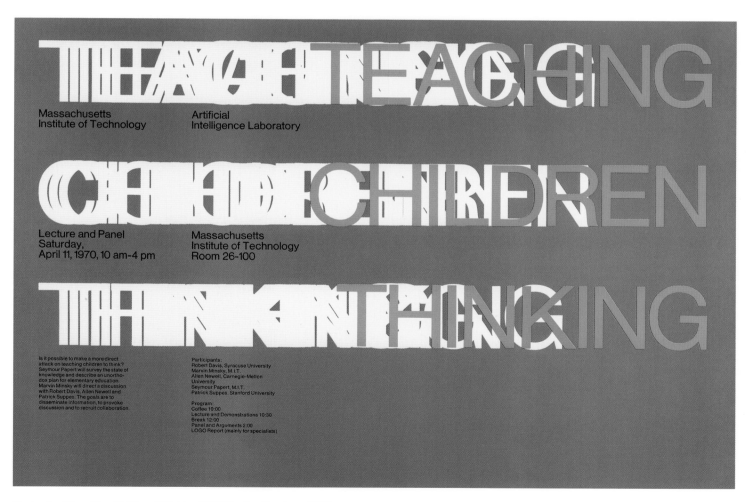

Poster for "Teaching Children Thinking," MIT Design Services, 1970

Samuel Bing, *Artistic America, Tiffany Glass, and Art Nouveau* (Cambridge, Mass.: MIT Press, 1970), design by MIT Press Design Department with Katherine McCoy

10

To M. Henri Roujon
Directeur des Beaux-Arts

M. le Directeur:

Upon my departure for the United States you asked me to return with a report on the development of art in America and its possibilities for the future.

This subject—by its novelty alone—would indeed merit a more erudite explorer, just as its complexity would really require a study of two or three volumes.

The following pages, brief notes of a tourist particularly interested in art, will perhaps suffice to indicate the unusual achievements of an enthusiastic people, whose vibrant youth is nurtured by the tangled remains of ages past.

S. Bing
Paris, November 1895.

The translator gratefully acknowledges the erudition and goodwill of Mr. William R. Johnston, Assistant Director, The Walters Art Gallery; Mrs. Dora Jane Janson; Professor Peter H. Von Blanckenhagen, and Colin Eisler, whose advice, concerning both style and content, heeded and unheeded, is ever appreciated.

I
Artistic America
(*La Culture artistique en Amérique*, 1895)
by S. Bing
translated by Benita Eisler

11

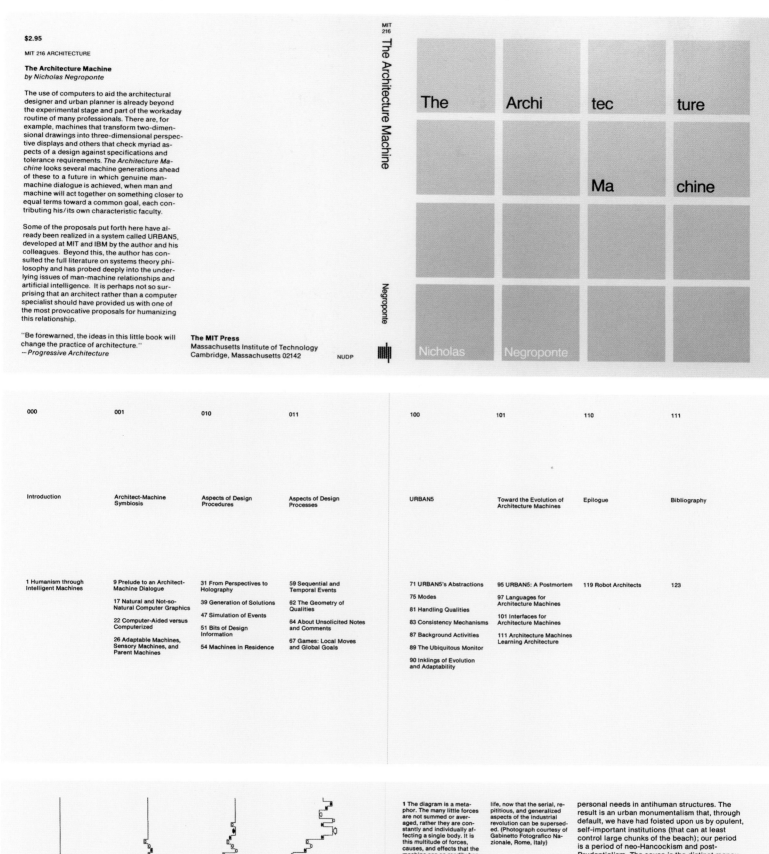

$2.95

MIT 216 ARCHITECTURE

The Architecture Machine
by Nicholas Negroponte

The use of computers to aid the architectural designer and urban planner is already beyond the experimental stage and part of the workaday routine of many professionals. There are, for example, machines that transform two-dimensional drawings into three-dimensional perspective displays and others that check myriad aspects of a design against specifications and tolerance requirements. *The Architecture Machine* looks several machine generations ahead of these to a future in which genuine man-machine dialogue is achieved, when man and machine will act together on something closer to equal terms toward a common goal, each contributing his/its own characteristic faculty.

Some of the proposals put forth here have already been realized in a system called URBAN5, developed at MIT and IBM by the author and his colleagues. Beyond this, the author has consulted the full literature on systems theory philosophy and has probed deeply into the underlying issues of man-machine relationships and artificial intelligence. It is perhaps not so surprising that an architect rather than a computer specialist should have provided us with one of the most provocative proposals for humanizing this relationship.

"Be forewarned, the ideas in this little book will change the practice of architecture."
-- *Progressive Architecture*

The MIT Press
Massachusetts Institute of Technology
Cambridge, Massachusetts 02142
NUDP

MIT 216

The Architecture Machine

Negroponte

The Archi tec ture Ma chine

Nicholas Negroponte

1 The diagram is a metaphor. The many little forces are not summed or averaged, rather they are constantly and individually affecting a single body. It is this multitude of forces, causes, and effects that the machine can so readily handle as individual events in a particular context.

2 Handling design problems solely at the building scale can provide a monumentalism by ignoring all the local forces. Of course, Brasilia works, but only as a symbolic statement of power and not as a place to live and work. It is the result of global and general (and perhaps unethical) goals housed at the wrong scale.

3 Mojacar in the province of Almeria, Spain. This is an example of local forces shaping the environment. The unity, which results from more global causes, comes from the limitation of materials, resources, weather, and so on. The photograph first appeared in *Architecture without Architects* [Rudofsky, 1964]. Photograph courtesy of José Ortiz Echagüe)

4 Italian hill towns. "The very thought that modern man could live in anachronistic communities like these [Positano, Italy] would seem absurd were it not that they are increasingly becoming refuges for city dwellers" (Rudofsky, 1964). The unmentioned amenities are in fact attainable in high-density urban

life, now that the serial, repititious, and generalized aspects of the industrial revolution can be superseded. (Photograph courtesy of Gabinetto Fotografico Nazionale, Rome, Italy)

personal needs in antihuman structures. The result is an urban monumentalism that, through default, we have had foisted upon us by opulent, self-important institutions (that can at least control large chunks of the beach); our period is a period of neo-Hancockism and post-Prudentialism. The cause is the distinct maneuverability gap that exists between the scale of the mass and the scale of the individual, the scale of the city and the scale of the room.

Because of this, an environmental humanism might only be attainable in cooperation with machines that have been thought to be inhuman devices but in fact are devices that can respond intelligently to the tiny, individual, constantly changing bits of information that reflect the identity of each urbanite as well as the coherence of the city. These devices need the adaptability of humans and the specificity of present-day machines. They must recognize general shifts in context as well as particular changes in need and desire.

The following chapters have a "pebble-prejudice." Most computer-oriented tasks today are the opposite: the efficient transportation system, the public open space, the flow of goods and money. Our bias toward localized information implies two directions for the proposed relationship between designer and machine. The first is a "do-it-yourselfism," where, as in the Marshall McLuhan (1965) automation circuit, consumer becomes producer and dweller becomes designer. Machines located in homes could permit each resident to project and overlay his architectural needs upon the changing framework of the city. The same machine might report the number of shopping days

5

Nicholas Negroponte, *The Architecture Machine: Toward a More Human Environment* (Cambridge, Mass.: MIT Press, 1970), design by Muriel Cooper and Nicholas Negroponte

Robert H. Brill, ed., *Science and Archaeology* (Cambridge, Mass.: MIT Press, 1971), design by Muriel Cooper

Science and Archaeology

edited by
Robert H. Brill

Chapter 5

Egyptian Blue as a Pigment and Ceramic Material

W. T. Chase
Freer Gallery of Art

Introduction

My interest in Egyptian blue stems from the arrival at the Metropolitan Museum of two excavated objects discovered at Hasanlu in the 1964 season (Figures 5.1 and 5.2). (See Reference 15.) One of these is a goblet, 4 13/16 inches high, made of a hard body material with blue, red, and black tinges. It arrived in fragments. The other is an object of unknown function which I will call a sistrum handle. At one time the Department of Ancient Near Eastern Art of the Metropolitan referred to this as a handle for a sistrum, and it seems to me preferable to use this shorter term to avoid repeating the longer, "object of unknown function."[1] Both of these objects when received were badly blackened by carbon from a fire, and in order to oxidize and remove the carbon it was decided to refire them to 400°C. During refiring the sistrum handle broke, and it became obvious that we should learn more about the behavior of Egyptian blue as a modeling or ceramic material. Incidentally, we later decided that the breakage occurred because of thermal shock from an overly rapid increase in temperature caused by a malfunctioning temperature control and not because of any property of Egyptian blue. These new breaks also gave us ample opportunity for sampling, of which we took full advantage as you will see later.

Definition

So far we have not answered the primary question: What is Egyptian blue? Egyptian blue is a calcium-copper tetrasilicate with the formula $CaCuSi_4O_{10}$ (or $CuO \cdot CaO \cdot 4SiO_2$). (See Reference 16.) So Egyptian blue is a definite chemical compound with a definite composition and crystallographic properties, just as malachite or salt are definite compounds.

The use of the term "Egyptian blue" has had some unfortunate consequences, as it leads to confusion with Egyptian faience which is usually bluish or greenish and which was made from some of the same raw materials: sand, natron, and a copper salt. Faience and its fabrication is a study in itself, and we must leave this for other investigators. (References 23 and 10). What makes Egyptian faience blue, however, is not Egyptian blue but a blue glaze formed by the migration of the soluble salts to the outside of the porous body where they were vitrified (turned into a glaze) in the firing, or by investing the pieces to be glazed in a mixture of various materials. Objects of Egyptian blue can also be confused with blue glass, but unlike glass Egyptian blue is very opaque, even at thin or broken edges.

Since Egyptian blue was the most important blue pigment in antiquity, it has been studied for a long time. Chaptal started about 1804 (Reference 6), and Sir Humphrey Davy investigated it in 1815 (Reference 11). In the 1880s, mineralogists in France became interested in it, and in 1889, Foqué established the composition as the calcium-copper tetrasilicate $CaCuSi_4O_{10}$. (See Reference 11.) He also synthesized the mineral and reported that the specific gravity is 3.04, that the substance belongs to the quadratic (now called tetragonal) system, that it appears in the form of scales flattened parallel to the base of the prism, sometimes of rectangular outline (Figure 5.3), that the optical properties are uniaxial negative, and that "these scales, seen under the microscope on their edge, with interposition of a nicol [or polarizer], offer a very remarkable pleochroism. With the rays vibrating parallel to the axis they are of a pale rose color; with vibrations in a direction perpendicular to the axis they are of an intense blue." A thin section from an Egyptian blue bead from the Lisht North Pyramid site illustrates this very well (Reference 9). The Egyptian blue in the bead crystallized in large plates, and the thin section happened to cut some of these plates parallel to the {110} face shown in Figure 5.3. Seen edge-on, the maximum pleochroism is visible; in a microscope slide made from an Egyptian blue pigment the plates most often lie with the {001} face parallel to the slide so that pleochroism is not easily visible. Pleochroism is still one of the best diagnostic features to determine the presence of Egyptian blue. The refractive indexes of Egyptian blue (ϵ 1.605 and ω 1.635) (see Reference 11) are higher than balsam, like those of azurite (Reference 7), and like azurite it is quite birefringent. The blue-lavender pleochroism of the prismatic plates of Egyptian blue seen on edge, however, immediately gives it away. A microchemical test with dilute HCl will, of course, immediately dissolve azurite with effervescence but will not affect Egyptian blue at all.

One of the best and most convenient ways to identify pigment materials is by means of X-ray powder diffraction. This technique is especially useful because only very small samples are required. X-Ray powder diffraction measurements can be used both for identification and for elucidation of the structure of a material. Some prints of X-ray powder diffraction films are shown in Figure 5.4. The films are all taken of Egyptian blue samples from different sources, except for the last which does not match, showing that it is a different material. A. Pabst of the University of California, Berkeley, has done the most comprehensive work on Egyptian

Identification

5.1
Goblet, ninth century B.C., made of Egyptian blue, height 4-13/16 inches. Found at Hasanlu in 1964 in burned building II. (Metropolitan Museum of Art, Rogers Fund. 65. 163. 36.)

5.2
Spade-shaped object, possibly a sistrum handle, ninth century B.C., made of Egyptian blue, height 6-1/8 inches. Found at Hasanlu in 1964 in burned building II. (Metropolitan Museum of Art, Rogers Fund. 65.163.37.)

$BaCuSi_4O_{10}$	
	d
001(2)	8.06Å
102	5.44
110	5.25
112	4.41

5.3
The crystal habit of Egyptian blue is identical to that of $BaCuSi_4O_{10}$ as represented by this idealized drawing. (Pabst "Structures of some tetragonal sheet silicates." *Acta Crystallographica,* 12, 1959. p. 738. fig. 2.)

5.4
X-Ray powder diffraction films of Egyptian blue. From top to bottom: Synthetic Egyptian blue; Egyptian blue from Tel-el-amarna (1370 B.C.); Egyptian blue from Nuzi (1500 B.C.); Egyptian blue from Ptolemaic statue (FGA D.899); Diopside from base of Egyptian statuette of the Roman period (FGA 0.862)

Egyptian Blue as a Pigment and Ceramic Material
80

[1] The Department of Ancient Near Eastern Art now calls this a "spade-shaped object," but for brevity I shall retain the term "sistrum handle" here.

81

Muriel Cooper in conversation with unidentified males, c. 1972

A Significance for A&P Parking Lots, or Learning from Las Vegas. Commercial Values and Commercial Methods. Billboards Are Almost All

Here is a plea for a proper architectural humanity and humility as well as a plan to accommodate the desires and values of ordinary people, who are too often dragged along on architectural ego trips and uplift programs. It is also a realistic examination of the American vernacular environment-as-it-is and a reexamination of the goal of

the architect.
The challenge is clear and forthright. Articles based on material in this book have already caused a great deal of controversy and rethinking. But at the present uncertain point in the development of the Modern movement, it's a useful controversy that could result in a firmer sense of future direction and closer accommodation to social realities.

Right. Architecture as Space. Architecture as Symbol. Symbol in Space before Form in Space: Las Vegas as a Communication System. The Architecture of Persuasion. Vast Space in the Historical Tradition and at the A&P From Rome to Las Vegas. Maps of Las Vegas: Las Vegas as a Pattern of Activities. Main Street and the Strip. System and Order on the Strip, and "Twin Phenomena." Change and Permanence on the

LEARNING FROM LAS VEGAS

Robert Venturi Denise Scott Brown Steven Izenour

Robert Venturi, Denise Scott Brown, and Steven Izenour,
Learning from Las Vegas (Cambridge, Mass.: MIT Press,
1972), design by Muriel Cooper

Symbol in Space Before Form in Space: Las Vegas as a Communication System

The sign for the Motel Monticello, a silhouette of an enormous Chippendale highboy, is visible on the highway before the motel itself. This architecture of styles and signs is antispatial; it is an architecture of communication over space; communication dominates space as an element in the architecture and in the landscape. But it is for a new scale of landscape. The philosophical associations of the old eclecticism evoked subtle and complex meanings to be savored in the docile spaces of a traditional landscape. The commercial persuasion of roadside eclecticism provokes bold impact in the vast and complex setting of a new landscape of big spaces, high speeds, and complex programs. Styles and signs make connections among many elements, far apart and seen fast. The message is basely commercial; the context is basically new.

A driver 30 years ago could maintain a sense of orientation in space. At the simple crossroad a little sign with an arrow confirmed what he already knew. He knew where he was. Today the crossroad is a cloverleaf. To turn left he must turn right, a contradiction poignantly evoked in the print by Allan D'Arcangelo. But the driver has no time to ponder paradoxical subtleties within a dangerous, sinuous maze. He relies on signs to guide him — enormous signs in vast spaces at high speeds.

The dominance of signs over space at a pedestrian scale occurs in big airports. Circulation in a big railroad station required little more than a simple axial system from taxi to train, by ticket window, stores, waiting room, and platform — all virtually without signs. Architects object to signs in buildings: "If the plan is clear, you can see where to go." But complex programs and settings require complex combinations of media beyond the purer architectural triad of structure, form, and light at the service of space. They suggest an architecture of bold communication rather than one of subtle expression.

2. The trip. Allan D'Arcangelo

WELCOME TO FABULOUS LAS VEGAS, FREE ASPIRIN — ASK US ANYTHING, VACANCY, GAS.

All cities communicate messages — functional, symbolic, and persuasive — to people as they move about. Las Vegas signs hit you at the California border and before you land at the airport. On the Strip three message systems exist: the heraldic (the signs) dominates; the physiognomic, the messages given by the faces of the buildings (the continuous balconies and regularly spaced picture windows of the Dunes saying HOTEL and the suburban bungalows converted to chapels by the addition of a steeple); and the locational (service stations are found on corner lots, the casino is in front of the hotel, and the ceremonial valet parking is in front of the casino). All three message systems are closely interrelated on the Strip. Sometimes they are combined, as when the facade of a casino becomes one big sign or the shape of the building reflects its name, and the sign, in turn, reflects the shape. Is the sign the building or the building the sign? These relationships, and combinations between signs and buildings, between architecture and symbolism, between form and meaning, between driver and the roadside are deeply relevant to architecture today and have been discussed at length by several writers. But they have not been studied in detail or as an overall system. The students of urban perception and imageability have ignored them, and there is some evidence that the Strip would confound their theories. How is it that in spite of "noise" from competing signs we do in fact find what we want on the Strip? Also, we have no good graphic tools for depicting the Strip as message giver. How can the visual importance of the Stardust sign be mapped at 1 inch to 100 feet?

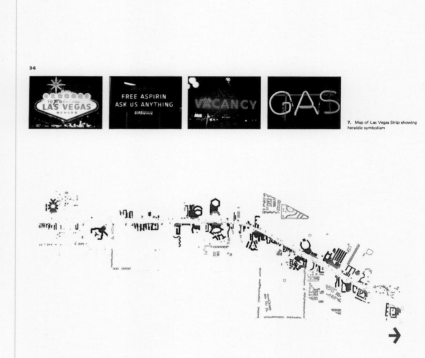

7. Map of Las Vegas Strip showing heraldic symbolism

"Not innovating willfulness but reverence for the archetype."
Herman Melville

"Incessant new beginnings lead to sterility."
Wallace Stevens

"I like boring things."
Andy Warhol

1. Peter Blake, God's Own Junkyard: The Planned Deterioration of America's Landscape (New York: Holt, Rinehart and Winston, 1964), p. 101. See also Denise Scott Brown and Robert Venturi, "On Ducks and Decoration," Architecture Canada (November 1968).

To make the case for a new but old direction in architecture, we shall use some, perhaps indiscreet, comparisons to show what we are for and what we are against and ultimately to justify our own architecture. When architects talk or write, they philosophize almost solely to justify their own work, and this apologia will be no different. Our argument depends on comparisons, because it is simple to the point of banality. It needs contrast to point it up. We shall use, somewhat undiplomatically, some of the works of leading architects today as contrast and context.

We shall emphasize image — image over process or form — in asserting that architecture depends in its perception and creation on past experience and emotional association and that these symbolic and representational elements may often be contradictory to the form, structure, and program with which they combine in the same building. We shall survey this contradiction in its two main manifestations:

1. Where the architectural systems of space, structure, and program are submerged and distorted by an overall symbolic form. This kind of building-becoming-sculpture we call the duck in honor of the duck-shaped drive-in, "The Long Island Duckling," illustrated in God's Own Junkyard by Peter Blake.[1]

2. Where systems of space and structure are directly at the service of program, and ornament is applied independently of them. This we call the decorated shed.

The duck is the special building that is a symbol; the decorated shed is the conventional shelter that applies symbols. We maintain that both kinds of architecture are valid — Chartres is a duck (although it is a decorated shed as well), and the Palazzo Farnese is a decorated shed — but we think that the duck is seldom relevant today, although it pervades Modern architecture.

We shall describe how we come by the automobile-oriented commercial architecture of urban sprawl as our source for a civic and residential architecture of meaning, visible now, as the turn-of-the-century industrial vocabulary was viable for a Modern architecture of space and industrial technology 40 years ago. We shall show how the iconography, rather than the space and piazzas of historical architecture, forms the background for the study of association and symbolism in commercial art and strip architecture.

Finally we shall argue for the symbolism of the ugly and ordinary in architecture and for the particular significance of the decorated shed with a rhetorical front and conventional behind: for architecture as shelter with symbols on it.

1. "The Long Island Duckling" from God's Own Junkyard
2. Road scene from God's Own Junkyard

3. Duck
4. Decorated shed

The Duck and the Decorated Shed

Let us elaborate on the decorated shed by comparing Paul Rudolph's Crawford Manor with our Guild House (in association with Cope and Lippincott). These two buildings are comparable in use, size, and date of construction: Both are high-rise apartments for the elderly, consisting of about 90 units, built in the mid-1960s. Their settings vary: Guild House, although freestanding, is a six-story, imitation palazzo, analogous in structure and materials to the surrounding buildings and continuing, through its position and form, the street line of the Philadelphia gridiron plan it sits in. Crawford Manor, on the other hand, is unequivocally a soaring tower, unique in its Modern, Ville Radieuse world along New Haven's limited-access, Oak Street Connector.

But it is the contrast in the images of these buildings in relation to their systems of construction that we want to emphasize. The system of construction and program of Guild House are ordinary and conventional and look it; the system of construction and program of Crawford Manor are ordinary and conventional but do not look it.

Let us interject here that we chose Crawford Manor for this comparison not because of any particular antagonism toward that building. It is, in fact, a skillful building by a skillful architect, and we could easily have chosen a much more extreme version of what we are criticizing. But in general we chose it because it can represent establishment architecture now (that is, it represents the great majority of what you see today in any architecture journal), and

MIT Press catalog, 1972

Design

3

(Top spread — left columns)

if total of 1, 2 and 3 is $50 select free book from 2 or 3 / if total is $100 select free book from any tier

BRONXBROOKLYNMANHATTANQUEENSTATENI PLAN FOR NEW YORK CITY

539 Volume 1: Critical Issues
$40 Volume 2: Bronx
541 Volume 3: Brooklyn
542 Volume 4: Manhattan
543 Volume 5: Queens
544 Volume 5: Staten Island
by the New York City Planning Commission
edited by Peter Richards
$15.00 $8.50 17 x 17 in illus
Each volume
546 Set of 6 Volumes
$90.00 $35.00 boxed

BROOKLYNMANHATTAN QUEENSTATENISLAN

545 Tensile Structures
Volume 1: Pneumatic Structures
by Frei Otto
translated from the German
$17.50 $10.00 320pp 1660 illus
547 Tensile Structures
Volume II: Cables, Nets, and Membranes
by Frei Otto
$17.50 $6.25 176pp illus
548 $15.00 for both volumes

SOLERISOLERISOLERISOLERISOLERISOLERISOL

536 Arcology: The City in the Image of Man
by Paolo Soleri
$25.00 $15.00

537 Sketchbooks of Paolo Soleri
by Paolo Soleri
$27.50 $20.00
$ 9.95 $ 7.00

538

ISOLERISOLERISOLERISOLERISOLERISOLERISOL

Arts of Science and Technology

552 Engines of the Renaissance
By Bertrand Gille
translated from the French
$11.50 $6.00 256pp illus

553 Brunelleschi: Studies of His Technology and Inventions
by Frank D. Prager and Gustina Scaglia
$12.50 $4.95 176pp illus

554 The Development of the Foundations of Mathematical Analysis from Euler to Riemann
by Ivor Grattan-Guinness
$12.50 $5.95 192pp

555 Essays in the History of Embryology and Biology
By John M. Oppenheimer
$12.50 $4.95 374pp

556 Toward a History of Geology
edited by Cecil J. Schneer
$22.50 $11.00 512pp

557 Alchemy, Medicine, and Religion in the China of A.D. 320: The Nei P'ien of Ko Hung (Pao-p'u tzu)
translated and edited by James R. Ware
JOURNAL OF ASIAN STUDIES
$15.00 $4.95 44pp

BERNALBERNALBERNALBERNALBERNALBERN

551 Science as History
559 Volume 1: The Emergence of Science
Volume 2: The Scientific and Industrial Revolution
Volume 3: The Natural Sciences in Our Time
Volume 4: The Social Sciences: Conclusion
3rd edition, illustrated
by J. D. Bernal
revised and richly illustrated in four volumes.
The set:
$40.00 $20.00 1120pp
$ 5.00 $ 4.95 176pp illus

BERNALBERNALBERNALBERNALBERN

TEXTILESTEXTILESTEXTILESTEXTILESTEXTIL

560 A History of Printed Textiles
by Stuart Robinson
$12.50 $5.00 192pp

561 A History of Dyed Textiles
by Stuart Robinson
$22.50 $11.00 112pp

562 $ 8.00 for both volumes

TEXTILESTEXTILESTEXTILESTEXTILESTEXTILE

563 The Paintings of Giovanni Battista Rosetti
$14.00 $5.00 256pp

CITIESSYSTEMSCITIESDESIGNCITIESSYSTEMSCITI

549 Emerging Methods in Environmental Design and Planning
edited by Gary T. Moore
PROGRESSIVE ARCHITECTURE
$18.50 $10.00 304pp

550 A Systems Analysis Model of Urbanization and Change: An Experiment in Interdisciplinary Education
by Carl Steinitz and Peter Rogers
JOURNAL OF HOUSING
$8.95 $4.50 120pp illus
551 $14.00 for both

EMSCITIESDESIGNCITIESSYSTEMSCITIESSYSTEM

(Top spread — right columns)

464 Thermodynamics
by Joseph H. Keenan
$3.95? $1.89 512pp

465 Properties of the Thirty-Two Point Groups
by G. F. Koster, J. O. Dimmock, R. G. Wheeler and H. Statz
Computing Review
$3.95? $4.25 400pp

466 Quantum Physics and the Philosophical Tradition
by Aage Petersen
$7.50 $3.25 217pp

467 Plasmas and Controlled Fusion
by David J. Rose and Melville Clark, Jr.
Applied Mechanical Review
$12.50 $6.95 493pp illus

468 Electrons, Ions, and Waves: Selected Works of William Phelps Allis
SCIENCE
$20.00 $7.50 447pp illus

469 Nuclear Forces: Introduction to Theoretical Nuclear Physics
by Gernot Eder
$17.50 $6.75 352pp

470 Transmission of Information: A Statistical Theory of Communications
By Robert M. Fano
$12.50 $3.95 389pp

471 STRESS: A Reference Manual
by Steven J. Fenves, Robert D. Logcher, and Samuel P. Mauch
$3.95 $4.25 400pp

472 SNOBOL5 Primer: An Introduction to the Computer Programming Language
by Allen Forte
$3.95? $1.25 137pp

473 Recognizing Patterns: Studies in Living and Automatic Systems
edited by Paul A. Kolers and Murray Eden
AXAR MODEL 1310
$11.00 $3.95 304pp

474 Applications of Optimal Control Theory to Computer Controller Design
by William S. Widnall
QUARTERLY OF APPLIED MATHEMATICS
$ 7.95 $ 2.45 160pp

475 Information, Mechanism and Meaning
By Donald M. MacKay
$3.95? $1.45 224pp

476 The Application of Plasmas to Chemical Processing
edited by Reinhard F. Baddour and Robert S. Timmins
$12.50 $3.95 380pp

477 The Technology of the Ceramics and Refractories
Translated from the Russian
$17.50 $8.45 400pp

478 The Physical Chemistry of Steelmaking
edited by June F. Elliott
$3.95? $6.95 493pp
METALS

479 Electromagnetic Fields, Energy, and Forces
by Robert M. Fano, Lan Jen Chu, and Richard B. Adler
$11.95 $4.95 511pp

480 Analysis and Stimulation of Multipoint Systems: The Bond Graph Approach to Physical System Dynamics
by Dean Karnopp and Ronald C. Rosenberg

international journal of electrical engineering
$10.00 $4.95 221pp

481 Structures Technology for Large Radio and Radar Telescope Systems
edited by James W. Mar and Harold Liebowitz
CHOICE
$30.00 $12.50 480pp

482 The Nature of Metals
by Bruce A. Rogers
$3.95? $3.95 220pp

483 ICES Systems Design
ENGINEERING NEWS RECORD

484 Transient Performance of Electric Power Systems
by Reinhard Rüdenberg
$20.00 $10.00 864pp

485 Boundary Layers of Flow and Temperature
by Alfred Walz
$17.50 $8.45 300pp

486 Fast Reactor Technology — Plant Design
POPULAR SCIENCE AND ENGINEERING
$30.00 $15.00 600pp

3 (Bottom spread — left columns)

go through / if total of 1, 2 and 3 is $100 select free book from 1 or 2 / if total is $100 select free book from any tier

BAUHAUS
Literature and Art

The Bauhaus:
Weimar Dessau Berlin Chicago
by Hans M. Wingler
487 As a formal institution, the Bauhaus was founded 50 years ago, in 1919. As an idea, its influence remains vital to this day; indeed, interest in it has been growing over the past decades. As a book, The Bauhaus is quite simply definitive: it fully documents the history and illustrates the life and works of the Bauhaus in all its phases and periods. About 200 documents, over 800 illustrations, nearly 700 pages.
$56.00 $28.00 696pp 24 color plates

488 Man
Teaching Notes from the Bauhaus
by Oskar Schlemmer

Richly illustrated notebooks of drawings, the image of figure as taught at the Bauhaus.

$ 8.95 $ 4.50 150pp

489 Cézanne's Portrait Drawings
by Wayne Andersen
$27.50 $14.75 320pp 240 illus

490 The Statues at Urbi: Arts, Crafts, and Professions in Ancient Greece and Rome
by Carl Roebuck
SCIENCE BOOKS
$12.50 $5.95 304pp 110 illus

491 Science and Aesthetics
edited by Robert R. Wilson
$30.00 $14.75 320pp illus

492 Bodel Appearance: A Study of the relations between painting and the natural sciences in this century
by G. H. Hamilton
L.A. TIMES
$25.00 $12.75 256pp 270 illus + 70 hand-tipped color plates

493 Museums: In Search of a Usable Future
by Alma S. Wittlin
WASHINGTON INTERNATIONAL ARTS LETTER
$10.50 $5.95 304pp illus

494 The Psychology of Art
by Lev Semenovich Vygotsky
$12.50 $5.95 352pp

495 History and Politics in the Soviet Union
by Heinz Wichter Heer
$12.50 $6.95 320pp

496 The Growth of Word Meaning
by Jeremy M. Anglin
The Linguistic Reporter
$ 5.95 $ 2.95 148pp

497 The Open Eye in Learning: The Role of Art in General Education
edited by Richard Reuner
$10.00 $4.95 304pp

498 Scientific Manpower: A Dilemma for Graduate Education, and Erik S. Edmonds, editors, KHD 831
$30.00 $14.75 320pp

499 Change and Apathy: Liverpool and Manchester during the Industrial Revolution
by François Vigier
JOURNAL OF HOUSING
$12.50 $5.95 264pp

500 The Idea of a New University: An Experiment in Sussex
edited by David Daiches
$ 2.95? $ 1.45 207pp

501 Revolution and Intervention: The Diplomacy of Taft and Wilson with Mexico, 1910-1917
by P. Edward Haley
BOOKLIST
$10.00 $4.95 280pp

(Bottom spread — center columns)

502 Number Words and Number Symbols: A Cultural History of Numbers
by Karl Menninger
$15.00 $7.50 480pp

503 The Vanishing Peasant: Innovation and Change in French Agriculture
by Henri Mendras; translated by Jean Lerman
Finance and Development
$ 6.95 $ 3.50 224pp

504 Explorations in Mathematical Anthropology
edited by Paul Kay
$10.00 $5.66 304pp

505 Science and the Future of Man
edited by Robert L. Carneiro and James B. Shanks, Jr.
$10.00 $4.95 192pp

Social Science

(Bottom spread — center-right columns)

VENEZUELAVENEZUELAVENEZUELAVENEZUE

506 The Politics of Change in Venezuela
Volume 1: A Strategy for Research on Social Policy
edited by Frank Bonilla and José A. Silva Michelena
$15.00 $7.50 264pp

507 The Failure of Elites
Volume 2 of The Politics of Change in Venezuela
by Frank Bonilla
$15.00 $7.50 336pp

508 The Illusion of Democracy in Dependent Nations
Volume 3 of The Politics of Change in Venezuela
by José A. Silva Michelena
$15.00 $7.50 300pp

509 $45.00 $18.00 for all 3

510 Regional Input-Output Study: Recollections, Reflections, and Diverse Notes on the Philadelphia Experience
by Walter Isard and Thomas W. Langford
$15.00 $5.95 502pp

VENEZUELAVENEZUELAVENEZUELAVENEZU

511 Eurocircuits in Collision: Five Color Studies in Area Transportation Planning
by Marvin A. Manheim
$10.00 $4.95 288pp

512 The Partitions of India: Policies and Perspectives 1935-1947
edited by C. H. Philips and Mary Doreen Wainwright
$15.00 $6.95 480pp

513 The Economics of Insurgency in the Mekong Delta of Vietnam
by Robert L. Sansom
$12.50 $5.95 304pp

514 Coping with Nucliferance: Sea Power and Global Politics in the Missile Age
by Jonathan Houx
$12.50 $6.25 416pp

515 The Decision to Go to the Moon: The Apollo Project and the National Interest
by John M. Logsdon
ANNALS
$10.00 $4.95 200pp

516 An Econometric Approach to a Marketing Decision Model
by Ronald E. Frank and William F. Massy
$15.00 $5.95 444pp

517 Selected Readings in Econometric Theory from Econometrica
edited by Kenneth J. Arrow
$15.00 $5.95 444pp

518 Selected Readings in Econometrics from Econometrica
edited by John W. Hooper and Marc Nerlove
$15.00 $5.95 512pp

ECONOMETRICAECONOMETRICAECONOMETRIC

521 Impact of New Technologies on the Arms Race
522 A Pugwash Monograph
edited by B. T. Feld, T. Greenwood, G. W. Rathjens, and S. Weinberg
$15.00 $5.00 288pp

523 A Peril and a Hope: The Scientists' Movement in America, 1945-1947
by Alice Kimball Smith
$3.95? $1.50

527 Hunting for Dinosaurs
by Zofia Kielan-Jaworowska
Translated from the Polish
$ 7.95 $ 3.95 200pp illus

528 Financial Management of Foreign Exchange
An Operational Technique to Reduce Risk
by Bernard A. Lietaer
$12.50 $5.95 192pp

529 Economic Cooperation in Latin America, Africa, and Asia: A Handbook of Documents
edited by Miguel S. Wionczek
LIBRARY JOURNAL
$15.00 $6.25 512pp

(Bottom spread — right columns)

524 An Econometric Model for Common Stocks
SCIENTIFIC AMERICAN
$ 5.95 $ 3.95 349pp

525 Security Pricing in a Competitive Market: Mean-Variance Framework
$12.50 $4.95 302pp

526 $ 8.00 for both

530 Dai: Prototype of Japanese Architecture
by Kenzo Tange and Noboru Kawazoe, with photographs by Yoshio Watanabe, preface by John Burchard
Art in America
$17.50 $8.00 212pp 189 illus

531 Programs and Manifestoes on 20th-Century Architecture
edited with a commentary by Ulrich Conrads
$ 4.95 $ 1.90 190pp illus

532 Housing and Economics: The American Dilemma
edited by Michael Stegman
$12.50 $7.25 544pp

533 Urban Dynamics
by Jay W. Forrester
AIA JOURNAL
$12.50 $6.25 290pp

534 On the Art of Designing Cities: Selected Essays of Elbert Peets
edited by Paul D. Spreiregen
$15.00 $7.95 464pp

535 Next Plan for the Development of Sofia
ARCHITECTURAL FORUM
$17.50 $7.95 368pp

Architecture and Urban Studies

M.I.T. Press
Media/Design/Production Classification System

CLASSIFICATION	MEDIA/DESIGN	PRODUCTION
0 Bound, Jacketed Books Consignment or distribution		
0+	We do jackets	
1 Camera Ready	Complete copy with r.h. and folio in place	
2 Simple	straight text; camera copy -- insert r.h. and folios	routine scedule, standard trim size, requires max. of 6 hrs. production time from ms. to bound bk.
3 Standard	0-25 illustrations 0-25 tables camera copy with specs.	routine schedule;standard trim size, requires max. of 10 hrs. prod. time from ms. to bound bk.
4 Complex	math; 25 ills. and over 25 tables and over partial dummy	Unusual schedule; odd size extra time, between ed. and design, binding extras. 10-15 hrs. from ms. to bound bk.
5A Difficult Media Production/Design	complete dummy	rush schedule, checking job on press, complicated settings involving frequent supplier contracts. 15-20 hrs. prod. time from ms. to bbk.
6 Difficult Media Design/Production and Editorial		All of the above, involving 20 hrs. and more production time

6/15/73

Identification system for possible use on programmable calculator and
later storage on IMLAC for both hour and work histories

0	0	1	Department Head	Muriel Cooper
0	0	2	Media Coordinator	Lauri Rosser
0	1	3	Design Manager	Sylvia Steiner
0	0	4	Production Manager	Judith Gimple
0	1	5	Design Associate	Betsy Hacker
1	1	6	Design Assistant	Mario Furtado
1	0	7		Patti Rogers
1	0	8	Production Assistant	Pat Mahon
1	0	9		Joan Holmes
2	1	10	Secretarial	Pearl Jusem
2	0	11		David Sanders
1	2	12	Imlac	Candy Giglio
5	1	13	Composition	Ellen Ogilvie
3	0	14	Part-Time	Jane Johnson
4	1	15	Voucher, etc. no EB	Michael Richie
4	1	16		Richard Harrington

COLUMN 1

0	Supervisory
1	Assistant
2	Secretarial
3	Part-time Salaried
4	Outside/Student
5	Temporary

COLUMN 2

1	Manufacturing In-house
2	IMLAC

COLUMN 3

01	number of persons working
02	in dept.
03	
04	etc.

CHARGE TO BOOKS SYSTEM

00	Non-Charge	02	Departmental Charge
01	Charge to Books	03	Miscellaneous Departmental (Media)

IDENTIFICATION NUMBERS
LN Books with Launch Numbers. Use Launch Number.

9-- Holdover Books which appeared on press-wide schedule from 7/70
 on have been identified with numbers 9 --. A list will be
 provided.

999 Old Books prior to 7/70 with no number identified with 999,
 Author and Title.

444 Paperbacks Until a system for numbering these is established,
 they should be identified as 444 plus author and title.

 New books which are paperback should be identified with Launch
 Number plus 444. I.e., L.N. 356.444

544 MIT Press books which are made in paperbacks should be identified
 by Launch Number if there is one.

 L.N. 356.544 to indicate reprint, P.B. classification, print no.,
 bind no.

555 Our Reprints - L.N. 253.555.1 (printing no.) .2 (binding no.)

666 Author and Title until launched

777 Journals
.1 Journal title

888 Marketing
.1 Exhibits
.2 Advertisements
.3 Catalogues
.4 Direct Mail
.5 Miscellaneous

456 Administration (Forms, etc.)

567 Departmental; moving furniture, internal matters, interviews, etc.

678 Outside Charges; I.e., publications, 3M Machine, etc.

6/12/73

0 Preliminary Preparation
 Procedural meetings - pre-launch/scheduling/list meetings, etc.
 Departmental procedures - Adm./ financial, general, personnel,
 salesmen and field trips
 Estimating, conferences, etc. on pending projects
 The card will identify the allocation of this kind of hour

1 Basic Planning and Specifications
 Design/Production discussions
 Design and specifications of sample pages through to distribution
 in Press/author
 Preparing estimates-cost sheets through to circulation of release
 Gathering information on jackets through to comp. for catalog or book
 Gathering information on direct mail - advertisements to the point
 of sending out for composition or to comp. stage

2 Preparation of materials for suppliers
 Marking manuscripts, any copy, spine, jacket copy, any handling
 Imposition sheets that have to do with instructions on materials that
 go to suppliers up to the first point of production

3 Composition
 In and out of house - any form of composition/excluding marking of ms.
 If in house, the manufacture of first galleys, corrections, paging
 short of mechanicals
 If typewriter, supervision from first pages on to complete pages ready
 to send to printer (first proofing?)
 IBM, Staromat, IMLAC

4 Manufacture
 If composition out, the handling of ggs, revisions, pages, corrections
 (film?)
 To include bluses and corrections, printing, paper, binding, etc.
 Scheduling, trafficing, routing, handling orders, specifications for
 paper, printing, binding, etc. through to update at warehouse

5 Special Problems
 Abnormal follow-up with suppliers, authors, trips to plant, etc.
 Production problems
 Interdepartmental meetings,especially difficult revisions of any part
 of the process

6 Illustrations
 Lists, tagging, organization, sizing, preparation for dummy, or
 illustrations for imposed film

7 In-House Materials
 Time spent on photostats, Transparex, 3-M, cost of materials separate

8 Dummying
 All work associated with pulling together material to be sent to
 printer, including normal conferences with editor, author, revisions, etc.

9 Mechanicals and Drafting
 Drafting and mechanicals for ads, dummy sheets, books, direct-mail, any
 administrative or departmental forms

4-73 author	cl	no.	lch date	7	8	9	10	11	12	1	2	3	4	5	6	7	8	9	10	11	12	
Anderson eHOpPM	PB	197 1	9-29-72			L 29 / RC 29	AD		RS 3	EB	EB 26	EB 2										
Berg eKPpPMdPR	NB	165 5a	5-18-72 / EI 5-72 / EO 6-72			RC 10 / IC 9	RS 10 / IC				EB	EB / AD / EB 24										
Lattner eHOpJG	PB	225 2	12-11-72						L 11	EI 16	EO 9	AD	EB									
Goldman aMCpJH	IM	223 0	12-13-72						L 13	RC 2 / RS 15	EB	EB 30										
Meynell aYApJH	IM	193 0	8-11-72			L 11	RC 22	RS 2	EB	EB	EB 30	EB										
Moholy-Nagy eHOpPM	PB	1	1-3-73	AD		RC 22			EB	L 3 / RS 3	EB 26	EB 23										
Otto eHOpPM	PB	1	12-12-72	AD					EB / L / RS 12	EB	EB 30											
Piene und Mack aJSeJSpJGdPR	NB	6	4-14-70 / EI 6-70 / EOIC1-71	EB 15	AD						EB	EB 30	EB 23									
Pugh eTMpJHdSS	RV / NB / PB	214 4	9-29-72 / 10-20-72			PL 29 / EI 29	L 20 / EO 20		IC 12	RC 10 / RS 30	EB 26	EB 30	EB 2									

5-73 author	cl	no.	lch date	7	8	9	10	11	12	1	2	3	4	5	6	7	8	9	10	11	12	
Yu aJSSeEApJGdLR	NB	149 5a	1-27-72 / EI 2-72 / EO 6-72 / RCS 6-72	IC 13							EB 30	EB 13	EB 23									
Zucker aMCeCDBpJGdLR	NB	184 3	8-3-72	SO 11 / EI 3	SI 20 / EO 26	RC 27	RS 10 / IC 15				EB 30	EB 2	EB 12									
Bhagwati, Eck aMCpJH	IM	212 0	9-29-72			L 29 / RC 29	RS 16		EB		EB	AD / EB	EB									
Dogan jJG	PB	229 1	12-11-72						L 11		AD		EB									
Dondis aMCeTMpJGdMF	NB	171 6	6-1-72 / EI 6-72	SO 14	SI 11	HC 20		EO 10 / AD / EB		RC 5 / RS 16	EB 9	EB 7										
Svzhenko aMCeTMpPMdSS	NB	118 5b	9-23-71 / EI 2-72			EO 6	EB / IC 10	AD	EB	RC 8 / RS 21	EB 26	EB 4										
Edwards aJSSeCGpJGdPR	NB	150 5	2-3-72 / EI 4-72 / EO 6-72 / SI 6-72	IC 1	RC 12 / RS 27						EB	EB	EB / EE 21	AD 4								
Grosswald aYReEApPMdLR	NB	134 6	12-3-71 / EI 1-71 / EO 3-72 / IC 6-72		.	EB		AD			EB	EB 20	EB									
Mandell, C&B eBApJHdSW	NB	146 4	9-22-72 / 1-27-72 / PL 1-72			EI / L 22		EO 17 / ME	CP	EE	AD	EB 13	EB	EE								

Mandell, C+B

PL Pre-launch
L Launch date
EM Est. Ms. date
EI Editorial In
EO Editorial Out
SO Specs Out
SI Samples In
RC Release Circ.
RS Release Signed
CP Camera Copy
IC Into Comp.
HC In Hse Comp
TC Typewrtr Comp
Z Imlac Comp.
EB Est. Bnd Bks
AD Announce date
PA Previously Ann.
OC Office Copies
WR Warehse Rec'd
WS Warehse Shpng

C. A. Doxiadis, *Architectural Space in Ancient Greece*, ed. Jaqueline Tyrwhitt (Cambridge, Mass: MIT Press, 1972), design by Muriel Cooper and MIT Press Design Department

3 Athens, Acropolis I, circa 530 B.C. Plan.

4 Athens, Acropolis II, circa 480 B.C. Plan.

5 Athens, Acropolis III, after 450 B.C. Plan.

[36]

[37]

Otto Piene, *More Sky* (Cambridge, Mass.: MIT Press, 1973),
design by Otto Piene, Muriel Cooper, and Sylvia Steiner

Exhibition 74

understood as event, does not have to be a dead word and a
worn-out procedure. What's worn-out are the traditional lo-
cations. Ships, city halls, mines, TV stations, the sea, for-
ests, farms, dairies, factories, homes, islands, airplanes,
the sky, and the moon seem to be better suited for exhibi-
tions than most galleries and museums. The latter were built
to house paintings and still sculptures. That's not enough.
Like zoos they present only samples, not living organisms.

Fairs/Carnivals 75

aside from being fun, offer a treasury of ideas to artists
with limited powers of imagination. I suggest that shooting
galleries be replaced by bubble halls challenging people to
produce the largest bubble ever. Prize-winning bubbles could
be hardened, then made into polarizing spheres and used for
music kraals.

Simulators of flying experiences have always been a major
part of the Palisades Park. In the future they will probably
shoot people up instead of dumping them down.

I can think of many places where fairs might be located; on
my imaginary list military sites have urgent priority.

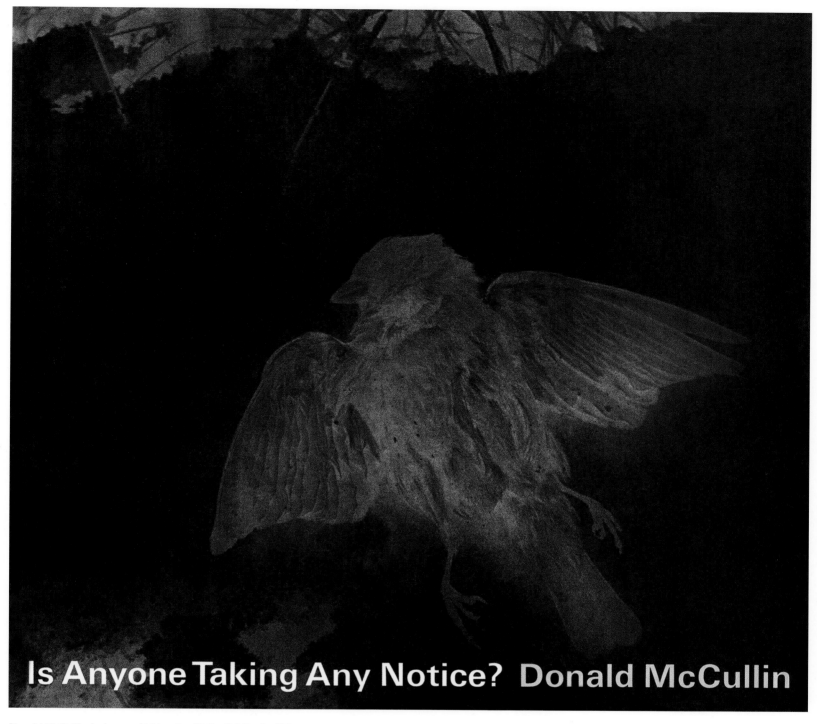

Is Anyone Taking Any Notice? Donald McCullin

Donald McCullin, *Is Anyone Taking Any Notice? A Book of Photographs and Comments* (Cambridge, Mass.: MIT Press, 1973), design by Muriel Cooper, Sylvia Steiner, and MIT Press Design Department

This Viet Cong soldier
had been lying in a bunker
for three days

Design

You find young men bellies hanging out throat wounds Photography's
being hit with shells that make got nothing
legs blown off terrible sucking noises to do with that

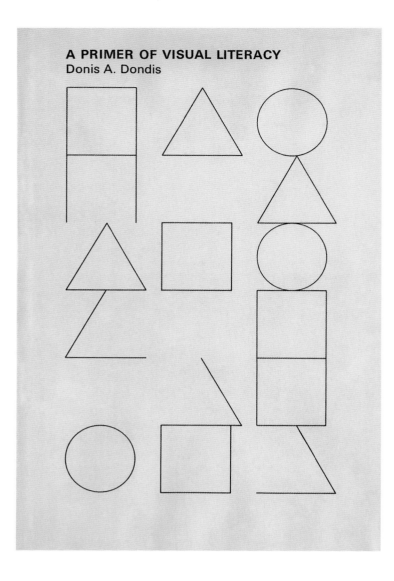

A PRIMER OF VISUAL LITERACY
Donis A. Dondis

Donis A. Dondis, *A Primer of Visual Literacy*
(Cambridge, Mass: MIT Press, 1973), design by
Muriel Cooper, Donis A. Dondis, and MIT Press
Design Department

ity to communicate specifically or in the abstract. As Henri Bergson puts it, "Art is only a more direct vision of reality." In other words, even at this lofty level of evaluation, the visual arts have some function or utility. It is easy to draw a diagram to place various of the visual formats in some relationship to these polarities. Figure 1.1 presents one way of expressing contemporary evaluative attitudes.

FINE ART ———————————————————— APPLIED ART
PAINTING SCULPTURE MONUMENTS ARCHITECTURE CRAFTS ILLUSTRATION PHOTOGRAPHY GRAPHICS INDUSTRIAL DESIGN

FIGURE 1.1

Such a diagram would look quite different were it to represent another culture, such as the Pre-Renaissance (1.2),

FINE ART ———————————————————— APPLIED ART
ARCHITECTURE SCULPTURE PAINTING CRAFTS

FIGURE 1.2

or the "Bauhaus" point of view, which would group any and all of the fine and applied arts on one central point in the continuum (1.3).

FINE ART ———————————————————— APPLIED ART
PAINTING SCULPTURE ARCHITECTURE CRAFTS PHOTOGRAPHY GRAPHICS INDUSTRIAL DESIGN

FIGURE 1.3

Long before the Bauhaus, William Morris and the Pre-Raphaelites had inclinations in the same direction. "Art," said Ruskin, who was their

spokesman, "is all one, any distinction between fine and applied art is destructive and artificial." The Pre-Raphaelites added one distinction to their thesis that put them totally out of sympathy with the later philosophy of the Bauhaus—they rejected all work of the machine. What is made by hand is beautiful, they believed, and though they espoused a cause of sharing art with all, turning their backs on the possibilities of mass production was an obvious negation of their self-proclaimed purposes.

What the Morris-led "Arts and Crafts" group did recognize in their reaching back to the past to renew interest in careful and proud workmanship was the impossibility of producing art without craftsmanship—a fact easily forgotten in the snobbish dichotomy between fine and applied in the arts. During the Renaissance, the artist learned his craft from the simple tasks on, and despite his estate, shared his guild or union with the basic craftsman. This provided for a stronger apprentice system, and, more important, less specialization. There was a free flow back and forth between the artist and craftsman, each able to participate in all levels of work, barred only by a measure of competence. But, as times change, modes change. What is labeled "art" can change as fast as the people who label it. "A hallelujah chorus," says Carl Sandburg, in his poem, "The People, Yes," "forever shifting its star soloist."

The contemporary view of the visual arts moves beyond the polarities of "fine" and "applied" art to questions of subjective expression and objective function and again has tended toward the association of individual interpretation with creative expression belonging to the "fine arts" and the response to purpose and use belonging to the "applied arts." An easel painter working for himself without commission pleases himself first without thought of the market place, and is, therefore, almost totally subjective. A craftsman fashioning a clay pot can appear to be equally subjective. He is making his pot in a shape and size to please his own taste. He has, however, a practical concern: can the design that pleases him also hold water? This modification of utility imposes on a designer some measure of objectivity not so immediately necessary or so apparent in the work of the easel painter. The American architect Sullivan's dictum, "form follows function," is most dynamically illustrated by the airplane designer, whose own preferences are limited by what assembled shapes, proportions, and materials will, in fact, really fly. The final product is shaped by what it does. But in the subtler problems of design, there are many products that can reflect the subjective tastes of the designer and still

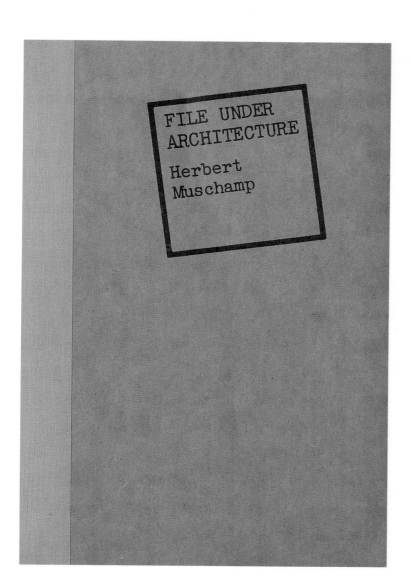

Herbert Muschamp, *File under Architecture*
(Cambridge, Mass.: MIT Press, 1974), design by
Muriel Cooper, Sylvia Steiner, and MIT Press
Design Department

CIVILIZATION AS
ELABORATELY
DEVISED
SENSORY
DEPRIVATION
CHAMBER.
WE WANT
EVERYTHING
TO BE AS BORING
AS POSSIBLE
ON AS MANY
LEVELS AS
POSSIBLE.
THIS IS KNOWN
AS
TOTAL
COMMUNICATION.

The infant
Frank
Lloyd Wright
playing with
Froebel blocks –
just what
grown-up
architects do,
necessarily
embellished
with talk and
intentions,
of course.

setting up spatial diagrams that were
plainly visible to the eye.

One of the most important concepts spun
off by the transition to a visual uni-
verse was the concept of time. Time was
no more than the cerebral synthesis of an
overwhelming body of ostensibly orderless
visual information (the apparent motions
of sun, moon, planets, and stars, wit-
nessed from a "fixed" point of view).
Stonehenge was built to give graphic sub-
stance to the necessary illusion of an
order amongst all those turning lights,
to fix the time-symbol synthesis in
visual, spatial, permanent, absolute
terms. Art historians have had a hard
time fitting Stonehenge into the aesthet-
ic continuum, for it was built when the
visual universe was relatively raw and
unexplored. To visualize was necessary,
not merely nice: there was not yet time
for such refined embellishments as flut-
ing and entasis. Later, when the visual
universe was well established, when
visual patterns had filtered down to all
levels of experience, time was taken for

"IN THE
ARCHITECTURAL
STRUCTURE,
MAN'S PRIDE,
MAN'S TRIUMPH
OVER
GRAVITATION,
MAN'S WILL
TO POWER,
ASSUME A
VISIBLE FORM.
ARCHITECTURE
IS A
SORT OF
ORATORY OF POWER
BY MEANS OF
FORMS."

—NIETZSCHE,
TWILIGHT
OF THE IDOLS

In the universe
of motion
by credit-card
transport,
architecture
is the
poor man's
environment.

granted, and there was no need for the
support of such an absurdly outsize mon-
ument. Soon the meaning of this corner-
stone mandala of the visual universe was
lost behind the weeds.

It should not seem so outrageous to sug-
gest that the Great Pyramid was built at
the precise geographic center of the
earth, for it was the mathematically ele-
gant truth of this fact that made the
pyramid a meaningful thing to do. Since
this site was the center of the universe
as well, it was no great sacrifice for
men to give up their lives for the privi-
lege of occupying so splendid a position.
But as it is the business of civilization
not merely to maintain a fixed status
quo but to be constantly in the process
of drawing order from chaos, the static
simplicity of the Egyptian cosmos pre-
cipitated its own destruction. Having
planted the pyramid precisely and per-
manently and invested all energy in its
perfection, there was no energy left
over to cope with the enormous problems
brought on by the state of inertia. The

92

93

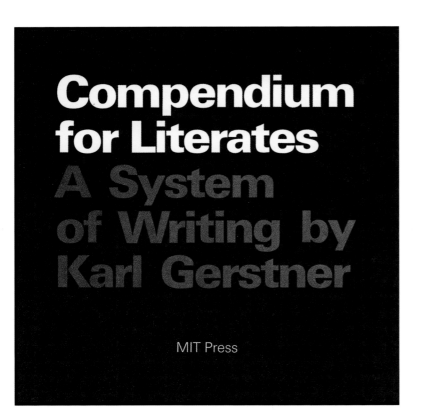

Karl Gerstner, *Compendium for Literates: A System of Writing* (Cambridge, Mass.: MIT Press, 1974), design by Karl Gerstner and MIT Press Design Department

32	Word picture
325	Configuration

Every form can alter its configuration through various projections.
For example:

325.4

= distort

In this configuration we probably perceive more word pictures than in any other.
The reason: what was originally printed integrally on a flat sheet of paper
inevitably looks distorted on the open pages of a book
– though not so obviously as here – because the paper surfaces are convex.

In the above case the word picture falls on an uneven surface,
in the one below on a flat but receding one:

86
87

325.5

= foreshorten

This is another case the reader meets more often than he thinks.
The reason: even when a surface is flat, he seldom sees it at right angles, frontally,
but usually more or less obliquely with the word picture foreshortened.

The privileged case of a parallel projection
is better known under its technical name.

kursiv schreiben

= italic writing

The Responsive House
edited by Edward Allen

DO YOUR OWN THING

An Attempt to Derive the Nature of a Human Building System from First Principles

Christopher Alexander

I wrote this paper for a seminar discussion in 1970. There is little in it which is precise enough to convince a person who is in a mood to doubt. However, for all that, I do believe that careful empirical study of the psychology of space, and the laws of efficient structure, will, in the long run show that my conclusions are fundamentally correct. For this reason, I am publishing them in this sketchy form with the idea that they may help some of my colleagues who are already looking in a similar direction.

When a person designs a building, he usually starts with certain known structure types: column and beam, load-bearing walls, stud construction, monolithic reinforced concrete, etc. The building forms which designers have created by this process are very unsatisfactory. To begin with, they fail to meet many important needs. What is far worse, though, these structure types are so sharply distinct, and the choices between them so arbitrary, that one is left with the feeling that none of them are really quite right, and that no one has ever plumbed the problem of defining the class of structures which are actually correct for a human building. For instance, comparison of columns-and-beams with load-bearing-walls, leaves you with the feeling that there

*The psychological arguments for Postulates 3, 6, 10, 11, 20 and 24 are given by the patterns <u>Ceiling height variety</u>, <u>Indoor space</u>, <u>Columns at the corners</u>, <u>Thick walls</u>, and <u>Sheltering roof</u> which will appear in the first edition of <u>The Pattern Language</u>, to be published in 1973. They are summarized, in part, in Alexander and Jacobson, <u>Specifications for a Human Building System</u>, this volume.

are certain pros and cons for each alternative, but that final choice among these alternatives is more or less arbitrary.

In this paper, I shall try to overcome this arbitrariness by arguing from first principles. I shall start with certain postulates, based on the human needs which occur in a building, and the laws of nature, and try to derive, from these postulates, a general description of the morphology--(i.e., the class of structure) which is correct for human buildings. As you will see, I believe we may conclude that any building structure which meets human needs, and follows the laws of structure, will have the general character of the room illustrated by the following drawing:

In order to derive the morphology of such a building without prejudice, it will be necessary to avoid assumptions about "types" of structure, like load-bearing-walls, shells, or column-and-beam--and instead carry on the discussion at a level of description which could apply equally well to any of these so-called types, and also to the very much greater variety of "mixed types" which lie between them. I begin with the most general description of a building:

Edward Allen, ed., *The Responsive House* (Cambridge, Mass.: MIT Press, 1974), design by MIT Press Design Department

Lawrence Halprin and Jim Burns, *Taking Part: A Workshop Approach to Collective Creativity* (Cambridge, Mass.: MIT Press, 1974), design by Lawrence Halprin, Sylvia Steiner, and MIT Press Design Department

1 Why take part?

What we are trying to do is describe the theory and practice of a process for collective creativity.

We have been developing this process both individually and collectively over a period of approximately twenty years.

But it is only within the last few years—with the development of the RSVP Cycles as a basis—that many of our methods have become more precise, more deeply rooted in demonstrable techniques, in specific formats and procedures and have come to be based on experience and testing.

It is easy to tell about the processes; but it is complex and difficult to convey the sense of energy, warmth, involvement, creativity, accomplishment, and even wonder that infuses groups of people during participation in a Take Part Process.

We have been working with the process long enough to know that it encourages powerful elements of creativity.

Its particular usefulness for us and the groups we have worked with is that it serves as a common and visible framework to which we can all relate.
In that sense, it has made the process of working together understandable.
The RSVP Cycles (explained in Chapter 2) and Take Part Processes have led to a common language with which we communicate, and its consistent use has generated more communication.

Collective creativity is a growing need in our society.

People are increasingly coming together for communal living purposes, in neighborhood interest groups, in special interest groups, and in groups struggling for personal growth and participation in the life/art experience.
More and more people are less and less inclined to turn over all decision making to elected or appointed officials or to instructors.

So much has happened to reduce confidence in bureaucratic techniques that people have become more and more determined to exert control over the course of their own lives.

This desire to participate extends to all art, to education, to theater and dance, to politics, to the women's movement.

It includes growing one's own food, and even religion and health care and the birthing of children.

Increasingly members of emerging subcultures and of third-world nationalities are searching for ways by which they can take a large role in determining their own futures.

But the desire to participate must be matched by a framework to allow it to happen.
It is not sufficient simply to <u>want</u> to be involved.

A graphic symbolization of the process that leads from the impulses of groups and individuals, through the system of the RSVP Cycles, into the permissive vehicle of Take Part Processes, to produce participation that evolves into collective creativity.

2 3

36
Lectures
in Biology

S. E. Luria

S. E. Luria, *36 Lectures in Biology* (Cambridge, Mass.: MIT Press, 1975), design by MIT Press Design Department

II. Biochemistry

Calvin cycle

phere? Because it is fixed into organic materials by a variety of biological processes, the most important of which is <u>photosynthesis</u>.

Photosynthesis is a remarkable process, which green plants, algae, and some bacteria use to convert the carbon of CO_2 to organic matter. [Note that the reaction that replenishes the Krebs cycle (page 78) also involves fixing CO_2 to organic matter; but it is a small capacity reaction, not geared for massive fixation and in addition requires a supply of organic compounds.] Photosynthesis operates by fixing CO_2 through a cycle of reactions called the Calvin cycle after an American biochemist (no relation of the 16th century Protestant reformer). This cycle has many instructive features.

Each circlet means one or more carbon compounds

(Figure represents 6 runnings of the cycle)

The cycle takes in six molecules of CO_2 one at a time and through a series of steps converts them into one molecule of glucose. The important points are:
1. Carbon enters only as CO_2 and exits only as sugar.
2. To convert 6 moles of CO_2 to one mole of sugar $C_6H_{12}O_6$ the cycle uses 18 moles of ATP, converting it to ADP and iP. This makes sense: when a cell burns sugar to form CO_2 in glycolysis and the Krebs cycle, it releases energy and stores some of it in the form of ATP. So, to make sugar from CO_2 there is need to use some ATP.
3. Just as glycolysis and the Krebs cycle release

Lecture 9

electrons to NAD^+, the reverse process of making sugar from CO_2 requires electrons. In other words, to reduce CO_2 to sugar one needs a source of <u>reducing power</u>. The cycle provides it in the form of NADPH (the relative of NADH; remember?). Twelve moles of NADPH are needed for every mole of sugar made; therefore the entire reaction should be written

$$6CO_2 + 12\underline{H_2O} + 18ATP + 12NADPH + 12\ H^+ \rightarrow$$

$$glucose\text{-}6\text{-}P + 6\underline{O_2} + 18ADP + 12NADP^+ + 17iP + 6H_2O.$$

NADPH is not a specialty of photosynthesis: it is used by most cells as the favorite electron donor for biosynthetic purposes.

[The Calvin cycle is used not only for photosynthesis but for all organisms that must make their organic carbon from carbon dioxide. Some important groups of bacteria, for example, oxidize H_2, or H_2S, or S, or even CO (the exhaust gas) and use the electrons from these compounds to get NADH or NADPH and to store energy as ATP made through an electron transport system. They use CO_2 for carbon source, fixing it by the Calvin cycle. This, however, contributes very little to the overall CO_2 fixation on earth.]

Light reactions

Note that in the equation of photosynthesis I have thrown in H_2O and O_2 and have left out light. The Calvin cycle constitutes the so-called <u>dark reaction</u> of photosynthesis. What does light do? It provides the energy needed to make ATP and NADPH by the <u>light-reaction</u> part of the process.

In plant cells this takes place in a complex apparatus called <u>chloroplast</u>.

Chloroplasts contain pigments that absorb specific wavelengths of light and convert it into chemical energy. Plants are green because the chloroplast

Edwin Diamond, *The Tin Kazoo: Television, Politics, and the News* (Cambridge, Mass.: MIT Press, 1975), design by MIT Press Design Department

Chapter 9
Psychojournalism: Nixon on the Couch

In the summer and fall of 1973, as the Watergate scandals propelled Richard Nixon into his seventh and most serious crisis, the state of the President's mental health became a national "issue." At least, the media made the President's mood and emotional well-being a prime subject of discussion. How much longer, many stories asked, could Richard Nixon "take the pressure"? His closest associates were falling one by one, and the vise of disclosure and evidence was tightening around him; would he "crack"? Indeed, had he *already* cracked?

These questions, in turn, created honest public apprehensions. The President's health is, obviously, a fit subject for public concern and serious discussion. Gene Smith in his excellent 1964 study of Woodrow Wilson, *When the Cheering Stopped,* described the tragedy of a President whose incapacity was shielded from the public by his family and the palace guard. And A. J. Liebling, in *The Earl of Louisiana,* showed how difficult it can be to remove a visibly sick official—in this case, Louisiana Governor Earl Long—even when his family and close aides lend a hand. A few years ago, the U.S. Congress, mindful of such experiences (as well as of Eisenhower's series of physical incapacities) provided a remedy of sorts in Section 4 of the Twenty-Fifth Amendment, which states that the vice-president and a majority of the Cabinet may, at any time, declare the president "unable to discharge the powers and duties of his office."

The Nixon White House, during late 1973 and early

THE NEW TELEVISION:

ESSAYS, STATEMENTS, AND
VIDEOTAPES BY VITO ACCONCI,
JOHN BALDESSARI, GREGORY
BATTCOCK, STEPHEN BECK,
WOLFGANG BECKER, RENE BER-
GER, RUSSELL CONNOR, DOUG-
LAS DAVIS, ED EMSHWILLER,
HANS MAGNUS ENZENSBERGER,
VILEM FLUSSER, HOLLIS FRAMP-
TON, FRANK GILLETTE, JORGE
GLUSBERG, WULF HERZOGENRATH,
JOAN JONAS, ALLAN KAPROW,

A PUBLIC/PRIVATE ART

DAVID KATZIVE, HOWARD KLEIN,
SHIGEKO KUBOTA, BRUCE KURTZ,
JANE LIVINGSTON, BARBARA LONDON,
EDWARD LUCIE-SMITH, TOSHIO MAT-
SUMOTO, JOHN MCHALE, GERALD
O'GRADY, NAM JUNE PAIK, ROBERT
PINCUS-WITTEN, DAVID ROSS,
PIERRE SCHAEFFER, RICHARD SERRA,
ALLISON SIMMONS, GERD STERN,
PAUL STITELMAN, HARALD SZEEMAN,
STAN VANDERBEEK, EVELYN WEISS.

Douglas Davis and Allison Simmons, eds., *The New
Television: A Public/Private Art* (Cambridge, Mass.:
MIT Press, 1977), design by Muriel Cooper and
Sylvia Steiner

Nam June Paik
The Video
Synthesizer
And Beyond

38

39

1963

The Fetishism of Idea seems to me the main critical criterion
in contemporary art.

Thirteen TV sets suffered thirteen sorts of variation in their
video-horizontal-vertical units. I am proud to be able to say
that all thirteen sets actually changed their inner circuits. No
two sets had the same kind of technical operation. Not one
produced only the simple blur which occurs when you turn
the vertical and horizontal control button at home.

The waves from various generators, tape recorders, and radios
were fed to various points to give different rhythms to each.
This rather old-fashioned beauty, which is not essentially com-
bined with a high-frequency technique, was easier for the nor-
mal audience to understand, maybe because it had some hu-
manistic aspects.

There are as many sorts of TV circuits as French cheeses. For
instance, some old models of 1952 are capable of certain kinds
of variation which new models with automatic frequency con-
trol cannot do.

Maybe one needs ten years to be able to perceive the delicate
differences between thirteen different "distortions"(?), as was
needed to perceive the delicate differences between many
kinds of "noises"(?) in electronic music.[1]

Design

95

Selected MIT Press book covers and dust jackets, 1967–1974

machines, and the problems of mechanical design (weight and inertia calculations, rotor design, rating and efficiency calculations, and the design of worm gears).

The later chapters introduce the working up of test data and the elements of curve fitting, QUIKSPEK (a computerized sales-order-specification system), and a final "Potpourri" of topics, including transient phenomena, synchronous machine design, distributed parameter problems, and electronic power supplies.

The volume is the fifth in the series, *Monographs in Modern Electrical Technology*, edited by Alexander Kusko. He is also coauthor of a book predating this series, *Computer-Aided Design of Magnetic Circuits*, described on the back cover.

Computer-Aided Design of Magnetic Circuits
by Alexander Kusko and Theodore Wroblewski

The general purpose of this book is to present the reader to the field of computer-aided design from an industrial viewpoint. All computer-aided design work has the common function of providing results that extend the engineer's ability to build and sell devices and equipment. However, each technical area has its own specialized techniques and problems, and the particular purpose of the book is to present those for the design of magnetic circuits.

After stating the design problem, the book discusses the pertinent assumptions, equations, and models; develops methods for handling the interface with the attached electric circuits and the sequence of steps for computer-aided design; and finally presents the flow diagrams and typical input and output forms in use.

The chapters are so arranged that the simplest magnetic-circuit device, the reactor, is considered first, followed by leakage-reactance transformers and regulating transformers. The last chapter covers conventional multiwinding transformers. For each class of device, the theory and modeling are treated, followed by numerical examples and the approach to computer-aided design. Many examples are oriented toward lamp ballasts, because their magnetic-circuit operation is realistically complex and because most of the programs were prepared for their design.

The authors originally developed the computer programs presented here for actual industrial use, in reducing design time for new transformers, in exploring new magnetic-circuit configurations, and in obtaining more accurate designs to reduce out-and-try work on prototypes. To accomplish this, much preliminary work was necessary to develop analytical techniques and mathematical models for the magnetic circuits and the electric circuits in which they were placed. The mere transfer of hand-design methods to computer programs would not have been successful in yielding useful and realistic computer-aided design methods.
MIT Press Research Monograph No. 55

Monographs in Modern Electrical Technology

This series covers selected topics that link scientific theory to the application of modern electrical technology in industrial production. Specifically, these monographs describe the state of the art in each technological field and focus on contributions such as those made by computer science, solid-state and plasma physics, and modern control theory.

The emphasis is primarily on industrial technology in such areas as electric power systems, energy conversion and control, transportation, lighting, and other fields involving the production of goods and services.

The purpose of the series is to provide the reader with the background of the technological area, the state of industrial development, the impact of scientific theory, and both the attainments and problems of the field. The technical material is as timely as possible and reflects a specialist's viewpoint and experience. Authors are primarily from industry or from the academic community, with strong industrial experience and background. In scope the series is broad enough to make it useful to senior and graduate engineering students, science students, and both general professional and specialized engineers.

Other titles currently available in this series:

Solid-State DC Motor Drives
Alexander Kusko

Electric Discharge Lamps
John F. Waymouth

High-Voltage Measurement Techniques
Adolf J. Schwab

The Theory and Design of Cycloconverters
William McMurray

The MIT Press
Massachusetts Institute of Technology
Cambridge, Massachusetts 02142

VCD

Computer-Aided Design of Electric Machinery

Cyril G. Veinott

$8.95

No single aspect of electric-machinery analysis and design has received so much attention in the literature as that of how computers can be used in the process. Nevertheless, most of this material is concerned with specific problems and applications, and until now a general view of the whole area, as seen from the perspective of historical experience, has not been available. Cyril Veinott is superbly qualified to fill this need. He was one of the very first engineers to realize the potential of digital computers in aiding the working designer and from the mid-fifties has been actively involved in utilizing the computer's services for this purpose. For 17 years, he was associated with the Reliance Electric Company, where he was engaged in the development of a computer system that was used for solving electrical and mechanical design problems of both dc and ac motors. He organized the company's Engineering Computer Center, which on his retirement was processing over 200 design problems daily. He was then a guest professor for two years in electrical engineering at Laval University in Quebec City.

The book opens with a look at the nature of a programmable engineering problem and discusses the selection and the mechanics of digital computer equipment. This chapter surveys the kinds of systems and subsystems presently available for various ranges of applications. Both equipment and procedures are judged in terms of economic considerations as well as from a strictly engineering point of view.

The author then describes the experiences of Reliance Electric's Engineering Computing Center and puts forth some general conceptual approaches regarding the nature of the design problem and outlines the analysis and synthesis approaches to design. Notes on programming explain such techniques as branching, decision and structure tables, flow charting, and iterative (or cut-and-try) procedures.

Some specific electromechanical applications are taken up next. These include the design of single-phase and polyphase induction motors, the calculation and design of laminations for both stators and rotors, the design of direct-current

MIT 235
ARCHITECTURE AND URBAN STUDIES

$4.95

Emerging Methods in Environmental Design and Planning
edited by Gary T. Moore

"This is a book about tools rather than solutions, means rather than ends. Ably edited by Gary Moore, it presents the papers and proceedings of a conference on design methodology in 1968, sponsored by the Design Methods Group; some thirty papers together with nine commentaries on them, by Americans and Britons, with a strong although not exclusively academic emphasis.

"The authors all try, more or less explicitly, to make public the design process, to clarify what the designer does, not only in order to explain his efforts to others but also to make him accessible to the possible contributions of others. This potential dialogue is particularly important now, when complex designs, offering valid solutions, may be rejected because their programs cannot be communicated or understood."
—*Progressive Architecture*

A major part of the volume is devoted to presentations and evaluations of specific new methods. Some areas are covered in depth—for example, building layout models, problem structuring, and computer-aided design—while others, necessarily because of the tremendous range of research under way, are limited to only two or three representative reports. To assist the reader, each section of the volume begins with a brief introduction and is concluded by a summary and commentary. Evaluations of current research and outlooks for the future are offered by such leaders in planning and architecture as

John P. Eberhard, Aaron Fleisher, Bernard Frieden, J. Christopher Jones, Horst Rittel, Michael Brill, Paul O. Roberts, Jr., Daniel Brand, and Charles W. Rusch.

Although most of the papers involve some application of computers, it would be wrong to imply that the book was only computer applications to design. The focus is on all methods for the solution of medium- and large-scale environmental problems, not just computer methods—however, where necessary to implement specific methods, computer programs and systems are introduced and discussed fully.

Gary T. Moore is currently a Canada Council Fellow in Psychology at Clark University. He holds degrees in both architecture and psychology. He was a founder of the Design Methods Group, first editor of the *DMG Newsletter*, and a cofounder of the Environmental Design Research Association.

The MIT Press
Massachusetts Institute of Technology
Cambridge, Massachusetts 02142

MEP

Emerging Methods in Environmental Design and Planning

edited by
Gary T. Moore

This primer is the most unintimidating teacher of Fortran around. It is designed to teach complete novices to communicate with the most sophisticated computer systems. It was written for people who could make direct use of the computer's skills but who themselves know nothing of computers and little math beyond that needed to define particular problems. It will teach them, bit by bit, to read and write Fortran IV, a succinct and powerful general-purpose computer language and one especially useful for solving scientific and mathematical problems.

The emphasis throughout is on programs that are prepared and tested by means of on-line interactions between user and computer. In the already visible future, the author observes, practically all computer users whose main professional interest is outside programming as such will make exclusive use of this mode. (In the interim, to cover computer installations that work off-line, the book also takes note of the techniques of batch processing.)

From the start, each chapter presents and explains an actual program, ranging from short and primitive to full-size and complex. In fact, the greater part of the text introduces various delimited concepts and methods by showing how they are embedded in programs that in themselves solve real and interesting problems. Thus, for example, subroutines first appear in a program that makes computations based on the progress of a 1000-step random walk; logical variables are defined in connection with a program that solves a chess problem; block data and run time considerations are taken up with an orbiting planet program; and 2-D arrays are introduced in the exposition of a spiral-drawing program.

The book is formatted as a computer print-out. And part of the book was actually written by a computer, in the sense that what the computer printed out in executing the programs assigned to it is directly reproduced.

Moreover, the book itself operates something like a program on the student. Quizzes at various points loop him back to previous sections if his answers do not match those given, and the student is encouraged to skip over certain expository sections and advance to new material.

The text is developed in such a way that it is not necessary for the student to have access to an on-line terminal. However, if he does, he will be able to progress in skill and confidence even more rapidly.

Oliver G. Selfridge is a staff member of the M.I.T. Lincoln Laboratory. His primer grew out of a manual developed to explain Fortran and its applications to other researchers there.

Also from the MIT Press

SNOBOL3 Primer:
An Introduction to the Computer Programming Language
by Allen Forte

The MIT Press
Massachusetts Institute of Technology
Cambridge, Massachusetts 02142

SFI

A Primer
for FORTRAN IV
On-line
Oliver G. Selfridge

A Primer for FORTRAN IV On-line Selfridge

MIT 232 EDUCATION
The Hidden Curriculum
by Benson R. Snyder
First paperback edition

In a penetrating analysis of student unrest, the Dean for Institute Relations at M.I.T. (and former chief of the psychiatric services both here and at Wellesley College) isolates a major cause of campus conflict: the overwhelming, nonproductive mass of unstated academic and social norms that divert the student from creative intellectual effort and from the attempt to define and reach his goals as independently as he is able.

The Hidden Curriculum "will gain recognition as one of the more cogent 'college unrest' books. Its main contention is simple. There exist, Snyder explains, two curriculums governing the university degree. In addition to mastering the substantive one (say, physics or history), a student must cope with its tactical complement, the academic game whereby his appropriate responses to institutional prejudices will best ensure a high letter-grade transcript.... [A] most provocative thesis."—*Saturday Review*

"...the formal requirements for courses or for success in higher education are often in sharp contrast to what it really takes for a student to complete a course successfully or to be acceptable to peers, faculty, and others.... The central task in studying the 'hidden curriculum' is to learn which patterns of behavior are tribally and/or institutionally sanctioned, and to learn to practice 'selective negligence,' that is, to identify the relevant and simplify the complex. The author calls for a searching dialogue on the disillusionment and gamesmanship that hide behind the specifics of the curriculum."
—*Library Journal*

The MIT Press
Massachusetts Institute of Technology
Cambridge, Massachusetts 02142

MIT
232

The Hidden Curriculum Snyder

SHCP

The Hidden Curriculum Benson R. Snyder

The MIT Press
Massachusetts Institute of Technology
Cambridge, Massachusetts 02142

The Open Eye in Learning Bassett, Editor

The Open Eye in Learning
The Role
of Art
in General
Education
Richard Bassett
Editor

In an age that has been criticized for its neglect of personal judgments and the decay of its environment, it would seem evident that visual re-education is necessary. The proposal to train the eyes to see with awareness is, in fact, one that has been advocated by leaders of educational thought from Pestalozzi to Dewey, yet traditional education with its basic orientation toward verbal and mathematical skills has failed to develop the necessary perspective on the role and importance of the visual arts in the curriculum.

The one discipline that does attempt to provide a systematic training of the eyes is the art course, and this work thoroughly examines the resources, values, and application of the courses and their present-day function from primary school education through college.

The contributors to this volume are not primarily concerned with building an argument with regard to "eye-training" but with the question, "What kinds of art courses are necessary to fulfill the objectives of general education and also satisfy a complex set of personal needs?" Meeting this requirement in practical terms, the book provides detailed outlines and proposals for studio and historical or critical art courses and presents outstanding models, such as the art course at Andover, for analysis and experimentation. An extensive Teaching Supplement covers the general philosophy of the medium, the patterns of learning and Gustave Britsch's theories, art and personality, alternative art courses for elementary, secondary, and college levels, a theory of color harmony, and concludes with a penetrating essay on the training of art teachers. This valuable study places the current status of visual training in a perspective to be applied in the future in general education.

The contributors to this volume were members of a Special Committee on the Study of Art, appointed by the Executive Committee of the National Association of Independent Schools. This committee consists of Richard Bassett, Former Instructor in Art, Milton Academy, William W. Barber Jr., Headmaster, St. Mark's School, Gordon Bensley, Instructor in Art, Phillips Academy, Andover, Mrs. Alexander Crane, Former Headmistress, Abbot Academy, Oliver H. Larkin, Professor of Art, Emeritus, Smith College, Norman L. Riche, Dean, College of Fine Arts, Carnegie-Mellon University, Theodore R. Sizer, Dean, Harvard Graduate School of Education, and John C. E. Taylor, Professor of Art, Trinity College.

Jacket design by
Allan Davis/Omnigraphics, Inc.

Francis Bitter Selected Papers and Commentaries Erber and Fowler, editors

Francis Bitter (1902–1967) left behind him a current of influence that surges on today, strong and lively. There is the Francis Bitter National Magnet Laboratory at M.I.T. There is a generation of students and researchers whom Bitter trained as a devoted teacher and as the author of widely used undergraduate texts. And, most pertinent of all, there is the monumental collection of scientific papers in which his results and his way of doing physics are preserved. This volume commemorates Bitter by reprinting a selection of the most significant of these papers.

Francis Bitter was intellectually restless and was possessed of — or by — an irrepressible curiosity. For him, once the broad range of a field had been gauged, it was time to move on to a new research area. That is why this volume contains papers on almost all aspects of magnetic physics, along with contributions to other areas of physics as well, as will be seen in the section titles below. It is also why much of his work represents the foundation if not the completion of some of the most important advances in recent years. For example, A. Kastler, in receiving the Nobel Prize for his work in double resonances, credited Bitter with establishing the basic principles on which a fully developed theory could be built.

The papers included here are grouped in eight broad sections, each section introduced by one or more of Bitter's colleagues. A biography and bibliography are also included. The sections are entitled as follows: The Magnetic Susceptibility of Gases (three papers, with commentary by J. H. Van Vleck); Ferromagnetic Studies (eight papers, with commentaries by William Fuller Brown, Jr. and L. Néel); The First M.I.T. Magnet Laboratory: The Design of Powerful Electromagnets (seven papers, with commentary by George R. Harrison); The War Years (two papers); Optical Pumping and Double Resonance (seven papers, with commentaries by J. Brossel, A. Kastler, and H. H. Stroke); Illumination Studies (two papers, with commentary by J. F. Waymouth); The Francis Bitter National Magnetic Laboratory (two papers, with commentaries by B. Lax and H. Kolm);and Megagauss Physics (three papers, with commentary by C. M. Fowler).

Francis Bitter
Selected Papers
and Commentaries
edited by T. Erber
and C. M. Fowler

The MIT Press
Massachusetts Institute of Technology
Cambridge, Massachusetts 02142

Space Grid Structures Borrego

Space Grid Structures by John Borrego

The MIT Press Massachusetts Institute of Technology Cambridge, Massachusetts 02142 MIT Report No. 11

Skeletal Frameworks and Stressed-Skin Systems

Top cover (Topics in Geophysics):

TOPICS IN
GEOPHYSICS
SMITH

TOPICS IN
GEOPHYSICS
PETER J. SMITH

$10.95

Also from The MIT Press
Understanding the Earth
A Reader in the Earth Sciences
edited by I. G. Gass, Peter J. Smith,
and R. C. L. Wilson
Second Edition

The related articles in this book were
originally prepared for use at The
Open University, England. When the
first edition was published in the Unit-
ed States in 1971, it was acclaimed in
such terms as the following, taken
from a review in American Scientist:
"This timely volume will be appreciat
ed by anyone attempting to teach mod
ern geology to beginning students.
The outstanding feature of this book
is the broad coverage of global tecton
ics under one cover, including sections
by F. J. Vine, Sir Edward Bullard, and
E. R. Oxburgh. This concept is devel
oped through sequential chapters on
continental drift, sea-floor spreading,
and plate tectonics. Preceding articles
provide the necessary background on
earth structure, composition, and
magnetism. In addition, geologic
implications of global tecton
ics are developed in chapters
on orogeny and volcanism.
Esbally timely articles
introduce the reader to

lunar geology, meteorites, a model for the
origin of life, and the primitive earth."
In this revision, several chapters are
updated, two are completely rewritten,
and two new ones are added - one on
the oxygen cycle, the other on "Re-
sources and the Environment."

The MIT Press
Massachusetts Institute of Technology
Cambridge, Massachusetts 02142

STG

sense that processes that occur deep
within the Earth must be inferred from
very few clear data, and they may be
interpreted in quite different ways.
The last topic is "Earthquakes: Char
acteristics, Prediction, and Modifica-
tion." This is a subject of everyday in
terest and, in some parts of the world,
of day-by-day interest here, the frames
of reference of "human time" and
"geological time" coincide. Because of
its social ramifications, this topical
subject might be called an example of
applied geophysics.

Exploration beyond the Earth has
tended to overshadow the less spectac-
ular but no less far-reaching and signif-
icant efforts to understand our home
planet—efforts that have in recent
years produced massive quantities of
new data and, beyond that, a radically
new way of looking at the Earth: a
new worldview, a Whole Earth ap-
proach, a global concept. As a result,
it no longer suffices to update older
texts with a scattering of new facts or
to write new ones based on older
models.
This genuinely new text, prepared by
the chairman of the geophysics course
team at England's Open University,
bases itself firmly (but undogmatical-
ly) on these new discoveries, in particu-
lar on "knowledge of the large scale
features of the Earth's surface and in-
terior in both their static and dynamic
contexts. This is the global picture of
the Earth as perceived by today's Earth
scientist, although it carries with it no
implication that will necessarily stand
for all time without change, or even
without radical change." The book
opens with a general chapter summariz-
ing this global picture, which is fol-
lowed by three topics—chapters care-
fully designed to present three differ-
ent aspects of geophysics and three dif-
ferent approaches to the science.
Among them, they explore the Earth's
crust, mantle, and core, but Smith has
chosen to examine a few aspects in
some detail rather than treat many in
passing. This, in a sense, is a case-study
text: it is meant for undergraduates,
and only simple mathematics is called
upon.
The first topic is "The Earth's Crust
and Uppermost Mantle." This typifies
the observational branch of geophysics
and draws its conclusion from experi-
mental evidence supported by a broad
data base.
The second treats "The Earth's Heat
and Thermal Properties," a subject
that Smith calls "the most important
of all branches of geophysics." Never-
theless, the material presented here is
not well covered in most texts, at least
in part because it represents a specula-
tive approach to geophysics, in the

Bottom cover (Sentences Children Use):

$1.95
MIT 203 Linguistics
Sentences Children Use
by Paula Menyuk

This book presents a summary of the
author's research on the acquisition and
development of language by children at
various stages of their development. The
techniques employed in studying sen-
tences children use were those of experi-
mental psychology within a framework
of a generative model of grammar. After
describing what a child acquires and
uses linguistically, the author examines
the ways in which children develop and
apply language.
"Teachers, psychologists, linguists, and
others interested in young children and
language development should find this
book a valuable resource, as it presents
well-conducted research on how lan-
guage is developed by children at vari-
ous stages of growth (ages 2 to 7). In-
cluded is a description of the language
the child acquires, how it is used linguis-
tically, and ways in which children de-
velop and apply it."—Childhood Educa-
tion
"The present work . . . distinguishes
itself both from the standpoints of
thoroughness of treatment and the cur-
rent need to know more about language
acquisition and usage by children. . . .
It has asked some of the right questions
about the sentences children use and
then proceeds with great thorough-
ness in answering them."—Elementary
English

The MIT Press
Massachusetts Institute of Technology
Cambridge, Massachusetts 02142

MIT
203

Sentences Children Use Menyuk

MSEP

I got everything what you got.
Him not try.
I didn't see at the other pictures.
I want a milk.
She has to make a lot of work.
This dress green.
I want the fire engine to talk.
Cat right back.
He liketed that funny game.
I no do this.
The teacher writes that numbers.
Count a buttons.
I don't know what him doing.
I making cake.
I don't like milk because I like eggs.
He be good.
The boy whats crying is her brother.
No ride feet.
The barber cut off his hair off.
You nice?
It isn't any more rain.
Sentences Children Use
Paula Menyuk

Also from The MIT Press:

Work in America:
Report of a Special Task Force to the Secretary
of Health, Education, and Welfare
Foreword by Elliot L. Richardson
Millions of Americans are dissatisfied with the
quality of their working lives--with dull, repeti-
tive jobs that stifle autonomy and initiative.
This year-long study prepared for the Department
of Health, Education, and Welfare by the W. E.
Upjohn Institute for Employment Research brings
together facts about the current nature of work
and the workplace that have ominous implications
for the social and economic strength of the nation
as a whole.
The New York Times remarks that "its findings di-
rectly challenge President Nixon's repeated asser-
tions that some Americans are abandoning the 'work
ethic' for the 'welfare ethic.'" In fact, just the
opposite is true. The study provides evidence that
satisfying work is a basic human need in that it
establishes individual identity and self-respect
and lends order to human life.
The study group that produced Work in America
was headed by Dr. James O'Toole, former coordina-
tor of field investigations for the President's
Commission on Campus Unrest.
available in hardcover and in paperback

The MIT Press
Massachusetts Institute of Technology
Cambridge, Massachusetts 02142

HRC

RECORDS, COMPUTERS, AND THE RIGHTS OF CITIZENS

RECORDS, COMPUTERS, AND THE RIGHTS OF CITIZENS

$10.00

$1.95

Yellow Pages of Learning Resources
edited by Richard Saul Wurman

"The city is education," this book proclaims. "The city
is education--and the architecture of education rarely
has much to do with the building of schools. The city
is a schoolhouse, and its ground floor is both bulletin
board and library. The graffiti of the city are its window
displays announcing events; they should reveal its peo-
ple to themselves, tell about what they're doing and
why and where they're doing it. Everything we do--if
described, made clear, and made observable--is educa-
tion: the 'Show and Tell,' the city itself.... It is a class-
room without walls, an open university for people of
all ages offering a boundless curriculum with unlimited
expertise. If we can make our urban environment com-
prehensible and observable, we will have created class-
rooms with endless windows on the world."

The design of this book imitates the Yellow Pages tele-
phone directory, but the intent is not to "let your fin-
gers do the walking"--the book is meant to draw you
out into the environment, to put you in contact with
a lot of different kinds of people, to teach you the what,
where, why, and how-to of all sorts of things that go on
in the real world. The intent, finally, is to let your head
do the thinking, your eyes do the seeing, and--it's good
exercise--your feet do the walking. "...The city is every-
where around us, and it is rife with invaluable learning
resources. Even more than classrooms and teachers, the
most valuable learning resources in the city are the peo-
ple, places, and processes that we encounter every day.
But in order to realize the vast learning potential of these
resources, we must learn to learn from them."

Yellow Pages of Learning Resources is a guide to the
city--any city, any town. It consists of some seventy
alphabetically arranged categories and tells how to tune
them in and why they are important to know about.
It is a specific guide to people (the pharmacist, the taxi-

cab driver), to places (the airport, the courtroom), and
to processes (candy making, city planning). Here are
some others: architect--bricklayer--cemetery--dry clean-
er--electrician--food distribution center--garbage man--
hospital--insurance company--junk yard--kindergarten
room--locksmith--museum--next-door neighbor--orches-
tra member--paper box factory--quarry--real estate
broker--social worker--tree stump (tree stump?)--
union boss--vacant lot--weather forecasting--x-ray tech-
nician--Yellow Pages telephone directory--zoo.

Other possibilities are left to the imagination of students
and teachers; these resources can then be sought out
once the book has made it clear how to get around.
"Student" here can be anybody--while the book is with-
in the range of school-age children, it is also open to
adults, except those who already know how locks work,
who the next-door neighbor is, and what ward leaders
really do. They are excused from class and are free to
go out and learn something new on the way home or
at home (like, why doesn't the furnace thermostat
work?). Some of the resources listed are also especially
suitable for group learning experiences, and thus the
book becomes a valuable tool for the teacher, parent,
boy or girl scout leader, or adult education leader.

Richard Saul Wurman is a partner in the architecture and
planning firm of Murphy Levy Wurman in Philadelphia.
His interest in education prompted the formation of
GEE!, Group for Environmental Education Inc., which
developed *Our Man-Made Environment--Book Seven;*
his interest in urban graphics is displayed in *Urban
Atlas: 20 American Cities, Making the City Observable,*
and *Man-Made Philadelphia.* All these publications are
available from The MIT Press.

The MIT Press
Massachusetts Institute of Technology
Cambridge, Massachusetts 02142

YELLOW PAGES OF LEARNING RESOURCES

WURMAN, EDITOR

Yellow Pages of Learning Resources

Resources Directory
Area Code 800

Yellow Pages of Learning Resources

WYP

1 Location and Space-Economy
 Walter Isard
2 The Location of the Synthetic-Fiber
 Industry
 Joseph Airov
3 Industrial Complex Analysis and Re-
 gional Development
 Walter Isard, Eugene W. Schooler,
 and Thomas Vietorisz
4 Methods of Regional Analysis
 Walter Isard
5 Domestic Airline Efficiency
 Ronald E. Miller
6 The Spatial Dynamics of U.S. Urban-
 Industrial Growth: 1800-1914
 Allan R. Pred
7 Locational Analysis for Manufactur-
 ing: A Selection of Readings
 Gerald J. Karaska and
 David F. Bramhall
8 General Theory: Social, Political,
 Economic, and Regional
 Walter Isard
9 An Analytical Framework for Re-
 gional Policy
 Charles L. Leven, John B. Legler,
 and Perry Shapiro
10 Regional Input-Output Study:
 Recollections, Reflections, and
 Diverse Notes on the Philadelphia
 Experience
 Walter Isard and
 Thomas W. Langford

Also from The MIT Press
Methods of Regional Analysis:
An Introduction to Regional Science
by Walter Isard and D. F. Bramhall,
G. A. P. Carrothers, J. H. Cumberland,
L. N. Moses, D. O. Price, and
T. W. Schooler

A treatise on the various known tech-
niques of regional analysis, including
some promising new ones not yet
tested.

A practical implementation of the
general theory in Isard's Location and
Space-Economy.

"The book is evidence of real progress
in regional science. It will save much
time and effort for those of us who
work in regional science. . . . it provides us with a
kit-bag of tools for ready reference and
for reference for students."—Economic
Geography

Location and Space-Economy
A General Theory Relating to Indus-
trial Location, Market Areas, Land
Use, Trade, and Urban Structure
by Walter Isard

The basic objective of this volume is to
improve the spatial and regional frame-
works of the social science disciplines,
particularly of economics, through the
development of a more adequate gen-
eral location theory. These general
principles provide some insights for
more practical studies of industrial lo-
cation, market analysis, land use, and
city planning.

In these discussions Isard does a
great service by clearly defining the
problem areas with which space econo-
mists have dealt and should deal. He is
able to transfer and utilize many con-
cepts from non-spatial economics. He
also points out the need to consider
certain problems that are unique to the
economics of space."—Journal of
Political Economy

"Walter Isard has written a truly im-
portant book . . . Isard's concept of
transport inputs and other related spa-
tial concepts affords a means of draw-
ing geography and economics together
into an analytical economic geog-
raphy."—The Professional Geographer

**Industrial Complex Analysis and
Regional Development**
A Case Study of Refinery-Petrochem-
ical-Synthetic-Fiber Complexes of
Puerto Rico
by Walter Isard, Eugene W. Schooler,
and Thomas Vietorisz

A case study that uses a new technique
for comparing the locational advantages
of different regions for a set of strongly-
interrelated industrial activities.

General Theory
Social, Political, Economic, and
Regional
by Walter Isard in association with
Tony E. Smith and Peter Isard, Tze
Hsiung Tung, and Michael Dacey

Present techniques for planning tend
to simplify the real world by assuming
an equal spread of needs. Moreover,
they act as if in a vacuum, neglecting
their essential integration with other
systems in the region. In attempting to
develop a unifying and cohesive theory
of systems, Professor Isard has inte-
grated the concepts of the various
disciplines into one terminology or
language. This book is the first to at-
tempt to define such concepts in math-
ematical terms. Such rigorous analysis
creates the framework of a dynamic
general theory.

All social scientists will find some-
thing to learn from this book. In his
Preface the author selects chapters of
particular interest for economists,
political scientists, operations research
analysts, management scientists, sociol-
ogists, urban regional planners, geog-
raphers, and psychologists.

The MIT Press
Massachusetts Institute of Technology
Cambridge, Massachusetts 02142

Regional
Science
Studies
Series
11

Michael J. Webber

Impact of Uncertainty on Location

$12.95

Impact of Uncertainty on Location Webber

WUL

Until now, the effects of uncertainty on
location patterns have remained largely
unexplored. Theories about the way in
which firms make decisions to locate
have long been restricted by the assump-
tion that these firms know all the rele-
vant facts when the decisions are made.
This book is an attempt to generalize lo-
cation theory to take account of the
fact that firms are uncertain when they
make their decisions.

Among the topics discussed are the lo-
cation of duopolists, the patterns of
towns, the production decisions of
firms, and the impact of the diffusion of
innovations on location. The emphasis is
theoretical rather than empirical. The
book contains a collection of largely in-
dependent models which need now to
be more fully tested and combined into
a mathematical theory.

This is an extremely important book
for geographers and regional scientists.
It should become a standard work for
all advanced university courses in loca-
tion theory.

Michael Webber is a graduate of St.
John's College, Cambridge, and of the
Australian National University. He has
been a Lecturer in Geography at the
Australian National University since
1968.

This monograph treats a large body of
problems in statistical theory of non-
equilibrium processes in a plasma. The
starting point is a closed system of equa-
tions for the microscopic phase densities
of each component of the plasma and
microscopic potentials of the electrical
and magnetic fields, charges, and veloci-
ties. Under fixed experimental condi-
tions, these functions cannot be uniquely
defined and must be considered random.
The statistical theory of non-equilibrium
processes in plasma thus reduces to
the determination of first, second, and
higher moments of these functions. This
work pays most attention to the approxi-
mation of the first two moments.

Drawing upon the work of L. D. Landau
(1936), A. A. Vlasov (1938), and N. N.
Bogolyubov (1946), Professor Klimonto-
vich develops his own method for ob-
taining the microstate to describe the
processes in a plasma. The book begins
with Maxwell's equations for slow and
fast processes when dispersion of the
medium must be considered; it then
treats the microscopic equations for a
plasma, averaging the equations and ex-
amining an approximate system of equa-
tions for the first and second moments.
Vlasov's system of equations with a self-
consistent field is then discussed, fol-
lowed by an examination of the statisti-
cal characteristics of spatially uniform
and non-uniform plasmas. The final
chapters treat the more general case,
when the correlation time of the pertur-
bations in a plasma can be comparable
to or greater than the relaxation time
for the first distribution functions, and
the hydrodynamic description of proc-
esses in a plasma. Bibliographical ref-
erences are included, covering material
supplementary to the content of this
monograph and related material not
touched upon here. As no known gas-
eous plasma is in equilibrium, this book
should be invaluable to all theorists in-
terested in plasmas.

**Hydrodynamics and Heat Transfer in
Fluidized Beds**
by S. S. Zabrodsky

Over 70 laboratories in the Soviet Union
are engaged in fluidization research, yet
their work is virtually unknown in the
western world. This book, originally pub-
lished in Russian, covers thoroughly the
recent work of Soviet authors in this field
up to the end of 1961. Designed both as
a graduate text in two-phase flow, and
as a reference for the practicing chemi-
cal engineer, the text proceeds logically
from consideration of basic fluidized
bed phenomena to application of various
fluid bed techniques. Although broad
in scope, the emphasis is on elucidation
of the physical bases of fluidization proc-
esses and presentation of workable and
reliable design equations.

The MIT Press
Massachusetts Institute of Technology
Cambridge, Massachusetts 02142

Statistical Fluid Mechanics Monin and Yaglom

$22.50

This book, originally published in Mos-
cow in 1965, is of interest to a wide sci-
entific and technical audience, including
geophysicists, meteorologists, aerody-
namicists, chemical, mechanical, and
civil engineers — in short, all concerned
with the fundamental problems of
flow, mass, and heat transfer. The au-
thors deal with the theory of hydrody-
namic instability and the development of
turbulence, the application of dimen-
sional analysis, and the theory of simi-
larity to turbulent flow in pipes, ducts,
and boundary layers, as well as free tur-
bulence. They discuss semiempirical
theories of turbulence, develop the simi-
larity theory for turbulence in nonhomo-
geneous media, and present Lagrangian
characteristics of turbulence and the
theory of turbulent diffusion. Every
effort has been made to present a wealth
of experimental material; a large number
of examples are drawn from physics
of the atmosphere, permitting a gen-
eralization of results beyond that which
can be obtained in the laboratory. Con-
siderable attention has been given to
Kolmogorov's theory of the local struc-
ture of developed turbulence and to the
theory of turbulence in stratified media.

Contents: I. Laminar and Turbulent Mo-
tion: Equations of dynamics of a fluid
and their most important consequences;
Hydrodynamic instability and develop-
ment of turbulence. II. Mathematical
Methods for Describing Turbulence.
Mean Values and Correlation Functions:
Methods for taking mean; The fields of
hydrodynamic characteristics regarded
as stochastic fields; The moments of
hydrodynamic fields. III. The Reynolds
Equation and Semiempirical Theories
of Turbulence; Turbulent flow in pipes
and in the boundary layer; Turbulent
energy balance and results derived from
it. IV. Turbulence in a Medium Stratified
with Respect to Temperature: Generali-
zation of the theory of the logarithmic
boundary layer to the case of a medium
stratified with respect to temperature;
Comparison of the theory with experi-
mental data on the atmospheric layer
near the ground. V. Motion of Particles
(or Elements) in a Turbulent Stream;
Lagrangian description of Turbulence;
Turbulent diffusion.

Statistical
Fluid Mechanics

A. S. Monin and
A. M. Yaglom

MST

$12.50

Civilizing American Cities:
A Selection of Frederick Law Olmsted's Writings on City Landscapes

Sutton, editor

A Selection of
Frederick Law Olmsted's
Writings on
City Landscapes
edited by
S. B. Sutton

$10.00

Models for the Perception of Speech and Visual Form Weiant Wathen-Dunn, Editor

The MIT Press
Massachusetts Institute of Technology
Cambridge, Massachusetts 02142

Tensile Structures
edited by Frei Otto

For the first time in this edition Frei Otto's two studies of nonrigid structures (*Pneumatic Structures* and *Cables, Nets, and Membranes*) are available in one volume. *Pneumatic Structures* deals for the most part with surfaces loaded by tractive forces. Special membranes, of high tensile strength, are made semirigid by means of differences of enclosed air or fluid pressure and can serve as roofings, halls, silos, dams, or for any other application where ease and rapidity of construction and transportation are essential. This section is illustrated with 1,660 numbered photographs and line drawings, including many striking photographs of both models and existing implements and structures. In *Cables, Nets, and Membranes* the subject of nonrigid architectural structures is continued with a detailed investigation of structures under tensile loads, of which suspension bridges and tents are the most commonly known examples. Like pneumatic structures, tensile structures have the advantages of mobility, light weight, ease and speed of erection, and low cost.

"The MIT Press has given us a volume so beautifully designed in black and white that it can easily lead a life of leisure on the coffee table as become dog-eared in hard design-room service Mathematically and pictorially illustrated in immense and beautiful detail."
— *Engineer*

Also from The MIT Press
Space Grid Structures:
Skeletal Frameworks
and Stressed Skin Systems
by John Borrego

The remarkable rigidity and economy of three-dimensional space structures has long been realized, but only during the last decade have they begun to come into widespread architectural usage. In an age of standardization and prefabrication, their simplicity of manufacture, ease of transportation, and speed of erection are sufficient recommendation. Even more important, however, the ratio of weight to area covered can be greatly reduced through their use, and they permit the construction of long-span structures with a far smaller number of intermediate supports.

Flat double-layer grids are of special importance. They consist of two plane-parallel grids, not necessarily identical, forming the floor and ceiling of a structure. Vertical and inclined "web" members connect them in such a way that external loads are distributed omnidirectionally among numerous bars. Even under the pressures of a heavily concentrated load, members at a considerable distance share the load, so that the network exhibits a remarkably even stress distribution.

The author considers the two main types of double-layer grids: lattice grids, which make use of vertical interconnecting members; and true space grids, which consist of a combination of tetrahedra, octahedra, or inverted pyramids, having triangular, square, pentagonal, or hexagonal bases.

The MIT Press
Massachusetts Institute of Technology
Cambridge, Massachusetts 02142

Cover photograph: German Pavilion at Expo '67, designed by Frei Otto and Rolf Gutbrod.

Tensile Structures
Otto, editor

MIT 222

Tensile Structures
edited by Frei Otto

CHITECTURE HISTORY OF MODERN A
MENT LEONARDO BENEVOLO VOLUME 2 THE MODERN MOVEMENT LEONARDO BEN
EONARDO BENEVOLO VOLUME 2 THE MODERN MOVEMENT LEONARDO BENEVOLO
HISTORY OF MODERN ARCHITECTUF
BENEVOLO VOLUME 2 THE MODERN MOVEMENT LEONARDO BENEVOLO VOLUME
THE MODERN MOVEMENT LEONARDO BENEVOLO VOLUME 2 THE MODERN MOVEME
Y OF MODERN ARCHITECTURE HISTOF

What is modern architecture? When did it begin? It certainly concerns us all. Whether as architects, contractors, clients, or users of the finished product, we are all involved in the constantly changing aspects of our own surroundings.

Leonardo Benevolo shows that modern architecture was born of the technical, social, and cultural changes connected with the Industrial Revolution, and that it began in earnest with the emergence of the European city. He describes the basic line of thought and action in modern architecture, which began with Owen and the Utopians of the first half of the nineteenth century, passed through Ruskin and Morris and avant-garde European experiments, to the work of American builders and of Wright. This line of thought became generally established in the years immediately following 1916 through the work of Gropius and the Weimar school, and ultimately gave rise to a unified "modern movement" in architecture, with a potential for developments far greater than those promised by its original premises.

In Volume One of this history, Professor Benevolo describes the component parts of modern architectural thought up to 1914, and examines their origins. Volume Two is concerned with the modern movement itself, and with the work of architects such as Mies van der Rohe, Aalto, and Jacobsen, who, it is shown, have begun an experiment in architecture in which we are all involved and upon which our way of life depends.

This is a translation of the third edition of a major work by a distinguished teacher and a practicing architect.

THE AUTHOR
Leonardo Benevolo studied architecture in Rome, where he graduated in 1946. He was Professor of the History of Architecture in Rome from 1955 to 1960, and then in Florence until 1963, when he became Professor at the Faculty of Architecture in Venice. He has written several books on architecture, one of which, *The Origins of Modern Town Planning* (The MIT Press, 1967), may be read as a prelude to the present work as well as an independent contribution.

The MIT Press
Massachusetts Institute of Technology
Cambridge, Massachusetts 02142

BMA2

MIT PRESS

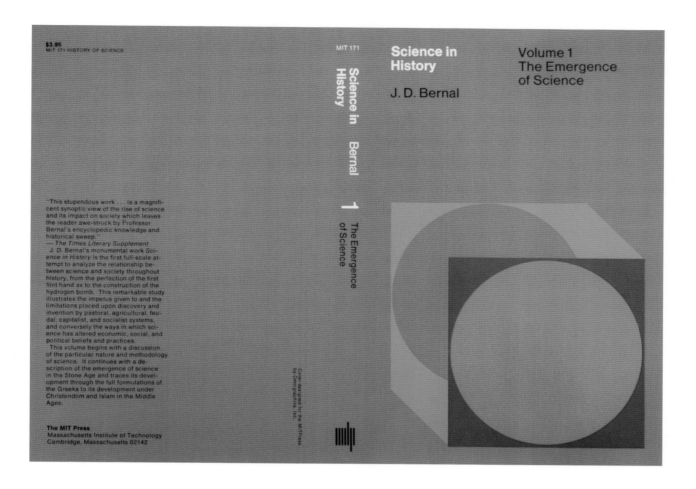

$3.95
MIT 171 HISTORY OF SCIENCE

MIT 171

**Science in
History**

J. D. Bernal

Volume 1
The Emergence
of Science

Science in Bernal History

1 The Emergence of Science

"This stupendous work . . . is a magnificent synoptic view of the rise of science and its impact on society which leaves the reader awe-struck by Professor Bernal's encyclopedic knowledge and historical sweep."
— *The Times Literary Supplement*
 J. D. Bernal's monumental work *Science in History* is the first full-scale attempt to analyze the relationship between science and society throughout history, from the perfection of the first flint hand ax to the construction of the hydrogen bomb. This remarkable study illustrates the impetus given to and the limitations placed upon discovery and invention by pastoral, agricultural, feudal, capitalist, and socialist systems, and conversely the ways in which science has altered economic, social, and political beliefs and practices.
 This volume begins with a discussion of the particular nature and methodology of science. It continues with a description of the emergence of science in the Stone Age and traces its development through the full formulations of the Greeks to its development under Christendom and Islam in the Middle Ages.

The MIT Press
Massachusetts Institute of Technology
Cambridge, Massachusetts 02142

Cover designed for the MIT Press by Omnigraphics, Inc.

$3.95
MIT 173 HISTORY OF SCIENCE

MIT 173

**Science in
History**

J. D. Bernal

Volume 3
The Natural
Sciences
in Our Time

Science in Bernal History

3 The Natural Sciences in Our Time

"This stupendous work . . . is a magnificent synoptic view of the rise of science and its impact on society which leaves the reader awe-struck by Professor Bernal's encyclopedic knowledge and historical sweep."
— *The Times Literary Supplement*
 J. D. Bernal's monumental work *Science in History* is the first full-scale attempt to analyze the relationship between science and society throughout history, from the perfection of the first flint hand ax to the construction of the hydrogen bomb. This remarkable study illustrates the impetus given to and the limitations placed upon discovery and invention by pastoral, agricultural, feudal, capitalist, and socialist systems, and conversely the ways in which science has altered economic, social, and political beliefs and practices.
 Volume 3 is devoted entirely to the twentieth century and the remarkable growth of scientific thought which has occurred in modern times — from the new sciences of nuclear physics and electronics to discoveries and advances in biology and related fields.

The MIT Press
Massachusetts Institute of Technology
Cambridge, Massachusetts 02142

Cover designed for the MIT Press by Omnigraphics, Inc.

Teaching

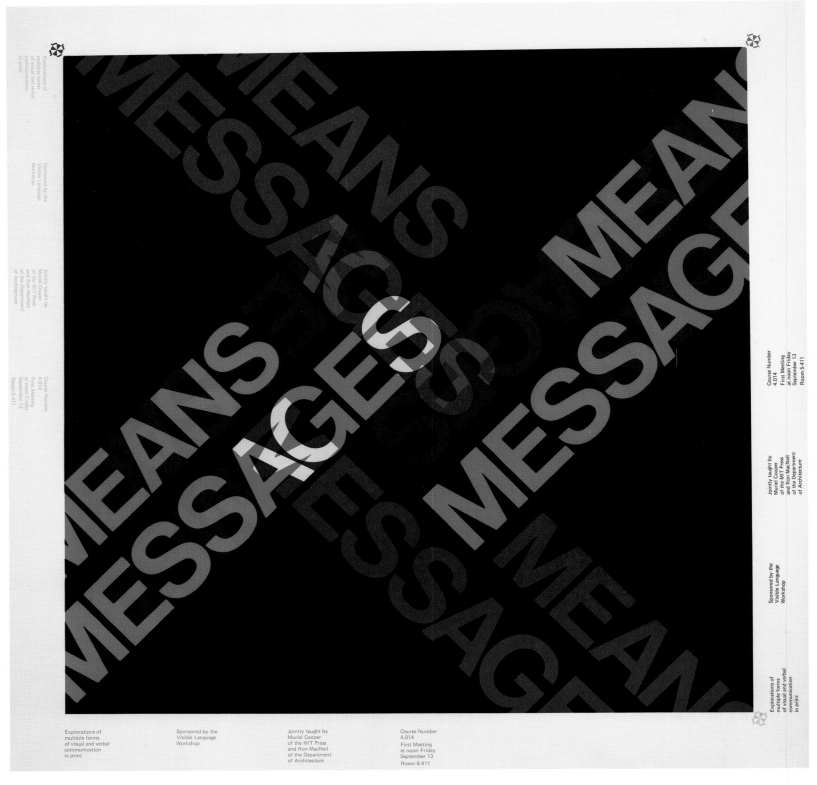

Messages and Means course poster, Muriel Cooper
and Ron MacNeil, 1974

Poster for "Music in Public Places," MIT Design Services,
printed at the Visible Language Workshop, c. 1974

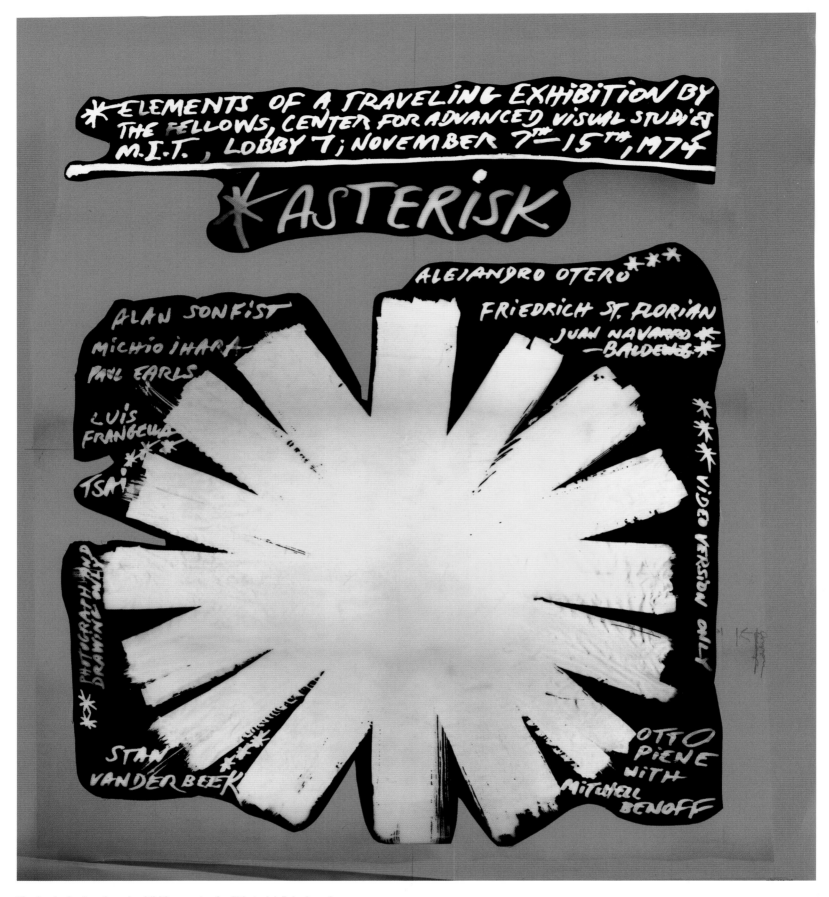

Mechanical artwork and exhibition poster for "*Asterisk," designed
by Otto Piene, printed at the Visible Language Workshop, 1974

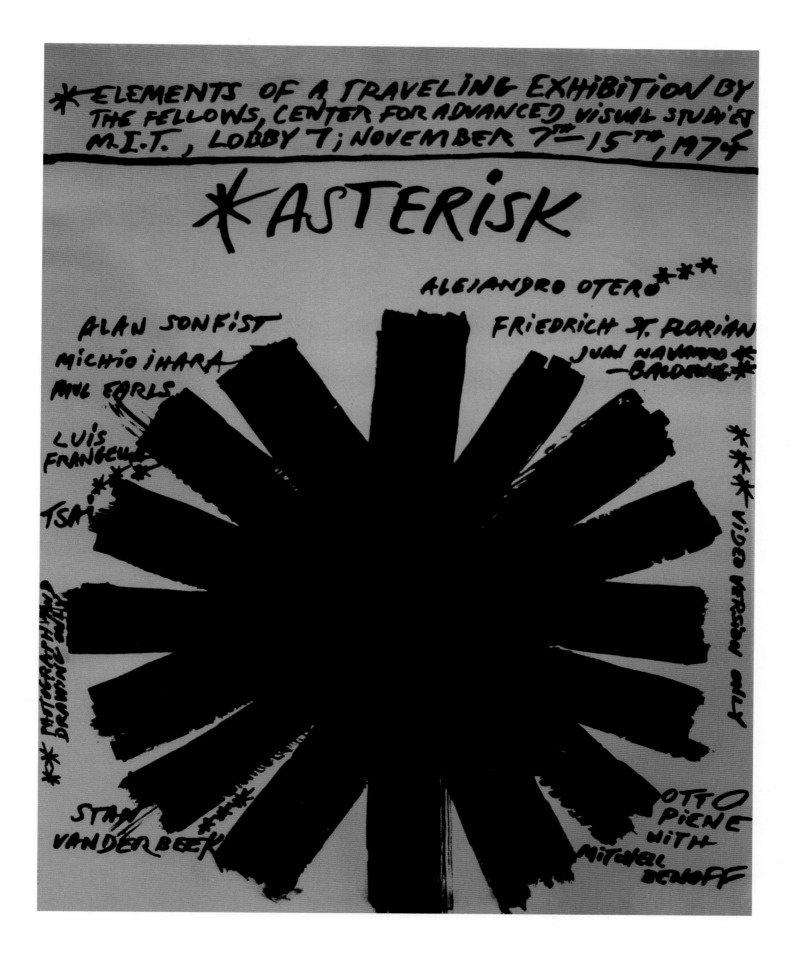

*ELEMENTS OF A TRAVELING EXHIBITION BY THE FELLOWS, CENTER FOR ADVANCED VISUAL STUDIES M.I.T., LOBBY 7; NOVEMBER 7th—15th, 1974

*ASTERISK

ALEJANDRO OTERO***

ALAN SONFIST

MICHIO IHARA

PAUL EARLS

LUIS FRANGELLA

TSAI

FRIEDRICH ST. FLORIAN

JUAN NAVARRO BALDWEG*

*** VIDEO VERSION ONLY

** PHOTOGRAPH DRAWING ONLY

STAN VANDERBEEK

OTTO PIENE WITH MITCHEL BENOFF

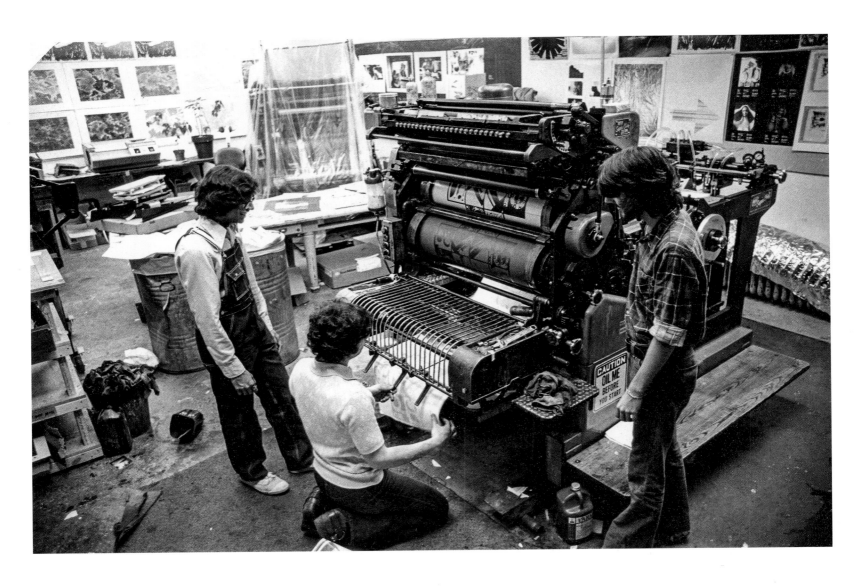

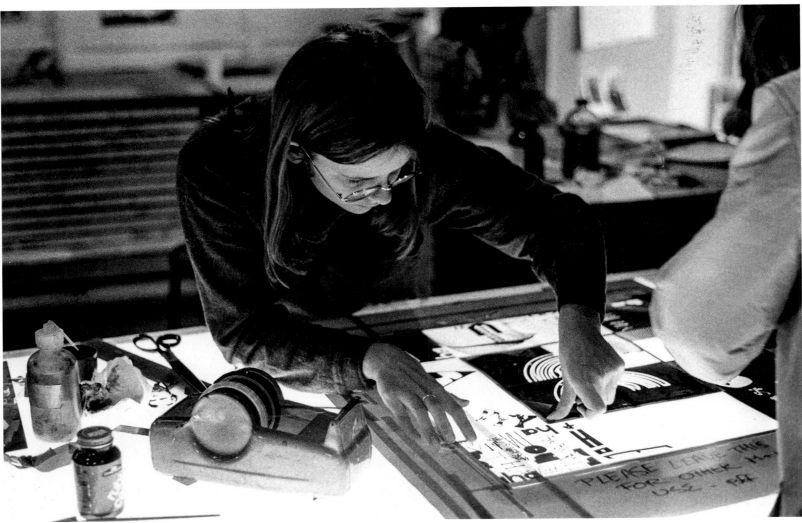

Messages and Means students in Building 5 workshop,
Department of Architecture, c. 1975

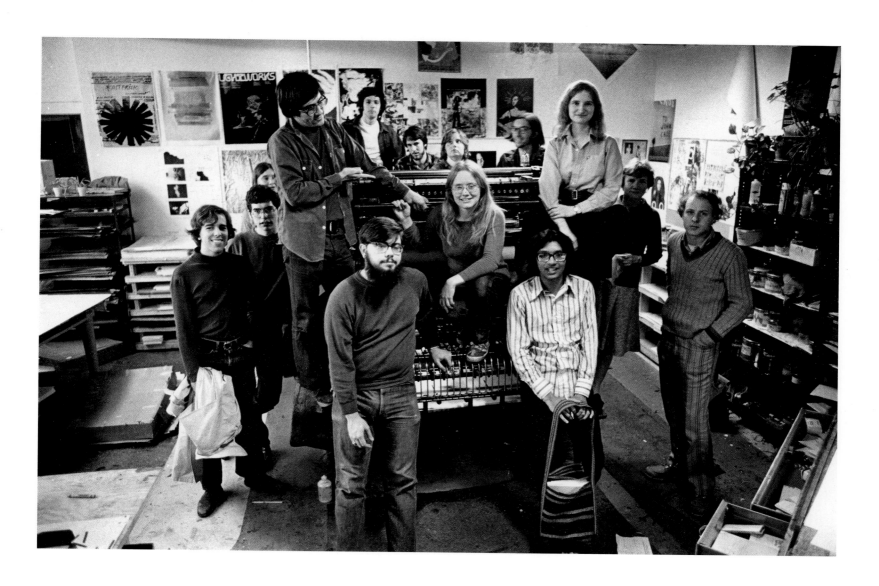

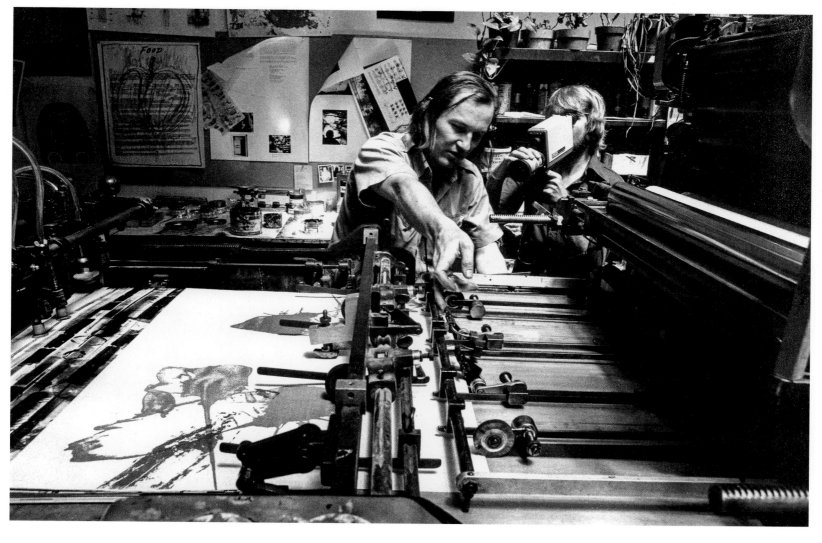

Teaching 115

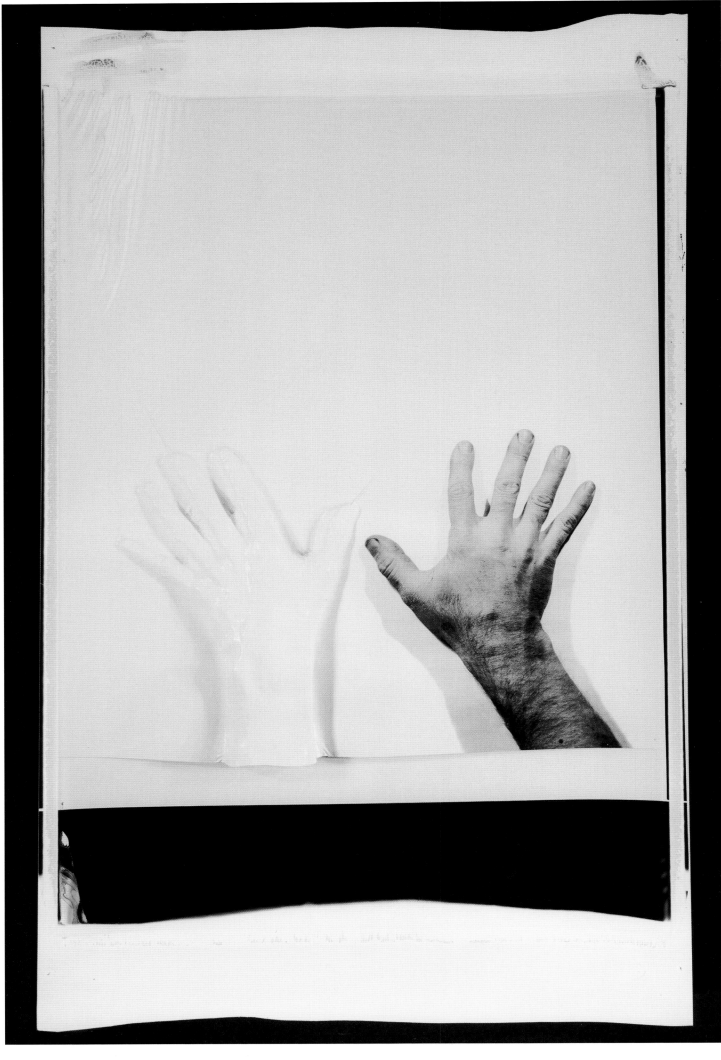

Ron MacNeil, Polaroid hand print, c. 1976

Teaching

Visible Language Workshop diazotype, c. 1976

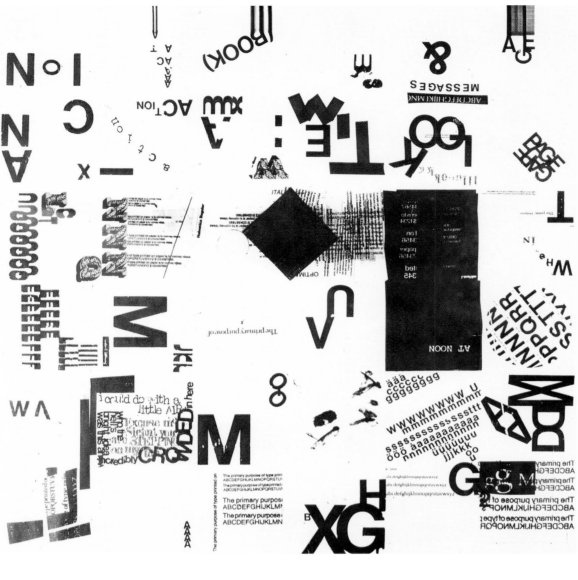

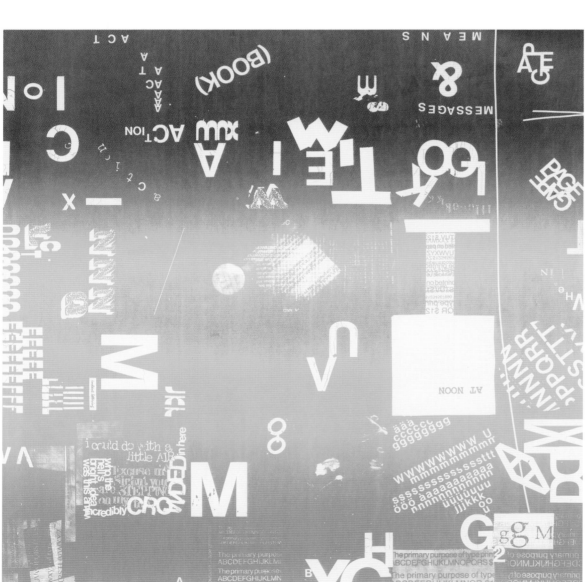

Teaching

Messages and Means student rotation prints, 1970s

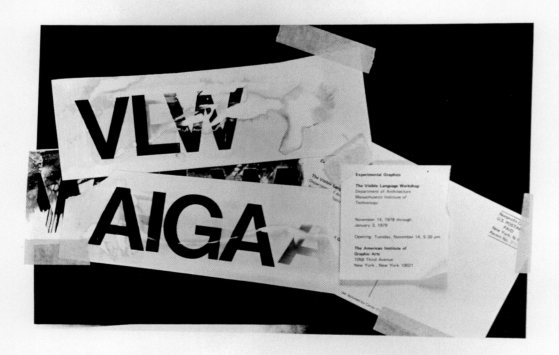

Visible Language Workshop

The electronic revolution has broken traditional definitions of the disciplines of photography, printmaking, graphic design and the graphic arts. Reproduction technologies and media proliferate, influencing both information transfer and artistic expression.

The Visible Language Workshop, a unique interdisciplinary graphics laboratory, was founded to explore verbal and visual communication as information and as art on both personal and public levels. The synthesis of concept and production processes is informed by tradition and technology.

The workshop environment is enriched by people from many disciplines—visiting artists, working professionals, guest lecturers and students with diverse backgrounds—and by innovative educational offerings—seminars, mini-courses, workshops and collaborations with other Arts groups, MIT departments and the community. MIT's Department of Architecture provides a context of architectural and visual concerns in film, video, photography, computer graphics, environmental art and history. MIT of course, offers unparalleled resources for advanced research.

The VLW facility includes traditional reproduction methods—offset and letterpress printing, silkscreening, gum printing, silver and non-silver photography as well as handset and computer composition. Electrographic tools such as color Xerox, video and electronics are used as integral media.

Research at the VLW has ranged from color Xerox to video imaging, from concrete poetry to photographic narrative interpreted through offset lithography, from computer-generated color separations for print to mixed media printing, from large-scale, computer-manipulated words and images to limited edition and experimental book design and publishing.

Independent collaborations occur on many levels. They include proposed research with the Architecture Machine in Books Without Pages, the production of print documentation of CAVS fellows' video research and graphic presentation of architecture and planning concepts.

Education at the VLW

Education at the VLW is holistic. The multiplicity of concerns requires the discipline of synthesis. Its major offerings are designed to provide entry, conceptual and technical, for both inexperienced and experienced students. Concentrated study in graphics, graphic design or printmaking is possible. Intermediate, advanced and graduate credits are offered.

The Department of Architecture is currently considering the inclusion of concentrations in graphics and photography in the Master of Science in Visual Studies Program. A decision is expected in time to allow applications for admission for September 1979 to be made by January 15, 1979.

Informal Offerings

The Independent Activities Period (IAP) has become the focus for many experimental and educational probes from portrait drawing to computer-generated imaging. Workshops, mini-courses and lecture series enhance the curriculum.

Photographics A research, experiment and print production course, using a wide variety of print processes and technologies, both traditional and innovative.

Experimental Color Imaging A production-based exploration of color theories and methods and experimental manipulation, synthesis and combinatory color imaging.

Messages and Means An examination of multiple forms of visual and verbal information in print, concentrating on the offset production of experimental print forms.

Typographics The study of traditional and experimental typography, the visual role of words in personal and public communication and the influence of its technologies on form and content.

In addition, two collaborative subjects are offered by the Creative Photography Laboratory and the VLW. The Graduate Seminar in which presentation and criticism of advanced work culminates with a student-implemented exhibit; and Total Exposure an undergraduate course introducing photography and graphics as separate and shared concerns.

Staff

Muriel Cooper, Associate Professor
Ron MacNeil, Assistant Professor
Joel Slayton, Workshop Co-ordinator

Information

About the VLW, please contact:
Muriel Cooper, director
Visible Language Workshop
Room 5-411
Massachusetts Institute of Technology
Cambridge, Massachusetts
02139
(617) 253-4416

About degree programs, please contact:
Department of Architecture
Room 7-303
Massachusetts Institute of Technology
Cambridge, Massachusetts
02139
(617) 253-7791

Produced at the Visible Language Workshop
Paper donated by Carter Rice Storrs & Bement

Posters announcing the exhibition "Experimental Graphics" at the American Institute of Graphic Arts, New York, by Wendy Richmond and Joel Slayton, 1978

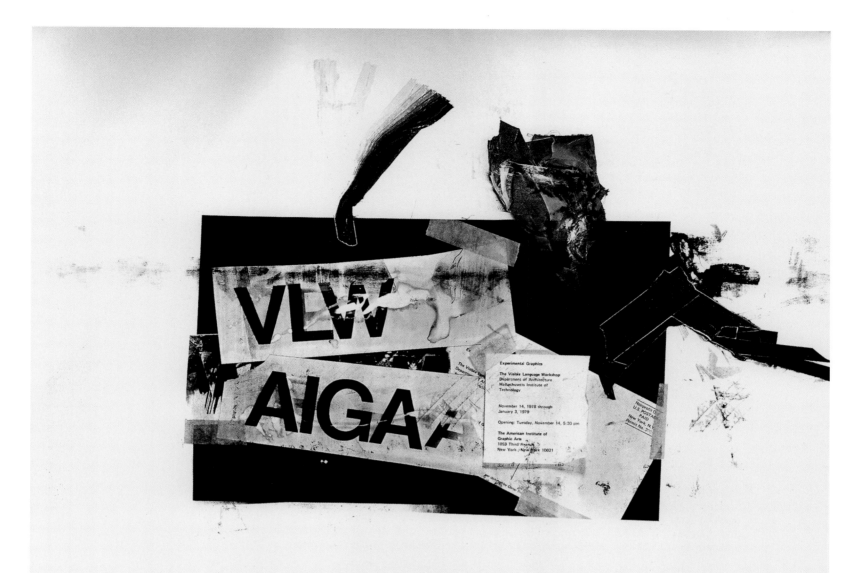

Visible Language Workshop

The electronic revolution has broken traditional
definitions of the disciplines of photography, print-
making, graphic design and the graphic arts. Repro-
duction technologies and media proliferate, influ-
encing both information transfer and artistic expres-
sion.

The Visible Language Workshop, a unique inter-
disciplinary graphics laboratory, was founded to
explore verbal and visual communication as infor-
mation and as art on both personal and public
levels. The synthesis of concept and production
processes is informed by tradition and technology.

The workshop environment is enriched by people
from many disciplines—visiting artists, working
professionals, guest lecturers and students with
diverse backgrounds—and by innovative educa-
tional offerings—seminars, mini-courses,
workshops and collaborations with other Arts
groups, MIT departments and the community.

MIT's Department of Architecture provides a
context of architectural and visual concerns in film,
video, photography, computer graphics, environ-
mental art and history. MIT, of course, offers
unparalleled resources for advanced research.

The VLW facility includes traditional reproduc-
tion methods—offset and letterpress printing, silk
screening, gum printing, silver and non-silver
photography as well as handset and computer
composition. Electrographic tools such as color
Xerox, video and electronics are used as integral
media.

Research at the VLW has ranged from color
Xerox to video imaging, from concrete poetry to
photographic narrative interpreted through offset
lithography, from computer-generated color separa-
tions for print to mixed media printing, from large-
scale, computer-manipulated words and images to
limited edition and experimental book design and
publishing.

Independent collaborations occur on many levels.
They include: proposed research with the Architec-
ture Machine in Books Without Pages, the produc-
tion of print documentation of CAVS fellows' video
research and graphic presentation of architecture
and planning concepts.

Education at the VLW

Education at the VLW is holistic. The multiplicity of
concerns requires the discipline of synthesis. Its
major offerings are designed to provide entry, con-
ceptual and technical, for both inexperienced and
experienced students. Concentrated study in
graphics, graphic design or printmaking is possible.
Intermediate, advanced and graduate credits are
offered.

The Department of Architecture is currently con-
sidering the inclusion of concentrations in graphics
and photography in the Master of Science in Visual
Studies Program. A decision is expected in time to
allow applications for admission for September
1979 to be made by January 15, 1979.

Photographics A research, experiment and print
production course, using a wide variety of print
processes and technologies, both traditional and
innovative.

Experimental Color Imaging A production based
exploration of color theories and methods and
experimental manipulation, synthesis and com-
binatory color imaging.

Messages and Means An examination of multiple
forms of visual and verbal information in print, con-
centrating on the offset production of experimental
print forms.

Typographics The study of traditional and experi-
mental typography: the visual role of words in per-
sonal and public communication and the influence
of its technologies on form and content.

In addition, two collaborative subjects are offered by
the Creative Photography Laboratory and the VLW.
The Graduate Seminar in which presentation and
criticism of advanced work culminates with a
student-implemented exhibit, and **Total Exposure**
an undergraduate course introducing photography
and graphics as separate and shared concerns.

Informal Offerings

The Independent Activities Period (IAP) has become
the focus for many experimental and educational
probes from portrait drawing to computer
generated imaging. Workshops, mini-courses and
lecture series enhance the curriculum.

Staff

Muriel Cooper, Associate Professor
Ron MacNeil, Assistant Professor
Joel Slayton, Workshop Co-ordinator

Information

About the VLW, please contact
Muriel Cooper, director
Visible Language Workshop
Room 5-411
Massachusetts Institute of Technology
Cambridge, Massachusetts
02139
(617) 253-4416

About degree programs, please contact
Department of Architecture
Room 7-303
Massachusetts Institute of Technology
Cambridge, Massachusetts
02139
(617) 253-7791

Produced at the Visible Language Workshop
Paper donated by Carter Rice Storrs & Bement

The Visible Language Workshop is a new enterprise
formed in January, 1974 for conducting the teaching, practice and research
in the verbal, graphic and imagistic arts.
Its organization is a collaborative venture among the
MIT Departments of Architecture and Humanities, and the MITPress.

Its purpose is to provide participatory creative and analytic work
that is shared by teacher and student,
by professional and apprentice,
by artist and technician
in a disinterested association between younger and older minds.

Its means to this end is publication in a variety of forms.

The special projects ranged from the production of limited editions
of fine prints, through the printing of several books of poetry
and the exploration of non-traditional modes of architectural presentation
to the designing and printing of a wide variety of publicity and poster material.

The two courses emphasized experimental conception and visual design.

Words and Images taught jointly by Patricia Cumming of the Humanities Department
and Jonathan Green of the Creative Photography Laboratory explored in theory and
in production content, emotion and imagery in poetry and photography.
Each student in this course produced in small edition a highly individualistic
publication. These ranged from the traditional signature bound book to
origami-like folded printed forms.

Messages and Means taught jointly by Muriel Cooper of the MITPress
and Ron McNeil of the VLW concentrated on designing in process and on the
creative uses of reproduction technology in visual and verbal design for
communication. Methods were developed to reduce the real-time gap between
concept and visualization. A unique rotational system produced a rich
vocabulary of offset prints, and the equivalents of four color printing with only
one plate. Through overprinting, quick color shifts on offset rollers enabled
students to interact responsively with the press and the image.

Visible Language Workshop descriptions, c. 1979

The existence of the VLW has generated printing interests from a wide variety of areas.
Besides a range of students from many departments, last spring the Workshop was used by faculty members from
Architecture, Humanities, Photography, CAVS, Design Services, and several visiting artists.

To meet the demands for use of the offset printing facilities, additional instructors, and
UROP and work study students were added to the staff.

The VLW now owns or has direct access to the following printing and reproductive machinery:
full color offset press, etching press, letterpress, Itek machines, 3M color on color machine,
IBM, staromat and foundry composition, full size copy camera and stabilization processor,
full size xenon source vacuum frame.

Practical production, the publishing of a variety of work by the Workshop's participants
and other groups at MIT, will be the cornerstone against which course work will be sharpened
and from which it will gain its edge.

All too often, teaching and learning stop at the classroom door.

When students complain about the lack of relevance in their studies
what they are really saying is that class exercises for their own sake are not enough.
They want seriousness.

Publication.
The presentation of work in the real world, is what makes that work serious.

The potential of technology for the making of art works is badly explored.
With the exception of art history research, the relation of technology and the arts has been empirical.

The chance to engage in making what is new by new means offers
in addition to what is made, the chance for genuine research contributions
in the exploration and exploitation of technology in the service of verbal and visual communication arts.

This aspect of the VLW's program will allow students to share in the research
upon which to a large degree, good teaching and learning depend
and to teach their teachers as well as be taught by them.

The Visible Language Workshop is an experimental graphics hands-on workshop with educational, research and professional programs.

It is a multi-disciplined group of users and makers concerned with the content, quality, and technology of visual and verbal communication in print.

The faculty, staff and students (graduates and undergraduates) include graphic designers, writers, engineers, computer scientists, printmakers and photographers.

The VLW is set in the context of the new Arts and Media Technology program in the Department of Architecture at MIT and shares the cumulative benefits of MIT's research history and programs.

Our own research in computer graphics and electrographics stems from the using and making of interactive graphic tools for print and experiments in reduction of real-time visualization between concept and product.

The first sponsored research at the VLW was to develop an interactive full color computergraphic system to drive a large, variable scale remote full color xy plotter for outdoor advertising.

This has resulted in a facility, system, staff and experience which is especially relevant to complex graphic arts soft- and hardware issues and has pointed up further directions worthy of continued research.

These directions fall under the rubric of interactive full color page makeup in both the design and production environment. Subsets, in the soft- and hardware areas, include text and image manipulations, font digitization for soft and hard copy, low cost instant color proofing, variable resolution and size, color separation and printing.

In the systems area are long-term complex issues of tutorial and user/machine relationships.

The facility includes a Perkin-Elmer computer system with a 3220 Processor, a 256K memory and a 300 Megabyte disc, a Grinnel image buffer with three overlay planes and a 2000 x 7000 point Reticon digital scanner.

Together, they provide powerful computing, storage and graphic manipulation capabilities.

The software, written in high level PLI and Assembler, enables fast changes. The operating system, modeled after Multics, is Magic 6, developed at the MIT Architecture Machine.

The system makes the development of complex ideas easy, fast and economical. It can, therefore, be used as a modeling tool for testing and developing algorithms for tandem implementation with our microcomputer development system to determine what components might be hardware, software or microcode, and where the quality/cost tradeoffs occur.

Teaching

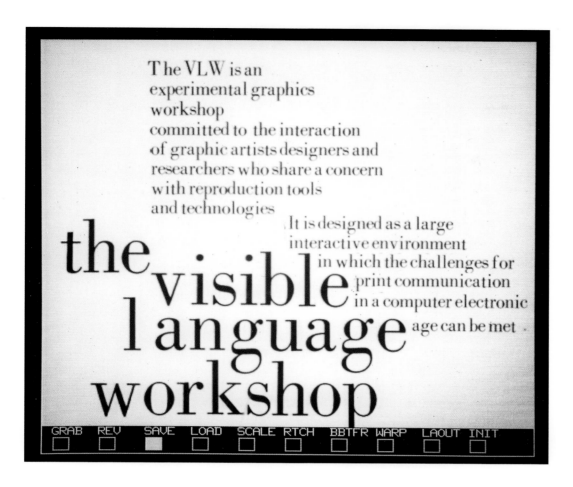

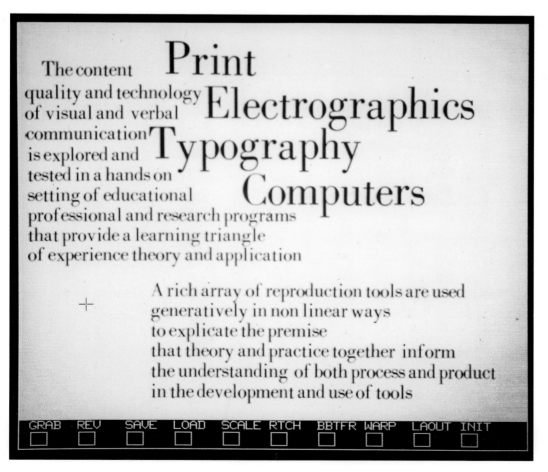

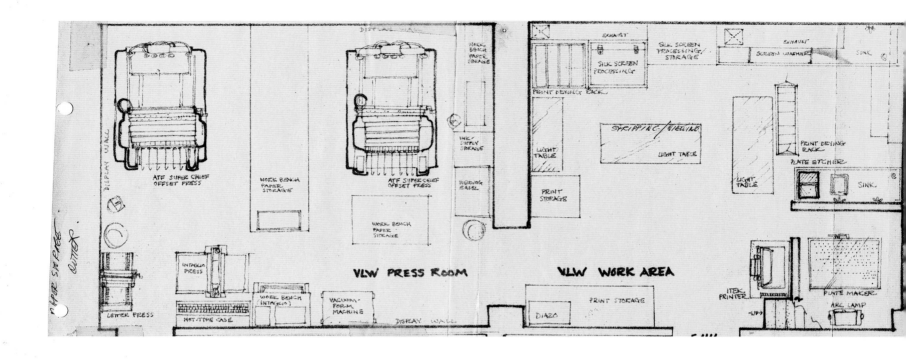

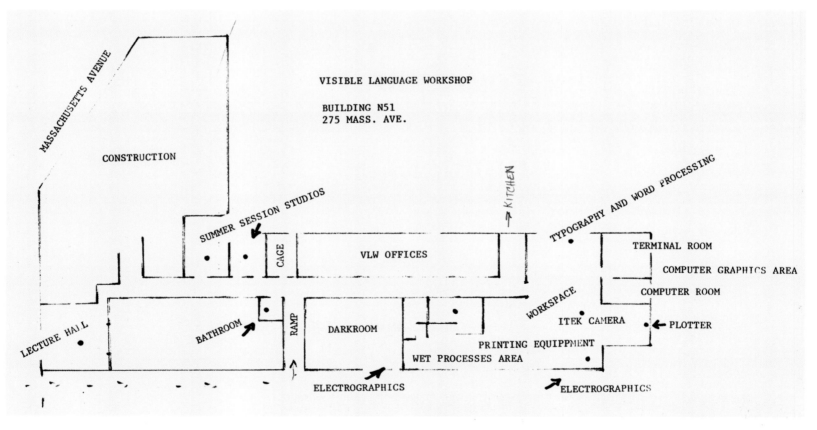

Floor plans of Visible Language Workshop in Building 5, 1976,
and the VLW's new space in Building N51, c. 1980

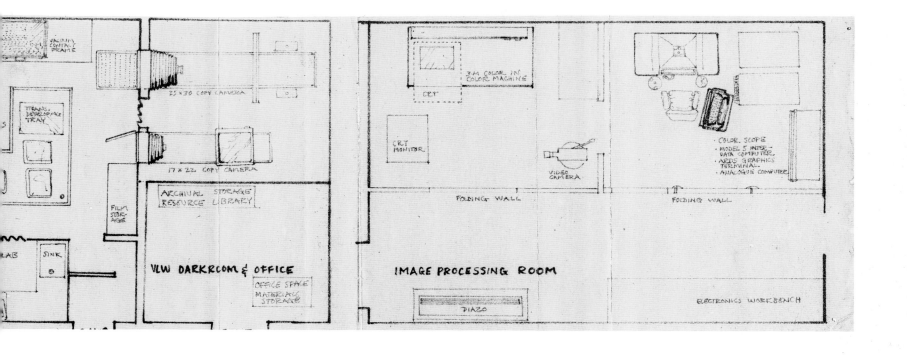

VLW DARKRCOM & OFFICE

IMAGE PROCESSING ROOM

Visible Language Workshop

Spring 1980

**Words, Images,
Graphics Tools
and Ideas
4.868**

Special Problems
in Graphic Communication

An introduction to the spectrum of graphics ideas and tools available at the Visible Language Workshop in communication, print and computergraphics.

It is designed to familiarize the student with ways of seeing, thinking and communicating in visual and verbal modes through the development and use of graphic languages and enabling tools—mechanical photo-mechanical and electronic.

Lectures, demonstrations and hands-on workshops will stress image making, making ideas visible, perception and personal response, photographic vision, image generation and processing, media communication, synthesis and communication visual poetry, messages and means and public communication through the use of print, reproduction tools, experimental photography and darkroom explorations, electrographics, visual poetry, typography, computer generated imagery and two and three dimensional environmental image making tools.

Class projects and assignments as well as midterm and final presentation.

Work is developmental as well as sequential and attendance is mandatory.

(A lab fee will be charged.)

0.9.0
Droege, Slayton
Thursday 7-10
Section TBA
Room 5-411

**Messages and Means
4.873**

2.4.6
Muriel Cooper
Lectures: Tuesday evening, 7-10 pm in 5-411

**Photo-Graphics
4.871**

2.4.6
Peter Droege
Monday and Wednesday, 7-10 pm in 5-411

**Graphic Workshop
4.878B**

Special Problems
in Graphic Design

This year the VLW will offer a series of three five-session graphics workshops.

These workshops are designed as intensive workshops to familiarize students with process and support or current VLW subjects.

Module I. Hand Processing Feb. 8 - March 7
Graphics Arts Darkroom, Silkscreen, Blue and Brown print, Kwik print magazine transfer on cloth and paper. Project will give a fabric wall hanging containing all processes.

Module II Typography and Print March 14 - April 18
Graphic Arts Darkroom
Typography, Letterpress, Offset and simple binding. Project will be a group calendar using all the processes.

Module III April 25 - May 16
Graphic Arts Darkroom, Papermaking, Electrographics, Bookbinding. Project will give a book including all processes.

The student may take one, two, or all three modules.

Enrollment through permission of instructor.

(A lab fee will be charged.)

0.9.0
Blacklow
3 Modules
3 Units each
Friday 9:30-1
Room 5-411

**Visual Communication
Workshop
4.878A**

Special Problems
in Graphic Design

This workshop is planned in three phases. The first emphasis analysis and use of visual design principles and motion of visual thinking and includes drawing, typography, color and image organization.

The second phase concentrates on the development of perceptive and communicative skills based on issues, as expressed through media including diagrams, maps (some computer graphics) photography, video and printed matter.

Lectures, workshops, demos, fieldtrips will be supplemented by key readings and short assignments and individual and final projects which may be slide show, photo essay printed report or other coordinated visual presentation.

(A lab fee will be charged.)

2.4.6
Droege
Monday-Wednesday 9:30-11
Section TBA
Room 5-411

**Electrographics
4.886B**

Approaches to Visual
Communication

An advanced workshop based on the technologies, processes and image making potential of electrographic tools.

Creative empathy with machines and tools is requisite to resolve technical and traditional aesthetics of these tools into a personal and cohesive product.

Lectures, demos, visiting artists will cover major issues. Research and personal graphic work will go on throughout. Students will be expected to contribute their findings to the existing body of research. Documentation will be compiled.

Topics to be covered include:
basic processes—xerography, thermography, electrophotography, color in color, diazo and include some video and computer image generation, telecopiers. Machine to machine and machine to person interactions. Issues of reproduction and original, generative visualization and static edition. Instant books, two dimensions and beyond, and social implications of these communication changes.

(A lab fee will be charged.)

0.9.0
Holmes/Norton
Thrusday 7-10
Section TBA
Room 5-411

**Advanced Workshop
4.886A**

Approaches to Visual
Communication

A production based workshop designed for intermediate and advanced students who are ready to investigate and test new methods of image generation to express serious personal communication concerns.

Emphasis will be on depth, quality and realization of concept and product through awareness and evaluation of the psychological and physical world synthesized with visual communication skills and appropriate media and related to historical, theoretical and critical frameworks.

The workshop will consist of lectures, field trips, visits by practitioners and monthly reviews by VLW faculty and visiting critics. Work will include on going assignments and students will be responsible for developing three major projects or their equivalent in consultation with the workshop leader and a faculty advisor.

(A lab fee will be charged.)

2.4.6
Slayton
Monday 7-10
Section TBA
Room 5-411

**Edges of Research,
Art and Education
4.889**

Special Projects
of Graphic Communication

An advanced seminar designed to explore interaction between research, art and education. Guest lecturers from MIT particularly will present work which attempt synthesis. The substance of the discussions will involve reports on actual research, the psychological and philosophical intention, and the reality of experience in the making of art and in learning. Student participation and response will take the form of documentation and final presentations.

cancelled/ fall 80

0.9.0
Cooper/MacNeil
Wednesday 12-4
Section TBA

Visible Language Workshop course catalog, Spring 1980

Muriel

is crazy. She's pounding away at the keyboard of a fifth generation, laser-output, electrostatic, computer-driven, digitized phototypesetter that doesn't work. But that's okay. This is a research environment and the tools aren't supposed to work. You're supposed to work. Besides, if you're not making mistakes you probably aren't learning anything. And if you can't make enough mistakes to learn anything there's nothing like a broken machine to help you along. Muriel runs this place or should we say (after that last thought), this place runs her. So if you want to get involved you should listen to her closely.

Inventory print portfolio, produced by Nathan Felde and Francis Olschafskie at the Visible Language Workshop, 1980

VISIBLE LANGUAGE WORKSHOP

Visible Language Workshop
letterhead with paste-up dummy,
design by Ralph Coburn and MIT
Design Services, c. 1977

Visible Language Workshop
Room N51-138
Massachusetts Institute of
Technology
275 Massachusetts Avenue
Cambridge, Massachusetts
02139

Visible Language Workshop
Room 5-411
Massachusetts Institute of
Technology
Cambridge, Massachusetts
02139

September 1979

The electronic revolution has broken traditional definitions
of the disciplines of photography, print-making, graphic
design and the graphic arts. Reproduction technologies and
media proliferate, influencing both information transfer
and artistic expression.

The Visible Language Workshop, a unique interdisciplinary
graphics laboratory, was founded to explore verbal and
visual communication as information and as art on both
personal and public levels. The synthesis of concept and
production processes is informed by tradition and technology.

The workshop environment is enriched by people from many
disciplines--visiting artists, working professionals,
guest lecturers and students with diverse backgrounds--
and by innovative educational offerings--seminars, mini-
courses, workshops and collaborations with other Arts
groups, MIT departments and the community.

MIT's Department of Architecture provides a context of
architectural and visual concerns in film, video, photography,
computer graphics, environmental art and history. MIT,
of course, offers unparalleled resources for advanced
research.

The VLW facility includes traditional reproduction methods--
offset and letterpress printing, silk-screening, gum printing,
silver and non-silver photography, as well as handset and
computer composition. Electrographic tools such as color
Xerox, video and electronics are used as integral media.

Visible Language Workshop
Room 5-411
Massachusetts Institute of
Technology
Cambridge, Massachusetts
02139

Visible Language Workshop
Room N51-138
Massachusetts Institute of Technology
Cambridge, Massachusetts 02139
(617) 253-4416

Muriel Cooper
Director, Professor of Graphics

Ronald MacNeil
Professor of Graphic Research

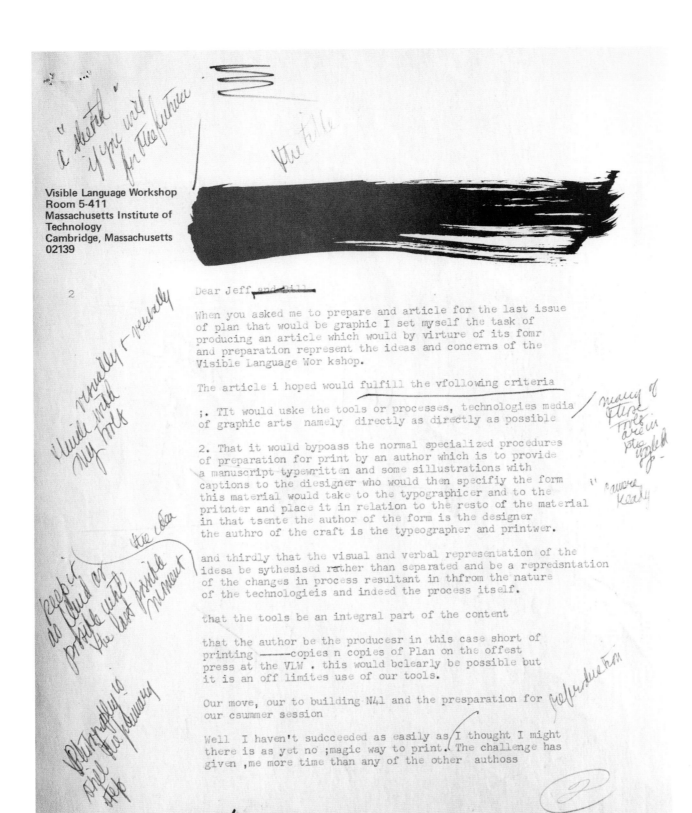

Visible Language Workshop
Room 5-411
Massachusetts Institute of
Technology
Cambridge, Massachusetts
02139

2

Dear Jeff, and Bill

When you asked me to prepare and article for the last issue
of plan that would be graphic I set myself the task of
producing an article which would by virture of its fomr
and preparation represent the ideas and concerns of the
Visible Language Wor kshop.

The article i hoped would fulfill the vfollowing criteria

;. TIt would uske the tools or processes, technologies media
of graphic arts namely directly as directly as possible

2. That it would bypoass the normal specialized procedures
of preparation for print by an author which is to provide
a manuscript typewritten and some sillustrations with
captions to the diesigner who would then specifiy the form
this material would take to the typographicer and to the
pritnter and place it in relation to the resto of the material
in that tsente the author of the form is the designer
the authro of the craft is the typeographer and printwer.

and thirdly that the visual and verbal representation of the
idesa be sythesised rather than separated and be a repredsntation
of the changes in process resultant in thfrom the nature
of the technologieis and indeed the process itself.

that the tools be an integral part of the content

that the author be the producesr in this case short of
printing ------copies n copies of Plan on the offest
press at the VLW . this would bclearly be possible but
it is an off limites use of our tools.

Our move, our to building N41 and the presparation for
our csummer session

Well I haven't sudccceeded as easily as I thought I might
there is as yet no ;magic way to print. The challenge has
given ,me more time than any of the other authoss

ee/Bill Por

Annotated draft and printed copy of Muriel Cooper and Visible
Language Workshop, "Words, Images, Tools and Ideas," Plan:
Review of the MIT School of Architecture and Planning, no. 11
(1980): 105–116.

July 15, 1980

Jeffrey L. Cruikshank
Editor, Plan
School of Architecture & Planning
MIT, 7-233

Visible Language Workshop
Room 5-411
Massachusetts Institute of
Technology
Cambridge, Massachusetts
02139

Dear Jeff:

When you asked me to prepare an article for Plan, I set myself the
task of producing a "graphic" article which would represent the
ideas and concerns of the Visible Language Workshop by virtue of
its form as well as its content.

In a computer electronic age we see print communication as a model
of changing user/maker relationships and the workshop as a place
in which the content, quality and technology of communication inform
each other in education, professional and research programs.

The article, "Words, Images, Tools and Ideas" would try to fulfill
the following criteria:

1. It would make use of the tools, processes and technologies of
graphic arts media as directly as possible and the tools would be
integrated with concept and product. Many of these are in the
workshop. In this case, they include a heavy use of all forms of
photography and our computer graphics system for both images and
typography.

2. The author would be the maker contrary to the specialization
mode which makes the author of the content the author, the author
of the form the designer, and the author of the craft the typo-
grapher/printer.

3. Visual and verbal representation of the ideas would be
synthesized rather than separate.

4. Time would remain as fluid and immediate as possible, leaving
room for feedback and change.

Much of the material was developed together with Professor Ron MacNeil
and the VLW staff. It has been a fascinating opportunity which has
elucidated many of the complexities of authorship into print. There
is still no magic way - but we propose to keep working at it.

This stands as a sketch for the future.

Best wishes,

Professor Muriel Cooper
Director

Teaching

The image within contains the following text:

There is a new
apple
in the Garden of Eden

Hopefully
at the core
are not only
the seeds of
knowledge
but of truth
beauty and
humanity

Apple

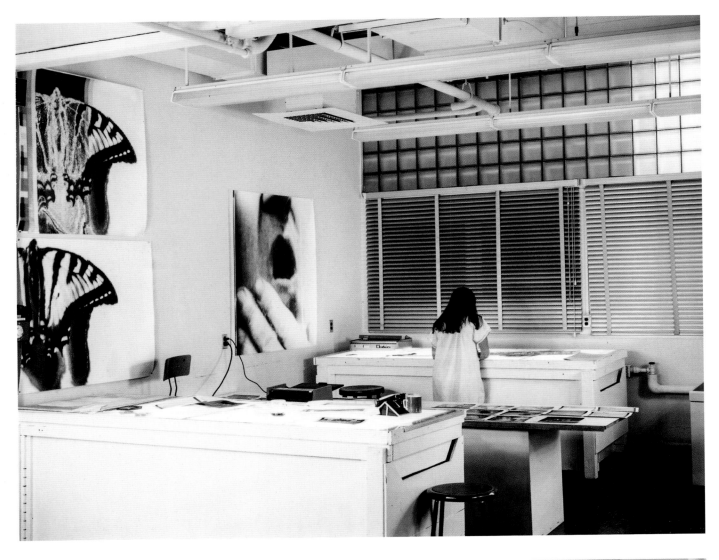

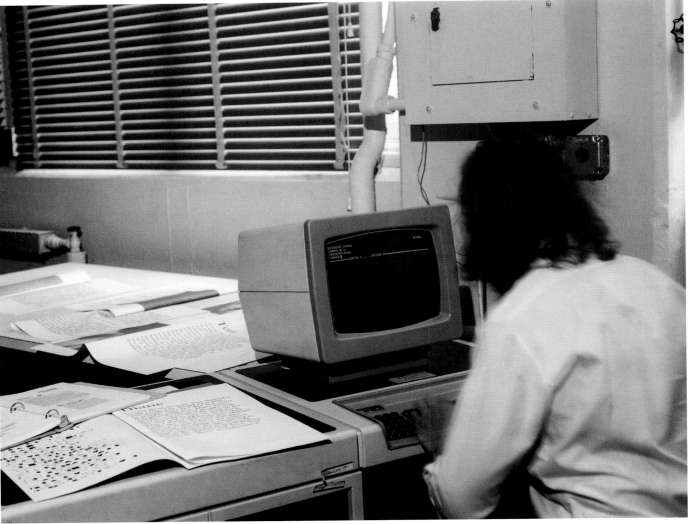

Visible Language Workshop in Building N51, c. 1980

Teaching

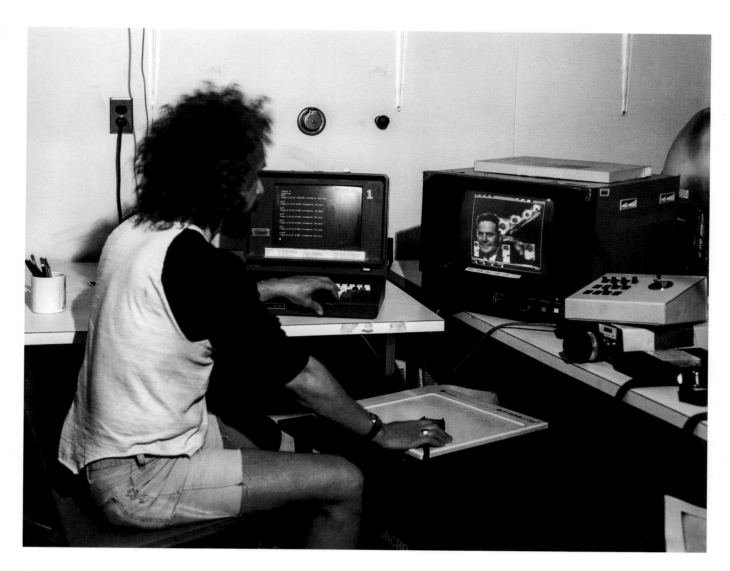

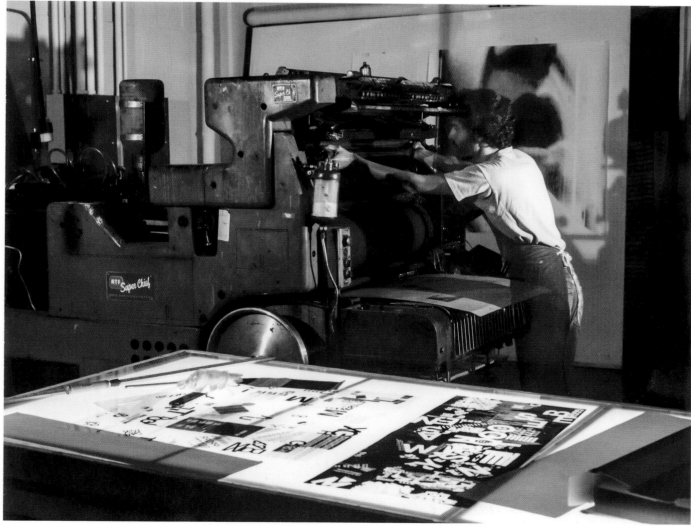

Teaching

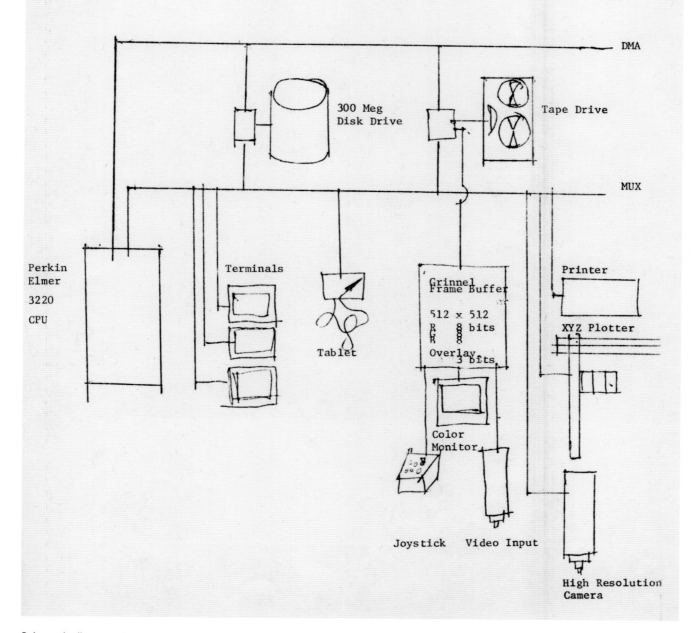

VLW Full Color Interactive System

11.12.80

DMA

300 Meg
Disk Drive

Tape Drive

MUX

Perkin
Elmer

3220

CPU

Terminals

Tablet

Grinnel
Frame Buffer

512 x 512
R 8 bits
G 8 bits

Overlay
3 bits

Printer

XYZ Plotter

Color
Monitor

Joystick Video Input

High Resolution
Camera

**Schematic diagram of electronic image manipulation and
output system at the Visible Language Workshop, 1980**

Ron MacNeil at computer with Airbrush Plotter, c. 1981

Teaching

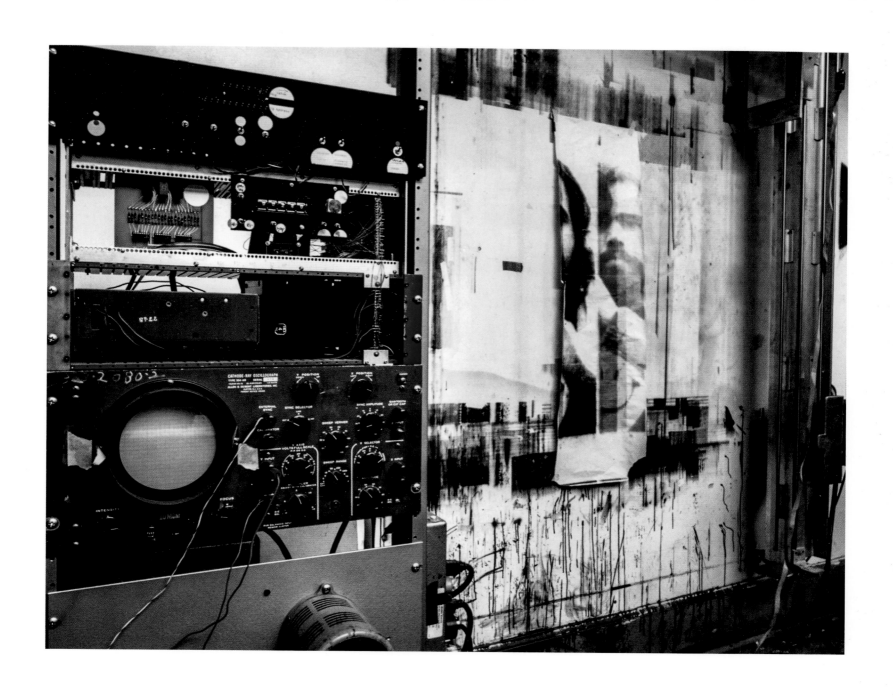

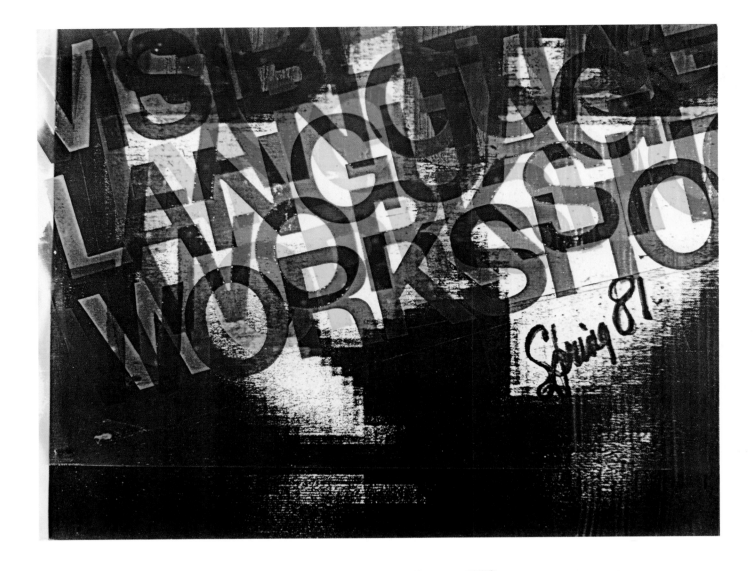

4.880
PROCESS AND PRESENTATION (A)
2.4.6
Joel Slayton
Tuesday 9-12
Lab TBA

A production-based workshop designed
for intermediate and advanced students
to investigate and test new methods of
image generation and to express serious
personal communication concerns.
Emphasizes depth, quality, and
realization of concept through
development of visual communication
skills and appropriate media.
Investigation includes historical,
theoretical, critical frameworks.
Students are responsible for
developing written proposals for a
production project, research documents
associated with this project, the final
realization of the product. Workshop
will include lectures, guest artists
and student presentations/critiques,
field trips, and periodic review by VLW
faculty and guests. This semester we
are fortunate to have Professor
Nathan Lyons, Director of the Visual
Studies Workshop in Rochester, as a
visiting artist/critic. He will
conduct an intensive one week seminar
dealing with Images, Media and Meaning.
February 5-12, 4-7 p.m. daily. Long-
term projects will develop from this
seminar, and he will return at the end
of the semester to review them. This
is an advanced subject and permission
of the instructor is required. This
workshop could support thesis work.
The Lab Fee is $35.

4.886
ADVANCED ELECTROGRAPHICS
Approaches to Visual Communication (A)
0.9.0
Virginia Holmes and Tom Norton
Wednesday 1-4
Lab Monday 1-4

A production-based workshop designed
for intermediate and advanced students
who are ready to work independently
on projects which explore the graphic
applications of electrographic tools
(processes and processors that handle
and control images by electronic
phenomena). Emphasis will be on depth,
quality, and realization of concept and
product. The workshop will consist of
lectures, visits by artists and
practitioners, and monthly reviews
(both one-on-one and group). The
ability to work consistently and
reliably on one's own is emphasized.
Students will also be responsible for
developing two to three major projects,
or the equivalent thereof.
Permission of the instructor is needed
to enroll.
The Lab Fee is to be arranged.

4.889
COMPUTER/TYPOGRAPHY SEMINAR
Special Projects in Graphic
Communication (A)
0.9.0
Muriel Cooper/Ron MacNeil and Staff
Tuesday 1-4
Lab TBA

A seminar designed for computer-
graphics and graphics people to
research and formulate the
relationships between those fields
with particular reference to
typography, layout, and pagination.
The seminar will include an intensive
introduction to computer-graphics and
typography by participants and guests.
There will be weekly outside projects,
a final paper, and two computer
projects demonstrating aspects of
research for future development.
Members will work in pairs or groups.
Participation will be limited to
serious graphic and computer students
who are actively relating the two
fields. Visiting lecturers will focus
on technological and qualitative
issues of hard and soft copy,
including font digitization for
reproduction, design, layout,
pagination, resolution, and static and
dynamic imaging.
Permission of the instructor is needed
to enroll.
A limited number of second meetings
and computer time will be arranged.
The Lab Fee is $25.

Visible Language Workshop course catalog, Spring 1981

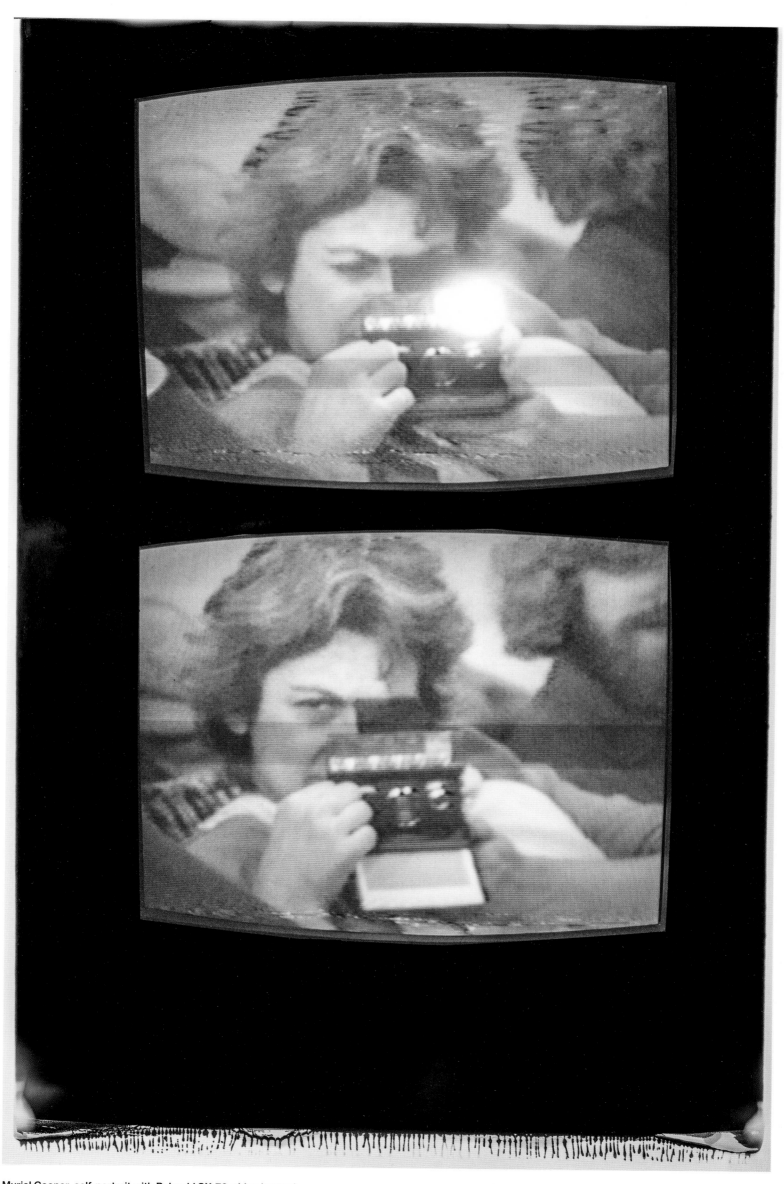

Muriel Cooper, self-portrait with Polaroid SX-70, video imaged
and printed at the Visible Language Workshop, c. 1984

Research

"Books without Pages," proposal to the National Science Foundation
by Nicholas Negroponte, Richard Bolt, and Muriel Cooper, 1978

Books without Pages

Proposal to: Office of Information,
 Science and Technology,
 NSF

Authors: Nicholas Negroponte
 Richard Bolt
 Muriel Cooper

Duration 1 October 1978
 30 September 1981

BOOKS WITHOUT PAGES

Table of Contents

advances and digital-video technology holds both promise and problem.

We propose to examine four selected problems relevant to information presentation in the areas of: Design, Technology, and Technique. They are presented in order of scope.

The role of the <u>design variable</u> is explored under the dual aegis of two: 1) Understanding text as a graphical event; 2) "Media fiducials," or media-inherent bases of orientation, certain of which are lost when we leave traditional paper media, and whose functional re-instatement in the new media needs definition.

A third area needing assessment is the implications of the rapidly emerging <u>videodisc technology</u> for readership (and authorship), and for systems design generally. How can the reader/viewer benefit from this remarkably flexible new technology?

Finally we look at the use of spatially distinct sound channels synchronized with text.

Before proceeding to an outline of six specific studies to be done, we would like to make an overview statement concerning the sort of future we envision for the operational and experimental environment of "reader" of the future.

3.0 OVERVIEW

Books without Pages is about interaction
and dynamism conducted in such a fashion
that it is not at the expense of usability,
availability, and understanding. The reader
becomes an active agent in the information
system with data in the round, itself a
world's fair of sound and light, words
printed and spoken, images animated and
filmed. Multiple media are deployed
concurrently as perceptual and cognitive
boosts from a plateau of formalisms common
to professional peer interaction, but
unintelligible to others. In the following
three subsections of this overview we look
upon some of the unspoken qualities of
traditional forms of communication which,
when without competition from dynamic and
computer-based media, were taken for
granted and not necessarily studied.

zeichnen

= drawing

An internal Rand
Corporation memorandum
(circa 1974) exists
with the same or
approximately the
same title as this
subsection, and with
the same theme. The
authors were unable to
locate it for proper
reference.

schreiben

= writing

malen

= painting

3.1 <u>On</u> <u>not</u> <u>throwing</u> <u>away</u> <u>the</u> <u>message</u> <u>with</u> <u>the</u> <u>medium</u>

Upon receiving a letter through our traditional non-electronic mail system, the scenario goes somewhat like the following. First, the printing on the envelope itself reveals a degree of personalization, later the fold marks of the letter will tell that it <u>did</u> travel in an envelope, and finally our own annotations and underlinings will serve as mental filters and amplifiers for further reading at a later date. Similarly, yellowishness from age, coffee stains and whisky stains reveal degrees of attention or lack of it. And, of course, it can be crumpled. All this is lost in soft copy.

While seemingly nostalgic, these anecdotal differences with computer terminals are some of the reasons people prefer paper to a CRT. While the "added value" of computer based information systems will justify suffering through these indignities, pencil and paper remain graphically richer and are still what most people find comfortable. It is for such reasons that we find ourselves motivated to be scientifically retrospective in the context of the most futuristic soft copy (Appendix II), driven by powerful computers, with the most advanced, sound-synch interactive computer graphics.

3.2 Quality as credibility

The qualities of media affect the qualities of content. We postulate, for example, that presentational quality affects credibility. A reader infers a fortiori truth from quality print and printing. Quality implies completeness and completeness is credible. On the surface, these generalizations have a fickle flavor and, in some circles, they are discounted as artifacts of merchandising and the coffee table. Upon close inspection, we submit that a great deal is to be learned about graphical quality.

A small number of Xerox Graphic Processors (XGPs) exist in research laboratories, particularly in universities, most specifically in Artificial Intelligence Laboratories. These devices allow for the rapid production of variable fonts and what might be called the Xerox original. In the eyes of a graphic designer, their output is shabby at best. But in comparison with most impact or thermal printers, they have an artbook quality. In fact, many draft papers printed on the XGP are read by peers and colleagues with a false sense of completeness. One is noticeably shocked by a misspelling in Times Roman.

In softcopy, we have very few examples of quality presentation. Most users of video terminals are given evenly spaced character matrices, composed of horizontal bands of blinking bits.

At the Architecture Machine, we have been working on high quality text since 1973, to accompany page layout of diagrams and photographs. Such text includes multiple greytones, which introduce a visual smoothness and remove scintillation effects. Also, we have added proportional spacing and kerning. The result is a display which has much of the appearance of quality print. The lack of X and Y resolution is overcome by articulating the Z-variable luminence. This can apply to colored characters as well.

The question is can such quality be controlled at one level to make softcopy reading bearable and at another level to shed added dimensions of credibility? The hypothesis can be lampooned with the extreme of presenting equivocations in

konstruieren

= constructing

Mickey Mouse fonts and substantiated axioms ⁹ in old Gothic. More soberly, we suggest that soft copy offers the opportunity of fine tuning formats, at once making softcopy perusal pleasant and divesting it of the culturally inherited filter of credibility.

tippen

= typing

kombinieren

= combining

setzen

= typesetting

3.3 The design of old systems

Too often the design of new information systems leaves behind valuable knowledge gained from old information systems. There are a number of reasons for this: 1) we tend to take for granted many hardcopy, old-fashioned comforts; 2) their value is frequently parenthetical or related to some other parallel task; or, 3) they are very hard to implement in computers.

To illustrate this we will describe two existing features in our Spatial Data Management System (Appendix II). The first is a page flipper derived from a simple animation procedure (pictured in the adjacent columns). When either browsing or reading, the sequence of pages is given a sense of forward, backward, and change. In comparison to an instantaneous substitution of one "page" for another, this small computational overhead of animation affords a feeling of going through the material in a manner that allows for a mental model of how far one has been. Like reading a book, one knows where one is vis-a-vis the full scope of the book. We call this a "media fiducial." If you are reading with both hands, your left hand holds the material you have covered and your right hand holds the balance. By sheer weight and size you always know (though may not consciously ask) where you are. By contrast, on a computer terminal (especially with on-line documentation) one rarely has a global sense of the whole and where one is within that whole. This animation helps.

The second example is annotation. Consider retrieving paper copy from your file cabinet, say a memorandum one month old. We submit that the annotation of that document can be as important, even more so, than the document itself. Annotations serve multiple purposes: 1) key words for recall of larger informational chunks; 2) highlights of the document's relevance upon receipt (ie: when annotated); 3) supplemental data in the memorandum (like a person's telephone number, jotted down at the time you received it and called). Annotation can also be irrelevant (like a grocery list). The latter has little afterlife, but underlines an important potential for concurrency: old systems allow for interruptions to be serviced by the same medium.

= foreshorten

Reich, S.S. & Cherry, C.;
"A direct access from
graphics to meaning: a
study of the stroop
effect in sentences",
paper presented at the
Conference on Processing
of Visible Language,
Eindhoven The Netherlands,
September, 1977.

Stroop effect: Stroop
(1935) found that the
naming of the color
in which a word was
printed was interfered
with if the word were
a color name. Such
"congruity effects"
have been discovered in
many other contexts,
such as when the relative
placement of an arrow
on a rectangular field
can interact with rapid
response as to which
way the arrow is
pointing.

Stroop, J.R.; "Studies
of interference in serial
verbal reactions", Journal
of Experimental Psy-
chology, 1935, 18, 643-
662.

5.1 Understanding text as a graphical event

"CAR WARS" said a poster, with text reced-
ing into one-point perspective, followed by
the name and address of a used car lot
offering galactic loans and astronomical
discounts. Such metaphors find more sober
application in spatial data management,
where text can live in three dimensional
space. Perusal is akin to driving up to a
billboard, gaining increasing detail up to
the copyright in the corner. In this
section, we focus upon text as a graphical
statement, both in concert and
contradiction with semantics. We are
concerned with the automatic augmentation
of communication through enhancements.

We note the recent study of Reich and
Cherry (1977) in which they varied the size
of printed words in sentences in a picture
verification task thusly: the picture was
of a boy and a girl, where the boy was
taller/shorter than the girl. Sentences
were of the form, e.g., "John is taller
than Sue." The size of the type in which
nouns or adjectives in the sentences were
printed was varied congruently or
incongruently with the meaning of the
sentence.

The important finding was that congruent
sentences were evaluated more rapidly than
incongruent sentences irrespective of the
locus of the size change, indicating a
"Stroop-like" effect not confined to a
single word, but generalizing to the entire
sentence.

We term departures from a regularized font,
spacing, and formatting, "dynamic text."
Not only can dynamic text depart from the
statically usual, but it can modulate in
real-time before the reader, even as a
function of where he is looking (Cf. Gould,
1974). Consider a text line where any word
may dynamically change in size, shape,
color, luminosity. This additional
dimension, call it "Z," can be an
intrinsically "non-spatial" dimension
(color, luminosity), or can be along
spatial dimensions into or across the page,
exhibiting actual movement. Why should text
move or change? We see at least five
reasons: to convey information that itself
is changing, to pace the observer, to save
"real estate," to amplify, and to be
attention getting. Each reason can be

addressed in terms of kinds of change,
which include (but are not limited to):
2-D/3-D translation and rotation; color
changes; shape transformations;
transparency; and transfigurations between
icons and symbols.

Dynamic text is found in its most popular
form on buildings and canopies, with text
running across a band of light bulbs,
telling the news or announcing a play.
Another general use is found in movie
titling, the least elaborate of which is
the simple vertical scroll of the cast of
characters.

Video terminals tend to scroll on a line by
line basis, substituting each line with the
line below it, with one falling off the top
edge and another coming in at the bottom.
We are alarmed by this short cut because
the text is <u>not</u> readable during the scroll.
Instead, simple bitwise or scanline-
by-scanline scroll would make the text
readable and would remove the flashing
effect (about which we know so very little
in terms of eyestrain, for example).

At Tektronix this is
sometimes called:
"Hollywood Scroll".

Coupled with sensing technologies (like
eyetracking) dynamic text offers very
important opportunities, simple and
complex. A simple example would be the
automatic expansion of an acronym should
the reader's eye dwell unknowingly upon it.
In technical writing, the reader is too
often left behind from not knowing
abbreviations or having forgotten their
expanded form, particularly if last seen at
a previous sitting.

We propose that forms of dynamism have
compatibilities and incompatibilities with
communicaton purposes and that there are
design rules which can be scientifically
established. . This part of the research
would entail articulating these rules and
testing their validity. A proper taxonomy
of dynamic transformations will include the
partition between those initiated by the
human being and those initiated by the
information system. For example, one
hypothesis would be that horizontal and
vertical scrolling are most effective when
explicitly (by touch or sight) induced by
the user, and that scrolling as a mechanism
for machine pacing is a counterproductive
method of saving display real estate. This
can be tested in terms of reading,
browsing, and searching, with measures of

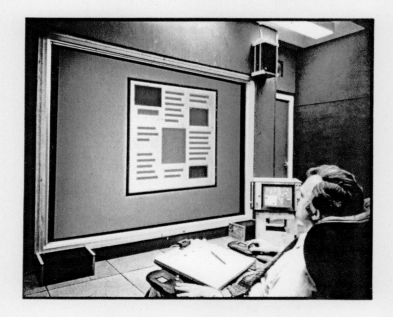

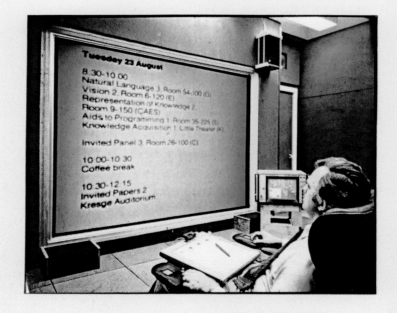

PLATE VIII

Architecture Machine Group Spatial Data-Management
MIT - Interim Report -
November 1977

Author: Dr. Richard A. Bolt
 Research Associate
 Architecture Machine Group
 Massachusetts
 Institute of Technology

Sponsor: Defense Advanced Research
 Projects Agency—
 Office of Cybernetics
 Technology

DARPA Contract Number: MDA903-77-C-0037

Contract Period: 1 October 1976-30 September
 1978

2.0 THE IMPLEMENTATION

This section will describe the prototype SDMS we have created
at MIT, specifically its state as of the close of our first
year. The setting of our SDMS is described, followed by a
description of its dynamics.

2.1 The Setting

2.1.1 The Media Room

The room at our laboratory which is the setting for SDMS
has been dubbed The "Media Room", due to its general role in
our laboratory as a test-ground for computer-based media. The
dimensions of the room are 18 feet wide, 11 feet deep, and
about 11½ feet high. Its walls are covered with 2-inch foam
rubber padding, dark grey in color, which serves as a sound
deadener and provides a neutral visual surround. One wall of
the room has been partially cut out and replaced by a large
sheet of tempered glass, about ¼-inch thick, coated on one side
so that the glass can be back projected upon. In an adjoining
room, to which this wall is common, a General Electric Light
Valve has been set up to back-project a color raster-scan
display. (See Fig. 2-1.)

-13-

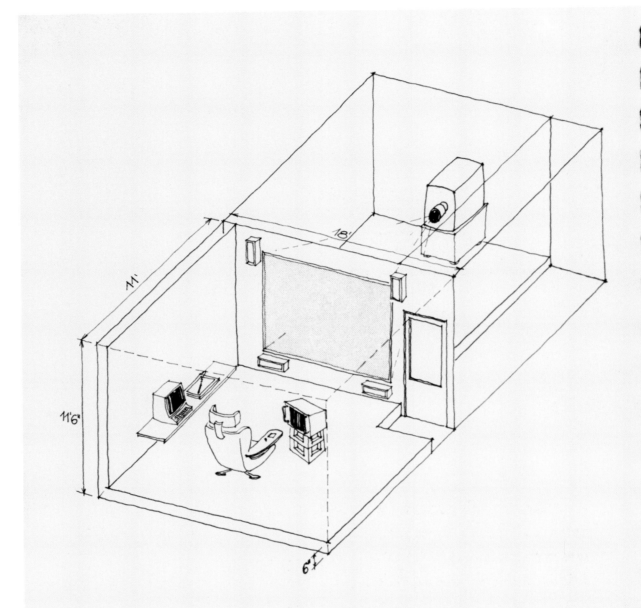

Figure 2-1.

The Media Room

-showing the adjoining room with the
GE Light Valve for back-projection
onto the large 6' by 8' screen.

-14-

Data-Space is a metaphor for
physical interaction. It means the active
engagement of the observer in an
interface which recognizes the real-space
characteristics of User actions:
directionalities in looking, speaking,
touching, and gesturing, together with
system knowledge of User position and
proximities.

By default these aspects of
Man/Computer communication are
generally unavailable to User and
computer alike, due to currently
insentient interfaces. However, this
insentiency becomes increasingly

Spatial Data Management System demonstration video, William Donelson, 1980 (continues on verso)

Large-format Polaroid digital print, slow-scan transmission, c. 1982

Large-format Polaroid digital prints by students of the Visible Language Workshop, 1983

'The name of the song is called
'Oh, that's the name of the song
interested..
'No, you don't understand,' the
vexed. 'That's what the name is
The name really is "The Aged /
'Then I ought to have said "Tha
Alice corrected herself.
'No, you oughtn't: that's another thing. The song is called
"Ways and Means": but that's only what it's called you know!'
'Well, what is the song, then?' said Alice, who was by this time
completely bewildered.
'I was coming to that,' the Knight said. 'The song really is
"A-sitting On a Gate": and the tune's my own invention.'

Lewis Carroll

'The name of the song is called "Haddock's Eyes".'
'Oh, that's the name of the song, is it?' Alice said, trying to feel
interested..
'No, you don't understand,' the Knight said, looking a little
vexed. 'That's what the name is called.
The name really is "The Aged Aged Man".'
'Then I ought to have said "That's what the song is called"?'
Alice corrected herself.
'No, you oughtn't: that's another thing. The song is called
"Ways and Means": but that's only what it's called you know!'
'Well, what is the song, then?' said Alice, who was by this time
completely bewildered.
'I was coming to that,' the Knight said. 'The song really is
"A-sitting On a Gate": and the tune's my own invention.'

Lewis Carroll

Anti-aliasing tests by students of the Visible Language Workshop, c. 1983

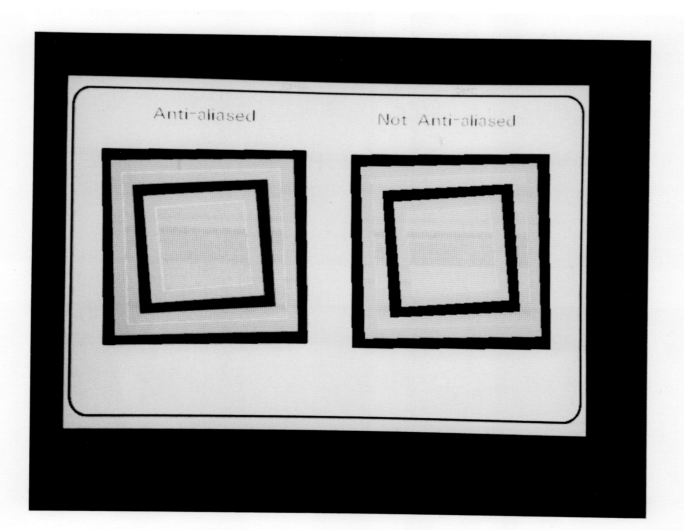

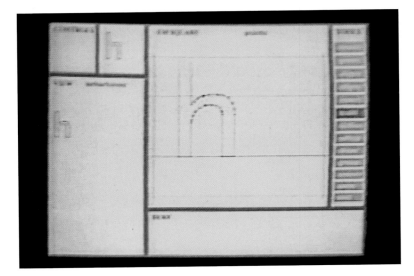

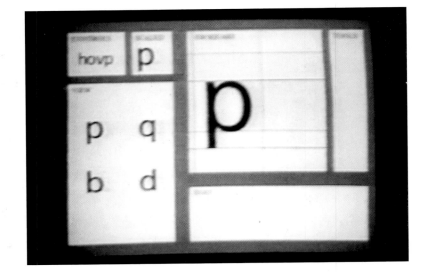

Stills from *Research Topics at the Visible Language Workshop*, video, 1986

MIT Media Lab promotional laser disc,
jacket by Betsy Hacker, MIT Design
Services; video text produced at the
Visible Language Workshop, 1986

Research

35 mm slide image of computer graphics, c. 1988

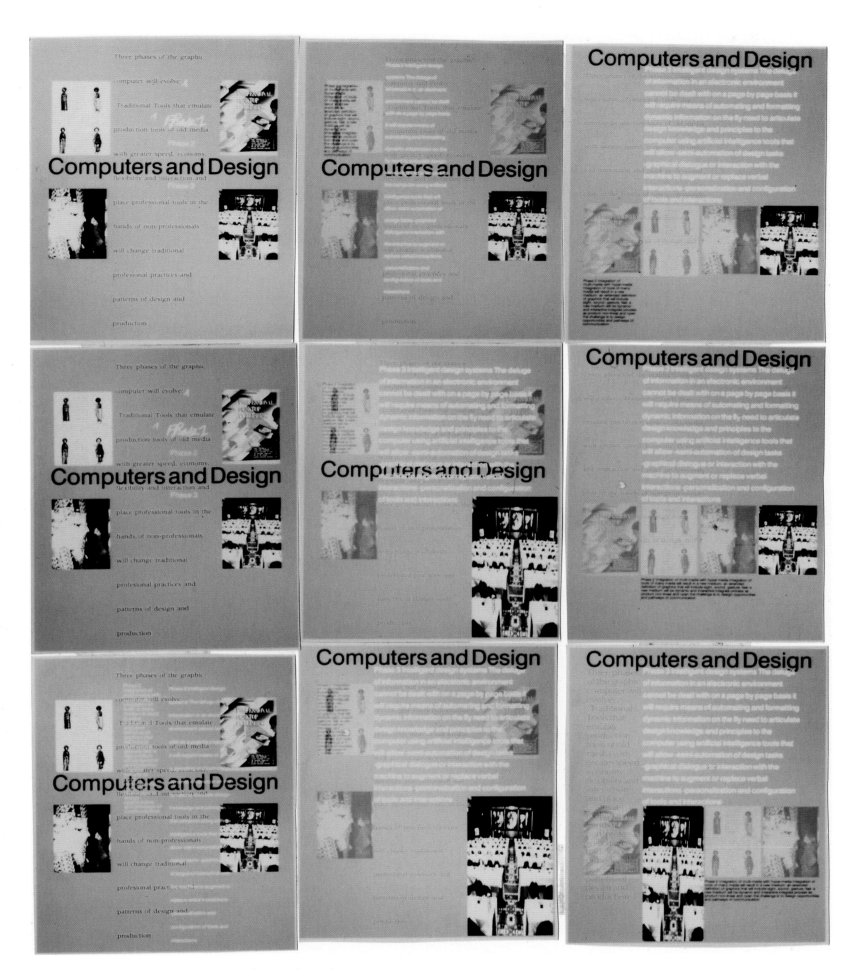

Polaroids with variable layouts for the cover of *Design Quarterly*,
no. 142, "Computers and Design," 1989

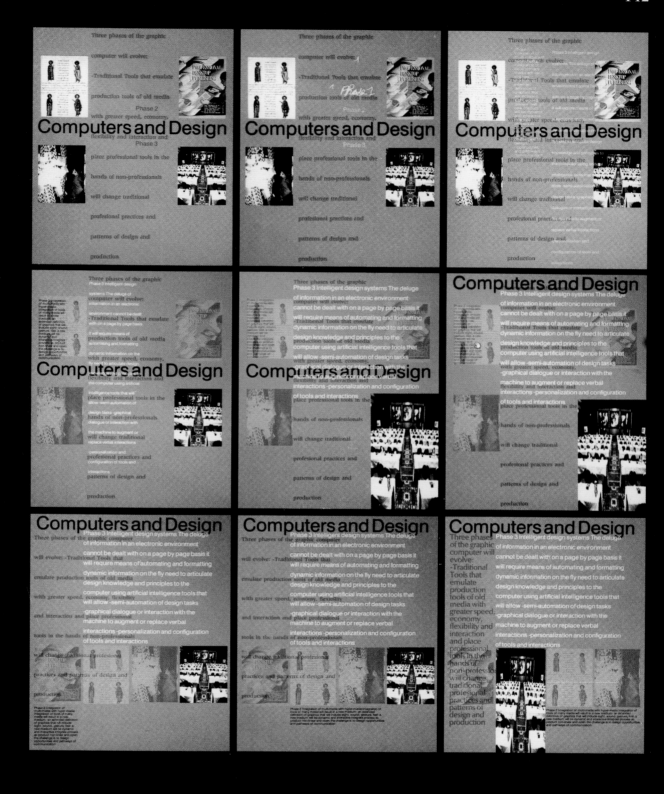

Design Quarterly, no. 142, "Computers and Design," 1989 (cover)

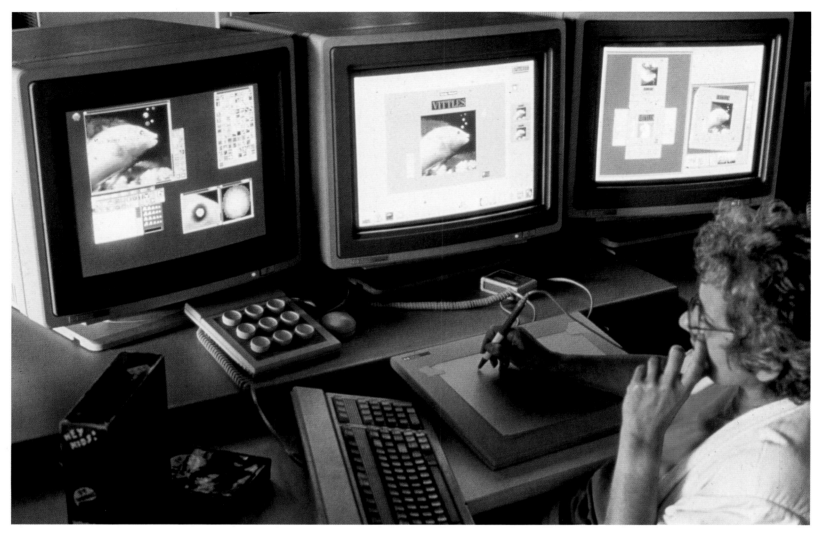
Muriel Cooper at three-screen workstation, 1989

Responsive typography, c. 1989

The Media Laboratory

Likewise, Americans are accepting the machines into their lives
under many different guises.
To students, computers are now familiar education tools.
Those who doubt the basic changes they have wrought
need only visit a slide-rule manufacturer.

Airlines are filled with business flyers intently tapping away at their laptop computers.
Nintendo has found its way into 22 million U.S. households.
Even the most unreconstructed compu-phobes
make daily use of chips in their autos, their kitchen appliances,
and, albeit to an embarrassingly small degree right now, their television sets.

Along with the spreading pervasiveness of computers
has come the surge in computing power.
Today, a person can put more computing power in his or her pocket
than was available on a desktop five years ago.
Tomorrow, people are likely to have more computing power on their wrists
than is found in today's most powerful workstation.

As their power increases and the size of the devices shrinks,
the public is certain to become less and less preoccupied
with their daunting complexity and will, instead, be inspired
to make creative use of the machines.
In a real and a figurative sense,
computers are beginning to touch people,
and therein lies the purpose of the Media Laboratory.

Some terminals

of the future

will be all knowing

rooms without walls.

Others will be flat, thin,

flexible touch sensitive displays.

And others will be

wrist watches

and cuff links

with the right hand

talking to the left

by satellite.

—Nicholas Negroponte,

1980

**MIT Media Lab fifth anniversary booklet, cover by David Small
and Jacqueline S. Casey, 1990**

The 12 Groups

Epistemology and *Learning*	Music and Cognition	Vision and Modeling	Spatial Imaging
Interactive Cinema	Movies of the Future	**Television of Tomorrow**	Electronic Publishing
Graphics and Design	Computer Graphics and Animation	Advanced Human Interface	Speech Research

Interactive
Cinema
Group

The Lab's purpose —
as its faculty
proclaims with
startling brashness —
is to invent
the future of
newspapers,
cinema,
television,
and music.

*—The New York Times
Magazine*

MICONS

MICONS or movie icons are postage-stamp sized,

photo-realistic cinema. Displayed in a small crt window,

they offer a "conversational" way for a user to navigate through

complex material, exploiting the z-axis of time. We see cinema,

the archetype of sequential story-telling, becoming a random

access medium for conversational forms of expression.

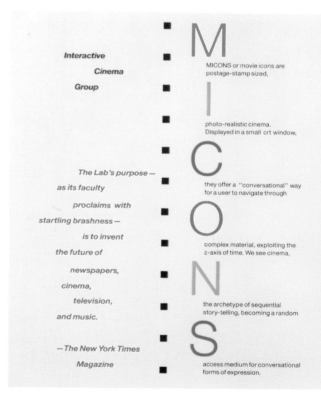

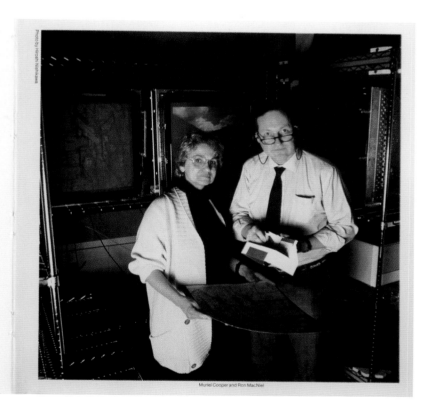

Muriel Cooper and Ron MacNeil

Henry Lieberman, 3D program representation, c. 1991

Stills from Muriel Cooper presentation at TED conference, video, 1994

Information Landscapes, Muriel Cooper, David Small, Suguru Ishizaki,
Earl Rennison, and Lisa Strausfeld, 1994

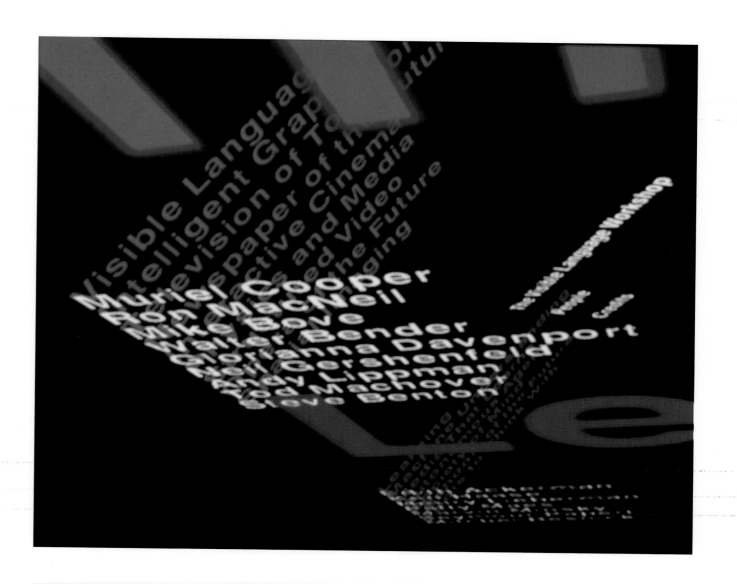

Research

Muriel Cooper
Ron MacNeil
Henry Leiberman
David Small
Rob Silvers
Tetsuaki Isonishi

Muriel Cooper
Ron MacNeil
Henry Leiberman
David Small
Rob Silvers
Tetsuaki Isonishi

Louis Weitzman
Jeffery
Robin
YinYin Wong
Lisa Stausfeld
Ishantha Loku
Xiaoyang Yang
Earl Rennison

Afterword: The Cartesian Gypsy

Nicholas Negroponte

Ping and Pong, Muriel's two large dogs, shed so much that her white Chevrolet Impala was a public hazard. With its roof down and in the slightest breeze, pedestrians would find themselves covered in dog hairs. For ten years Muriel drove me to work every day. My solution was to wear four large garbage bags – a makeshift hazard suit that I stored in her glove compartment.

Her car was a mess beyond dog hairs, cluttered with bits of electronics, cables and AC adapters, and most notably the confetti of ignored parking tickets. Muriel actually had to be arrested and handcuffed to finally make her pay all her overdue fines.

Was the driver of that car really the person who designed the MIT Press logo? Was she one and the same as the person who used grids famously and Helvetica unfailingly, out-Swissing the Swiss with her precision, clarity, and Cartesian thought?

Yes. The same person. Muriel was a person of complexity and contradiction – a person of extremes. She explored everything through its limits and knew boundaries only by pushing on them so hard that they suddenly were boundaries no more. She was great at truth and dare. She dared me to eat a gross of oysters (144 of them) in one sitting, buying and lugging the sack and, with more cunning than Mark Twain, getting me to open (and eat) all of them.

Summer Session

In the summer of 1967, I was a 23-year-old new professor at MIT. In those days, as a faculty member, you could get an extra one-ninth of your salary if you agreed to teach a two-week summer session, which I did (for the money) and Muriel audited (gratis, as MIT staff). The program included an entire week of computer programming, and in this era it was FORTRAN. It was her first brush with computation and the beginning of a long friendship.

Seymour Papert and Marvin Minsky, codirectors of the MIT Artificial Intelligence Lab, were both speakers in this class. One year later, they coauthored an MIT Press book called *Perceptrons*, for which Muriel (by then named head of the MIT Press design department) was personally the layout and jacket designer. Trust me, it was not your normal design process, because Marvin did the illustrations, Seymour edited, reedited, and re-reedited the text, and my home was actually the typesetting venue. The four of us became fast friends. Furthermore, we engaged in an unrelated and parallel collaboration in cooking, what became a lifelong hobby to make the most complicated recipes we could find.

Keep in mind that we were all at MIT. I was in architecture, Seymour in math, Marvin in electrical engineering, and Muriel at the MIT Press. What none of us knew at the time was that fifteen years later we would be cofounders of the MIT Media Lab.

In that same period of gestation, Muriel reinvented herself and reinvented the field of graphic design. She was veritably the first graphic designer to move

from hard copy to soft copy with the skill of a master and the curiosity of a child. She questioned everything and assumed nothing. She moved from ink to glass, taking the world with her.

4096 Pixels

Imagine a world without flat panel displays. All displays at the time Muriel started toying with computers were cathode ray tubes (CRTs) whose doubly curved surface was uninviting and only palatable at a distance, as experienced in a living room, for example, typically in a group experience at a recommended distance of six times the diagonal. Sitting in front of a CRT, one on one, with it about a foot away from you was never considered a positive experience, let alone one that would occupy so much of our time in the future — albeit with screens that would be LCDs, not CRTs.

At the same time, so-called raster scan displays started to emerge, and with them came the jaggies — artifacts more technically called aliasing. Straight lines were staircased, fonts were ziggurats, and displays were monochrome. In no way were these computer images a plausible, general-purpose display medium that might ever compete with the crisp resolution and color gamut of print media. Nobody believed that computer displays would be as good as paper, not to mention that they would be as ubiquitous. She was the first designer to do so.

What tipped her curiosity was a $100,000 five-inch-square piece of glass in my nascent lab at MIT, circa 1975. It had 64 columns and rows of dim, black-and-white pixels, 20 percent of which did not work. Nonetheless, she saw its future. The leap was akin to a resident of New Amsterdam imagining Manhattan.

Flatland Goes 3D

Muriel was obsessed by that small piece of flat glass and knew very well that it would eventually be full-color, high-resolution, large, bright, and low-cost. We coauthored proposals that postulated a world filled with such displays. One of those proposals showed a device indistinguishable from an iPad today.

But more than any other thing, Muriel became fascinated with the potential of introducing motion, animated text, moving scenes, and changing points of view. She was arguably the Charlie Chaplin of graphic design. Enter motion graphics.

By the time the Media Lab opened its doors for business in 1985, it was clear that graphic expression was no longer handcuffed by ink and paper. It could leap off the page, move, make sound, and the experience would not be like pressing your nose against a TV set. It would be more like looking at *National Geographic*, but with new layers of opportunity. Those layers were Muriel's new career.

For the next nine years, until her untimely death, Muriel took some very simple concepts, like blur and translucency, and used them in the human interface in a way that enriched overlapping windows. Steve Jobs loved and admired her work. Bill Gates envied it.

I remember many conversations with Muriel about layers of information and the ability to see more things in a growing but still limited area (think Apple Mac 512K). It was a bit like people in the eighteenth century who handwrote letters and when they got to the bottom of the page rotated the paper 90 degrees and continued writing a second page on top of the first. It was perfectly readable and it saved paper. We needed to do the same with screens. That is, until Muriel burst into 3D and created information landscapes.

Information Landscaping

The Defense Advanced Research Projects Agency (DARPA) was a steady sponsor of Muriel's, ostensibly for advanced mapping. Site visits to the Media Lab were very popular with generals and admirals, a couple of whom seemed to be in love with Muriel. She would relentlessly tease them and their entourage of minions. She fascinated the military brass with her language, manner, and bare feet. I remember when one crew-cut Marine told his commander that the men's room was a hand-grenade's throw down the corridor, Sir! Muriel never let him forget the incident. When they talked with her about theaters, she would digress and change the discussion to the other kind, the kind for which you write plays.

Corporate and government sponsors adored Muriel. She was different from anybody they knew. She said things they never expected, including calling Avery Fisher a "fat cat" to his face. She was comfortable questioning any basic assumption and asking about things she did not know, even if it looked like everybody else in the room did.

In February of 1994, Muriel delivered her first and only TED talk. Another first-time speaker that year, far less popular, was Bill Gates, who immediately asked for copies of Muriel's videos. It was a triumph and turning point for Muriel; her work was being acknowledged, her ideas were beginning to break Windows. The work became so popular that Muriel was asked to host an annual meeting of DARPA contractors in Boston three months later. That evening followed a quick trip to London, after which she was extremely tired. She insisted on doing it anyway, collapsed after her dinner speech, and died a few hours later, out of what we all assumed was exhaustion but turned out to be a serious heart disease we did not know about; nor did she.

When Muriel died, the Media Lab lost a lot of color. It lost one of its best teachers and most genuine researchers. Many of us lost a best friend.

Perhaps the greatest compliment that history can pay is to credit you for something that is obvious today but considered silly, strange, or outright wrong-minded at its time. It is such a good feeling to be right when everybody thought you were wrong.

Muriel you were so.

Illustration Credits

Index

Page numbers in boldface indicate illustrations.